DRAWING
in the
CLASSROOM

DRAWING
in the
CLASSROOM

by

Roger Kukes

kukes@teleport.com
www.rogerKukes.com
(March)

KLASSROOM KINETICS
Portland, Oregon

Cover illustrations:

"R," **Travis Ludahl,** Grade 6
"Self Portrait," Artist Unknown, Grade 5
Illustration for his story, "Dark Vietnam," Ken Vu, Grade 4
Imaginary Insect, Jenny, Grade 3

©1998 Roger Kukes

Library of Congress Cataloging In Publication Data

Kukes, Roger.
Drawing in the classroom: a guide for teachers and students grades 1–8.
Lessons, extensions, curriculum connections, resources, assessment/
Roger Kukes.

1. Drawing–Study and teaching (Elementary/Middle School).
2. Curriculum integration.

Lib. of Congress Catalog Card Number: 97-93703

ISBN 0-9622330-1-3 (pbk.)

First Printing 1998

Published by Klassroom Kinetics
3758 SE Taylor Street
Portland, Oregon 97214
tel: (503) 235–0933
email: kukes@teleport.com

Designed by Susan Bard

For my wife, Linnea,
love of my life

Contents

Two students collaborate on a drawing, "In a Funny Neighborhood."
Grade 1

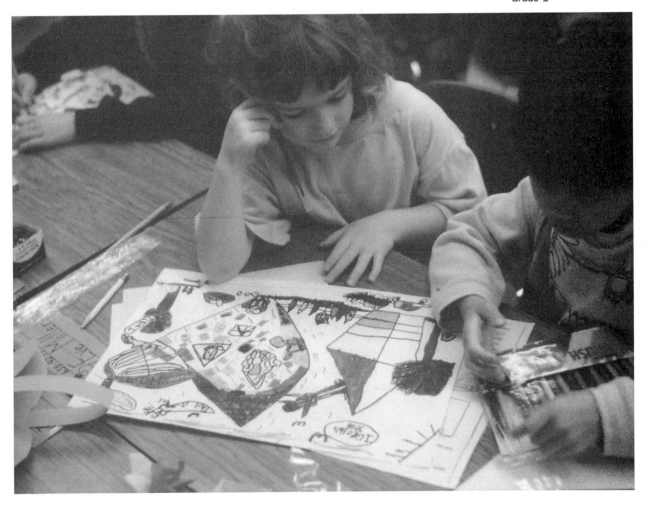

Acknowledgments

I would like to thank the following individuals for their contributions, direct and indirect, to *Drawing in the Classroom*:

Susan Bard, for her graceful and intelligent design of the book. Most especially for her patience with me, and with the endless changes that a project of this scope requires.

Ken O'Connell, Michale Gabriel, Bea and Sam Goldstein, Pauline and Lloyd Anderson, Judee Axelsen, Judy Mann, Anita Halstead, Gary Kukes, Fine and Jerry Gelfand, Ralph Kester, Vicki Poppen, Roseanne Kotzer, Luella White, Suzanne Argyle and Marge Rich for their unflagging encouragement over the long haul.

Professor Arne Nixon, beloved colleague, humanist, magician and storyteller who died in July, 1997. My work in classrooms with both teachers and children will always owe an inestimable debt to you.

Anita Halstead, prime mover of Art-Based Curriculum, for her vision and tenacity, and for the inspiring leadership she has brought to the teachers of the Monroe (Washington) School District. In a dark age of arts education, you are a beacon.

Lisa Barnes, Vicki Poppen and Margaret Eickmann, my dedicated and good humored colleagues at the Artists-in-Education program in Portland.

Professor Howard Gardner for his many fine books, and especially *To Open Minds*. It helped me better understand the two poles in my own pedagogic personality: one inclining toward encouraging children's free, unstructured expression; the other, dedicated to helping young artists build basic skills through direct instruction. After reading Dr. Gardner's analysis of American and Chinese arts education, I saw clearly the two aspects, not as contradictory, but wholly compatible, mutually enriching and critically important to my maturation as an educator.

Rex Crouse of the Oregon Department of Education for encouragement, and for his useful comments on assessment and standards based education.

Maya Kukes, Judy Mann and Eleanor Pronman for their careful reading of the manuscript.

Norah Gilson, my daughter, for her many fine drawings.

Joey Novak for permission to use his drawing, "Log Truck," on p. 251.

Diane Neutzmann for permission to reproduce the researched based calendar, "Endangered Species" appearing on p. 287.

Linda Adler for sharing ideas relating to *Abstract Drawing*, p. 93.

Marjorie and Brent Wilson for their inspiring writing on imaginative drawing, and for the project, *Silly Stack Ups.*

Linda Carlton for the delightful writing she did with her sixth grade students to accompany the **Extension**, *Rooms We Can View*, p. 222.

John O'Halloran for permission to use his inventive project explicating narrative structures. (See an example, John Bui's fairy tale drawing on Color Plate p. 4.)

Anne Fontaine for ideas that inspired *Snakes*, p. 136.

Cheryl Wengard for sharing animal drawings by her third graders appearing on pp. 208 and 209.

Lori Schumway for *People Poems*, p. 176.

Cynthia Hubbard for ideas appearing in *Autobiography*, p. 175.

Alice Street, Shaerie Bruton, Barbara Holmes, Ann Austin, Kevin Plough, Bonnie Ball, Jeanne Mikesell, Julie Winder, Linda Roberts, Tony Paget, Francey Heffernen, Liz Simmons, Ida Sugahiro, and countless other wonderful teachers and friends who contributed drawings, advice and good wishes.

Thanks are also due to The Regional Arts and Cultural Council, Portland, Oregon for a generous grant; and to Dover Publications, Inc., Mineola, NY for permission to use images appearing on pp. 32, 142, 151 and 181.

Finally to the hundreds of teachers who welcomed me into their classrooms from Whittier, Alaska to San Diego, California; and to the countless children who challenged and inspired me, my heartfelt thanks. Without your creative energies, there would be no *Drawing in the Classroom*.*

Roger Kukes

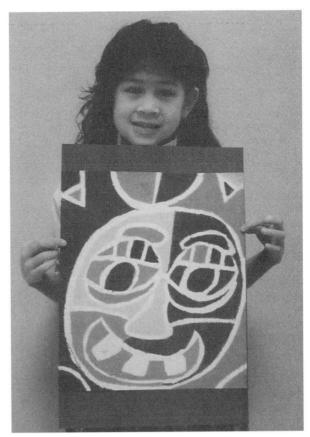

"Fantastic Face"
White chalk
and oil pastel.
Grade 3

*Alas, some of the drawings in the book are not credited. At times photocopies or slides of drawings were made in a rush, or unsigned pictures were gathered long before I thought of writing *Drawing in the Classroom*. To these unacknowledged creators, young and old, my apologies. Hopefully, future editions of this book will include your names.

Roger Kukes in his studio with some of his drawings.

Introduction

As a visiting artist, I came with reams of paper, markers and colored pencils. In tough inner city schools, ritzy suburban classrooms and pastoral rural settings we drew together —self-portraits, scenes from the Oregon Trail, real flowers, mammals, predators. We designed dream houses, bizarre cars, weird rooms and traveled to distant planets.

At first I was surprised by children's love of drawing, and by their hunger for information. ("How do you draw a dolphin?" "How do you mix turquoise?") I learned quickly that with information, guidance and encouragement children could produce drawings that were everything I knew terrific drawing to be: inspired, unique, meaningful, beautifully crafted.

But I was distressed, too. For many of the children I worked with, *I* was their yearly art experience. The coincidence of shrinking tax bases and the back to basics movement of the 1970s and '80s triggered the phasing out of art specialists in elementary schools from Oregon to Florida. The responsibility for teaching art fell to untrained, overwhelmed classroom teachers. What I saw in hallways bore out my concerns: generic illustrations, slapdash posters, cookie cutter holiday art projects. (Of course, there were and are individual classrooms, and occasionally whole schools, where adventurous art plays a key role in the lives and learning of children. Alas, these oases of skill and creative excitement are the exception, not the rule.)

My concern reached critical mass in the 1990s when it became clear that the "triple whammy"— never enough time, untrained teachers, and the coming of computer clip art — might actually threaten the existence of drawing in schools. As more and more students gained access to computers at home and at school, I feared, teachers and kids alike might be tempted to take the path of least resistance: use clip art and stock images to illustrate student stories, poems, reports and publications. Goodbye handmade kid art. Hello anonymous digitized pictures of anything under the sun—in nano seconds.

As the millenium approaches, I offer this practical text, designed especially for teachers and kids, grades 1–8. It presents drawing as—
- **A series of easy to teach skill building lessons.**
- **Doable in today's schools** with their time constraints and limited supply budgets.
- **A teaching and learning tool** capable of promoting perceptual, intellectual and emotional growth.
- **A unique form of communication and expression.**
- **A part of an adventurous art program** that embraces standards based education, "Multiple Intelligence Theory," curriculum integration, and alternative forms of assessment.

Drawing will always play an important part in the healthy development of happy children. With the insistence of enlightened educators, drawing will always have a place in school.

Roger Kukes
Portland, Oregon
1998

Getting Started

"The child only remains fixed on a single image or on a way to draw if he is not presented with other models, or encouraged to seek out other ways to draw."
Marjorie and Brent Wilson, Teaching Children to Draw

"If there is too great a stress on untrammeled creativity...the child may end up without skills and thus be able only to communicate or fantasize with himself. On the other hand, if there is unrelieved focus on skill development the child may end up unable to execute anything different from the models he has emulated."
Howard Gardner,
To Open Minds

**Rinneke Dierken
Teacher**

Why the Lessons?

Why not just turn kids loose to draw in their own way? We should. Children need plenty of time to draw freely at home and at school with fun materials and without adult direction.

Yet, there is a phenomenon that many of us have observed in elementary classrooms. Throughout first grade and well into second, most children draw and illustrate unselfconsciously–and with gusto. By grade three (I have seen it start much earlier), kids begin to notice that the drawings that previously brought them immense satisfaction are beginning to look crude, or—as one fourth grader told me—"Dopey, like a first grader did it."

It's not surprising that children feel frustrated. Art, if it's taught at all, often presents itself in the classroom as one of the following: the weekly half hour lesson (e.g., "Autumn Colors"), art appreciation (e.g., a brief look at the collages of Henri Matisse) or a curriculum connected project (e.g., topographic maps of "our state" made out of papier mache).

"Picnic Dinner"
Norah Gilson
Grade 1

While the aforementioned are laudable and clearly intend that children have some sort of art experience, something is missing. Kids have told me so, over and over:

- *"I wish we could do more art. You know. The kind we like to do. Draw cars. People. Aliens. Horses. Only get better at it."*

- *"I want to draw things so they look real!"*

- *"I want to learn how to color so my pictures look good."*

It's no wonder that untrained teachers and frustrated kids increasingly resort to the use of computer generated clip art to embellish student reports, publications and displays. These slick, anonymous pictures are sad symbols of the demise of art education in the United States. It doesn't have to be so.

Children *want* to make images by hand. But they want to feel that their pictures represent them proudly. And, that they are making progress as young artists just as they are progressing as readers, writers and math problem solvers. And they can.

Norah Gilson
Grade 1

The eleven **Lessons** are the heart of *Drawing in the Classroom*. Their purpose is to empower children to become more intelligent, confident and expressive visual artists. The **Lessons** are fun, yet challenging. They invite every student's participation, growth and success. In designing the **Lessons** I've tried to strike a balance between teacher guided instruction and student activities that invite personal invention.

The **Lessons** are presented in order of difficulty and should be done in sequence. (Ideally, one or two **Lessons** per week starting as early in the school year as possible.) Within each **Lesson** the easiest activities come at the beginning, and the more challenging material at the end. Most of the activities can be done, with slight adaptations, comfortably by children in grades 1–8.

Time

Realizing the time constraints that almost every elementary teacher is under, I've tried to make each **Lesson** last no longer than an hour to an hour and a half (the amount of time mandated for art instruction weekly in many school districts across the United States).

Materials

The basic materials for classroom drawing are:

- **Softer lead pencils (#2/HB)**
- **Fine nibbed black pen**
- **White plastic erasers**
- **Colored Markers**
- **Colored pencils**
- **Photocopy paper**
- **Drawing paper**

Some or all of these will be listed for use in the **Lessons**.

All brands are not created equal. You'll find my recommendations under **Media** starting on p. 246. The good news is that most items on my list can be found routinely in school supply rooms.

The only extravagant recommendation I'll make are Prismacolor colored pencils. They are incomparable.

Following each **Lesson**, you'll find additional categories: **Extensions, Teacher Tips..., Curriculum Connections** and **Resources**. Each contributes something unique to the practice of classroom drawing.

The **Extensions** present additional projects that under-score and expand on the material presented in the **Lessons**. They can be done by individual students or by entire classrooms. Often, the **Extensions** are more open-ended than the teacher directed lesson. Finding the time to do one or more will greatly enhance a student's drawing ability.

The *Guidelines* presented for each **Extension** are a list of the main points to be addressed as students complete the assignment. Some of these "main points" can also be used as "criteria" to evaluate completed student work. (See **Assessment**, p. 290.)

Write the *Guidelines* list on the chalkboard or overhead for students to refer to while they're working. (Simplify the language in the *Guidelines* as you deem necessary.) Remind students regularly to make sure they are addressing the "main points" as listed. This will help them "stay on target."

TEACHER TIPS

In **Teacher Tips...** you'll find suggestions, random thoughts, and additional bits of information, all designed to help you better understand and teach the material under discussion.

CURRICULUM CONNECTIONS

Far from being an exhaustive list, **Curriculum Connections** are designed to tweak your imagination. Though we may not have the time or inclination to draw "across the curriculum," I have no doubt that we could. *Every* subject could profit from a partner-ship with drawing. Hopefully, the material presented here will stimulate new possibilities for drawing as a teaching tool in your classroom.

Jill Knoblich
Grade 4

RESOURCES

Resources provides me with the opportunity to share books, magazines, articles, videos and on-line information I know will enrich your (and your students') experience and understanding of the content of each **Lesson**.

Sue Cowan
Teacher

Student
Grade 5

ADDITIONAL FEATURES OF THE LESSONS

Script

In an effort to make the material you'll be presenting as clear as possible, I've included a kind of italicized "script," i.e., words that a teacher might speak as she introduces the central concepts and techniques of each lesson. My intent here is neither to put words in your mouth, nor to sound patronizing. It is to offer you courage and support by providing a vivid example of what I myself might say if I were to visit your classroom. Clearly, my language can't be yours. Think of the italicized words as a starting point.

Black Line Masters

To facilitate teaching and learning and to save you time, **Black Line Masters** can be used throughout the **Lessons**. All the black line masters, numbered in order, can be found starting on p. 344. I'll specify when a **Black Line Master** should be copied on to an overhead transparency for teaching purposes, and when it should be photocopied for student use. Because of a special flexible binding, the book can be opened flat as often as you like when photocopying, and it won't come apart.

Symbols to look for

P Look for the symbol at the left when an activity is appropriate for primary aged students (grades 1–3).

I Look for the symbol at the left when an activity is appropriate for intermediate aged students (and older).

Materials

The **Lessons** assume the availability of the materials mentioned above. To facilitate your preparation, materials will be "called out" in boxes adjacent to an activity or project.

Vocabulary

In an effort to help students develop a serviceable artist's/illustrator's vocabulary, I've highlighted key words whenever they appear (e.g., *pattern, detail, composition,* etc.). These key words are defined when first introduced. Many are listed in the **Glossary** in the back of the book.

While most of the terms I use are familiar art vocabulary, a few are part of an "art speak" of my own invention. *"Nail the White," "3–M," "Shapes Galore,"* etc., helped me explain concepts or techniques to large groups of students, and to make them memorable. These original terms are always presented in quotation marks. My apologies to art purists.

A WORD TO TEACHERS

Skill Building: Modeling and Practice

I believe that children build skills and understanding quickest when tools, techniques and concepts are modeled for them. Done properly, modeling doesn't inhibit children's creativity. Rather, it excites possibilities that simply could not exist had a particular model not been presented. (Yes, I am going to ask you to be a "modeler" even if you can't draw a straight line with a ruler.)

After modeling comes student practice. There are two different kinds.

The first asks students to pretty much copy what's been presented. I call that form of practice *"mimicking."* Actually *"mimicking"* is a time tested form of art instruction. It's the way that six year olds in China learn to paint masterful goldfish, frogs and cattails. And, it's the way thousands of art students have penetrated the working processes and paintings of Rembrandt, Renoir and Cezanne.

Amy Chapman
Grade 5

The second form of student practice is very different. I call it "invention." After grasping the concepts or the skills in the model(s) presented, e.g., *parallel lines* or *contrasting colors*, students are invited to practice, discover or explore in their own way. Although everyone's working with the same concepts and *guidelines*, everyone's product will be unique. (That's good. That's art!)

Student
Grade 5

Scratch-Foam® print

B. Holmes
Teacher

"But I can't draw!"

Don't worry. You're not alone. Remember: no one expects you to be an art teacher extraordinaire. *Your* performance isn't the issue. Your willingness to deliver information, create opportunities, and set standards is. To succeed, you'll need:

• A willingness to try new things yourself.
• The desire to share new possibilities with children.
• An open and honest attitude.

It's okay to tell kids, "I'm no art expert, but I'm trying! We'll learn and grow together." (And you will!)

If you have art skills or training—great! It will be even easier to share the material that follows.

Be sure to read through an entire **Lesson** or **Extension** before teaching it. Try the student activities yourself whenever possible. Doing so will help you build skills, provide you with samples (however humble) to share with kids, and enhance your ability to empathize with student artists. And remember: the first time you teach a lesson is the toughest.

Adapt—Invent

As you proceed, remember that the **Lessons** I'm proposing aren't part of some rigid drawing system. They represent my best efforts to distill and share strategies that have worked for me in hundreds of classrooms. As your own experience with this material grows:

• Adapt for developmental appropriateness.
• Dispense with a part of a **Lesson** that seems inappropriate or passé and replace it with an **Extension.**
• As students gain skill and confidence invite them to create original activities and **Extensions.**

Proceed Positively—and Gently

A few years ago I visited a middle school art room. Above the chalkboard hung a sign that said in bold black letters **"NO NEGATIVES."** I asked the art teacher about it. "It's simple," she said. "Kids can think whatever they want, but I won't allow thoughtless and mean comments about a child's work in my classroom." Nor will I.

Nor should you, for obvious reasons. People, regardless of age, feel relaxed, energized and better able to learn when they feel safe, secure and supported. And conversely, people of all ages feel uneasy, depleted, and less able to learn when their best efforts are invisible, criticized or ridiculed.

As teachers we can do far more than "disallow" negatives. We can use art as yet another way to support student growth and confidence, and build a sense of community. (See *"Appreciation,"* p. 285.)

As you begin the **Lessons,** proceed with patience and gentleness, especially when teaching primary aged young-sters. Honor every child's unique response to the material presented. And remember, the goal is playful and enthu-siastic participation, not perfect performance.

Scratch-Foam® print

Hyueyeon Lee
Teacher

Line

Lesson 1

"Lines are as basic to drawing as letters and words are to writing."
Roger Kukes

"A line cannot exist alone. It always brings a companion along."
Henri Matisse

Student
Grade 1

Lines can be seen everywhere: on the palms of our hands, as cracks in sidewalks, in the webs of spiders. Lines are as basic to drawing as letters are to writing. As we shall see, there are many more nameable lines than we ever would have thought: *"whisper,"* vertical, *pattern*, tapered... Line is the perfect place for students to begin drawing practice and to begin building an artist's/illustrator's vocabulary.

MATERIALS

Drawing paper 8.5″ x 11″ (3 sheets per student)

Pencils and erasers

Black Flair pen (See *Media*, p. 252)

Markers having a variety of nib sizes (See *Media*, p. 251)

Black Line Master #1

LESSON

Tell students:
Today we're starting the first of a series of drawing lessons. Each lesson will teach you something new about drawing and picture making. As we draw together, we're going to learn and use terms that real artists and illustrators use — words like horizontal, pattern, diagonal and parallel. Everyone, absolutely everyone, is an artist, and everyone can be successful. Our first lesson is on line.

Straight Lines

Teacher draws the three different straight lines on the chalkboard, labels them and asks students to find examples in the classroom.

vertical horizontal diagonal

Curved Lines

Teacher asks students to look for examples of curved lines in the classroom, then draws a few curved lines on the chalkboard.

building

monster

snail

Give students time to practice drawing straight and curved lines. (*"No pictures, please—just lines for now."*) After drawing, ask students to write down a word or two describing what a particular line or line series reminds them of, if anything. (Metaphorically minded children, in particular, will enjoy this activity. It can be done following any of the line activities).

Parallel Lines

Teacher draws a few straight and curved line figures on the chalkboard (below), then shows students how to draw parallel lines. As you draw your parallels, provide students with a definition: *"Parallel lines are lines that are always the same distance apart. They never touch or cross"*.

Now show students that hatched and cross hatched lines are comprised of a series of parallel lines.

hatched cross hatched

Invite students to draw their own parallel lines comprised of straight, curved, hatched and cross hatched lines. Their parallels might form letters, numbers, even shapes— anything goes.

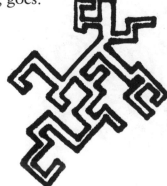 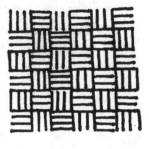

"All Kinds O' Lines"

Teacher draws the lines described below on the chalkboard. (As you draw your lines, invite students to draw along with you.)

1. *"Whisper lines"*

Whisper lines are drawn very lightly. They're so lightly drawn you can barely see them. They're like a "visual whisper."

What's good about whisper lines? They can be easily erased if you want to make changes in your drawing.

What's bad about whisper lines? You can barely see them!

2. Line Weight: Thick and Thin Lines ("T n' T")

Lines have "weight." They can be very thin or very thick, and they can be everything in between. Show **Black Line Master #1** on the overhead.

Which words are easiest to read? Why? The darker and bolder lines.

The darker and bolder a line, the easier it will be for us to see it.

Try some slender, "barely there" lines. Try some bold lines. Which lines would be better to use a for a book title? Why?

 Using different drawing tools, draw lines having at least four discernible line weights

Using different drawing tools, draw lines having at least eight discernible line weights

"All Kinds O' Lines"

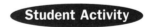

"Whisper lines"

Student Activity

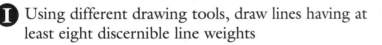

Nine different line weights created with various drawing tools.

3. Tapered Lines

Show students that lines can taper—i.e., gradually change thickness. "Tapering" is most easily accomplished by drawing two lines that slowly converge, then filling in the space between the lines.

4. Broken Lines

Broken lines are comprised of small marks (dots, dashes, x's, circles, etc.) that extend across the paper.

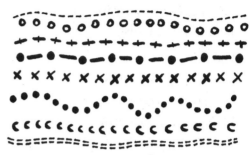

5. Pattern Lines

Not a pattern **A pattern!**

Pattern lines can be very simple

tipi

wave

castle

Patterns can remind us of something

Lines of all kinds (straight, curved, long, short, thick, thin, tapered, even broken) can form patterns. In order for a line to be "patterned," there need to be a minimum of three components that repeat.

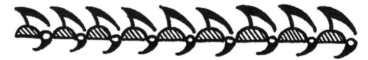

Some patterns can be pretty complex

Notice how the "fancy" pattern lines below incorporate many of the lines we've discussed–straight, curved, parallel, "T n' T," and tapered.

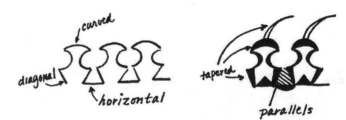

Student Activity

Invite students to create *"All Kinds O' Lines,"* *"whisper,"* "T n' T," tapered, pattern, broken, as well as lines of their own invention. As they draw, remind them that— *It's okay to copy some of my examples, but to be sure and create some original lines as well.*

All of the following **Extensions** encourage the playful use of line, the development of fine motor skills and good old creative thinking. Unless otherwise noted, they can be done in the media of your choice: pencil, ink, or colored markers.

Older students may wish to start with *"whisper lines"* and *"finish in ink."* (Light pencil lines are darkened with black Flair pen and, after the ink has dried, all pencil lines are erased.)

Before students attempt any of the **Extensions** below, or throughout the book, take a few minutes to explain the concepts and techniques by modeling them. (Modeling is "the great explainer.") Once your modeling is finished, ask students: *Are you going to copy mine? Of course not! You are young artists with your own great way of doing things.*

Be sure to list *Guidelines* for each **Extension** you teach on the chalkboard. (You might want to simplify your guideline list for younger children.) *Guidelines*, a series of specific task instructions, establish standards while presenting clear learning targets that every student can hit.

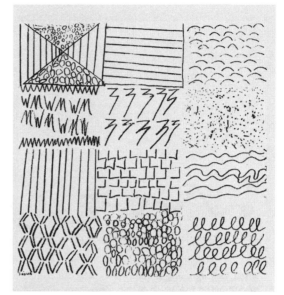

"All Kinds O' Lines"
Grade 3

1. Alien Writing

Alien Writing is my name for an imaginary script that could have been produced by an artistic A.L.F.(alien life form) from a distant galaxy. It requires students to use the "Draw-pause-draw-pause method" (i.e., drawing a line, pausing to change direction, then drawing again). You'll see that using "Draw-pause, draw..." will yield lines of script that are far more intricate and unique than lines made with one continuous movement of the pencil.

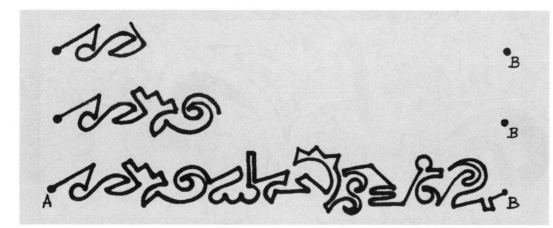

Three stages of Alien Writing

Alien Writing using a continuous line (no pauses or changes in direction), above, is far less unique and intricate than "script" produced using the "draw-pause, draw-pause method," below.

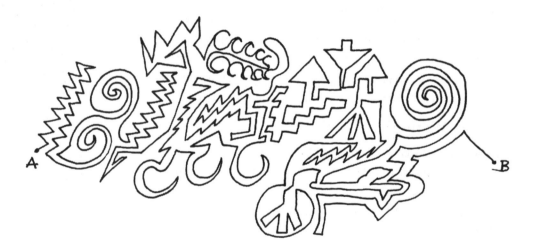

2. Maze

This variation on *Alien Writing* asks students to use long, short, straight and curved lines to create elaborate mazes.

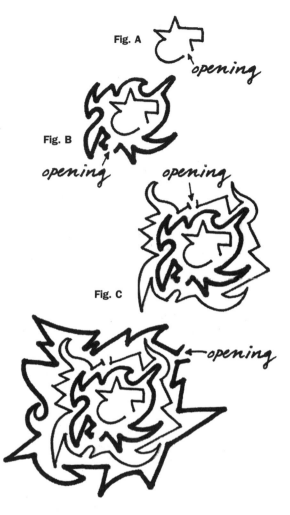

The step by step creation of a maze using the "draw-pause, draw-pause method."

GUIDELINES

- Begin your drawing in the middle of a sheet of paper 8.5"x 11."

- Use the "Draw–pause, draw–pause method" to create a linear construction with a small opening in it (fig. A at the right).

- Draw a second linear construction a little larger than the first (fig. B), and a third a little larger than the second (fig. C), and so on until the paper is filled.

- Use at least five different kinds of lines. Anything goes, except broken lines.

This project is most beautiful when students use colored markers to create their mazes.

Here are three different possibilities to consider:

- **A–B Color Pattern Maze**
 Alternate the colors of the linear constructions— e.g., first one–red; second–black; third–red; fourth–black, etc.

- **Rainbow Maze:**
 Go through the colors of the rainbow (and around the color wheel, p. 273) sequentially—e.g., first linear construction–red; second construction–orange; third– yellow, etc.

- **Crazy Quilt Maze**
 Change colors randomly and frequently as the parts of the linear constructions are created.

A finished maze. Notice the distinctly different "line weights."

3. Line That Name

This exercise in imaginative name writing is a great way to expand children's understanding of letter forms.

intended line mistake

Example of making
a mistake work....

"Mistake" made into
something new

4. Lines — Your Way

At last, the freedom to draw anything, with a couple of stipulations. First, that our young artists work in *"straight ahead ink,"* — i.e., use a fine nibbed black marker from the very beginning of the project so that erasing isn't possible. Second, that they practice a strategy called *"Make a mistake work in your favor."* Real artists work with their mistakes all the time. Rather than start over when a mistake is made, take a deep breath and say, "Okay, I've got a 'boo boo' here. It's something I didn't intend and probably don't even like. The question is, how can I look at this mistake another way. How can I turn it into something that makes my drawing even better than it would have been."

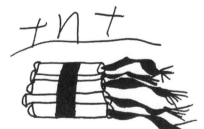

Satirical drawng
of thick and thin lines.

Student
Grade 4

1. From the beginning of the very first lesson say to your students as often as you need to, *Drawing isn't just for students who may be blessed with talent, it's for everyone. Everyone can do these activities and everyone can be successful.* As we shall see, learning to draw isn't only about reproducing recognizable items, a chair, a horse, a face. It's about using visual elements like line, shape, pattern, skillfully, and creatively. And, it's about practicing fine motor skills.

2. The only way students will develop an artist's/illustrator's vocabulary is by learning and using the terminology. Valuing and using the language of art and drawing begins with you. Students should know what *"whisper lines"* are, and the difference between horizontals and verticals, pattern lines and parallels. This will come with practice and with using the lingo regularly.

3. While the basic materials (pencils, markers, colored pencils) recommended for classroom drawing are certainly adequate for all of the student activities and **Extensions** described above, for fun, and variety, consider some of the alternative drawing materials discussed under **More Drawing Media**, p. 265. Crayon, oil pastels, bleach, scratch foam board, will all work superbly as media for line discovery, play and practice.

4. For optimal fine motor control when creating parallel lines, try this old calligrapher's trick. As you draw your parallels, watch the space in between the lines, not the line that you're drawing. Focusing on this so called *negative space* makes it much easier to regulate the distance between the lines. The same strategy will be helpful when creating pattern lines—especially intricate ones.

5. Many years ago, a poet friend described the great time she was having writing poetry with young children. "Kids love playing with words," she told me. "Playfulness engenders a love of language." I have found the same thing to be true when teaching line, shape and color to kids. Playfulness engenders a love of *anything*. Think of the student activities and **Extensions** as invitations for children to play with visual elements.

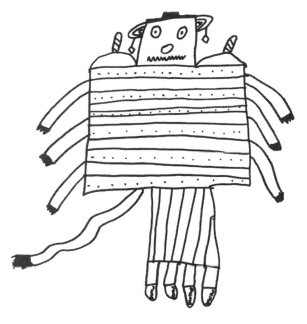

Student
Grade 2

MATH

• Lines are an integral part of geometry. A couple of the **Extensions** above (e.g., *Alien Writing* and *Mazes*) can be used to help students build math vocabulary as well as drawing prowess.

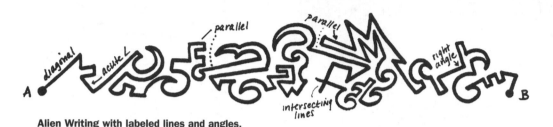

Alien Writing with labeled lines and angles.

• **Pattern lines** (p.14) are an effective way to teach children about simple (A and AB) and complex (ABC and ABCD) patterns while encouraging creative thinking and *craftsmanship*, as well as fine motor and design skills.

LITERATURE

• **Line List** presents a rewarding opportunity to "see more," a goal for all visual artists and writers. Start by looking for examples of lines in the classroom. Then give this assignment: *During the next three days, be a "line scout." Your job is to find and list intriguing and unusual examples of lines.*

One fifth grader's list included these:
Crack on the ceiling over my bed
Parallel lines on my watch band
Wood grain on the floor
Vertical lines, decorating a light switch
Wrinkles in my pants
Rain coming down
Telephone wires
Longitude and latitude lines on a globe
Shoe laces coming out of my shoe
Lines on my turtle's shell

Collograph (print)
Martha Rudersdorf
Teacher

• Reduce and repeat photocopied borders (p.144) to create handsome fringes. These can be used to decorate student made stationary, book covers or writing projects.

• When making book covers, posters or displays where strong visuals are required, remind students to use thicker, bolder lines for words and graphics so their ideas, (verbal and visual) have greater impact.

RESOURCES

1. Johnson, Crockett. (1955). *Harold and the Purple Crayon.* New York: Harper and Row.
Pint sized Harold draws the things of our world with one continuous line emanating from the tip of a purple crayon.

2. Siebold, Otto. (1993). *Mr. Lunch Takes a Plane Ride.* New York: Viking Kestrel.
A dog is invited to appear on a TV talk show with unexpected results. Siebold's slick and whimsical shapes, colors and especially lines, derive from handmade drawings that were manipulated on his Power Mac. At last, terrific computer generated illustrations!

3. Marzollo, Jean. (1992). *I Spy.* New York: Scholastic Inc.
Check out the array of everyday objects which are also lines: paper clips, springs, pins, spirals, tracks, key chains, etc., scattered across pages 12 and 13 in this handsome "find it" classic.

4. Blackman, Hall and Richard. (1981) *Northwest Coast Indian Graphics.* Vancouver: Douglas and McIntyre.
An introduction to the magnificent silk screen prints of artists working in traditional and contemporary styles. Almost every print illustrated showcases ingenious use of line—especially thick and thin.

5. Fagin, L. (1991). *The List Poem.* New York: Teachers and Writers Collaborative.
If you're at all intrigued by the "Line List" on p. 20, you'll want to take a look at Fagin's book. It's full of writing ideas that use lists as quirky, failproof poetry starters. I've used "lists" of all sorts while teaching drawing for years. Lists are a great way to engage and excite linguistic learners while drawing. Highly recommended.

6. Black and white comics in daily newspapers.
From the simple, scratchy drawings of Scott Adams (Dilbert) to the facile, rounded brushstrokes of Jim Davis (Garfield), there's no better place to discover the many ways cartoonists use "all kinds o' lines" (and line weights, too).

7. Goble, Paul. (1978). *The Girl Who Loved Wild Horses.* New York: Bradbury Press.
While the vast majority of artists and illustrators use black lines to outline their pictures, Gobel has always used a white line. It snakes its way through every picture, enlivening clouds, cliffs and animals. The results are unique and striking.

8. Johnson, Stephen. (1995). *Alphabet City.* New York: Viking.
So real they look like photos, these lush paintings of city details (handrails, fire escapes, street lamps, signs, sidewalks , etc.) are also recognizable as letters of the alphabet and as "all kinds o' lines."

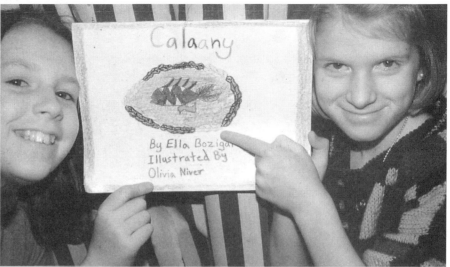

Fourth graders Ella Bozigar and Olivia Niver (left) discover that bolder words and graphics attract attention to their picture book, *Calaany*.

Lesson 2

Shape

"Shapes all around us.
Shall we play a game?
I'll say a shape —
You say its name!"
Paul Rogers
The Shapes Game

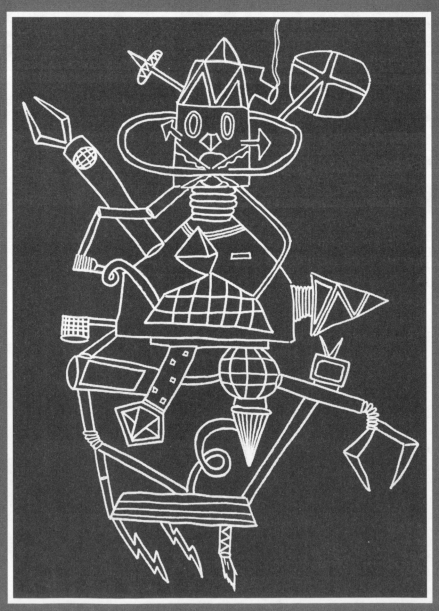

Rory Cooper
Grade 5

As drawn lines flow across sheets of paper they naturally form shapes—shapes that represent anything a young artist can see or imagine—from the eyelet of an athletic shoe to the silhouette of a dinosaur. In the same way that we introduced students to new ways of creating and naming lines in **Lesson 1**, we can expand their shape making repetoire in **Lesson 2**.

MATERIALS

Black Line Masters #2 and #3 (photocopied for overhead and student use)

Pencils and erasers

Drawing paper

Flair pens

Colored markers (optional)

LESSON

What is a Shape?

Many students aren't sure what a shape is. The following should make it clear.

Teacher draws the three figures resembling those to the right on the chalkboard.

Ask students: *Are any of these figures shapes? Which one(s)? What would we have to do to make A and C shapes?*

The answer, of course, is to close the gaps between lines so there's no space.

Tell students, *A* **shape** *is any closed form.*

Shapes Galore

"Shapes Galore" is my name for all the different kinds of drawable shapes. There are three different categories students should be familiar with:
• Shapes with names
• Freeform shapes
• Geometric solids

Shapes with Names

(e.g., "Circle," "Square," "Oval"...)

Teacher asks students: *Name as many shapes as you can.* As student names a shape, draw it

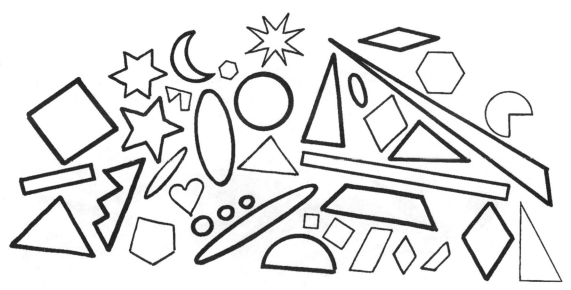

(or have a student draw it) on the chalkboard. Be sure to show students that certain shapes (triangles, rectangles, ovals, etc.) can be drawn in different ways.

Provide students with **Black Line Master #2.**

Student Activity

Give students time to practice drawing "shapes with names" any way they like. Encourage them to:

• Draw shapes that are new to you, as well as familiar shapes.
• Draw shapes of varying sizes.
• Connect and combine shapes playfully.

Freeform Shapes

"Freeform shapes" are made up of combinations of long and short straight and curved lines. Like all shapes they are "closed," but each one is unique. (As I like to tell kids, *"There are as many different 'freeform shapes' as there are fish in the sea."*)

Teacher draws a few "freeform shapes" on the chalkboard and explains that

• *Freeform shapes don't have names like "rectangle" or "diamond," but they are closed figures, and they **are** shapes.*
• *They're made up of straight and curved lines.*
• *They can be kind of simple or "plain;" and they can be complex or "fancy."*

Teacher draws a few "freeform shapes" on the chalkboard, like the ones to the left, and asks students, *Which shapes are "plain?" Which are "fancy?" Why?*

Student Activity

Challenge students to find examples of "freeform shapes" in the classroom. Give students time to practice drawing original "free form shapes," especially fancy ones.

Geometric Solids

Black Line Master #3 — *for overhead and student use can be found on p. 347.*

Though not technically shapes (art educators refer to them as "geometric forms," and some math teachers as "space figures"), I include geometric solids here because they are closely related to shapes and they are great fun to draw. (Kids love 3-D drawing!)

Teach kids to draw the five basic geometric solids. (Practice drawing them yourself first). Invite kids to draw with you step by step.

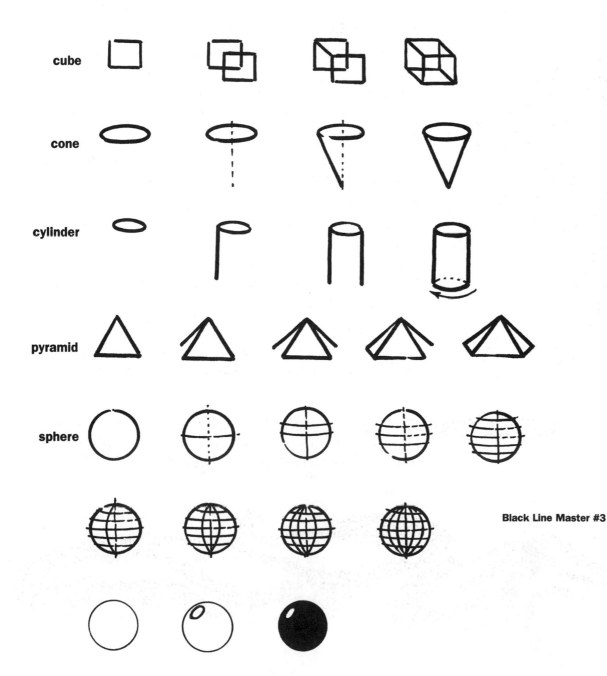

cube

cone

cylinder

pyramid

sphere

Black Line Master #3

**Drawing paper cut
into sheets
5.5" x 8.5"**

**Pencils and
erasers**

Colored markers

1. Shapes in Shape

This drawing game invites children to create and arrange shapes of all kinds while introducing them to *"3-M"* ("macro," "medium" and "micro").

GUIDELINES

- Draw a large "freeform shape" that "bumps the edges" (i.e., touches the edges of the paper) four times—once on each edge.

- Fill the inside of the large shape with "Shapes Galore" ("shapes with names," "freeform shapes" and geometric solids).

- A shape drawn inside another shape must touch or "bump" the larger shape's edge at least three times.

- Use "3-M" i.e., shapes of differing sizes: *"macro"* (very large), *"medium"* (not too big and not too little) and *"micro"* (small to tiny).

- Use *"All Kinds O' Lines"* to enrich your drawing.

- Start with *"whisper lines"* and finish with colored marker (optional).

**Shapes in Shape
by student
Grade 2**

2. You "Auto" Get in Shape

For decades, automobile manufacturers have used elegant shapes and shape combinations as car logos. Have students "scout" and record as many different logos as possible starting in the school parking lot. Challenge kids to keep looking after they've identified "the easy ones"—Chrysler, Toyota, Chevrolet, etc. (I've "scouted" at least twenty on Oregon highways!)

GUIDELINES

- Be on the lookout for car and truck logos (on the way to school, while driving with an adult, in your neighborhood, etc.).

- Single letter logos—e.g., "H" for Honda are OK. No word logos (e.g., "Ford").

- Make accurate sketches of as many logos as you can.

- Note not only the shapes used, but the line weights comprising the shapes. (Many logos utilize thick and thin and/or tapered lines.)

I Redraw the logos carefully on to pieces of drawing paper cut into pieces 4.25″ x 5.5″.

- Start with *"whisper lines"* and *"finish in ink."*

- Write the name of the car manufacturer at the bottom of the paper and list the names of the shapes (or lines) that comprise the logo.

- Display logos (one brand per paper) on a classroom bulletin board. Keep adding to the display as new logos are discovered.

3. Balancing Act

After drawing a baseline near the bottom of a tall, skinny sheet of paper, student draws a shape. Atop the first shape she draws a second, and atop the second, a third shape, and so on until the paper is filled.

GUIDELINES

- Create a "stack up" of *"Shapes Galore"* (a mixture of "shapes with names") "freeform shapes" and geometric solids.

- Every shape must be touching at least one other shape.

- Use *"3-M"* i.e., shapes of differing sizes: "macro" (very large), "medium" (not too big and not to little) and "micro" (small to tiny).

- It's okay to stack more than one shape on the shape underneath or above.

- It's okay to draw shapes inside of other shapes.

- *"Finish in ink"* or fully color the completed "stack up."

- Leave the background white.

Elliot
Grade 4

MATERIALS

Drawing paper cut into sheets 4.25″ wide and at least 12″ high

Pencils and erasers

Flair pens

Colored markers

Black Line Masters #2 and #3

Writing paper

Drawing paper

Pencils and erasers

Black Line Masters #2, #3 and #4

4. Robots

Students design robots that will help or serve humans in some way.

GUIDELINES

■ List at least four things (Primary) or seven things (Intermediate) that robots could do to help/serve people, e.g., "Stop crimes before they happen," "Help me with my homework," "Completely remodel our house," "Transport me anywhere," "Cook fancy dinners," etc.

■ Think about the connection between form and function i.e., How can you draw your robot so it really looks like its capable of doing the job it's supposed to do?

■ Draw your robot using "Shapes Galore" ("shapes with names," "freeform shapes" and geometric solids).
 • Use your imagination. Don't worry about drawing conventional looking robots.
 • Your robot won't look like anyone else's — and that good!

(I) Include "adventurous" drawings of geometric solids.

■ Older students can use the Black Line Master #4 on p. 348 to practice creating stretched, twisted and overlapping geometric solids.

Rory Cooper
Grade 5

5. Fantastic Faces

Faces can be represented realistically (think of portraits by Leonardo di Vinci, Rembrandt or El Greco) or abstractly (think of Haida totem pole carvings, African masks or the stylized portraits of Picasso). Whether realistic or abstract, all are recognizable as faces.

Show students a variety of art works depicting the human face. Ask students to distinguish between realstic and abstract representations. Tell students that they will be creating a series of abstract or "fantastic" faces.

Jess H.
Grade 5

To further inspire students, collect and share colorful pictures of masks from around the world. (Many books on the subject exist. One of my favorites: *The Letts Guide to Collecting Masks* by Timothy Teuten, see **Resources** p. 33.)

MATERIALS

Examples of "fantastic faces"

Drawing paper 8.5"x 11"

Pencils and erasers

Flair pen

Colored pencils

GUIDELINES

- Draw at least three "fantastic faces" (Primary), or five (Intermediate).

- Draw faces only (no necks or bodies).

- Include the basic facial features (eyes, nose, mouth, etc.).

- Include interesting details (eyelashes, nostrils, teeth, etc.).

- Use at least three different kinds of lines.

- Make each face unique (i.e., noticably different from the other faces you've drawn).

- Include at least one pattern in each of your faces (optional).

- Use Shapes Galore as you design your faces.

- Includes "*3-M,*" a variety of shape sizes, i.e. "macro" (some shapes that are very large), "medium" (shapes that aren't too big or too little) and "micro" (shapes that are small or tiny).

- Start drawings in pencil and *"finish in ink."*

- Color with colored pencils (optional).

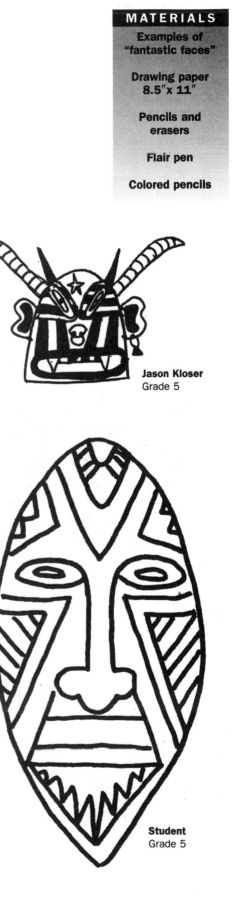

Student
Grade 5

Student
Grade 5

Jason Kloser
Grade 5

Jason Kloser
Grade 5

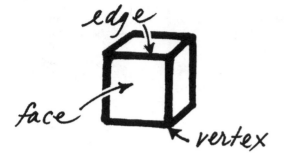

MATH

Like line, shape and geometric solids (aka "space figures") are a prominent part of almost every elementary math curriculum. Besides being able to recognize and name shapes, students are expected to understand concepts like symmetry, asymmetry and congruency. These can easily be explained while students practice drawing "shapes with names" and/or "free form shapes." The nameable parts of geometric solids, (face, vertex, edge) could also be taught in the context of drawing practice.

• The ability to depict three dimensional figures convincingly on a two dimensional surface, then to manipulate them (see **Extension 4** above, and **Black Line Master #4**), enhances, not only a student's drawing ability, but also his visual/spatial acuity.

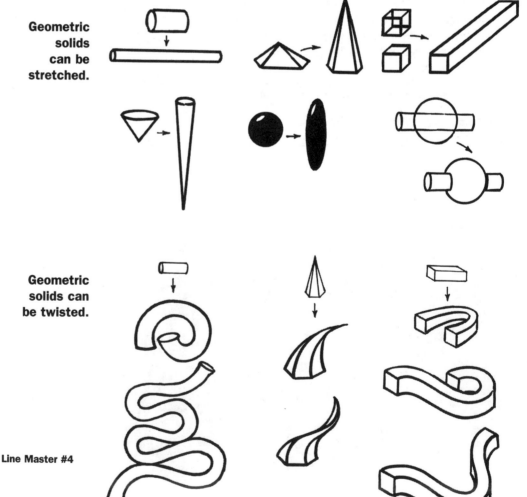

Geometric solids can be stretched.

Geometric solids can be twisted.

Black Line Master #4

MATH AND SOCIAL STUDIES

Recently, Linnea Gilson's third and fourth graders struggled with their drawings of different kinds of domestic Indian structures. Then they discovered that most could be represented by starting with a single geometric solid, or a combination of solids.

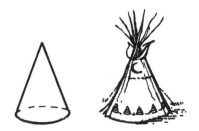

• Plains Indian tepees are basically cones. In fact the base was always a circle, a sacred symbol of the interconnectedness of all things.

• Inuit (Eskimo) igloos and Algonquin wigwams, "dome" shaped structures, are essentially half spheres.

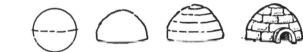

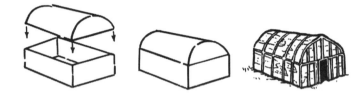

• The Iroquois bark long houses can be drawn by placing a half circle prism atop a rectangular solid.

• The plank houses of the Indians of the coastal Pacific Northwest can be created by connecting a triangular prism to a rectangular solid.

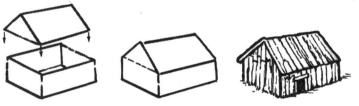

• The unique, "apartment complex" like structures of the Pueblo Indians of the American Southwest are cubes and rectangular solids joined so that the flat roof of one level serves as the floor and the front yard of the level above it.

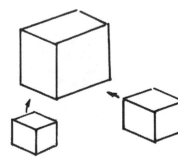

LANGUAGE ARTS AND MATH

The following list demonstrates how a class of perceptive fourth graders started seeing **"Shapes and Solids Everywhere."** Their quirky "list poem" could easily have become a small illustrated class book. Here's an excerpt:

The window is a rectangle.
The clock is a circle.
The soccer ball's a sphere. So is a globe.
The table cloth is covered with squares.
A telephone pole is a big cylinder.
Our hands are free form shapes.
There are tiny circles at the bottom
 of the computer.

MULTICULTURAL EDUCATION

Shape (and line) are the building blocks of the extraordinary arts and crafts of native people from British Columbia to New Zealand, and from the American Southwest to the Ivory Coast. Anytime you are studying indigenous cultures of North or South America, Mexico, Africa, Australia, Asia or the Pacific archipelago, seek out examples of their carvings, masks, baskets, poles and prints. I can think of no better way to showcase the visual elements we have been discussing so far: parallel lines, *"3-M,"* "Thick n' Thin lines," "freeform shapes," etc.

Left: Carved soapstone zebra from Zimbabwe, Rhodesia.

Middle: Small mammalian design carved on Fang bone counter, Gabon.

Right: Fanti scraped calabash dog design, Ghana.

RESOURCES

1. Bartelos, Michael. (1995) *Shadowville*. New York: Viking.
At dusk, the tireless shadow characters in this rollicking, rhyming tale head for Shadowville where they shop, exercise, eat, even shave. Bartalos' whimsical silhouettes are always on the move. Every page is a satisfying hubbub of shapes.

2. Angelou, Maya. (1994) *My Painted House, My Friendly Chicken and Me*. New York: Clarkson Potter.
Shapes of every size and color adorn the magnificent stucco houses painted by the Ndebele women of South Africa. Thandi, an eight year old Ndebele girl, explains how the precise designs are executed: "You must fill a chicken's feather with paint and draw a line as straight as a spear."

3. Bulloch, Ivan. (1994). *Shapes*. New York: Thomas Learning.
Suggests simple and fun arts and crafts projects for children ages 5 – 10 that use principles of symmetry, tessellation, and two and three dimensional shapes. Part of the handsome "Action Math" series that includes Games, Measure *and* Pattern. *Worth a look.*

4. Ehlert, Lois. (1992). *Circus*. New York: Harper Collins.
Playfully combines simple geometric and freewheeling "freeform shapes" to convey the color, motion and spirit of a wacky circus. Because Ehlert has used velvety black backgrounds, her electric colors explode off every page.

5. Teuten, Timothy. (1991). *Letts Guide to Collecting Masks*. London: Charles Letts.
Outstanding examples of masks from around the world are presented in this reasonably priced buyer's guide. Large pages with gorgeous photos. Terrific resource for Extension 4 *above, "Fantastic Faces."*

6. Grover, Max. (1996). *Circles and Squares Everywhere*. New York: Harcourt Brace.
Grover's dazzling acrylic paintings of tires and trucks, windows and houses, boats and boxes alert young readers to the ubiquity of circles and squares.

7. Hoyt-Goldsmith, Diane. (1990). *Totem Pole*. New York: Holiday House.
In Kingston, Washington, David Boxley, a Tsimshian Indian, is asked by the Klallam tribe to design and carve a forty foot totem pole. David's son describes the making and raising of the pole in detail. Memorable both for its clarity about a complex artistic process, and its respect for ritual and tradition.

8. Rogers, Paul. (1989). *The Shapes Game*. New York: Henry Holt.
Bright colors, Matisse like designs and rhyming riddles introduce nine basic shapes from simple circles and squares to diamonds, spirals and stars. A delightful first shapes book.

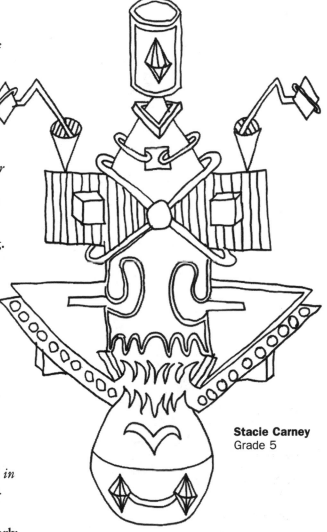

Stacie Carney
Grade 5

E-Z Drawing

"If I can see it I can draw it — and so can you!"
Roger Kukes

Casey Abero
Grade 5

The natural desire to combine lines and shapes to create detailed pictures brings us logically to **"E-Z Drawing."** It's a process that teaches children to "see like artists," and to create "respectable," recognizable drawings of practically anything—from artichokes to zebras.

"E-Z Drawing" has three basic steps:

MACRO*

The young artist observes the largest, simplest shapes in his chosen subject, and draws them.

MEDIUM

The young artist observes the medium sized shapes, and draws them.

MICRO

The young artist observes, the smallest shapes (the *details*) and records them.

During the activities that follow, it may seem that **"E-Z Drawing"** will yield little more than generic "look alike" drawings" produced in lock step fashion. Not to worry. As we proceed, you'll quickly see that our intent isn't to limit originality or self-expression. It's to demystify the drawing process, to provide young artists with a way to think about drawing as well as do it. Ultimately, our goal will be to empower kids to solve many of their own drawing problems.

When teaching "E-Z Drawing," I often use the "3-M" formula—"macro, medium and micro" first mentioned in* **Lesson 2 *. For many students it makes the process easier to remember. If it seems unwieldy or confusing, use "Large," "Medium" and "Small" (i.e., detail) stages instead.*

LESSON

Introducing "E-Z Drawing"

Tell students: *Today I'm going to show you how you can learn to draw just about anything. The method we'll use is called "E-Z Drawing." Here's how it works:*

1. Decide what you want to draw

Let's say I want to draw an ice cream cone. Now you may know very well how to draw an ice cream cone. Let's just use it as an example.

2. See like an artist

When an artist (or illustrator) looks at the world, she can see it two different ways. First, she sees it the way non artists do, the regular way. There's a clock, there's Jenny, there's an an ice cream cone (Mmmm. That sure makes me hungry!).

When I look at the world through an artist's eyes, I see things in a special way. Everything I see is made up of some combination of lines, shapes, details, colors. That means if I look at the clock I might notice it's ten o clock, but I also see a white circle, two red lines (the hands) and a series of black straight and curved lines (the numbers). If I look at Jenny, I see a nine year old girl, but I also see an oval shape (her head), two parallel, vertical lines (her neck) and a bright yellow and white checkered pattern (her blouse). And if I were to look at an ice cream cone, I'd see two circles (the scoops) and a triangle with a diamond pattern on it (the cone).

Take a minute and look at our classroom through an artist's eyes. Let's look for the lines, shapes, colors that make up the things of our world, and let's share a few discoveries. (Don't forget to look for details, too.)

• I see that the American flag has thin red and white stripes. It also has lots of small white stars on a dark blue background.

• The books in the book case look like little rectangles, and they're all different colors. There are lots of letters, too that are little lines and shapes.

• The door is a big rectangle. The glass in it looks square. The yellow shade is a cylinder when it's all rolled up. The pull down thing is a small circle attached to a skinny string that has little lines on it.

3. Use "whisper lines"

When doing "E–Z Drawing," it's best to start with "whisper lines" (light, sketchy lines that can be erased easily). Draw a few *"whisper lines"* on the chalkboard. Ask students: *What's the advantage of drawing with "whisper lines?"* (They're easy to erase if you make a mistake or if you want to make changes.) *What's the disadvantage of drawing with "whisper lines?"* (You can't see them very well.)

Give students a couple of minutes to practice drawing two small "whisper" shapes. Ask them to erase their shapes after drawing them to make sure they're drawing lightly enough. (Alas, no matter what we do, some students will have a lot of trouble with *"whisper lines,"* and that's okay. Encourage them to "Do the best you can." (Practice will help.)

Okay, let's actually draw an ice cream cone. Now we don't have a real ice cream cone or even a picture. Those would probably help us, but we've all seen ice cream cones. We can remember what they look like. Ask students to "mimic" your drawing.

4. Draw the "macros"

Using "whisper lines," let's draw the largest, simplest shapes that make up the cone. What shapes should I draw? (Draw triangle and circles on the chalkboard.) *We'll call these the "macros."*

5. Draw the "mediums"

Now let's add the next group of lines and shapes. They're not too big, and they're not the details. Let's call them the "mediums."

6. Draw the "micros" (details)

Lastly, let's add all the **details** *—the little things that make our cone special and unique—e.g., the whipped cream and cherry, the chunks of chocolate and fruit in the ice cream scoops, the waffle pattern, even the "indents" in the waffle pattern. We'll call these the "micros."*

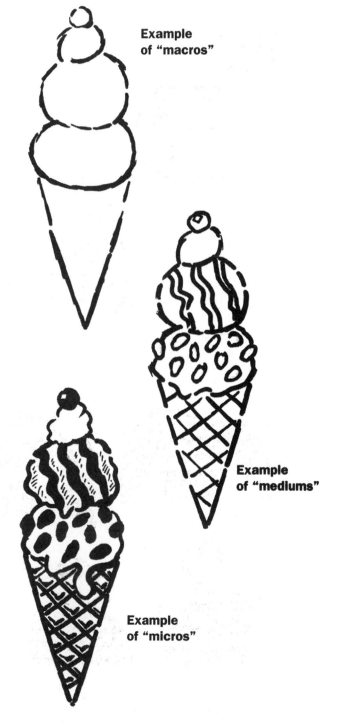

Example of "macros"

Example of "mediums"

Example of "micros"

7. Add the finishing touches

Look at your cone. What else could you do to make your cone look even better? Take a minute to do that. Now you can "Finish in ink," i.e., go over your pencil lines with a black pen and erase the pencil lines.

Using the same *"E-Z Drawing"* sequence, lead students through the creation of an umbrella.

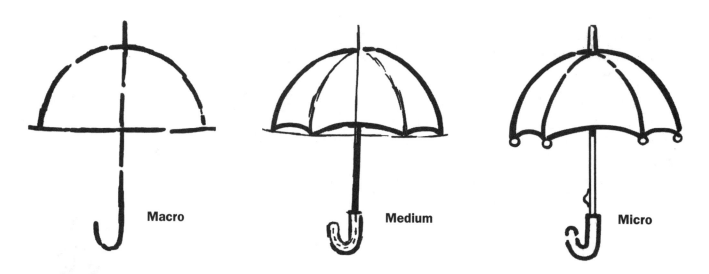

Macro Medium Micro

For more step by step *"E-Z Drawing"* examples, see **Black Line Masters #5, #6 and #7** on p. 349–351.

EXTENSIONS

The following **Extensions** will help students become more practiced and self-reliant in their use of the *"E-Z Drawing"* method. Before starting work on any **Extension**, emphasize to students the importance of choosing items (whether from photos, illustrations or life) that they really want to draw. Kids bored with their drawing subjects tend to produce boring drawings.

1. Picture Practice

Student looks through magazines, newspaper or books and selects a picture of a single item she wishes to draw (e.g., hamburger, tennis racket, mallard, etc.).

Casey Abero
Grade 5

2. Real Things

Student selects a real object (e.g., model airplane, doll,
baseball mitt, etc.) and goes through the *"E-Z Drawing"*
steps listed above.

Macro **Medium** **Micro**

Norah Gilson
Grade 5

Brandy Bender
Grade 5

3. Our E-Z Draw Book

Students create a class book which shows others how to use the *"E-Z Draw"* method. Encourage participating artists to choose different items to draw. Share the finished book with other classes.

GUIDELINES

- Select an item that you really want to draw. It can be a two dimensional image or a real object.

- Follow the steps of the *"E-Z Draw Method"* (See Extension #=87*-+*-1, above).

- Produce three drawings—each drawing should be approximately 3" x 3."
 - Drawing 1 should show the the "macros" only.
 - Drawing 2 should show the "macros" and "mediums."
 - Drawing 3 should show the "macros," "mediums" and "micros" (details) and be *"Finished in Ink."*

I Create one drawing *"finished in ink,"* then trace drawings one and two from the finished drawing (optional).

- Trim individual drawings and glue onto sheets of paper 4" x 12" in sequence.

- Create a cover for your book.

- Photocopy and staple pages so that every student can receive a copy of the book.

Norah Gilson
Grade 6

1. *"Whisper lines"* are a choice, a technique, not a must. There will be many occasions when children (particularly the younger ones) will prefer the spontaneity and immediacy of their first marks made with pencils, pens or markers.

2. Why do some kids have so much trouble with *"whisper lines?"* I've talked to scores of teachers about this question. There doesn't seem to be a definitive answer. Certain younger children may simply lack the fine motor skills (see **Tip #3** below). Others were taught to "press hard" as they formed their first handwritten letters. The real reasons may be that no one ever gave kids a reason to draw lightly, modeled the technique—or gave them the opportunity to practice it.

3. *"Whisper lines"* may be developmentally inappropriate for younger primary aged students (though I've worked with many first grade teachers who insist that their kids love *"whisper lines,"* use them by choice and with great success). It depends on the maturity of the group—it depends on the kid.

4. The ability to use *"whisper lines"* profoundly changes the drawing process for kids. Being able to erase (without leaving horrible scars on their papers) teaches them that there's no urgency to get it right the first time, that drawings can be developed gradually, and that changes can be made—for the better! This approach is very similar to the dynamic nature of the writing process pioneered by Donald Graves, Lucy Calkins and many others. (In fact, "the process" of fully developing a drawing and a piece of writing are remarkably similar. See p. 196, **Extension #4**.)

Anthony Leonardi
Grade 3

5. *"E-Z Drawing"* can best be summed up in the following **Seven Step Process**:

A. Decide what you want to draw.
Try and select something you really want to draw!

B. Make sure you have enough visual information to draw the item convincingly.
In some cases you may be able to mentally picture or remember the item you wish to draw, but in most cases you'll have to do research, i.e., gather pictures and/or look at the real thing.

C. See like an artist.

Try to see the subject as lines and shapes that you can draw. Patiently, try to see the largest, simplest shapes and the longest lines—the "macros," then look for the "mediums." Finally notice the details, "the micros."

D. Draw the "macros" using *"whisper lines."*

E. Draw the "mediums" using *"whisper lines."*

F. Draw the "micros" (details) using *"whisper lines."*

G. Add the finishing touches.
- Revise lines and shapes so they look just right.
- *"Clean up"* the drawing by erasing any extra pencil lines.
- *"Finish in Ink"* and/or add color.

Brandy Bender
Grade 5

6. When the object to be drawn is fundamentally a geometric solid, it makes sense to start with that form (or combination of forms) when drawing the "macros." (see p. 102.)

7. Encourage student autonomy. You can't provide kids with step by step drawings to copy indefinitely. Hopefully, from the exercises you've done together, students will begin to see how they can create their own drawings starting with "macro" shapes and finishing with "micros." The next inevitable step is encouraging them to select their own items to *"E-Z Draw."*

8. Visual Information. One of the great misconceptions about artists and illustrators is that they can draw anything right out of their heads (or out of their hands); kangaroo, maple leaf, cumulus cloud. You name it, I draw it—perfectly. It isn't so. The first sketches I did for the garden sequence of my animated film *UP* were embarrassing. I knew much less about flowers than I thought I did. Time to do research. In a neighbor's yard I studied and drew violets, alstromeria and peonies. I spent two humid days in a greenhouse sketching orchids. I copied pictures out of botany books. Five weeks later, with scores of practice drawings under my belt, I was ready to create my garden. Gaining access to visual information about the things we're trying to draw is the key to success. As I tell my students, "If I can see it, I can draw it, and so can you!"

9. A few years ago a 5th grader who knew *"E-Z Drawing"* well came to me looking lost.

"I need to draw a dolphin for my illustration and I don't know how," he told me glumly. "Well, I can't just sit down and draw a picture of a dolphin either," I told him. "But I can draw one if I can see one. You need more visual info." I sent him to the library. He returned with a book on dolphins and a *picture file* filled with ocean mammals. With a couple of photos in front of him, I watched him go through the *"E-Z Draw"* process. Twenty minutes later he called me over to his desk to show me his drawing of a plump, blue-black dolphin. He was beaming. It may not always be this easy. However, kids who are well versed in *"E-Z Drawing"* and who have access to the supporting visual information they need, can do passably well drawing just about anything.

10. Step by step drawing sequences are generally the easiest thing for children to copy. (See **Resources** below.) Next easiest are illustrations, then photographs. (Both are already flat and they don't move around.) Hardest to draw are real things. Though challenging, there's a vitality about drawing 3-D items, both inanimate and animate, that every child should experience. (We'll do that in **Extension #2**, and in **Lesson 4:** *"Seeing and Drawing."*

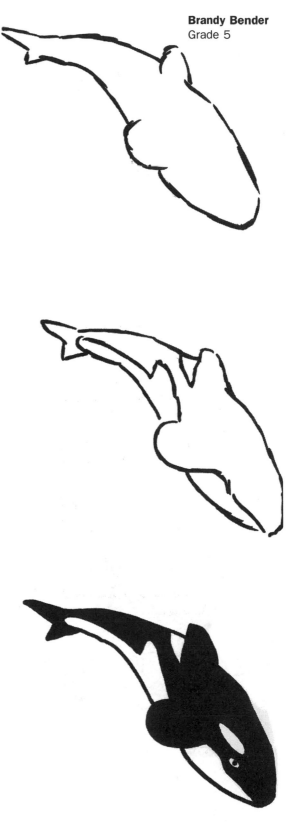

Brandy Bender
Grade 5

11. *Picture Files.* It's fine to send kids off to the library to get the pictures they need. Here's another idea. How about starting a *picture file* in your classroom? The operative word here is "start." It's taken me years to accumulate the hundreds of pictures of spiders, mesas, cacti, water, clouds, meteors, etc., that fill scores of file folders in my studio file cabinet—and inspire my drawings. Whenever you've got a special project going, take a few minutes to have kids rip pictures out of old magazines—animals, or modes of transportation or flowers. Remember, filling file folders isn't just about collecting "pretty pictures," it's about research.

Steven Kozak
Grade 5

CURRICULUM CONNECTIONS

LANGUAGE ARTS

Vocabulary Building

Labeling, an effective language aquisition strategy for lower primary, visual learners, ESL, foreign language study, and reluctant readers and writers becomes an even more meaningful activity when kids are labeling their own detailed drawings. (Kids will always feel a greater sense of kinship to drawings they've produced than to anonymous worksheets.) With *"E-Z Drawing,"* anything becomes drawable. Visual Dictionaries (see **Resources**) are a terrific source for clear, simple drawings, photos, diagrams, and accurate labels.

"E-Z Drawing" and Descriptive Writing

"E-Z Drawing" is an exotic, yet effective way to help students improve their descriptive writing. Start by showing students two drawings, e.g., the "macro" and "micro" stages of our ice cream cone. Ask them, *Which drawing do you like better?* They'll tell you, "The 'micro'." Ask them, *Why?* and they'll say, "There's more to it, more info, neat stuff, fun details to look at!"

Noelle Lounsdale
Grade 4

Then share two pieces of writing. One should provide bare bones facts, like the "macro" stage of *"E-Z Drawing."* The second sample should be the verbal equivalent of the "micro" or detail stage.

- I ate an ice cream cone. It had two scoops. It filled me up.

- I ate an ice cream cone. A double dip on a waffle cone. Yum! The bottom scoop was a creamy ball of dark chocolate packed with chunks of velvety peanut butter. The top scoop was my favorite: raspberry sorbet, ruby red and so cold, my tongue was numb. It filled my mouth with a fruity river that ran toward the back of my throat in a torrent of prickly sweetness.

Aaron Hersey
Grade 4

Ask students, *Which piece of writing is a more satisfying description of eating an ice cream cone? Why?*

Some of my teacher friends have come to use the "macro" and "micro" drawings of the ice cream cone as a metaphor for "ho hum" and vital writing. One glance at the two drawings and the point is made— rapidly! *Detail* adds life to both drawing and writing.

SCIENCE AND SOCIAL STUDIES

Any research-based project involving drawing will benefit from the skills that *"E-Z Drawing"* teaches. Diagrams, illustration, photographs, works of art all become easier to understand and to draw when children view them in terms of "macro," "medium" and "micro." As *detail* enters the vocabulary and drawing lives of even young children, they'll begin to see it everywhere: in the veins of leaves, in the clothing of American pioneers, in the arrangement of feathers on a bird's wing. Previously, the term "research" may have referred primarily to words. It should become increasingly clear that objects, and pictures can be important sources of information as well.

Mary Erwin
Grade 4

Luke Robinson
Grade 5

The following *"E-Z Draw"* books provide a step by step approach of one sort or another.

Max Yeager
Grade 4

1. Emberley, Ed. *The Big Orange Drawing Book. The Big Green Drawing Book. The Big Purple Drawing Book* (and many other titles). Boston: Little Brown.

 For twenty years, children ages 5–9 have drawn from Emberley's books. His gentle line by line, shape by shape instructional approach gives young artists confidence as he guides them to create a myriad of characters and objects.

2. Tallarico, Tony. (1984). *I Can Draw Animals*. New York: Simon and Schuster.

 More challenging than Ed Emberley's process, yet simpler than Lee Ames' (below), I Can Draw Animals delivers on the title's assertion. If kids are patient and focused, they will amaze themselves with their drawings of tigers, bats, anteaters and more.

3. Emberley, Michael. (1985). *Dinosaurs: A Drawing Book.* Boston: Little Brown.

 Emberley breaks down the drawing of the best known dinosaurs into clear step by step sequences that anyone seven or older can follow. If you're studying the "terrible lizards," this resource is a must.

4. Ames, Lee. *Draw 50 Famous Cartoons. Draw 50 Animals, Draw 50 Buildings and Other Structures* (and many other titles). New York: Doubleday.

 Children are fascinated by Ames' drawing ability and rightly so. The dude can flat out draw anything–horses, cartoon characters, antique autos. Talented kids thrive under his guidance. The less facile may not fare so well. (I've seen some kids with hang dog looks on their faces, when, after following all his steps, their drawings don't resemble his.)

5. Foster, Walter. (1986). *Animated Cartoons.* Tustin, CA: Walter Foster Publishing.

 Far simpler (and less sophisticated) than Preston Blair's Animation (below), this is a fine first book for beginning cartoonists and animators.

6. Blair, Preston. *Cartoon Animation.* Tustin, CA: Walter Foster Publishing.

 In hundreds of drawings and simple language, an old time Disney animator shares his profound understanding of character design and motion. For children 10 and older who have already practiced the simpler drawings presented in Foster's Animated Cartoons (above). A masterpiece!

Also of interest to *"E-Z Drawers:"*

Visual Dictionaries

Visual dictionaries are a must, not only for their accurate, plentiful labels but for their vivid pictures. They are one very important pictorial resource to hand to the student who asks, "How do you draw a_____?" A few of my favorites:

7. *Junior Visual Dictionary.* (1989). Archambault. New York: Facts on File.

8. *Visual Fact Finder.* (1993). New York: Kingfisher.

9. Bunting, Jane and Hopkins, David–Illus. (1995). *The Children's Visual Dictionary.* New York: Dorling Kindersley.

10. *Scholastic Children's Dictionary.* (1996). New York: Scholastic Reference.
Though not a visual dictionary per se, the Scholastic Children's Dictionary *is packed with hundreds of beautifully rendered, clear pictures and diagrams. Because the vast majority of the images are created by hand, they're easy for children to learn and draw from. (Even crystal clear photographs can provide a lot of extraneous information.)*

11. Bellerophon Books.
Presented thematically (e.g., "Castles," "Clowns," "Cowboys," "Dinosaurs," etc...), each inexpensive booklet presents an enormous amount of information, not only verbally but in the form of clear detailed coloring book style illustrations that students can draw from. Worth investigating. For their colorful catalog, send a self-addressed business envelope with three first class stamps on it to:
 Bellerophon Books
 36 Anacapa Street
 Santa Barbara, CA 93101

"Motel Room"
ScratchFoam® print
Jim Johnson
Teacher

Seeing & Drawing

*"Nobody sees a flower—really—it is
so small we haven't time, and to see takes
time, like to have a friend takes time."*
Georgia O'Keefe

"To see more is to become more..."
Tielhard de Chardin

Judy Heiks
Teacher

House, tree, face. Kid created symbols like the ones below will serve their creators well until about grade three. It's then that many children begin to notice that their drawings are inadequate. Unreal. Too simple. Not accurate enough. Repeated hundreds of times, the once vibrant visual symbol system of the five and six year old has become old hat.

"E-Z Drawing" will help. As we saw in **Lesson 3**, it teaches children to look at the world the way an artist does: to see people, animals, objects, not merely as familiar, but as combinations of lines and shapes that are "drawable."

There's another step we can take to train perception, to bring the things of the visible world into even sharper focus for young artists. I call it *"Seeing and Drawing."*

Look at the three drawings below: **A** is a generic symbol for hand, the sort of drawing we might expect from a seven year old. **B** is a more or less a detailed version of **A**. **C** is a whole new ball game. This is a hand closely observed by a young artist. It's not generic, not a symbol, it's a one of a kind hand.

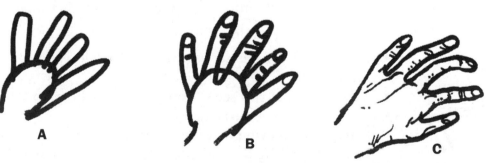

The primary goals of *"Seeing and Drawing"* are to get kids past drawing symbols, and bring them into contact with *real* things that they can observe and draw with increasing accuracy.

Introducing *"Seeing and Drawing"*

Tell students: *Today I'm going to show you a new way to draw. It's a little different from the drawing we've done so far. It's called "Seeing and Drawing." Here's how it works.*

1. Decide what you want to draw.

"Seeing and Drawing" requires that I draw something real. (No pictures!) It's best if I start with something fairly small. I'm going to draw one of my fingers.

2. Practice "Blind Contour."

During this warm up stage, my job is to really see my finger and to draw only it's contour—no wrinkles, no nail, no details—just the outline. And I can't look at my paper at all.

On the chalkboard, model the drawing process for students. *My eye slowly follows along the edge of my finger and as it does, I draw exactly what I see. If there's a bump —I draw the bump. If there's a little curve—I draw that.*

After completing your drawing demonstration, ask students, *"Why do you think I looked only at my finger while I was drawing?"* Older students usually get it: this isn't about drawing the *symbol* of a finger. It's about drawing a *particular* finger. And in order to draw that finger, you've got to see it!

"Blind Contour" drawings of fingers.

Student Activity

Students create blind contour drawings of one of their fingers. Before drawing, the student should tape down her paper. She should rotate herself away from her paper so that all of her attention is focused on seeing her finger.

As students draw, remind them —

- Look only at your finger as you draw—no looking at your paper!
- Draw only what you see—don't make anything up.
- Draw only the contour (the outer edge).
- If you finish drawing one finger, try another.
- No talking during the exercise. There's no way you can see and draw and talk.
- Don't worry about making a drawing that "looks good." This lesson isn't about making "pretty pictures." It's about seeing and recording what we see. (Don't expect your drawing to look like a finger.)

3. Practice "80%-20% Contour"

Tell students: *"Blind contour" is a good way for us to warm up. Now we'll try "80–20 contour." Here's how it works. I'm still going to draw the contour of my finger. (No details yet.) But this time I get to glance back at my paper about twenty percent of the time.*

Ask students: *Why do you think I'm going to be looking at my finger most of the time?*

The answer, of course, is that *it's* the source of information. If I don't really look at it, I'll be drawing what I *think* a finger looks like, not an actual finger.

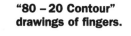

Student creates "80%–20% contour drawings" of one (or more) of her fingers. She should still rotate herself away from her paper so that most of her attention is focused on seeing her finger. While students are drawing, you should walk around the classroom and remind them:

* Look at the paper only when you need to (not more than 20% of the time!).
* Don't be concerned about creating "great drawings."

Students, especially older kids, sometimes begin to feel greater pressure to produce presentable drawings when they begin glancing at their papers. Do everything you can to relieve "product pressure" and to keep the atmosphere light. (See also **Teacher Tips on "Seeing and Drawing,"** p. 57.)

After students have completed their drawings, ask them: *What was the difference between "Blind contour" and "80–20?" Was one way easier for you than the other? Which one? Why?*

**"80 – 20 Contour"
drawings of fingers.**

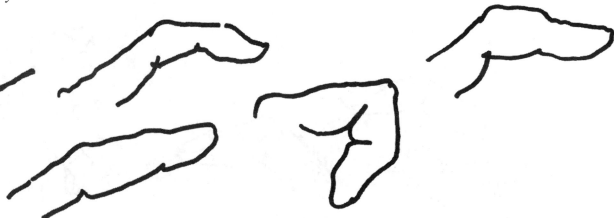

4. Practice "70%–30% Detail" Drawings.

The first two preliminary steps, *"Blind Contour"* and *"80–20 Contour,"* are crucial preparation for this challenging and rewarding exercise. Now, we invite students to "see and draw," not only the contour, but every visible line, shape or mark that comprises the finger. As you model this stage of the process for students, tell them to watch your eyes. *Most of the time (70%) I'm looking at my finger, with only occasional glances at my drawing.*

Student Activity

Students create *"70–30 Detail"* drawings of one (or two) of their fingers.

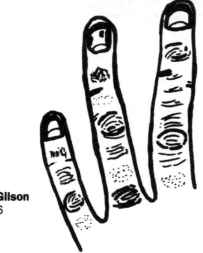

Norah Gilson
Grade 6

As students draw, remind them:

- Draw only what you see—don't make anything up.
- Look at your paper no more than 30% of the time.
- Draw the contour and as many details (nail, wrinkles, hairs, etc.) as you can. Work slowly and carefully. There's no way this exercise can be done quickly. ("Rush and you get junk!")
- Try different finger positions: bent and side views as well as straight.
- No talking during the exercise.
- Don't worry about producing a drawing that looks good. This lesson isn't about making "pretty pictures." It's about seeing and recording what we see.
- The more you practice this kind of drawing, the better you'll get.

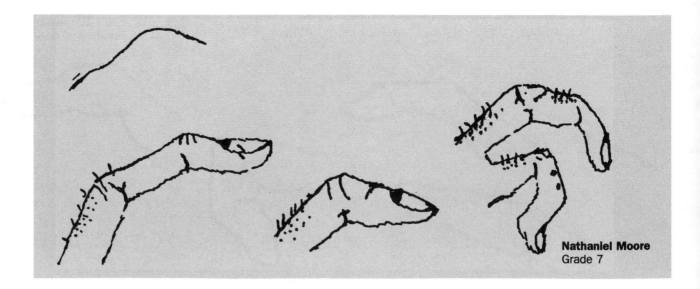

Nathaniel Moore
Grade 7

1. Veggies and Fruit

This is a great place to begin *"Seeing and Drawing,"* or the logical next step after tackling fingers. *Veggies and Fruit* are terrific because of their manageable size and universal availability. I've had great success with sliced cucumbers, lemons and kiwis; cherry and grape clusters; mushrooms, jalapenos (uncut!), snow peas, green beans, cherry tomatoes, Brussels sprouts and smaller pieces of savoy cabbage. Set items on strategically placed pieces of paper toweling.

"Blind Contour"
Donavon Powell
Grade 6

GUIDELINES (and Drawing Steps)

1. Select the item you wish to draw.
■ Try to choose something that interests you.

2. Position the item so you like the way it looks.
■ Make sure it's close enough so you can really see it.

3. Warm Up.
■ Draw the item "Blind" and "80–20."

4. Draw the item "70–30 Detail."
■ Now's the time to "see and draw" both the outer edge and every mark, every detail that distinguishes this particular item.

5. Don't worry about creating a "great" drawing.
■ Concentrate on doing your job: draw the item just the way it looks to you.

6. Do your best work!
■ Don't make anything up!
■ No talking!

It's impossible to see and draw and talk at the same time.
■ Take your time. Rush and you get junk!

Brian
Grade 4

Above:
Brandy Bender
Grade 6

Left:
Jenna Blazer
Grade 4

After drawing, ask students to answer these four questions in writing:

- What was hard or frustrating about this process?
- What was easy, enjoyable, fun?
- Describe a couple of things you learned about the object you were drawing.
- Describe something you learned about yourself.

"80–20 Contour"
by the author.

2. Flora

One of the happiest hours I ever spent drawing with children occurred in a sun drenched, second grade classroom overflowing with May flowers. First, the kids beamed, because no one had ever asked them to draw "real" flowers before. (They were genuinely honored.) Then they went to work with an earnestness that was touching. Their drawings were knockouts.

If possible, older kids should practice drawing *Veggies and Fruit* (**Extension #1** above) before tackling flowers. (Flowers are more challenging.) Once they really understand *"Seeing and Drawing,"* they'll love flowers. Be on the look out for students who place too much emphasis on "product." A key to success is having students practice drawing small parts of flowers first (e.g., a few petals, a leaf, etc.). Attempt whole flowers only after confidence and skills have been firmly established. Be sure to share the lovely *Alison's Zinnia* by Anita Lobel (see **Resources** p. 62).

Judy Heiks
Teacher

GUIDELINES (and Drawing Steps)

1. **Select the flower you wish to draw.**
 - ▪ Take a few minutes to eyeball the available flowers.
 - ▪ Look at flowers from different angles before selecting one that really appeals to you.

2. **Position the flower so you like the way it looks.**
 - ▪ Make sure you're close enough so that you can see the part you're drawing.
 - ▪ Holding the flower is okay.

3. **Warm Up.**
 - ▪ Take a few minutes to draw "Blind" and "80–20."

4. **Draw the item "70–30 Detail."**
 - ▪ Practice drawing a series of smaller detailed areas before trying to draw the whole flower.

5. **Don't worry about creating a great drawing.**
 - ▪ Concentrate on doing your job. Draw your item just the way it looks to you.

6. **Do your best work!**
 - ▪ Don't make anything up!
 - ▪ No talking! It's impossible to see and draw and talk at the same time.
 - ▪ Take your time. Rush and you get junk!

3. Little Objects

Have kids bring in a selection of objects no larger than a small stuffed animal (e.g., key chains, tools, dolls, figurines, transformers, souvenirs, refrigerator magnets, wristwatches, seashells, etc.). Manmade objects are a tad tougher to draw than natural ones, but well worth the effort, especially when: a) a student feels some sentimental attachment toward the object, or b) the object really intrigues or grabs her visually.

Use *Guidelines* (and **Drawing Steps**) presented under **Extension 1** above.

Norah Gilson
Grade 1

Jenna Blazer
Grade 4

Donavon Powell
Grade 6

Ⓘ 4. Hand

Drawing hands in various positions is one of the more challenging, and potentially most rewarding projects intermediate and middle school age children can undertake. Nothing beats it for teaching kids about primary, secondary and tertiary lines (see **Teacher Tips #8** below). Teach *Hand* only when students are comfortable with *"Seeing and Drawing"* basics. Start with individual fingers, and gradually build to two and three fingers. When it's time to attempt whole hands, combine *"E-Z Drawing"* and *"Seeing and Drawing"* (described below). Encourage kids to try various hand positions as they practice. Be sure to share Laura Rankin's remarkable *The Handmade Alphabet* (see **Resources** p. 62).

Combining "E-Z Drawing" and "Seeing and Drawing"

MATERIALS
Pencil
White plastic eraser
Flair pen
Drawing paper, 8.5" x 11"

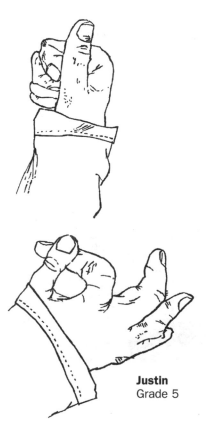

Justin
Grade 5

GUIDELINES (and Drawing Steps)

The following sequence is suggested, not only for "Hand," but for any larger three dimensional subject.

1. Position your subject (your hand) so you like the way it looks.

2. Try and see it like an artist. Look at your hand. Try to see it as consisting of drawable lines and shapes.

3. Draw the "macros."
 - Using "whisper lines" and looking at your hand at least 70% of the time, draw the "macros" (the outer edge and the longest internal lines and largest shapes). Try to make your hand life-size. Erase and redraw until you're satisfied.

Grade 6

Macro

4. **Draw the "mediums."**
 - Using **"70–30"** and *"whisper lines,"* draw the "mediums."
 - Erase and re-draw until you're satisfied.

5. **Draw the "micros."**
 - Using **"70–30,"** draw the "micros" in either pencil (*"whisper lines"*) or ink. Carefully observe and draw the details: wrinkles, finger nails, hairs...

6. *"Finish in ink."*
 - Carefully ink over every pencil line. After the ink has dried, erase all remaining pencil lines.

7. **Add color (optional).**

Medium

Hand illustrates the effectiveness of combining *"E-Z Drawing"* and *"Seeing and Drawing"* strategies. When children:

- use *"whisper lines,"*
- erase and redraw until they get it right,
- follow the *"3-M"* drawing sequence,
- closely observe their subject,

drawings of extraordinary quality often result.

5. Shoe

This classic classroom drawing project invites kids to take off one of their shoes and draw it as accurately as they can. When drawing larger, three dimensional subjects (like shoes, people, animals, etc.) children do better when they use *"E-Z Drawing"* and *"Seeing and Drawing"* techniques in combination.

Use *Guidelines* (and Drawing Steps) presented under **Extension 4** above.

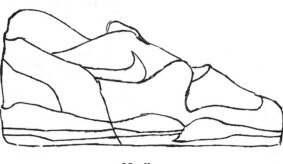

Micro

"Finish in ink"

Notice how the addition of a variety of line weights, hatched lines, dots, broken lines, and solid blacks enriches the final product. See also *Media–Ink*, p. 253.

1. Modeling is crucial when teaching *"Seeing and Drawing."* Go through the basics yourself (p. 50–52) before teaching them to kids. If you've never done this sort of drawing, you'll probably experience many of the emotions that older children feel (from doubt and self-consciousness to hope, even exhilaration). Showing kids how to "see and draw," even when you're inexperienced, is critical to student success. It's not extraordinary product that we're after, but the process of recording our seeing.

2. For best results, set aside uninterrupted chunks of time for drawing: 15–20 minutes for primary; 45 minutes to an hour for intermediate and older. Students need time to make the transition from school's endless distractions to the focused, contemplative, quiet of *"Seeing and Drawing."*

3. Insist on quiet. No one can do the careful eye-hand coordination work that *"Seeing and Drawing"* requires with jabbering going on.

4. When drawing with younger children (K–3), the emphasis should be on the fun and novelty of trying to "draw just what you see." Don't worry about polished finished products. Kids will love the process! Older kids, who practice regularly, will see their products improve dramatically over time.

5. The older the drawer, the more likely the *"internal critic"* will be to "speak up." The *"internal critic"* is that part of us that's a "doubting Thomas," doesn't care about our growth, and can be ruthlessly harsh. "It" (or he or she) may say things like, "Why bother? You can't draw! You're wasting your time!" (Or worse!) Here are a few tried and true ways to subdue this pest:

• Simply say, "Take a hike."
• Consciously affirm your right to learn and grow, and dismiss "him" as an annoying distraction.
• Acknowledge that the *"internal critic"* does, indeed, have a right to be a judge. However, judgment, especially harsh judgment, doesn't support work that's trying to get done. It subverts it! Say, "Look, right now my job is to be a creator, to see and to draw. At the end of the process, we'll evaluate. Then you can say what you think."

**Drawing "little objects"
(Extension 3)**
Grade 5

**Drawing of a manual pencil
sharpener by T.D.**
Grade 5

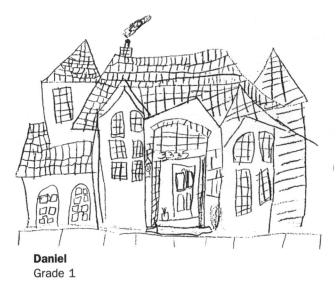

Daniel
Grade 1

6. For drawing smallish items accurately, nothing beats *"Seeing and Drawing."* When things get bigger (let's say, larger than an adult hand), combining *"E-Z Drawing"* and *"Seeing and Drawing"* works particularly well for young artists. This approach is discussed in **Extension #4** above, and on p. 55.

I **7.** At the beginning of each *"Seeing and Drawing"* session, take a few minutes to go through the preliminaries, "Blind contour" and "80–20 contour." If you don't, students, in their rush to get to "70–30 detail," may forget that the goal is to "draw what you see, not what you *think* your item looks like."

I **8.** For Advanced *"Seeing and Drawing,"* students can use three distinctly different line weights: "primaries," "secondaries," and "tertiaries." When students look at their subjects, encourage them to try and differentiate between the strongest, boldest lines (the "primaries"), the secondarily important lines, and the subtlest lines (the "tertiaries"). "Primaries" can almost always be used to define the outer edge of an object as well as to indicate the strongest lines inside it.

Note the difference in the two drawings above. The top is a competent "70–30 detail" drawing done in a single line weight. The bottom shows the same subject done with "primary," "secondary," and "tertiary lines."

To achieve three distinct line weights there are a couple of ways to go.
• Use pencils.
 By varying pressure, students can create a bold, a medium and a fine line.
• Use three different pens (Sharpie Fine Point markers for "primaries," Flair pen for "secondaries," and an extra fine ball point pen for the "tertiaries."

9. *"Seeing and Drawing"* can be summed up in the following six steps:
• Select the item you wish to draw.
• Position the item so you like the way it looks.
• Warm Up.
• Draw the item "Blind" and "80–20" before attempting to draw it "70–30 (detail)."
• Draw the item **"70–30 (Detail)."**
• Use combined *"E-Z Drawing"* and *"Seeing and Drawing"* if the item is larger than an adult hand (see **Extension #4** above).

- **Don't worry about creating a "great" drawing.**
 - Concentrate on doing your job. Draw your item just the way it looks to you, line by line, mark by mark. In time, and with practice, the product will take care of itself.

- **Do your best work!**
 - Don't make anything up!
 - No talking!
 It's impossible to see and draw and talk at the same time.
 - Take your time. Rush and you get junk.

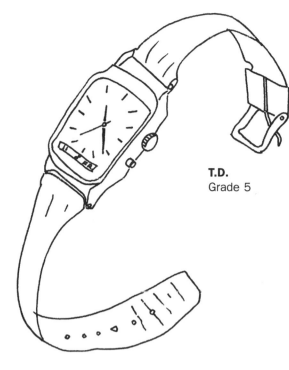

T.D.
Grade 5

CURRICULUM CONNNECTIONS

The ability to observe closely will have positive repercussions across the curriculum.

SCIENCE

The drawings and diagrams of young scientists, their leaves, spiders, crayfish, records of plant growth, moon phases, etc. should all reflect the close scrutiny they've brought to their drawings of fingers, "veggies," shoes. Hopefully, this ability to look closely, and to draw with patience will transfer to other areas of scientific study. "Use your eyes..." "Record only what you see..." "Don't make anything up..." echo basic principles of scientific investigation and objectivity.

Drawings of crayfish.
Left to right: Nick Conrad, Ryan Quillin, Kyle Piro, Lindsay Dam
Grade 4

LANGUAGE ARTS

Writing

Sensory Sentences

Many of the same qualities that serve young scientists well— the ability to patiently observe, to notice *details*— can empower young writers. Too often, children's writing is "flat," colorless, non specific. We encourage our students to "show—don't tell," use juicy descriptive language, add more detail. Sharing examples of writing that successfully "paint pictures with words" will help (see **Resources** p. 62). So will this exercise. It parallels the drawing process we explored while *"seeing and drawing."* I call it *"Sensory Sentences."* Take students, with paper and pencil, out on to the playground, or for a slow walk around the block.

Then, encourage them to:

• Look, listen—use all your senses.
• Try to discover something worth describing.
• Write a single sentence describing your discovery.
• Your writing should recreate your experience in words.
• Don't make anything up. Everything must be true and based on perception.
• Write only one sentence about each of your discoveries.
• Use no more than fifteen words per sentence.
• Write at least three "sensory sentences."

Here is a list of fourth and fifth grade "sensory sentences" gathered both in the classroom and outside it:

I saw a yellow shoe lace with mud on it.

I saw the sun shining on a door knob.

I saw a shadow shaped like a rabbit.

I saw that Kristin's blouse had tiny yellow and pink balls and hearts on it.

I saw a stapler lying on its side like it was shot.

I saw a dark house with one broken window.

I heard two pigeons cooing, cooing.

I heard a violin and a wrong note.

I heard a squeaky door open and a voice say, "I'll see you later."

I smelled fresh hot rolls and my mouth watered.

Shoes

Teacher Kathy Ryan, suggests that students use *"Shoe,"* not simply as a challenging drawing project, but as a way to practice different kinds of writing. After their drawings are finished, students could chose to do "shoe writing" that is:

- Imaginative (e.g., "A Day in the Life of a Shoe")
- Persuasive ("Why You Should Let Me Buy Those $150 Nikes")
- Expository ("Are Asian Workers Paid Enough? A Look at labor Practices at Nike and Reebok Shoe Factories in Korea and Vietnam")
- Descriptive ("The New Air Jordans")
- Narrative ("The Shoes I Had to Have")

LITERATURE

The qualities of attentiveness and vividness that *"seeing and drawing"* inspire will help students better appreciate the way professional authors use observation and rich descriptive language (e.g., William Steig, E.B. White and Roald Dahl), and the way certain illustrators endow their work with realism and *detail* (e.g., Graeme Base, Steven Kellogg and Susan Jeffers).

"A Day in the Life of a Shoe." Writing and drawing.

Jacob Ashton
Grade 5

NIKE AIR FLIGHT

One day I was a nice brand new NIKE AIR Flight sitting on a shelf in the back room of the shoe deparment at JC Penny's. I was wondering when somebody was going to buy me. Finally somebody came back and got me, brought me out and dropped me right in front of somebody's foot. Then that somebody jammed his foot right into me. And let me tell ya, it didn't feel good! Then that somebody jerked my laces so tight that it felt like I was being hung to death. And let me also tell ya, that didn't feel so good either. Then he tied me REAL TIGHT. At least I fit. Then, he bought me and I was happy. But later on I wasn't so sure about it.

After a couple days it was pretty good. I got a lot of compliments about my good looks. But at recess he slide tackled somebody playing soccer and I got all muddy. But after recess he cleaned me off. So, it wasn't the best, but it was okay. Then I figured out that his name was Jacob because when we were playing soccer LEFT NIKE heard somebody say, "Jacob, pass." Then he kicked me into the ball and the ball went flying straight to the guy that told Jacob to pass the ball to him.

At night he's okay. He leaves me on until he goes to bed. But one time he left me on in bed and it felt like I was being SUFFOCATED!

But that is all the bad stuff. Most of the time he treats me pretty good. I am happy to be Jacob's shoe.

1. Edwards, Betty. (1979). *Drawing on the Right Side of the Brain.* Los Angeles: Jeremy Tarcher.
This classic offers many sound strategies for helping students see and draw with remarkable accuracy. Ideal for middle school and older. Many of Edward's projects can be adapted for elementary classrooms.

2. Brooks, Mona. (1996–revised). *Drawing With Children.* Los Angeles: Jeremy Tartcher.
Brooks, like Edwards, believes that anyone can learn to draw. She sets out to prove it in five useful lessons. Many luscious samples by her able students are included. The new edition has additional chapters on "Reaching Special Education and At Risk Students" and "Using Drawing to Teach Other Subjects."

3. Lobel, Anita. (1990). *Alison's Zinnia.* New York: Greenwillow.
Though Lobel's paintings are in full color, the accurate drawing that she brings to each of her twenty six, alphabetical flowers is inspiring. Alison's Zinnia is an exemplary resource for aspiring realists.

4. Rankin, Laura. (1991). *The Handmade Alphabet.* New York: Dial Books.
When I first saw this book I cheered. First of all, it's gorgeous. It's filled with highly realistic pastel drawings of old and young hands signing the manual alphabet. Second, it appeared at precisely the time I was engaged in drawing hands with two challenging sixth grade classrooms for the first time. (The kids cheered, too!)

5. Ernst, Karen. (1994). *Picturing Learning.* Portsmouth, New Hampshire: Heinemann.
This fascinating book documents Ernst's twenty fifth year of teaching and her first as an art teacher. An experienced English teacher, Ernst asked her art students to write daily about the work they were doing as young artists. A bonus: it's filled with Ernst's own sensitive contour drawings of her students at work.

6. Base, Graeme. (1987). *Anamalia.* New York: Harry N. Abrams.
Base's tour d'force illustrations turn the alphabet upside down. The classic Anamalia *is a curious blend of playful, alliterative language, unmitigated fantasy and super real drawing. You can bet that Base has done his share of "seeing and drawing." The realism is utterly convincing, and the details go on forever.*

7. Kellogg, Steven. (1996). *I Was Born About 10,000 Years Ago.* New York: Morrow Junior Books.
All of Kellogg's many picture book's display deft draftsmanship, dizzying detail, and a strong roots in realism. The man can draw, and fast! If you want to see how fast, invite him to your school. He can draw all of the Island of the Skog *in under thirty minutes.*

Tara Lowe
Grade 6

8. Lindberg, Reeve. Jeffers, Susan–Illus. (1987). *The Midnight Farm*. New York: Dial Books for Young Readers.
A mother and her young son discover the gentle side of the dark on a family farm. Jeffers represents chairs, dogs, stoves, barns, trees and raccoons with equal skill. Ever the realist, she renders each scene first in pencil, then overlays the pencil with ink and subdued color washes. In The Midnight Farm, *Jeffers' always robust compositions are suffused with moonlight and an air of expectancy.*

9. Lucht, Irmgard. (1995). *The Red Poppy*. New York: Hyperion Books.
For a single day a red poppy blooms. During that time insects must fertilize its pistil with pollen from another poppy. Lucht approaches her subject with the objectivity of a scientist, the skill of a medical illustrator and the wonder of a child. Her meticulously painted close-ups of poppy petals, stamens, pollen granules, beetles, flies and stigmata are as sensually beautiful as they are scientifically accurate.

10. Steig, William. (1976). *Abel's Island*. New York: Farrar Straus Giroux.
Steig, a distinguished maker of picture books, is that rarity: an illustrator who writes as well —or better—than he draws. Pick up any Steig book and his succinct, lyrical prose envelopes you in an absolutely unique perfume. Abel's Island, *a chapter book, is no exception.*

11. Dahl, Roald. (1961). *James and the Giant Peach*. New York: Bantam Books, Inc.
Dahl's outrageous characters and over the top plots sometimes distract us from the language. The language...O' my! It's everything image and detail aficionados could ask for. Consider this: "Aunt Sponge was enormously fat and very short. She had small piggy eyes, a sunken mouth, and one of those flabby faces that looked exactly as though it had been boiled. She was like a great white soggy over boiled cabbage."

Silkie Kuilman
Grade 5

Lesson 5

Drawing People

"...the scribbles of the child give rise to geometric forms, and eventually to realistic ones..."
Howard Gardner, Artful Scribbles

Vanessa Hagebusch
Grade 5

Kids begin drawing "tad pole people" as early as age three. By four and five, the first stick figures make their appearance. The normal development of children's drawing leads us to expect people formed from geometric shapes and the increasing addition of detail by ages six and seven. However, children who do not draw very much, receive no instruction and little encouragement often become stuck at the stick figure stage. (See below.)

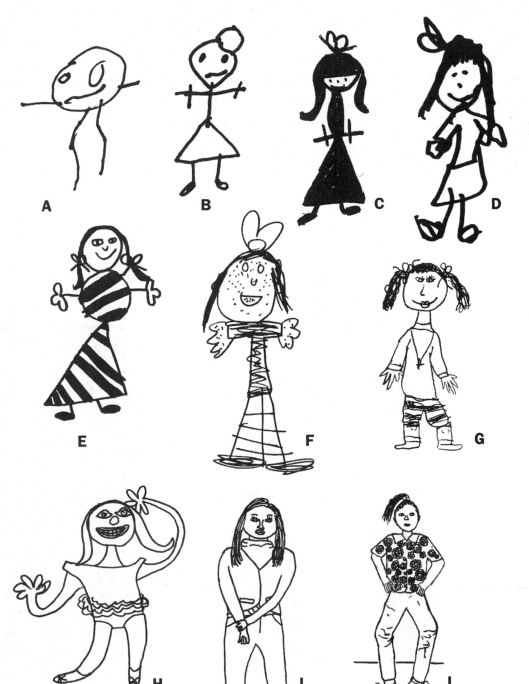

A B C D

E F G

H I J

The progressive stages of children's figure drawing, ages two to eleven.

Fig. A shows the typical "tadpole person."

Fig. E, a person formed from geometric shapes. Children, unless they are naturally gifted seldom advance beyond fig. G without instruction. Figures I and J are drawings by two fifth graders done from in-class models.

Fig. I is above average.

Fig. J is extraordinary.

While we don't want to offer children rigid formulas for representing anything, including people, it's valid to suggest a few simple strategies that will help them draw human figures that are more life-like, dynamic and detailed.

LESSON

The following lesson builds on much of what students have practiced thus far: shapes, the use of *"whisper lines,"* *"E-Z Drawing"* and *"Seeing and Drawing."*

People: Shapes *and* Detail

This exercise is a fine starting place for students of any age, especially primary, who consistently produce stick figures and/or shape people lacking detail.

Teacher draws something like the "shape person" at the right on the chalkboard using *"whisper lines."* (Notice that you're using *"E-Z Drawing"* and creating the "macros" only.) As you draw ask students: *"Why do you think I'm drawing my lines so lightly?"* The answer is always the same. *So that I can revise.*

Model *revision* as you draw (i.e., erase and redraw parts to make them look a little better).

As you draw, you might want to ask a student model to stand nearby so that you can point out things like:

- The shoulders are wider than the the head.
- The waist is about half way between the top of the head and the bottom of the feet.
- The arms and legs are divided into two parts.
- The hands hang almost to mid-thigh (a lot lower than most people draw them).

Remember, no one expects you to draw a perfect person. Whether you are comfortable with drawing, or a novice, it helps to concentrate on drawing the *shapes* that will eventually comprise a recognizable person. Practicing your "shape person" before hand will certainly help. So will consulting **Black Line Master #9**: "Proportions of the Human Figure." (You may even want to have it on the overhead while you're drawing.)

Using a pencil and drawing paper cut into sheets 8.5" x 5.5," ask student to create a "shape person" that's similar to yours. Encourage them to:

- Use *"whisper lines."*
- Draw your shape person so that it fills up the paper.
- Hold your paper at arms length periodically to make sure your figure is fairly straight on the page. (Don't expect it to be perfect.)

Ask a student who's wearing pants, and is capable of holding a pose, to come to the front of the room and stand very still. (As much as possible, position the student so she is facing her classmates.) Ask students to look at their drawing and look at the person.

- *What's similar about the drawing and the person?* (Both have heads, bodies, arms, legs...)
- *What's different about the drawing and the person?* (There are lots of *details* on the person; none in the drawing.)

Ask students to look closely at the posing student. Make a class list of all the *details* they could add to their drawings, e.g., belt, fingers, finger nails, freckles, mouth, ears, shoelaces, wrinkles in the pants, etc.

Ask students to look very carefully at the posing student and to *"see and draw"* every *detail* using *"whisper lines."* (*Don't make anything up. Draw what you see. Try not to leave anything out!*)

**Left to right:
Shauna Mehl,
Marcus LaFleur,
Matthew Gregoire**
Grade 5

These figure drawings by fifth graders reflect the wide spectrum of competency levels, even when instruction is offered.

A "stiff" looking figure. No joints means no movement.

Fig. 1

People in Motion

Drawing figures that look like they're running, jumping, skipping rope, hitting baseballs, etc. is something most children want to do. It's often a frustrating experience. This exercise takes us to the heart of the matter. It presents ovals and circles as the building blocks of action figures, and focuses attention on movable body parts. It is the first stage of drawing action figures successfully.

Teacher draws something like the figure at the top left on the chalkboard (or use the figure at the top of **Black Line Master #8**). Tell students: *Now we're going to draw people that move.* Point to the figure and ask: *Does this guy look like he could move?* No, of course not. He looks stiff!

Have kids stand in place and move various body parts. *What are these movable/ bendable places called?* Joints. With input from students, indicate the location of major joints by drawing a small circle.

Tell students: *Let's try drawing a person actually doing something.*

Using *"whisper lines,"* draw something like Figure 1 (or put **Black Line Master #8** on the overhead). Ask students, *What is this figure doing?* He's a weight lifter! Call their attention to the joints, the bendable places.

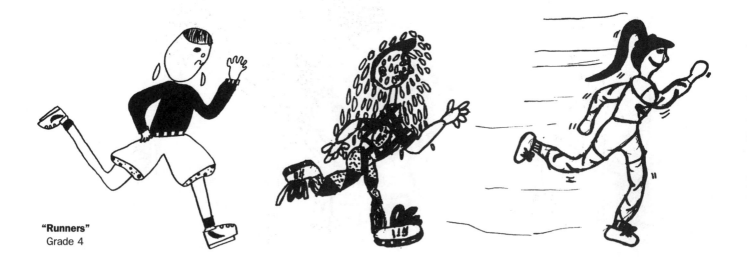

"Runners"
Grade 4

Weight lifter

Invite students to create their own weight lifter on sheets of drawing paper 8.5" x 5.5."

- Your drawing doesn't have to look exactly like mine or the drawing on the **Black Line Master #8**.

I • Use *"whisper lines."*

- Revise as needed.
- Hold your drawing at arms length periodically to check for straightness on the page.

Once they've drawn the basic body shapes and joints, the real fun begins. Now students can develop a weight lifter "character."

- Your weight lifter can be male or female, young or old, muscular or puny, wearing anything you like — e.g., shorts, sweats, a leopard skin, a tank top, Nikes, knee socks, Birkenstocks — anything goes.
- Shape the arms and legs as you draw.
- Add interesting details.

After students have refined their characters and added *details*, they can leave them in pencil, *"finish in ink,"* or add color.

"Weight lifters"
Grade 4

EXTENSIONS

1. All Kinds O' People

This free wheeling drawing game, inspired by Marjorie and Brent Wilson, invites kids to fill their papers with pictures of real and imaginary people. For best results, challenge kids to think about how vast this subject is before they draw. Make a list of their ideas on the chalkboard—the longer the better. Be sure to include people doing specific jobs, family members, characters from books, video/computer games and the media. (A recent exchange with fourth graders yielded among others: "football player," "blindman," "Cinderella," "my priest," "teacher," "baseball player," "Michael Jordan," "the fattest person in the world," "a doctor giving a shot," "Sarah Cynthia Sylvia Stout," "Superman," "scuba diver," "a cowboy," "ballerina," "James Bond," and "my dad.") See also **Resources** #1, p. 82.

GUIDELINES

■ Draw different kinds of people.
 • Be sure to draw the whole body.

■ Fill up your entire paper.

■ Draw a minimum of five people.

■ Try and make each person special and unique.
 • Include interesting details for each person so that we can tell it's a baseball player or a doctor, an Olympic gymnast or a police officer.

Elise Hoff
Grade 5

**All kinds
of People**
Grades 3 – 5

Teacher Julie Winder, Glencoe Elementary, Portland,
Oregon, poses for her students wearing a sweater
with abundant *detail*. Drawings of Mrs. Winder are by
Lucy Armendariz (left) and Jessica Bowers (right).
Grade 4

See *Models*, Extension #2, p. 72.

"Portrait of our Principal"
Colin Young
Grade 5

2. Models

Invite someone from the school community to come to your classroom to pose. A class letter could be sent to likely candidates (principal, custodian, nurse, parent volunteer, etc.) explaining the project.

Models also works beautifully when unusual work clothes or an exotic costume is worn by a visiting model. (Over the years, I've seen a bride, a clown, a chef, a cowboy and a baseball player pose in elementary classrooms.) For best results, position the model so that she faces as many students as possible and is visible from head to foot. If students are too close to the model, they will have trouble drawing her. (I recently enticed a school principal to stand on the teacher's desk.)

Students will follow the same steps used in the **Lesson**, *"People: Shapes* and *Detail"* above.

GUIDELINES

- Use *"whisper lines."*

- Use the *"E-Z Draw"* method to draw the the basic shapes of the posed model ("the macros").

- Hold your drawing at arms length periodically to check for straightness on the page.

- Revise as needed.

- Note and record the "mediums."

- Carefully *"see and draw"* the details ("micros").

- Darken pencil lines or *"finish in ink."*

When students don't hold pictures at arms length periodically to check for straightness on the page, figures can end up "leaning" noticably.

I 3. Action Figures

Ask students to bring in pictures of people in motion: batters swinging, goalies saving, ballerinas leaping, Olympians sprinting, etc. (Pictures are easier for children to draw than live action figures.) Be sure to save all the photos, illustrations, drawings and diagrams and store them in an "Action Figures" *picture file*.

To warm up, have students select and draw one of the action figures from **Black Line Master #10**, (p. 354).

MATERIALS

Pencils and erasers

Flair pens

Drawing paper 8.5″ x 11″

GUIDELINES

- Select a picture that you really like and feel that you can draw.

- Start with *"whisper lines."*

- Draw the entire figure (head to foot) so that it pretty much fills the paper.

- *"E-Z Draw"* the basic shapes (i.e., the "macros") of your action figure (including joints).

- Once you're satisfied with the "macros," go on to the "mediums" and the details (*the* "micros").

- Don't expect your drawing to look exactly like the picture you're copying.

- Hold your picture at arms length periodically to make sure your figure looks as good vertically as it does on your flat desk.

- Keep revising your drawing until you're satisfied.

- Darken pencil lines or *"finish in ink."*

Student
Grade 5

Fig. 2
Drawings of a batter originally created for a zoetrope strip (below).

4. Animated Action Figures

Instead of drawing a "stationary moment" from an action sequence (**Extension 3** above), kids draw at least three different stages of the motion (Fig. 2). A few kids can visualize the movements in their heads. Others can work them out on paper. Still others like to "walk through" a motion sequence repeatedly before attempting to draw it. (That's what animators do.) Most students will do much better with something to look at. One source to check out is the sports section of larger circulation newspapers. They occasionally show the stages of an athlete's performance (e.g., a spinning skater entering her jump, twirling around and landing...). These sequences, often presented as simple diagrams, are great for kids to copy—and they'll make a fine addition to your "Action Figures" *picture file*.

Another possibility: create a twelve frame motion sequence that will fit in a zoetrope (a pre-motion picture optical toy) and view the figures *literally* in motion (see **Resources** #12, p. 83 and p. 332).

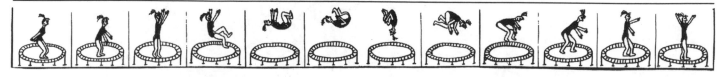

**"Trampoline Performer" zoetrope strip
by a teacher.**

5. Artists and Active Models

This project is done either in the school gym or outside. Students chose partners and take turns acting as artist and model. The "artist" suggests action poses to her "model." ("Could you please skip rope..." "Could you please pretend you're going to throw a ball...") Any pose is okay, stationary or moving, as long as the model understands what the artist wants her to do, and she is comfortable doing it.

Like all observational drawing, this activity requires a good deal of concentration. Make sure student artists realize their time for drawing will be limited, and that soon it will be time for them to become models. As the **Guidelines** state below, this project isn't aimed at creating finished drawings. However, students may wish to refine sketches later (either back in the classroom or at home), add *detail* and *"finish in ink."* (See also *Action Figures* on p. 73 and "quickie" sketches on p. 251.)

(See also *Action Figures* on p. 73 and "quickie" sketches on p. 251.)

MATERIALS

Pencils and erasers

Something flat to draw on (clipboard, slate, large book, etc.)

Drawing paper 8.5"x 11"

GUIDELINES

■ **Chose a partner you're compatible with.**

■ **Communicate with your partner clearly and politely.**

■ **Make sure she is comfortable holding the action pose you request.**

■ **Artists and models should switch every ten minutes (or so).**

■ **Artists should do a series of quick sketches of action poses.**
 • **Remember to look at your model.**
 • **"E–Z Draw" the "macros" and the joints.**
 • **Use *"whisper lines"* — Erase and redraw until you get the pose right.**
 • **If a pose is too hard to draw, try one that's easier.**
 • **Refine the shapes of the figure as time allows.**

■ **Don't worry about finished products.**

"Samantha Shooting a Basket"
by Yuriy
Grade 4

1. One of the first things that teachers often ask me when drawing people is, "What about proportion?" Adults are more concerned about this issue than children. If we give kids opportunities to practice *"E-Z Drawing"* and *"Seeing and Drawing"* regularly they will usually do acceptably well figuring out proportion on their own. There are two ways we can address this issue in the classroom, should it arise.

P With a model standing in front of the class, arms at her side, call children's attention to the relative size and position of body parts:

• Are the arms long or short? Where do the hands come to rest? Above the waist or below it?
• Are the shoulders a lot wider than the head?
• Which is bigger, the distance from the waist to the top of the head, or from the waist to the bottom of the feet? (It's about the same.)

I Use the same strategy just discussed. In addition, have kids do the following drawing exercise.

On a piece of drawing paper 8.5"x 5.5" have students copy **Black Line Master #9.** Doing so will help some children begin to grasp relative sizes and lengths in a way that observation might not. (Encourage students to create drawings that are at least the same size as the figure on the **Black Line Master**.)

2. Beware over emphasizing proportion. While some children are hungry for information that will help them draw figures that are convincingly proportioned, other children don't care very much about it. (In fact, they may feel frustrated and impatient when it's pushed.) The "art of teaching" asks us to differentiate between kids who are ready for greater accuracy and realism, and those who aren't.

Black Line Master #9

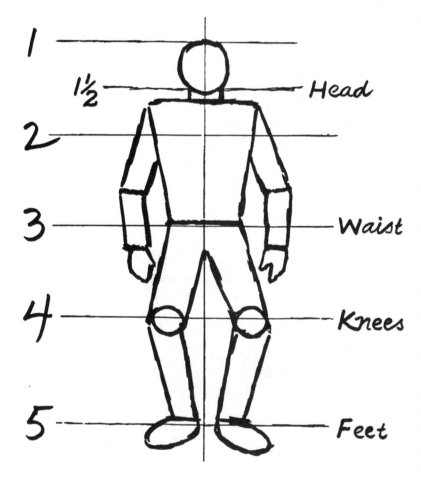

3. Faces. When drawing people with primary, I usually do a mini-lesson on the accurate positioning of eyes within the oval (about mid way), but I don't place a lot of emphasis on producing realistic faces. Little kids have enough to think about when drawing torsos, limbs, etc. Having done *"E–Z Drawing"* and *"Seeing and Drawing"* they usually do just fine with features. With intermediate and older, I insist that kids give faces the same attention that they give to drawing other parts of the figure. (See **Lesson 9**, p. 152.)

4. Copying is a fine idea. Encourage kids to be on the look out for representations of the human figure that grab them. Photos in apparel catalogs and sports magazines, illustrations in books, diagrams in newspapers all offer unique challenges and rewards. In our picture rich world, copying is yet another strategy that can empower young artists.

5. When children struggle with figure drawing it may very well be because they've abandoned the strategies that have helped them draw with greater accuracy. Just because children have practiced *"E–Z Drawing"* and *"Seeing and Drawing"* we shouldn't assume that they will automatically use *"whisper lines,"* start with the "macros" and, above all, *look* at the posing model or at their photo. In fact, most children will revert to untutored ways of drawing unless they are reminded to do otherwise. Old habits, even those practiced for a few short years, die hard. We must revisit our learning targets — our *Guidelines* — if students are to authentically build skills and break new ground. Howard Gardner makes an interesting point about skill building. Although he's talking about "basic skills," much of what he's says has relevance for the drawing classroom. Gardner says that basic skills training fails in the United States because everyone underestimates "the degree of drill, dedication and motivation needed on the part of both student and teacher over the long haul."

Example of poor proportion

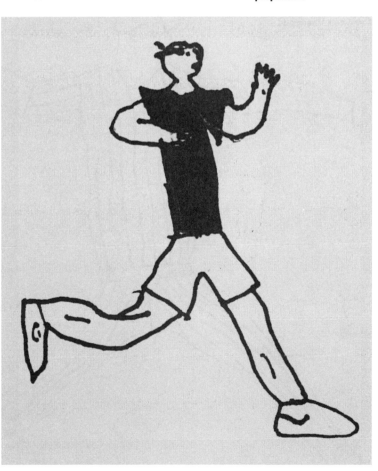

LANGUAGE ARTS

Literature/Art

As you share picture books with children, be sure to discuss the different ways that illustrators depict people. Some favor realism (Susan Jeffers, Jerry Pinkney, Chris Van Allsburg); others create naive, childlike figures (Nancy Carlson, Frane Lessac); still others build their abstract characters out of lines, shapes and colors (Gerald McDermott, Heidi Goennel, David Diaz). Though a majority of children may be impressed by realism, it's important for them to know that many different "styles" or ways of representing the human figure exist. (See **Extension #1** above and **Resources** below.)

Writing and Illustrating

We are so used to seeing the sometimes charming, often stilted "shape people" that children draw for their original stories, poems, and reports, we forget that alternatives are even possible. Exposure to varied interpretations of the human form from books and paintings, coupled with the opportunity to practice drawing live models and moving figures, can transform the way children think about and represent people.

In some cases, students may become more adventurous writers *because of drawing*. One fifth grader began writing a series of highly descriptive baseball stories that were inspired as much by his new found ability to draw players hitting, sliding and catching, as they were by his personal experiences as a Little Leaguer.

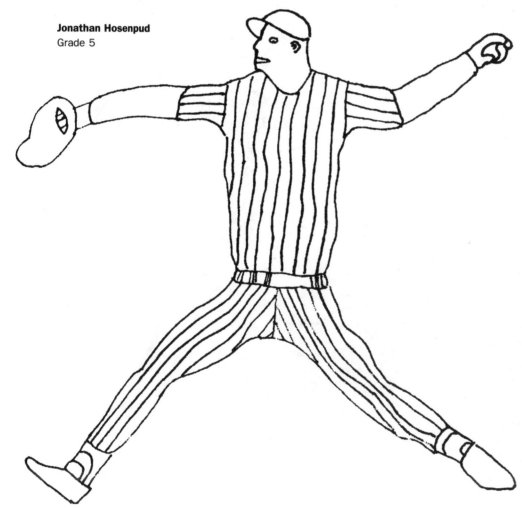

Jonathan Hosenpud
Grade 5

SOCIAL STUDIES

The ability to draw people in *detail*, and in a variety of postures, enriches not only children's literary illustrations. Their drawings of historical figures (Native Americans, colonists, Civil War soldiers, etc.) and people from distant countries, whether for reports, class murals or publications, are all vitalized. Most importantly, kids come to realize that it's often better not to make up details, but to do the required research. (Do Navajo Indians wear feather headdresses? Did soldiers of the American Revolution wear their medals when they fought in battles? Do Indonesian men wear sarongs?) We must remind students regularly that accurate information, whether pictorial or verbal is always available, and that accessing it will help us do our best work.

Sketch of a scout for the mural, "Along the Oregon Trail" by Chris Edmonds Grade 4

MATH

Children of all ages will enjoy this drawing/math game. It may be especially worthwhile for students who like drawing, but who may be reluctant "word" problem solvers.

- Decide on a sport.
- Draw a minimum of five sports action figures, each wearing a number.
 - do research as required.
 - start in pencil and *"finish in ink."*

Once your drawings are complete, use the players' numbers (or anything else you can think of) as a basis for creating a series of grade appropriate word problems.

1. What is the sum of all five players' jersey numbers?

2. What is the average of the numbers on jerseys I, II and III?

3. If player II had twelve identical brothers, what would the sum of all their jersey numbers be?

4. If players I and III were cloned, what would one third of all their jersey numbers total?

5. Player II, a goalie, was scored on three times in seventeen consecutive games. During the eighteenth game, he was scored on only once. During the nineteenth and twentieth, he shut out the opposing team. How many times was he scored on altogether? What was the average number of goals scored in each of the twenty games? Create a bar graph showing the scoring for all twenty games.

I

Nick Seed
Grade 5

II

III

Nick Seed's soccer players provide the prompt for a series of inventive word problems for fifth graders.

IV

V

Pencil drawing
Norah Gilson
Grade 6

RESOURCES

1. Spier, Peter. (1980). *People.* New York: Doubleday.
Spier's information packed overview of humankind overflows with crisp colorful drawings of people of every race, age, occupation, religion, nationality. Best of all, Spier makes a a case for tolerance and celebrates uniqueness and diversity without sounding preachy or patronizing.

2. Hanford, Martin. (1988). *Find Waldo Now.* Boston: Little Brown.
Literally thousands of little cartoon figure drawings of people on the move, viewed from every possible angle. The book is remarkable, not only for it's teeming human activity, but for its historically accurate depiction of apparel—from the rags of Egyptian slaves to the opulent gowns of French royalty.

3. Kindersley, Anabel and Barnabas. (1995). *Children Just Like Me.* New York: D.K Publishing.
This big, beautiful book introduces us to children from more than thirty countries. The full figure photo portraits of the the kids, often in native dress, invite classroom artists to become familiar with Korean hanbok, Mongolian deel and Maasai rubeka. Talk about visual information! This is a peerless multicultural resource.

4. Gerstein, Mordicai. (1987). *The Mountains of Tibet.* New York: Harper and Row.
The story of a simple Tibetan woodcutter experiencing, of all things, reincarnation! Not to be missed on page seventeen: Gerstein's vision of a multicultural utopian gathering, people from every nation in native dress, join hands in a celebratory dance.

5. Krull, Kathleen, and Diaz, David–Illus. (1996). *Wilma Unlimited.* New York: Harcourt Brace.
This handsome picture book tells the story of sickly Wilma Rudolph who, in 1960, became the fastest woman in the world. Caldecott winner Diaz's illustrations swarm with strong, elegant African American "shape people," singing in church, riding in cars and running like the wind.

6. Jardine, Don. (1989). *Creating Cartoon Characters.* Tustin, CA: Walter Foster Publishing.
This inexpensive "how to" book presents a basic shapes approach to drawing any human figure, stationery or moving, cartoon or not. On the down side, the progressions from rudimentary to fully developed figures could have used a few more in between steps. Still, there's a lot to like about Jardine's clean cartoons. See also **Resources: Faces,** *p. 181.*

7. Lessac, Frane. (1990). *My Little Island.* New York: J.B. Lippincott.
At first glance, these colorful paintings of a small Caribbean Island appear to have been done by a child. Look more closely and you realize you are in the presence of a folk artist of enormous skill. Show her illustrations to kids who struggle with realism. Her simple figures exude warmth and vitality as they, swim, cook, run and dance.

8. Wood, Audrey. (1989). *Weird Parents.* **New York: Dial Books.**
*Wood's fabulously patterned cartoon characters, exemplify the term
"body language." They explode with laughter, blow kisses like Bette
Midler, and party like it's always midnight on New Year's Eve.*

9. Kalman, Maira. (1989). *Sayonara, Mrs. Kackleman.*
New York: Viking Kestrel.
*Kalman's childlike surrealism gets a Japanese send up. Lulu and
Alexander fly to Tokyo, visit a school, temple, restaurant, fish market...
Though this is Kalman's most restrained, accessible book, it's still happily
crammed with her idiosyncratic observations and her wacky figure
drawings.*

10. Ringgold, Faith. (1993). *Dinner at Aunt Connie's House.*
New York: Hyperion Books for Children.
*While Ringgold has certainly created a book that celebrates renowned
female African Americans, she has unintentionally, given us a textbook
on drawing the human figure. Her terrific paintings of Melody and
Lonnie in a plethora of positions remind us that there are many ways
to sit, kneel and stand. Children could copy many of these poses —
with happy results.*

11. McDermott, Gerald. (1974). *Arrow to the Sun.* **New York:
Viking Penguin.**
*McDermott's abstract representations of the human figure are still rad-
ical a quarter century after winning the Caldecott medal. His flat,
geometric images of people, shamens, gods offer striking alternatives to
the realism of Jeffers, Pinkney and Van Allsburg; the cartoon drawings
of Nancy Carlson and Babbette Cole; and the faux naive illustrations
of Maira Kalman.*

12. Kukes, Roger. (1985). *The Zoetrope Book.* **Portland, OR:
Klassroom Kinetics. (See Order Form, p. 333.)**
*Shows kids and teachers how they can build a simple movie projector out
of a Baskin Robbins ice cream container and a Rubbermaid turntable
(aka "lazy Susan"). Zoetropes are one of the simplest and cheapest ways
to produce and view animation in the classroom. Motion sequences
of people are among the more challenging zoetrope strips to produce,
but well within range for students who have practiced drawing
action figures.*

Vanessa Hagebusch
Grade 5

"Jumping Rope"
Zoetrope Strip
by Kathy Larsen
Grade 5

Space

"Every line splits a singularity into a plurality. Every closed contour evokes, in addition, notions of "inside" and "outside" and the suggestion of "near" and "far away," of "object" and background."

M.C. Escher
Approaches to Infinity

Kelsey Barnett
Grade 4

Though the paper we draw on is literally flat, it's possible to produce pictures that appear to have depth. Creating the third dimension on a two-dimensional surface is illusion, of course, a sort of graphic magic that fascinates children. There are many ways to achieve it, some well beyond the skill level of young artists (e.g., perspective,* "sighting,"** and the *chiaroscuro* drawings of Chris Van Allsburg). Still, there are a couple of basic spatial strategies that we can explore in an hour lesson: *overlapping* and *size and location*. Used individually and in combination, they will dramatically change the way students think about their drawings.

MATERIALS

Book and chalkboard eraser

Pencils and erasers

Drawing paper

Black Line Masters #11–#14

Black Line Master #15 (photocopied for student use)

LESSON

Hold up a piece of white paper and ask kids: *Is this piece of paper flat, or does it have depth?* They'll tell you that it's flat.

Tell kids: *Today I'm going to show you a couple of ways to create drawings that look three dimensional—drawings that look like they have depth.*

1. Overlapping

A. Moon and Clouds

Hold up any book and ask students, *What do you see?* A book, of course.

Is there anything in front of it? No.

Now hold up a chalkboard eraser (or any other small object), and ask students, *Now is there anything in front of the book?* Yes, an eraser.

Tell students: *When one thing is in front of another, partially blocking it, that's called **overlapping**. Can you find any examples of **overlapping** in the classroom?*

*Perspective, a rigorous system for creating the illusion of deep space on flat paper, is in my view "a can o'worms" for the vast majority of elementary age artists. I deal with it only when specifically asked to do so. Perspective, I believe, is an issue best saved for the middle school years (and beyond), or bagged entirely in favor of "sighting."** (See *Drawing on the Right Side of the Brain*, p. 62.)

*Artists and illustrators often use **overlapping** as a way of creating depth in their drawings. Here's a simple example.*

Teacher draws a circle or a crescent using *"whisper lines"* on the chalkboard.

*Here's a moon. Let's put some clouds in front of the moon (step 2 below). Notice I'm using "whisper lines." What lines should I erase to make the clouds look like they're in front of or **overlapping** the moon? Was it a good idea to use "whisper lines?" Why?*

Teacher models these steps

1 2 3

Student Activity

Give students a couple of minutes to draw a moon partially obscured by a cloud.

B. Saturn

Are you ready for something a little more challenging? Let's say we want to draw the planet Saturn. We'll start with a circle.

What does Saturn have going around it? A ring. *Okay, let's draw the ring* (step 2 below). *Notice, I didn't draw all of the ring. Why not?* Part of the ring is *behind* the planet (we can't see it).

Now let's draw a parallel line so the ring looks a little more real (step 3). What lines should I erase so it looks like the ring is in front of (or overlapping) the planet? (step 4).

Teacher models these steps

1 2 3 4

Give students a few minutes to draw their version of Saturn. Remind them to use *"whisper lines"* so they can easily erase their overlapping lines.

I C. Saturn with Three Rings

Just for fun, let's add a second ring to our planet (step 5). *Which lines should I erase so it looks like the second ring is in front of the first ring? And now, let's add a third ring* (step 6). *How many layers are there now? Which ring appears to be closest to us? Which one is farthest away?*

Teacher models these steps

| 5 | 6 | 7 |

Give students a few of minutes to draw a multi–ringed planet. Have them add a #1 to the ring that appears closest to the viewer, a #2 to the ring second closest and so on until all the rings are numbered.

2. Size and Location

There's another way we can make our pictures look like they have depth. It's called **size and location***.*

Try this. Hold a hand up in front of your face as far from your nose as you can. What do you see? A hand, of course! *Now slowly, very slowly move your hand toward your nose. What happens?* The hand appears to get larger. *Does it really get bigger?* No, it just appears to.

Teacher Demo

Draw two large rectangles side by side on the chalkboard and say: *Let's see if we can use this idea of smaller and bigger to create greater depth in a drawing.* In one of the rectangles draw a horizontal line from side to side and ask: *Does anyone know what this line is called?* It's called

Step 1

Teacher models these steps

Step 2

the *horizon line*. *The horizon line separates the ground and sky. Now let's draw two trees* (Step 1, left). *Do I have to draw great trees? No, because this lesson isn't about drawing trees, it's about adding depth to drawings. Does one tree appear to be closer to us than the other? No. How can we make it look like one tree is closer,* and the other farther away? Draw a rough facsimile of Step 2 (above) in the second rectangle.

By drawing one of the trees larger and lower on the paper, and the other smaller and higher, we've given our drawing the illusion of depth. The **size** *of the items we draw, and their* **location** *on the paper helps give our drawing depth.*

Put **Black Line Master #11** on the overhead.

Let's look at **size and location** *one more time. Okay, we've got a horizon line and we've got two people. Does one person appear to be closer to us than the other? No.*

How can we give this drawing greater depth?

Put **Black Line Master #12** on the overhead.

Does this drawing appear to have greater depth? Yes! *Why?* Because one person is larger (and lower) and the other is smaller (and higher) in the drawing.

Black Line Master: #11

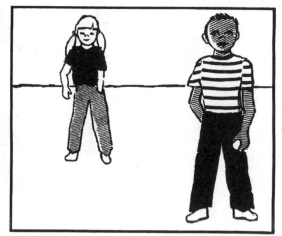

Black Line Master: #12

Show **Black Line Master #13**. *How about this one? What's different about this drawing?* The closer person is a lot bigger. In fact, she's so big, part of her goes off the paper. *Is it okay to draw someone or something so large that a part goes off the paper?* Yes! *Notice how we've made the person in the distance even smaller.*

Now let's look at all three drawings at the same time. (**Black Line Master #14**) *Which shows the most depth? Why? Which drawing do you like best? Why?*

Black Line Master: #13

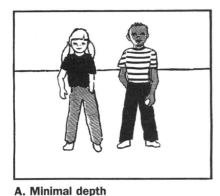

A. Minimal depth

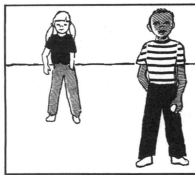

B. Greater depth

C. Greatest depth

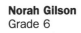
Student Activity

- In the middle of the rectangle provided (**Black Line Master #15**) draw a *horizon line*.

- Draw a picture with two people in it (either sex, any age).
 - Your people can be dressed in any outfit, costume or uniform.

- Draw one person so she appears to be closer to us, and the other so she's farther away.
 - As you work, think about the size of the people you're drawing and their location within the rectangle.
 - It's okay to have part of the figure that appears to be closest to us go off the paper.
 - Add *detail* to your people as time allows.

Norah Gilson
Grade 6

EXTENSIONS

1. Crazy Freeway

We've all seen photos of California freeways taken from the air with their plentiful ramps, overpasses and clover leafs. This extension takes the notion of urban expressways to Kafkaesque lengths. It's also a fun way to practice *overlapping*. Don't be surprised if students want to add buildings, cars, trees to their drawings. (If kids have trouble relating to the freeway angle, call the project "Layered Labyrinth.")

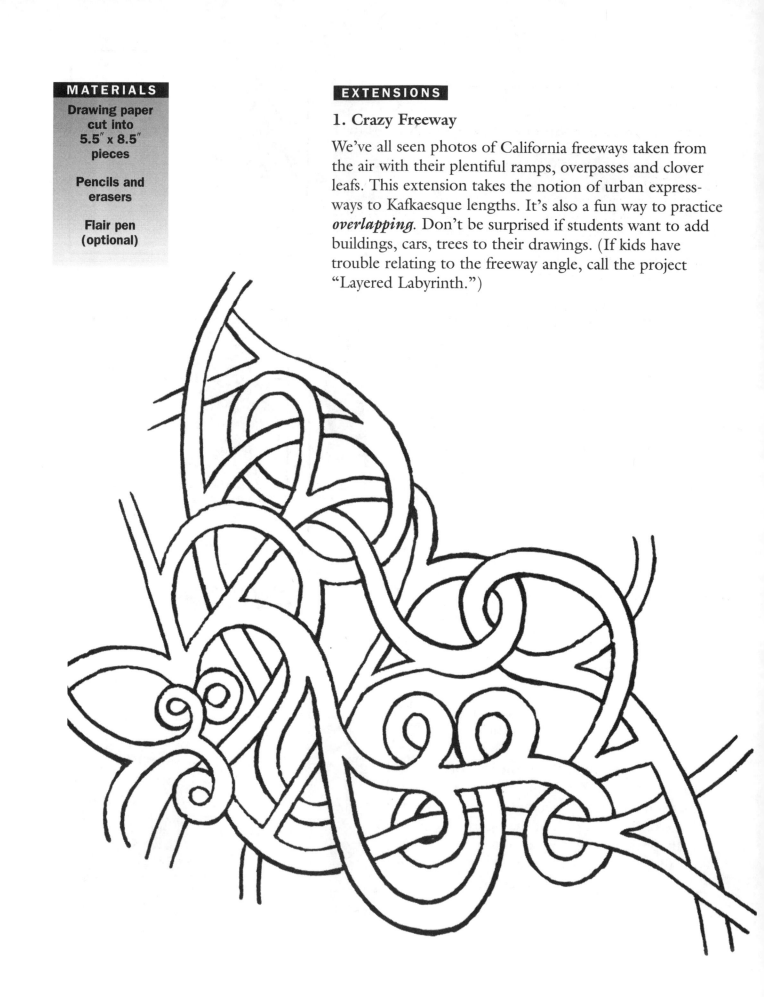

- **Create a drawing of a bizarre, multi-layered highway system**
 - **Begin by creating a series of lightly drawn parallel lines that form the edges of a road. (Lines can be straight and curved.)**
 - **Draw a series of overlapping, yet continuous roadways.**
 - **(P) • Include at least one example of each of the following (see list below the intermediate guideline):**
 - **(I) • Include at least three examples of each:**
 - **A road that forks or splits.**
 - **A road that connects with another road.**
 - **A road that passes over or under another road.**
 - **A road that loops over or under another road.**

Before starting *Crazy Freeway,* students should practice each of the following:

A. Lightly drawn parallel lines that form the edges of a road.

B. A road that forks or splits (below).

C. A road that connects with another road (right).

D. A road that passes over or under another road (left).

E. A road that loops over or under another road (right).

I To further enhance the 3-D look of their drawings students can:
- Add shadows
 - Pretend there's a light source (e.g., a sun that's situated to the left of the "freeway"). A shadow will be cast wherever one roadway crosses over another *on the side opposite the sun.*

F. Roadways with shadows.

2. Abstract Drawing

Show students abstract works by twentieth century masters Wassily Kandinsky, Joan Miro, and Stuart Davis (see p.107). Make it clear that drawings (and paintings) don't always have to include recognizable things like people, animals, objects. They can be abstract, or more accurately, "non-representational." The following **Extension** encourages students to revisit *"All Kinds O' Lines"* and *"Shapes Galore"* while creating drawings that have a distinctly spatial look.

MATERIALS

Black Line Master #15 (photocopied for student use)

Pencils and erasers

Flair pen and/or colored markers (optional)

GUIDELINES

■ In the rectangle provided create an abstract drawing (no pictures of objects, people or anything recognizable).

• Include *"All Kinds O'Lines"* and *"Shapes Galore."*

• Use *overlapping* as well as *size and location* to enhance the "depth" of the drawing.

 P – Include a minimum of four "overlaps."

 I – Include a minimum of eight "overlaps."

• Use *"whisper lines"* as you develop your drawing.

• *"Finish in ink"* and/or fully color your drawing (optional).

• Give your drawing a title.
 – Titles of abstract drawings and paintings run the gamut from simple ("Giant Cube") to silly ("Window Shopping Marshmallows") but are always based on something the picture suggests to the artist. (There are no wrong answers!)

"Abstract Drawing"

Student
Grade 5

MATERIALS

Black Line
Master #15
(photocopied for
student use)

Pencils and
erasers

Flair pen
(optional)

Colored markers
(optional)

3. Deep Space

Outer space is fertile territory for young artists to visit imaginatively, and it's a natural subject for spatial drawing. Without a horizon line to worry about, the entire paper can be thought of as limitless space. Though pop culture can't help but be an influence, dissuade students from trying to recreate scenes from "Star Wars," "Star Trek" or some shoot 'em up intergalactic video game. Tell them: *We're interested in your version of outer space, not George Lucas'.*

"Outer Space"

Student
Grade 4

GUIDELINES

- In the rectangle provided, draw a large planet (ringed or ringless).
- Surround and/or overlap the planet with an assortment of outer space items—meteors, moons, flying saucers, rockets, gas clouds, stars, asteroids, etc.

Ⓘ - Start with *"whisper lines."*

- Use *overlapping* and *size and location* to give your drawing dramatic depth.

Ⓟ • Create at least three "overlaps."

Ⓘ • Create at least six "overlaps."

- *"Finish in ink"* and/or fully color your drawing (optional).

4. Foreground, Middle Ground, Background

One of the simplest ways to get kids to understand graphic space is to use only three terms: foreground, middle ground and background. They succinctly describe three different spatial positions: one very close to the viewer; one in between background and foreground, and one off in the distance. Kids can easily recognize foreground, middle ground and background in paintings and illustrations by pros. Creating and identifying the three positions themselves is no big deal as long as they keep their drawings simple.

MATERIALS

Black Line Master #15 (photocopied for student use)

Pencils and erasers

Flair pen (optional)

GUIDELINES

■ Create a simple drawing having a foreground, middle ground and background.
 • In the rectangle provided, draw a *horizon line.*
 • Using *size and location*, draw three items in three distinctly different spatial positions.

Remember, drawing an item lower on the paper and larger means it will appear to be closer to us; drawing an item higher and smaller on the paper will make it appear to be farther away.

 • It's okay to have part of an item going off the paper.
 • You may draw anything you like in each of the three positions as long as its size seems realistic in relation to the other items.
 • Start your drawing with *"whisper lines."*
 • Use the *"E–Z Draw method"* as required.
 • Do research when necessary.
 • Darken your pencil lines or *"Finish in ink."*

 (**I**) • Add shadows to your drawing (optional). See *Teacher Tips on Space*, #4, p. 100.

MATERIALS

Black Line
Masters
#16 and #17
(photocopied for
student use)

Pencils and
erasers

4. Outdoors

These step by step drawing exercises (one for Primary **P** and one for Intermediate **I**) show students how to design an outdoor scene using *overlapping* and *size and location*. While the resulting pictures will be more complex than the one produced in **Extension #3** above, it should still be fairly easy for students to identify the items comprising the foreground, the middle ground and the background.

GUIDELINES

■ **In the rectangle provided (Black Line Master #15)**

P **Copy Black Line Master #16: "Circus."**

I **Or copy Black Line Master #17: "Landscape"**

■ **Start by drawing the horizon line (i.e., the line the foothills are resting on).**

I ■ **Next, draw the item that appears to be closest to you, item #1; then the second closest, item #2, and so on until the paper is filled.**

■ **Use *"whisper lines."***

■ **As you draw, think about *overlapping* and *size and location*. Can you name the items in the foreground? The middle ground? The background? In pictures with many items and lots of *overlapping*, is there only one correct answer?**

Black Line Master #16

Black Line Master #17

1. Even very young children can routinely create depth in their drawings using *overlapping*. *Overlapping* can be as simple as drawing a tree "in front of" a house, or a hose "between" a dog and a house, or a moon "behind" a mountain. The key words, are "in front of," "between" and "behind." These are "space" terms. Each can be modeled and learned with ease.

Examples of *overlapping*

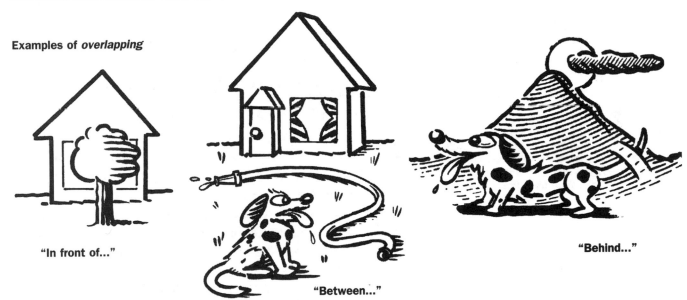

"In front of..."

"Between..."

"Behind..."

2. When teaching spatial drawing, the concept of the *horizon line* is fundamental. In flat empty places, or at the seashore (where the sky meets the ocean), you can really see it. Often, you can't because it's obscured by buildings, trees, hills, but it's there. Why is the *horizon line* important? It's presence can be a reminder to students that "the ground" isn't a straight line you mindlessly stick stuff on top of (Fig. A, right). It's the edge of a plane stretching from the far distance toward us (Fig. B on next page). When students really understand this, they're more likely to use *overlapping* and *size and location* in their drawings. By doing so, they'll naturally create the illusion of depth.

Fig. A.
When children have no sense of space in their drawings, they automatically draw items on top of the horizon line.

To make the concept of the *horizon line* more vivid, take students outside. Depending on where you live, you may or may not be able to see it. (Hopefully, you'll catch a glimpse.) Regardless, students will certainly see instances of *overlapping*, and examples of closer items looming larger than distant ones.

Fig. B.
As children develop a spatial sense in their drawings, the horizon line becomes the edge of a plane upon which they can draw objects of varying sizes. The size of the items will depend on their distance from the viewer.

3. When drawing interiors, the *horizon line* isn't a factor, but a *floor line* is. It separates the wall from the floor (Step 1 below). It's also the rear edge of the floor plane which stretches toward the viewer. Rooms can be made to look noticeably "deeper" by using this simple formula: add a vertical line to suggest a corner and a diagonal line to indicate the line separating the side wall and floor (Steps 2 and 3 below). Once the floor is in place, things can be "placed on it," just as they can be "placed" on the ground of an outdoor picture. (See also illustrations on pp. 214 and 215.)

Steps for drawing the *floor line* and corner. It's important to use *"whisper lines"* so that extraneous lines can be erased.

Step 1

Step 2

Step 3

As in outdoor scenes, a lower position (the cat and high chair) suggests closeness to the viewer; a higher position (the woman and sink) means items are "farther away."

Drawing by a teacher

I **4. Shadows.** Adding shadows to a picture is yet another way to accentuate the third dimension. Shadows, of course, couldn't exist without a light source of some sort. The light source doesn't have to be visible in the picture, it can be implied. Look at the illustrations below. It's pretty clear where the light is coming from in both examples. While shadows can get complicated, simple shadows like the ones in figures C and D below are easy to add. A few dark horizontal strokes to the right of the base of any drawn item, both anchors it to the ground (or floor), and helps the viewer better understand its location in the picture.

Fig. C

Fig. D

In both illustrations above the light source is coming from the left. The cast shadows both anchor the trees to the ground and accentuate the three-dimensional illusion of the picture.

5. Though it can be challenging to get certain kids to use *"whisper lines,"* it's worth the effort (if they're nine or older). There is, after all, a compelling reason for using *"whisper lines"* when drawing spatially: *overlapping* will be more complex, and more intelligently accomplished when erasing is an integral part of *the drawing process*.

As children get used to thinking and drawing spatially, they will plan and position their *overlaps* automatically, and the use of *"whisper lines"* will become less critical.

Over the years, I have seen students (and teachers) create wonderful *straight ahead ink drawings* that were filled with intricate *overlaps*. How did they do it? They thought and planned ahead as they drew.

Left:
Alice Street
Teacher

Right:
Jeanne Mikesell
Teacher

Two views of an imaginary city. The overlaps were planned as teachers drew. *"Straight ahead ink"* was used for both drawings so erasing wasn't an option.

6. Besides *overlapping* and *size and location*, there's a third strategy that students can utilize when creating spatial drawings or illustrations: color. When pointed out to students, it's pretty clear that brighter, lighter colors appear to advance or come forward, while darker, duller colors tend to recede. The best way to teach the concept is by finding and sharing examples in picture books. A case in point: Barbara Berger's *Grandfather Twilight*. The luminous old man and his pearl-moon consistently jump out at us, while the darker forest and sky colors retreat.

I 7. *Foreshortening* is a drawing "trick" that enables us to create the illusion of depth quickly and dramatically. To see *foreshortening* for yourself, hold a quarter between your thumb and index finger in an upright position. You should see a circle. Now, rotate the quarter until it looks like figure E. One edge *appears* to be noticeably closer to us than the other. That's *foreshortening*. Once we start to look for foreshortened objects we'll see them everywhere: table tops, throw rugs, stereos, plates... Have students look for foreshortened objects in the classroom and at home. Drawing foreshortened geometric solids like the ones below will help them grasp the concept. The next step is developing geometric forms into recognizable objects. (See **Teacher Tip #8,** p. 102.)

Fig. E
Rotate a quarter so that it's front edge appears to be closer to the viewer.

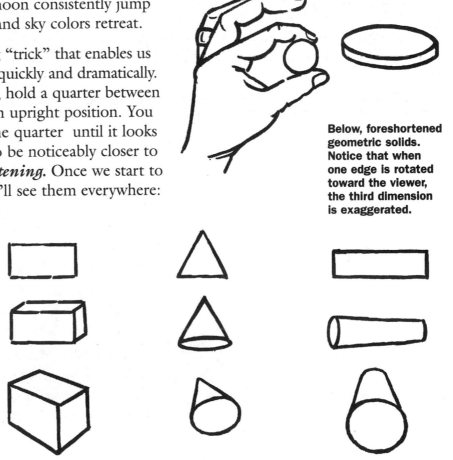

Below, foreshortened geometric solids. Notice that when one edge is rotated toward the viewer, the third dimension is exaggerated.

8. Many older children are no longer satisfied with "flat" drawings of objects they know to be three dimensional. And why should they be? Their knowledge of geometric solids, *"E–Z Drawing,"* and *foreshortening* should enable them to draw practically any object so that it has depth. Start by drawing the item as a series of geometric solids (steps 1 and 2 below). Then, using the *"E–Z Draw"* method, the rudimentary sketch can be developed into a more detailed drawing.

Combinations of shapes and geometric solids can be developed into objects that look convincingly three dimensional. See also *Shape*, p. 31.

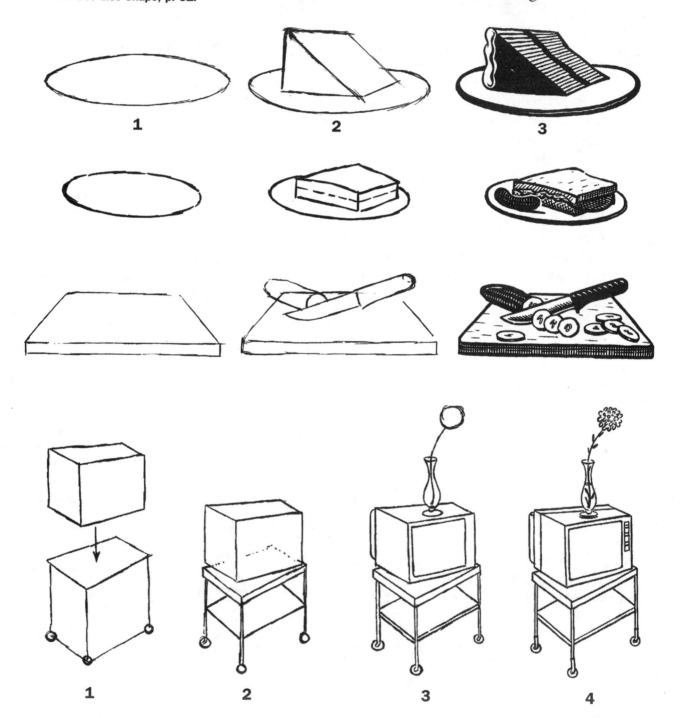

ART/LITERATURE

Children need to see pictures that excite spatial thinking if they are going to create adventurous spaces in their own drawings. Every strategy we've discussed can be found in the work of our favorite artists and illustrators. The following picture books have much to teach us about space:

The Girl who Loved Wild Horses (Paul Gobel), *Sometimes I Like to be Alone* (Heidi Goennel) and *Family Vacation* (Dayal Khalsa) offer rich examples of **overlapping.**

The Santa Cows (by Cooper Edens; illustrated by Daniel Lane) and *Tuesday* (David Wiesner) provide inspiring instances of **size and location.**

The Room (Mordecai Gerstein) shows clearly how three-dimensional interior spaces can be created with a few straight lines.

Family Farm (Thomas Locker) presents vivid examples of **horizon lines.**

Max Makes a Million (Maira Kalman) and *Monkey Business* (by Vivian Walsh; Illustrated by J. Otto Siebold) shows that space need not be conventionally configured; it can be convoluted, shallow, ambiguous and still contain images that are delightful and engaging.

Donna Bade
Teacher

MATERIALS

Pencils and
erasers

Rulers

Black Line
Master #18
(photocopied for
student use)

Drawing paper

Flair pens

Student Activity

MATH

When a child draws any geometric solid, he is creating the illusion of depth. Sadly, only a tiny percentage of school age children ever have the opportunity to do it. While this may seem like a small opportunity lost, it's a loss that need not occur. Any second grader (and many first graders) can draw geometric solids with the best of them when they are taught to do it step by step (p. 25).

I **Stacked Solids**

One of my favorite math drawing games asks students to create a series of precariously balanced geometric solids. In order to draw "stacked solids" successfully, students should use *"whisper lines,"* understand *overlapping* and be able to draw the five basic solids with confidence. The following mini-lessons will enable students to create ever more complex and inventive spatial arrangements:

• Show students how to stack one solid atop another.

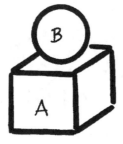

The bottom of sphere B
should rest in between the
front and rear of cube A.

All of the base of cube B is
on top of cube A.

All of the base of
pyramid B is on top of
cone A.

• Show students how to draw one solid coming out of another.

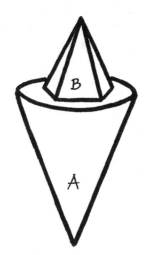

The addition of a
"lip" on a cone
(or cylinder)
is optional.

- Show students how to draw a solid passing through (or penetrating) another solid.

Producing successful "stacked solids" depends absolutely on practicing the strategies described above. Afterward, students can practice "stacking solids " by copying the examples presented below and on **Black Line Master #18.** Make sure students can draw arrangement 1 before tackling 2 or 3. While copying is a fine place to begin, the ultimate goal should be the creation of original stack ups.

"Stacked Solids" can be extremely simple (1); fairly complex, (2); or infinitely intricate, (3) depending on the age, preparation and ambition of students. Notice in 2 and 3 the prominent role that *overlapping* plays. (See also pages 298 and 299.)

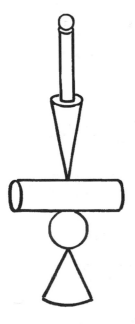

When a cube is near the top of the stack, draw it so that we can see its bottom.

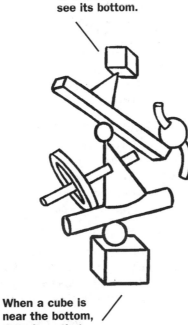

When a cube is near the bottom, draw it so that we can see its top.

1

2

3

Black Line Master #18

1. Kistler, Mark. (1988). *Draw Squad.* New York: Simon and Schuster, Inc.

*Kistler has captivated thousands of children with a PBS program called "Draw Squad." Almost every one of Kistler's 30 lessons, from the TV series, is based on spatial drawing fundamentals such as simple perspective, **overlapping**, shading, **foreshortening**, and the manipulation of geometric solids. The elaborate, cartoony, Escher-like cities that children create using his system are out of this world.*

2. Edwards, Betty. (1979). *Drawing on the Right Side of the Brain.* Los Angeles: Jeremy Tarcher, Inc.

Edwards teaches her adult learners to create depth in their drawings through "sighting." Sighting is a process of comparing the relationships of angles, "points," shapes and spaces in the thing(s) observed. It takes practice, patience and persistence. Sighting is explained in Drawing on the Right Side of the Brain, *an indispensable resource for anyone 12 or older who wants to produce realistic drawings from life or nature (some of the projects Edwards suggests can be adapted for younger children.)*

3. Khalsa, Dayal Kaur. (1988). *My Family Vacation.* New York: Clarkson Potter.

*Colorful and ingeniously composed, Khalsa's illustration are also spatially intriguing. Though **overlapping** is her central strategy, she consistently uses simply drawn **foreshortened** objects (suitcases, beds, picnic tables, beach blankets) to direct the viewer's eye deeper into her pictures.*

4. Siebold, J. Otto, and Walsh, Vivian. (1995). *Monkey Business.* New York: Viking.

*Siebold, who manipulates his drawings on a Macintosh computer, uses all the spatial devices I've discussed (**overlapping**, **size and location**, shadows, **floor** and **wall lines**, **foreshortened** geometric solids). His freewheeling, intuitive approach to creating and filling space, along with the high tech polish of the drawings make his work striking and immediately recognizable.*

5. Wiesner, David. (1991). *Tuesday.* Boston: Houghton Mifflin.

Wiesner's incredible technical ability is happily matched by his sense of humor. At dusk, lily pad riding frogs take to the skies. There's only one catch. They have to be back in the swamp by dawn. Tuesday *is a textbook of spatial illustration with stupendous examples of **overlapping** and **size and location** on almost every page.*

6. Banyai, Istvan. (1995). *Re Zoom.* New York: Viking.

This sequel to Banyai's enormously successful Zoom *(p. 208) is as visually intriguing as the original. Every quirky composition is built on graphic devices designed to heighten the illusion of depth on the page: **overlapping**, **foreshortening**, and especially **size and location**.*

7. Narahashi, Keiko. (1987). *I Have a Friend.* New York: Margaret McElderry Books.

Blue violet cast shadows help to define the deep spaces in Narahashi's lovely watercolors. Across a beach, down stairs, even underwater, a little boy's shadow follows him everywhere.

Barbara Holmes
Teacher

8. Wilson, William. 1993. *Stuart Davis's Abstract Argot.*
Rohnert Park, CA: Pomegranate Books.
*Davis' jazzy paintings from the 1930's and 40's are great examples of
abstract art. Have kids take a look at them before attempting
Extension 2 (p. 93). Though the space in his paintings isn't deep, Davis
manages to create an agitated, spatially ambiguous surface through his
cagey use of **overlapping**. Be sure to share some of Davis' titles , too—
e.g., "The Mellow Pad," "Swinging Landscape," and "Arboretum by
Flashbulb."*

9. Escher, M.C. and Locher, J.L. (1971). *The World of Escher.*
New York: Harry Abrams, Inc.
*More than a master of idiosyncratic **pattern** and the modern tessella-
tion, Escher also created countless drawings and prints of buildings,
reflective surfaces, spheres and spirals that are as profoundly spatial as
they are visually mystifying. No one outdoes Escher when it comes to cre-
ating the illusion of the third dimension on a flat surface. Remarkably
he almost always does it in black and white!*

10. Kalman, Maira. (1988). *Hey Willie, See the Pyramids.*
New York: Viking. (1990). *Max Makes a Million.* New York:
Viking. (1991). *Ooh– la la (Max in Love).* New York: Viking.
*Kalman's books, strongly influenced by surrealism, Dada and the car-
toony Chicago painters known as the "Hairy Who" aren't like anyone
else's. Neither is her treatment of space. On a typical Kalman two page
spread, figures and objects might be huge or tiny, grounded or floating.
Perspective (when she uses it at all) is skewed, **overlapping** is kept to a
minimum, and text is an integral part of the picture. Surprisingly,
Kalman's universe isn't chaotic. It's sweet, silly and worth a look.*

**Overlapping plays an
important part in this
design. Notice too,
the strong and intriguing
use of *negative space*
(see p. 188).**

Alice Street
Teacher

Lesson 7

Color

Pink flamingo!
Have you just been
Newly painted?

Haiku, Grade 4

"The moment I had this box of colors in my
hands, I had the feeling that my life was
there."

Henri Matisse

"Butterflies"
Grade 1

Orangey sunsets, red fire engines, white clouds, pink flamingos—a world without color would be unimaginable. While color enriches our sight beyond words, it can delight, challenge and even frustrate young artists.

Allison, a quiet second grader wields her felt tip markers with authority. Slowly but surely her paper fills with magical color combinations: a house with black and turquoise shingles, a peach colored moon, a yellow cat flecked with red asleep on a blue gray chair. Matt, on the other hand, is a "speedy colorist," covering his paper with with hasty, careless strokes. Minutes after starting his drawing he announces to his classmates, "I'm done!" Sarah has always thought of color as fun, but hard. "I know I'm supposed to use green for grass and blue for sky, but after that, I'm stuck." Saddest of all is Jason. Bright and industrious, he works on his drawing for nearly an hour, then unexpectedly, crumples up his paper in disgust. "I hate my colors!" he fumes.

We've all known children like the ones I've just described. In the average classroom, success with color runs the gamut from inspired to disastrous.

Color is a huge topic. While we can't expect to answer every color question or solve every problem, we can make a strong start. We'll need a full hour and a half to address these color issues: coloring techniques (and *craftsmanship*), *contrast* and *"limited palette."*

MATERIALS

Pencils and erasers

Flair pen

Colored pencils and colored marker (for more on color media, see pp. 254–262)

Cut triangles for the contrast mini lesson (p. 117)

Sheets of colored paper 9″ x 12″

Drawing paper 8.5″ x 11″

Drawing paper 4.25″ x 5.5″

LESSON

Coloring Techniques

All the color theory in the world won't do a thing for the quality of children's colored drawings unless we address the issue of technique. By technique I mean the actual application of colored media (markers and colored pencils) to paper. The following techniques are meant to be introductory only. (You'll find more options on p. 260.)

Tell students: *Today we're going to learn some new ways to color. We'll try five techniques. I'm not saying there are only five ways to color, just that these five are pretty basic. They're a good place for us to start. I'll model each of the coloring techniques, then ask you to practice it. Sometimes we'll be using colored pencils, sometimes markers. You don't have to use the colors I'm using. You can use any colors you wish.*

"Five shapes" can be geometric, freeform, symmetrical or asymmetrical.

• Create a five shape

First we're going to create a "five shape." A "five shape" is a large shape divided into five smaller parts. Here are some samples. (Teacher draws a few of the five shapes below on the chalkboard.)

*Now, practice drawing your own original "five shapes" on your **brainstorm paper**. Once you've drawn a "five shape" that you like, redraw it with Flair pen so that it nearly touches the edges of the small sheet (4.25" x 5.5") of drawing paper.*

Brainstorm paper filled with practice drawings of "five shapes."

A "five shape" drawn so that it fills a small piece of drawing paper.

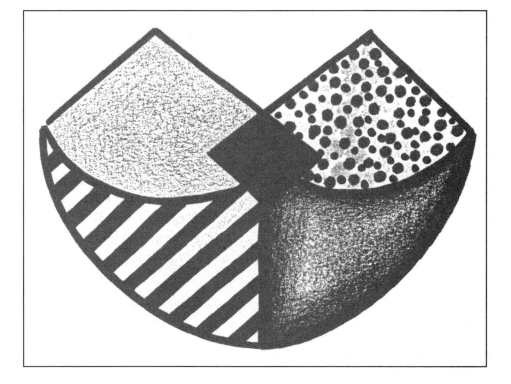

A fully colored "five shape" showing all five coloring techniques.

• The five basic coloring techniques

Before modeling techniques #1–#5 below, take a few minutes to practice them yourself.

Technique #1: *"Nail the white"* — One Color

Teacher Demonstration

*For this exercise. I can use a marker, or a colored pencil. Notice how I start by outlining the contour of one of my mini shapes, then I'm going to fill it in. As I fill it in, I'm going to **"nail the white."** **Nailing the white** means I'm going to make sure that every bit of the white paper is completely colored. (If you're using a colored pencil, you'll have*

to press fairly hard and you may have to color in different directions to cover all the white.) Do you see any white in my first shape? No! Now you try it.*

- Select one of your "five shapes."
- Using one colored pencil or marker, ***"nail the white."***

* Prismacolor pencils applied in this way are capable of delivering colors as rich and intense as oil paint!

Technique #2: Exotic Mix (Light pressure using three colors)

Teacher Demonstration

Now I'm going to mix a color using a combination of colored pencils. (No markers!) I can chose any three colors to create my mixture. First, I'll apply color #1. Notice that I'm not pressing very hard. My strokes are light and even. Now I'll rotate my paper a little (about 45 degrees), and color over my first strokes with color #2. Again, my strokes are as light and as even as I can make them. (Don't expect your strokes to be perfect. This takes practice!) Now let's try color #3. I'll rotate my paper again (about forty five degrees) and try to make my strokes light and pretty even. If I need to, I can go back and use color #1 or color #2 again.

*As I mix my colors, I'm experimenting. Maybe I'll end up with a color that's weird. Maybe I'll give my mixed color an interesting name like "Rotten Banana" or "Stormy Sea Gray" or "Day Break Pink." I call these mixed colors "exotics." "Exotics" are unusual colors that are mixtures of three colors (or more). It may take a while to get the "exotic" color I want. I'm not rushing. I want my work to look great when I'm finished. That's good **crafts-manship**! Now you try it.*

Diagram showing the gradual build up of three mixed colors using light pressure.

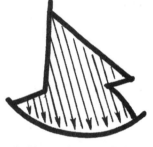

1. First color: parallel strokes and light pressure in one direction.

2. The second color is applied at an angle to the first.

3. Color #3 is applied at an angle to the first two colors.

4. Repeat colors #1, #2 and #3 as necessary. Keep pressure light. Slowly but surely an exotic mixture is created.

In one of your shapes, create a mixture of three colors using light pressure.

Technique #3: Stripes

Teacher Demonstration

*Now I'm going to create a series of stripes as I fill in shape #3. I can use any combination of markers and colored pencils, light and heavy pressure, mixed and unmixed color. Stripes can run in any direction: horizontally, vertically or diagonally. They may or may not be parallel; colors may or may not be repeated. I want to **"nail the white"** (except where I'm using colored pencil and applying light pressure on purpose). When I'm finished, the entire shape will be striped. Notice how I'm taking my time and doing my very best work. I want to be a good **craftsman**. Now it's your turn.*

Fill in shape #3 with stripes:

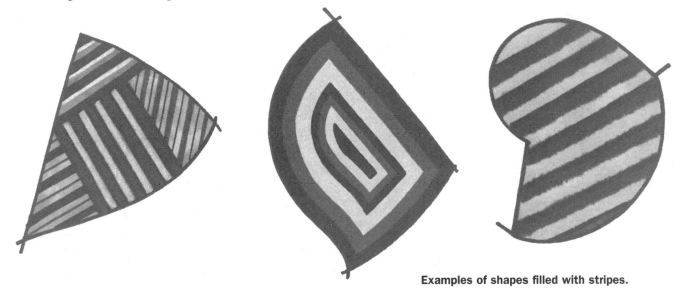

Examples of shapes filled with stripes.

Technique #4: Dots (See also Art History— Pointillism, p. 129)

Teacher Demonstration

*I'm going to fill up my fourth shape with dots. My dots can be the same size or different sizes. I can use colored pencils if I want to, but markers work best for this technique. With color #1, I'll make a series of dots all over the shape. I'll leave some white in between my dots so there's room for another color. Now I'll dot with color #2, then color #3, until the shape is completely filled. See, I've **"nailed the white"** using dots. All the white in my shape has disappeared and that's good! Now it's your turn.*

Completely fill in shape #4 with a series of colored dots using at least two colors.

Examples of shapes filled with different sized dots.

Technique #5: Light pressure mixed color with shaded outline

Teacher Demonstration

For technique #5, follow the directions for technique #2 above. As you create your light pressure mixture say to students: *Notice how I'm taking my time as I fill in the shape. I want my work to look great when I'm done. That's good* **craftsmanship**!

Now that I've got my shape filled in with a light pressure mixture, let's add a shaded outline. There are two parts to shading:

- *First, I'll use one of the colored pencils I already used to create a strong* **"nail the white"** *outline along the inner edge of the shape. Notice that in order to* **"nail the white,"** *I'm going to use a lot of pressure.*

- *Second, I "feather" the outline, i.e., gradually diminish my pressure as I break down the line of demarcation that separates the* **"nail the white"** *outline and the light pressure mixed color. Notice how the feathering ends well before it reaches the middle of the shape. The middle part of my shape remains nice and light.*

Now, you try it.

1. A light pressure mixture of three colors is created (Technique #2 above).

2. A strong *"nail the white"* outline is added to the edge of the shape (use one of the three mixed colors).

3. The *"nail the white"* outline is feathered.

- Fill in your fifth shape with a light pressure mixture using colored pencils (Technique #2 above).

- Using color #1, #2 or #3, create a *"nail the white"* outline, then "feather" it.

- Make sure the center of your shape remains light in color.

Contrast

Contrast determines how much or how little adjacent colors separate from one another. If I place a very light color on a very dark color, I'll get high contrast (e.g., yellow on dark blue). Very noticeable separation occurs. Juxtapose two colors that are very similar (e.g., light blue and light green) and I get low contrast. Hardly any separation occurs.

High Contrast

Low Contrast

Black, white and gray images can be thought of as having high or low contrast, too.

Why is *contrast* important?

Young artists should know about *contrast* for a couple of reasons:

- High contrast gives drawings *zip*. *Zip* means *oomph, graphic power, pizzazz*. Kids are drawn to high contrast images like bears to honey — to the black and white illustrations of Chris Van Allsburg and the colorfully "contrasty" images of Paul Gobel, Max Grover, Dayal Khalsa and Heidi Gonnel. (See **Resources** p. 130.)

- *Contrast* determines whether figure and background will separate sufficiently.

Look at Fig. 1 below. You can really see the fish. The fish is light, the background, dark. A classic example of high contrast. In Fig. 2 you can't see the fish very well. The reason? Low contrast. Maybe that's bad because we really want to see the fish. Or, maybe it's very good because we're doing a project on camouflage. Low contrast is exactly what's required if we want the fish to blend in with its background.

Figure 1.
High contrast: The fish really stands out from its background.

Figure 2.
Low Contrast: It's very hard to see the fish. A fine drawing — if camouflage is the goal.

Teaching Kids About Contrast

Before doing the following mini lesson, take a few minutes to prepare no more than five or six cut out paper triangles (assorted colors, including white, about 5″ to 6″ in height), and sheets of 9″ x 12″ construction paper (assorted colors, including black).

High Contrast: Dark and Light

Place a white triangle on a black sheet of construction paper and ask students, *Is it easy or hard to see the triangle?* When they say, "Easy!" ask them, *Why?* During your discussion it will be clear that it's because one color (or *value*) is very dark and the other one's light.

High Contrast: Warm and Cool

There's another way to achieve high contrast. Place a "warm" colored triangle (e.g., red) on a "cool" colored piece of construction paper (e.g., green). Ask students, *Is it easy to see this triangle?* The answer is "Yes" because "warm" and "cool" colors tend to *contrast* noticeably. (You may have to do a quick color wheel lesson with students if they're not familiar with "warm" and "cool" colors. If you would like to brush up on basic color terminology yourself, see p. 272.)

High contrast

The basic color wheel.

Warm colors are Yellow, Orange, Red (Y-O-R).

Cool colors are Purple, Blue, Green (P-B-G).

Tell students: *Whenever there's a big difference between adjacent colors, whether it's because the colors are dark and light, or because they're warm and cool, (or both), that's called high contrast*. (See if they can find examples of high **contrast** in the classroom.)

Low Contrast

Now juxtapose two colors that aren't very different. (The "closer the colors are the better, e.g., cream on light yellow, or maroon on a dark red, etc.) Ask students: *Is it easy or hard to see the triangle?* During your discussion it should be clear that it's harder to see the triangle because it's not that different from the background color. Tell students: *When there's not that much difference between adjacent colors, we say* **contrast** *is* **low**. (See if they can find examples of **low contrast** in the classroom.)

Low contrast

Limited Palette

"Limited palette" refers to an artist's/illustrator's decision to reduce the number of colors used in a picture. Instead of using 16 or 17 or 18, she may elect to use only six, or five or four colors in the *whole* picture.

Why is "limited palette" important? Remember our friend Jason who threw his drawing away because he hated his color? I counted the number of colors he used: twenty one! Kids who have no intuitive feel for color often use too many different colors. When their pictures stare back at them, they don't see the harmonious color relationships they'd hoped for. Instead, they're faced with discord and disappointment. If a young artist limits the number of colors used, he will usually have to repeat colors. Repetition of color joins the disparate parts of an image together. It helps to create a unified, harmonious whole.

Student Activity

"Limited Palette"

Tell students, *We're going to try a color experiment. It's called "limited palette." Here's how it works:*

- Draw a fun and interesting original shape that's divided into 12–15 smaller shapes.
 - The shape should pretty much fill a sheet of drawing paper 4.25″ x 5.5.″

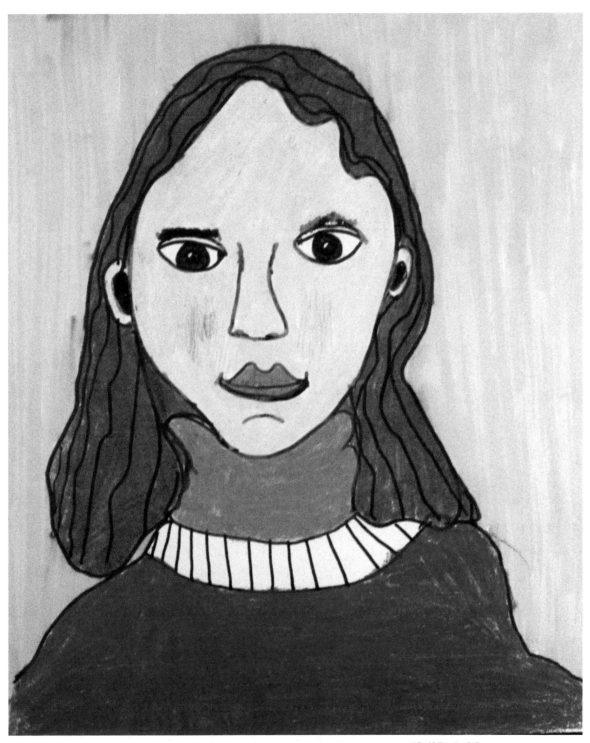

"Self Portrait"
(Flair pen and Prismacolor pencils)
Student
Grade 4

**Top: "Self Portrait" in progress.
(Flair pen and Prismacolor pencils)**
Grade 5

The finished drawing can be seen on the cover of *Drawing in the Classroom*.

**Below: "Self Portrait"
(Flair pen and Prismacolor pencils)
Tim Wilson**
Grade 5 (See p.168.)

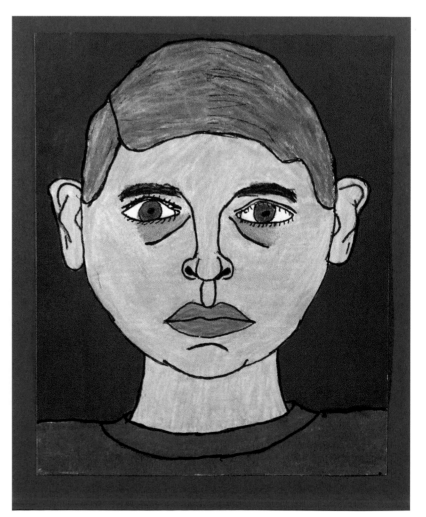

Left: "Circles" (Prismacolor pencils)
Norah Gilson
Grade 6 (See p. 120.)

Below: "Five Shape"(Flair pen and Prismacolor pencils)
Grade 4 (See p. 110.)

Having the opportunity to learn and practice a variety of coloring techniques adds immeasurably to the quality of student drawings.

Left: Michael Kim puts the finishing touches on the illustration for his story, "The Wrong Person."

(Flair pen and Prismacolor pencils)
Grade 4

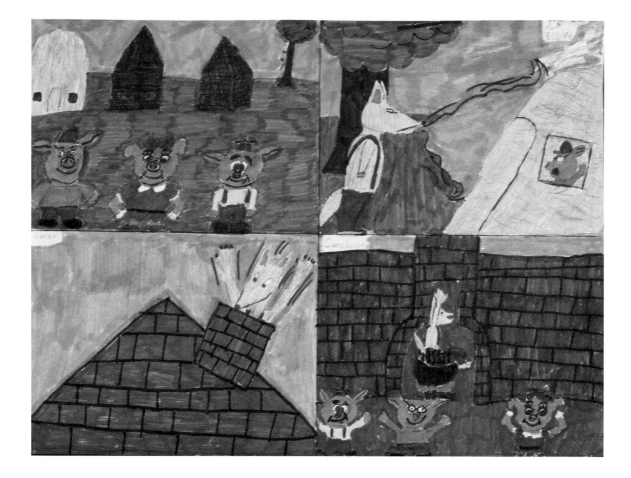

**Above: "The Three Little Pigs"
(Colored markers)
John Bui**
Grade 7

**John's four drawings depict the parts
of a simple narrative structure:
exposition (upper left); conflict
(upper right); climax (lower left) and
conclusion.**

**Below: Illustration for her story,
"Sledding" (Flair pen and
Prismacolor pencils)
Tiel Keltner**
Grade 3

**Above: Illustration for her story,
"Christmas on the Plains"
(Flair pen and Prismacolor pencils)
Lucy Armendariz**
Grade 4

**Exposure to picture books
of extraordinary quality is
an important part of a young
illustrator's education.
Lucy's drawing, while unmistakably
original, was inspired by
Paul Gobel's,** *The Girl Who
Loved Wild Horses.*
See p. 150.

**Below: "Rooms We Can View"
(Flair pen and Prismacolor pencils)
Jill Austen**
Grade 6

**For Jill's stories about each
of her four rooms,** see p. 223.

Right: "Fish"
(Flair pen and
Prismacolor
pencils)
Student
Grade 5

Above: "Fantasy Flower"
(Flair pen and Prismacolor pencils)
Student
Grade 2

Right: "Ice Cream Treat"
(Prismacolor pencils)
Student
Grade 3

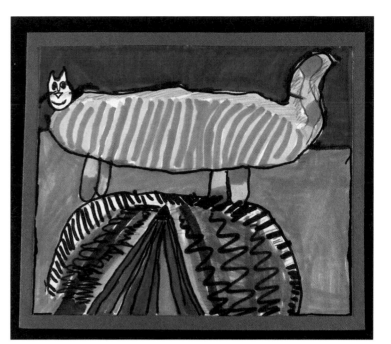

Above, left: "Flowers on a Distant Planet"
(Flair pen and Prismacolor pencils)
Student
Grade 5

Above, right: "Ruff the
Underwater Cat"
(Flair pen, colored markers and
Prismacolor pencils)
Erin Welsh
Grade 1

When we make a variety of coloring
tools available to younger children
and show them mixing techniques,
they frequently *"nail the white"*
naturally.

Left: Illustration for her poem,
"I Know Horse Shows."
(Flair pen and Prismacolor pencils)
Emily McMurdo
Grade 5

As we guide children to create
finished products of the highest
possible quality, we notice, they
aren't simply building skills. They're
experiencing elevated self esteem
and an enhanced sense of personal
possibility. Emily is a case in point.
Her delightful illustration is more
than matched by her poem
which went through multiple
revisions. See p. 205.

Above left: "Night Forest"
(Oil pastel on black construction paper)
Norah Gilson
Grade 1

Above right: "Animal Self-Portrait Totem Pole"
(Flair pen and Prismacolor pencils)
Emily Green
Grade 4 (See p. 229.)

Left: "Great Horned Owl" (Watercolor)
Ben Rector
Grade 6

Improved drawing and a firm grasp of composition have a positive impact on children's picture making, regardless of the media they're using. Ben's deft handling of watercolor and his decision to use a "medium shot" bring us face to face with his magnificent owl. See p. 188.

- Color your shapes using no more than five colors. (You can use fewer colors than five, if you wish.)
 - Spend a few minutes choosing your five colors.
 - Try various combinations on a practice paper.

 - Make sure you like the way the five colors look together.
- *"Nail the white."*
 - Use any of the coloring techniques that enable you to *"nail the white"* including "one color," "stripes" and "dots."
- Practice good *craftsmanship.*
 - Take your time. No rushing. Do your best work. Care about the thing you're creating. (If you don't care, who will?)

After students have finished coloring, discuss the following questions:
- Have you ever tried *"limited palette"* before?
- Did five colors seem like enough? Why? Why not?
- Did you successfully *"nail the white?"*
- Would you chose to do *limited palette* again? Why? Why not?

Examples of fun and interesting original shapes that have been divided into 12 – 15 smaller shapes.

Black Line Master #19 (photocopied for student use)

Drawing paper

Pencils and erasers

Colored pencils

Colored markers

Flair pen (optional)

1. Circles (*Limited Palette*)

Starting with one of the reproducible circles on p. 363, create a design using no more than five colors. (This project could also have a *pattern* emphasis. (See p. 146, *Circle a Pattern.*)

GUIDELINES

- Chose one of the circles on Black Line Master #19 to color.
- Using *"whisper lines,"* design one segment of the circle, then repeat the same design in the other segments. (Don't expect every segment to be exactly the same.)
- Use no more than five colors.
 - Think about and test color combinations on a practice paper before settling on your colors.
 - Use any combination of markers and colored pencils.
 - Color adventurously, *"nail the white"* in different ways, e.g., "one color," "stripes," "dots," etc. Mix and shade.
- Segments need not be colored identically.
- Practice good *craftsmanship*.

I • Students could create larger or smaller circles using compasses, and divide them into segments free-hand, with rulers, compasses and/or protractors.

Designing a six segment circle. (Colored pencil)
Grade 4

Students shouldn't expect each of their segments to be exactly the same. Persnickety older students could design one "master component," then use it to trace each of the circle's segments. (See the *"tracing method,"* p. 201.)

**Master element drawn
in one of the circle's segments**

**Master element redrawn (or traced)
into all six segments**

See also colored "Circles," Color Plates, p. 3.

2. Butterflies

Starting with one of the outlines on p. 364 (or one of your own creation), design and fully color a butterfly.

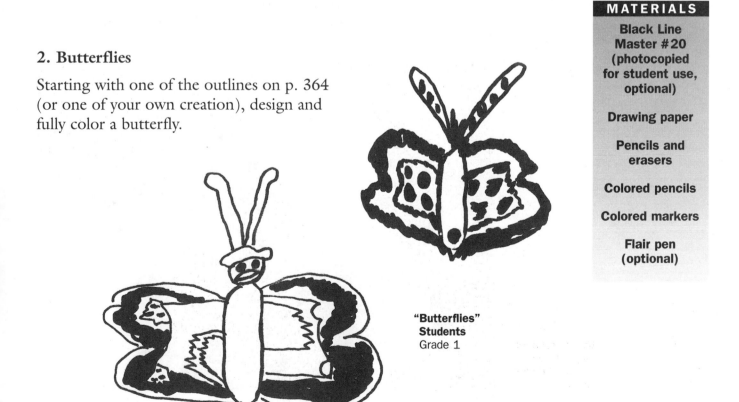

**"Butterflies"
Students
Grade 1**

MATERIALS

Black Line Master #20 (photocopied for student use, optional)

Drawing paper

Pencils and erasers

Colored pencils

Colored markers

Flair pen (optional)

3. Trees (High & Low Contrast)

Student practices drawing the silhouettes of trees. (Weather permitting, take students outdoors to look at and draw the shapes of real trees.) Once student has decided on the two trees she wishes to draw, make drawing paper available. Be sure to revisit the concepts high and low contrast.* (Keep drawing paper on the small side because the entire paper will be colored.) The proportions of the paper can vary to accommodate the shape of the tree: taller pieces for conifers, e.g., 5"x 3"; squarer pieces for the deciduous variety, e.g., 4.5"x 3.5".

High contrast tree.

GUIDELINES

- After looking at real tree shapes and tree pictures, create two tree drawings that pretty much fill your papers.

- Trees can be one color or a combination of colors.
 - Think about and test color combinations on a practice paper before settling on your colors.
 - Use any combination of markers and colored pencils.
 - Color adventurously, *"nail the white"* in different ways, e.g., "one color," "stripes," "dots," mix and shade.

- Color your entire paper.
 - Color one tree so that it dramatically separates from its background (*high contrast*).
 - Color the second tree so that it barely separates from its background (*low contrast*).

- Practice good *craftsmanship*.

*If possible, show students the paintings of French Impressionist Claude Monet (See **Resources**, p. 130). Monet, a master colorist, painted certain subjects — haystacks, cathedral facades, the bridge over a pond in his garden—many times. As the light changed on his subjects, so did his perception, and his application of color. Like our young artists, Monet was familiar with high and low *contrast*. In some of his paintings subjects separate dramatically from their backgrounds. In others, *contrast* between figure and ground is minimal.

Low contrast tree.

"Stormy Sky"
Colored pencil
Grade 4

4. Sky

Skies are a colorist's delight. This **Extension** should change students' perceptions of skies forever.

GUIDELINES

■ Look at different ways that skies have been represented by artists and photographers (e.g., *Sky Tree* by Thomas Locker, El Greco's painting, "Storm Over Toledo," Van Gogh's "Starry Night," *Big Sky Country* by Michael Melford.

■ Go outside at opportune times and discuss some of the sky colors you see. Is there a real sky that you remember seeing that was remarkable in some way? Talk about and list all the different kinds of skies that one might draw and color: sunrise, storm, perfect summer day, sunset, immediately after a rain shower, full moon sky, meteor shower, rainbow sky, etc.

■ Cut out swatches of exotic skies from photos in popular magazines (*National Geographic* is a good bet; so are car ads.) Make them available for students to copy.

■ Create "a patch of sky" drawing (4.25″ x 5.5″).
 • Fully color your entire paper.
 • Think about and test color combinations on a practice paper.
 • Use any combination of markers and colored pencils.
 • Color adventurously, *"nail the white"* via "one color," "mixing," "shading."
 • Experiment with new coloring techniques.

■ Practice good *craftsmanship*.

Student *thumbnail* for "Stormy Sky."

1. Time permitting, have students create a "menu" of combined colored pencil and marker techniques. The techniques practiced for their "five shapes" are a great place to start. More techniques can be found on p. 260. Encourage students to share discoveries ("Look! If you color over the tree with a white colored pencil, then rub it with your finger, it looks like fog.") Encourage them to add new coloring techniques to their menus throughout the school year. Also, creating a pattern sampler, our work in **Lesson 8**, will greatly expand and enrich color possibilities.

2. It's hard to describe coloring techniques in words. As anyone who's wrangled with software manuals can attest, it's so much easier when someone in the know shows you. Not to be discouraged. Remember: some techniques are trickier than others and each technique requires practice. As always, "practice makes better."

3. Practice the coloring techniques yourself first (p. 111–115). They're fun to do! The more confident you are wielding markers and colored pencil in combination yourself, the more comfortable you'll be modeling them for children.

4. When doing any modeling, make sure that kids can really see what you're doing. If they can't see you, they won't get it.

5. Why am I so insistent about *"nailing the white?"* Obviously, there's no rule that says you must make the white of the paper disappear. However, I've noticed for twenty years, with few exceptions, that children admire richly colored images whether in work produced by their peers or by professional artists and illustrators. Most kids want to achieve the same vibrancy of color in their own work. It's just that they don't know how to do it. We can show them.

6. *"Nailing the white"* may not be developmentally appropriate for primary age children, especially first graders. (Though I've met hundreds of little kids who loved the look and the challenge of *"nailing the white."*) Proceed with caution. Remember, the goal is for kids to learn to love color and coloring, not become slaves to technique. For best results with primary aged colorists,

Rattling rattlesnakes,
rattle on the railroad,
rockets roaring from rainbow to rainbow,
the radical colors of Ronnie Robot
make the Epic record shimmer
and the yellow ruler quiver.

"R"
Drawing and alliterative poem
Travis Ludahl
Grade 6

The color version of this illustration can be seen on the cover of *Drawing in the Classroom*.

In the process of mixing colors (and media), younger children often *"nail the white."*

"The Mountain Cat"
Nathan Hornocker
Grade 1

make a variety of coloring agents available (see pp. 254–262). Encourage them to mix colors. In the process of combining colors, they'll not only end up with unexpected mixtures, they'll (mostly) ***"nail the white."*** Best of all, they'll love their color.

7. Small is Beautiful. Where is it written that children must always draw on paper 9″ x 12″ or larger? How many times have you seen kids start to color large, beautiful drawings only to burn out half way through? To those who say, "Oh, but little kids need bigger papers," I'll agree if they're painting, or working with media like chalk or oil pastel. For major projects, when the entire paper is to be colored with markers and/or colored pencils, I have primary students work with papers 6″ x 7,″ and intermediate (and older) on papers 5″ x 6.″ Working smaller has these advantages:

- Coloring goes faster.
- Burn out is much less likely.
- *Craftsmanship* can be a high priority for every student.

Obviously, we don't have the time or need to fully color every drawing or illustration. Pick your projects, work smaller, then don't be shy about asking for quality work. (See also *Thumbnails* to the right, and the fully colored student drawings, Color plate pages 1–8.)

8. Where major projects (fully colored drawings) are underway for grade 4 and older, *thumbnails* can be an indispensable tool. *Thumbnails* are small replicas of the designs, drawings and illustrations that kids are working on. They're the recommended place for testing color combinations before students begin final drafts. (I started using them routinely when I saw older students struggling with decisions about color.) *Thumbnails* can either be redrawn, scaled down versions of student final drafts (remind kids that replicas don't have to be perfect), or produced by reducing the original pencil or ink drawing on a photocopier.

These *thumbnails* by fourth graders were hand drawn. They are smaller, simplified facsimiles of their final drafts.

9. The toughest color problem that older students face is creating adequate separation between backgrounds and the objects, people, etc. that make up the foreground. Students need to be reminded regularly that an artist's or illustrator's job is to make sure that the most important parts of his picture show up. That can't happen if there's insufficient *contrast*. Understanding the basics of *contrast* (p. 115) will certainly help. So will the use of *thumbnails*.

Illustration for the story "When They Moved to Florida." The above *thumbnail* was created by reducing the original line drawing on a photocopier.

Tashina Cliff
Grade 4

LANGUAGE ARTS

Literature/Art

Whether we are sharing Gerald McDermott's *Arrow to the Sun*, or Malcah Zeldis' *Honest Abe*, color can play an important part in our discussion. We might ask, "Why do you think the illustrator used these colors? Do you always like bright colors best? Do you like some color combinations more than others? Which ones?" Try to get conversations going, to hear what young artists see, think and feel. "Why does David Diaz use such weird colors in *Smoky Night*? How does Barbera Berger, author/illustrator of *Grandfather Twilight*, make her pictures looks so soft?" Sometimes, we can actually see children developing personal taste as they encounter new images. And their

preferences begin to show up in *their* pictures. Recently, after exposure to the books of Chris Van Allsburg, a fourth grader decided to use black and white exclusively for the illustrations in his book on birds. "I like the way he (Van Allsburg) does it," he told me. "Sometimes, you can say it all without using color."

ART HISTORY

Introduce young colorists to the work of the Pointillists. Pointillism, a brief but fascinating chapter in the history of art, was practiced in the late 19th century by Georges Seurat, Camille Pissaro and their followers. In order to make their daring paintings, the Pointillists covered their canvases with little dots and dabs of color. Close up, the paintings looked utterly abstract, but from a distance, the small blobs of color coalesced into recognizable shapes and forms: dogs, shadows, parasols, people. Interestingly, Pointillisim anticipated modern color printing (look at any printed photograph with a magnifying glass and you'll see that it's made up of minute colored dots), and the digitized pixels that comprise today's computer images.

Close up, the work of the pontillists appears to be abstract.

SCIENCE

The addition of color to the observational skills learned while "*seeing and drawing*" equips young artists to create ever more accurate drawings of the natural world. Start small; practice parts of flowers and sections of autumn leaves before tackling whole flowers and leaves, or larger items like amphibians, birds, mammals. As skills grow, share the astonishingly detailed colored engravings of John Audubon (*Birds of America*), any of Ruth Heller's many fine books, and Irmgard Lucht's remarkable, *The Red Poppy*. Though light years beyond children's ability level, these artists can still instruct and inspire.

RESOURCES

1. Bjork, Christina. and Anderson, Lena. (1985). *Linnea in Monet's Garden.* New York: R&S Books.
Ebullient Linnea and her friend Mr. Bloom visit Giverny, the pastoral home of Claude Monet. Full of happy banter, historic photos and reproductions of Monet's paintings. Don't miss the four different "impressions" Monet painted of the Japanese bridge over his famous lily pond. The last one—a torrent of red—was painted when he was almost blind!

2. Goennel, Heidi. (1987). *When I Grow Up.* Boston: Little Brown.
Goennel carefully designs and arranges flat, undetailed color shapes to make her spare and striking pictures. Like her artistic ancestors, Matisse and Milton Avery, Goennel is as interested in shape and color for their own sake as she is in the charming people, objects and places pictured. Her color combinations are often unusual and beautiful.

3. Berger, Barbara. (1984). *Grandfather Twilight.* New York: Philomel Books.
Grandfather Twilight removes yet another tiny moon pearl from a magical necklace, walks through a forest of whispering leaves, and gently "gives the pearl to the silence above the sea." If this book is ultimately about serenity, Berger's colors (opalescent whites, minty greens and misty blues) are a big part of the reason.

4. O'Neill, Mary. (1961). *Hailstones and Halibut Bones.* New York: Doubleday.
O'Neill's classic celebrates twelve colors in rhyming verse. Though some of her couplets can be a bit sugary, she hits the mark more often than she misses ("The hottest and most blinding light is white/And breath is white/When you blow it out on a frosty night..."). Great for introducing metaphor and for prompting "colorful writing." Look for the new edition with John Wallner's sensitive watercolor illustrations.

5. Wyeth, Sharon and Colon, Raul– Illus. (1995). *Always My Dad.* New York: Apple Soup/Knopf.
Based on the author's relationship with her father and their special summer visits on a farm in Virginia, Always My Dad *evokes real emotion—loss, joy, and wistfulness. Raul Colon's scratchy, olive drab, sunset orange and sepia suffused illustrations suggest old photographs come to life.*

6. Fry, Roger. (1971). *Seurat.* New York: Phaidon Press.
A reserved, methodical and obsessive artist, Seurat invented a system for portraying the visible world that is as much science as art. He called it "ma methode," but the world knows it as Pointillism. His paintings of late 19th century France, comprised of dabs and dots of warm and cool colors, are utterly original. Up close they're abstract, a jumble of atomized color, but at a distance the blues, oranges, greens, magically coalesce into bathers, picnickers, nudes, circus performers, and radiant, empty spaces.

7. Heller, Ruth. (1985). *How to Hide a Polar Bear and Other Mammals.* **New York: Grosset & Dunlap.**
While we usually talk to students about creating sufficient contrast in their drawings and illustrations, low contrast is desirable when the subject is camouflage. Here, Heller tackles the subject with her usual sure handed realism and clever rhymes. Many other titles are also available in this series: How to Hide an Octopus and Other Sea Creatures, How to Hide a Butterfly and Other Insects, *etc.*

8. Kunhardt, Edith, and Zeldis, Malcah–Illus. (1993). *Honest Abe.* **New York: Greenwillow Books.**
Younger children love Zeldis' raucously colored illustrations. Older kids are baffled by her quirky proportions and idiosyncratic drawing. The truth is, Zeldis, an internationally known folk artist, sees the world— and paints it—like no one else. Honest Abe's shrill contrasts—icy blues played off against glowing ochers, ruddy browns colliding with bright greens—remind everyone that artists can be as original in their color choices as in drawing or compositional design.

9. Thomas Locker. (1995). *Sky Tree.* **New York: Harper Collins.**
This lovely book shows the same tree, painted at different times of the day and year against an ever changing sky. The relationship between tree and sky is handled with imagination, as well as meticulous observation. Use Sky Tree *to initiate lively discussions about contrast, and as a way to inspire young artists to look at the sky with new eyes.*

Teacher Susan Hirt's terrific illustration for her story about a Chinese cook with magical powers. Her *thumbnails,* below right, were created on a photocopier. The use of *thumbnails* enable young (and older) artists to approach the addition of color to their drawings intuitively *and* methodically.

10. Grover, Max. (1996). *Circles and Squares Everywhere!* **New York: Harcourt Brace.**
For bold and brassy color (school bus yellows, pumpkin oranges, fire truck reds,), no one beats Grover. Whether you're a little kid or over the hill, this rollicking first shapes book will wake up your retina and make your optic nerve tingle.

Pattern

*"Visual pattern . . . offers the eye a
reassuring instance of orderliness in a
haphazard world."*
Roger Kukes

Shaerie Bruton
Teacher

Patterns go unnoticed until we look for them. Then they're everywhere. Brainstorming a list of patterns with a lively group of 4th graders recently yielded: "stars on the American flag," "squares on the light fixture," "my angel fish stripes," "the balloons on the wrapping paper in the recycling bin," "lines on the mini blinds," "the hearts on Sarah's blouse," "shingles on the house across the street," "the shapes on a giraffe."

Visual pattern, whether manmade or natural, formal or informal, offers the eye a reassuring instance of orderliness in a haphazard world. Its presence satisfies the left brain's craving for regularity and the right brain's love of decoration. For young artists, pattern may mean the addition of stripes to the body of a tiger, flowers to the gown of a princess, or bricks to the facade of a castle. As we shall see, pattern is a sure way to enrich any drawing.

MATERIALS

Black Line Master #23

Pencil and eraser

Colored markers

Colored pencils

Black Flair pen

Graph papers having squares of varying sizes

Drawing paper

Colored construction paper

Scissors

Glue sticks

LESSON

"All Kinds O' Patterns"

• Homework Assignment

On the day prior to the introduction of this lesson, tell students:

*Tomorrow we are going to start our study of pattern. Finding out more about pattern will help us create drawings and illustrations that are richer and more complex. First, let's make sure everyone knows what a pattern is. A **pattern** results when any combination of lines, shapes, colors or objects repeats at least three times.*

These aren't patterns...

These are patterns...

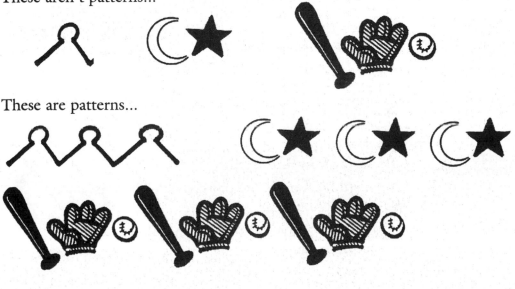

I Tell students: *There are two kinds of pattern: "formal" and "informal."*

"Formal" patterns are usually manmade. They are very regular and predictable like the squares on a checkerboard, the wire spirals along the side of a notebook, or black and white piano keys.

"Informal" patterns usually occur in nature. They are less exact than "formal" patterns, but are still repetitive, like the stripes on a zebra, spots on a Dalmatian, or the leaves on a tree.

Who can show me an example of a "formal" pattern in this classroom?

Who can show me an example of an "informal" pattern? ("Informal" patterns are tougher to find, especially in manmade environments.)

P & **I** Tell students: *Here's a homework assignment that's due tomorrow: Come to school with an example of a pattern. Your example can be anything: an article of clothing; a picture in a book or magazine; a sheet of wrapping paper; a piece of fabric; an object; an item from the world of nature. It can be absolutely anything as long as it displays a pattern of some sort.*

Don't just chose any old pattern. Chose one that you think is unusual, fun or interesting. Consider at least three patterns before selecting the one you will share in class.

Student Activity **Pattern Show and Tell**

Each student shares her pattern with the class and addresses these three questions:

• Why is your selection a pattern? (Point out the repeating elements.)

- Why did you chose that particular pattern? (What's special about it?)
- Is there anything you like (or dislike) about the pattern?

I • Is your pattern formal or informal?

Place the student selected patterned items/objects in a display area in the classroom. Encourage students to be on the look out for additional, unusual patterns. Add to the display regularly.

Pattern Sampler

Using white drawing paper and/or graph papers having different sized squares, Flair pen and colored drawing media, invite students to produce a series of varied patterns. As students work encourage them to:

- Create at least five different patterns (Primary) or eight (Intermediate).
- Look around the classroom, and at books to get ideas (see **Resources,** p. 149).
- Consult **Black Line Master #23** for ideas.
 - It's okay to copy some of the patterns, but be sure to create some original designs as well.
- Produce patterns that are
 - "Formal" (rigorously regular—like the squares on a checkerboard).
 - "Informal" (less rigorous, but still repetitive, like the spots on a Dalmatian).
- Produce smaller pattern swatches rather than larger ones.

As individual students produce noteworthy examples, share these with the whole class.

Once an ample number of patterns have been generated, each student cuts out her swatches, arranges them, and glues them on to sheets of colored construction paper.

Student Activity

Pattern Sampler based on designs by Mariet O'Leary
Teacher

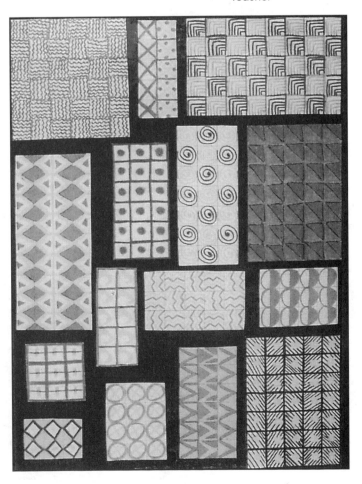

Snake patterns

EXTENSIONS

Ⓟ 1. Snakes

Students start by drawing a series of coiled and undulating, snakes. Drawings need not be carefully researched or detailed since the focus of the project isn't realism, but pattern. Once drawn, the snakes are "decorated" with patterns of the student's choice. This is a particularly good opportunity for teaching younger children about repeating patterns: AB, ABC, even ABCD.

GUIDELINES

■ Draw at least three snakes, coiled and/or extended.

■ *"Make a mistake work in your favor."*

■ "Pattern" your snakes using AB, ABC, and ABCD repetitions.

■ *"Nail the white."*

Ⓟ 2. Elmer and Friends

There's no better way to introduce younger children to lavish patterns than by sharing David McKee's delightful picture book, *Elmer*. Linger over the final two page spread. It shows a dozen profusely patterned pachyderms dancing and playing musical instruments. When it's time to draw, encourage each students to come up with one original fully patterned elephant. It should pretty much fill a trimmed sheet of drawing paper. If kids are having trouble drawing elephants, you can always do an elephant *"E–Z Draw mini-lesson"* based on the drawings at the left.

Upon completion, the student carefully cuts her elephant out, and all elephants are stapled to a bulletin board covered with green paper. Add the good, gray Elmer, and let your version of the "Elmer's Day Parade" begin.

Daron Ryan
Grade 2

3. Balloons

After drawing six to ten balloons, student decorates each with a unique pattern. It's best if some of the balloons *overlap* (i.e., are drawn to look as if they are in front of or behind one another).

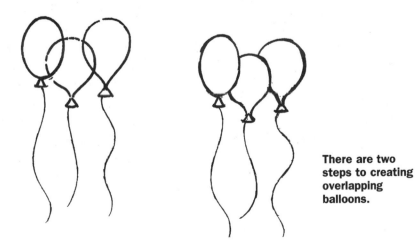

There are two steps to creating overlapping balloons.

4. Pattern that Name

A more elaborate version of *Line That Name* (p. 18), this **Extension** emphasizes shape and pattern. It requires that students know how to form "shape letters." If students haven't done that before, do a mini–lesson on the creation of bubble and shape letters (below).

Lauren Beddle-Stiles
Grade 4

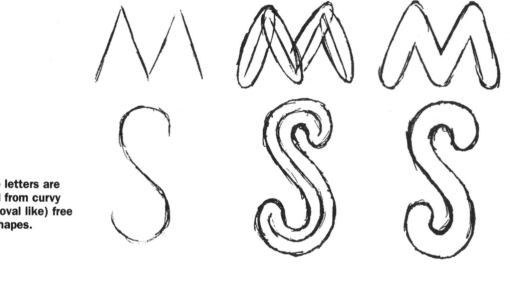

Bubble letters are formed from curvy (often oval like) free form shapes.

Shape letters are similar to bubble letters, except they can be far more inventively designed. Still, they need to be easily legible.

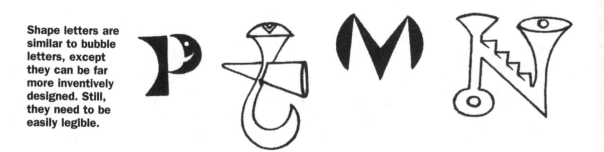

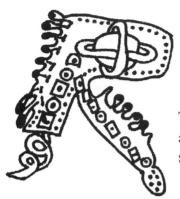

This is a pretty weird **R**, but it's still recognizable as an **R**.

This one, to the right, is ambiguous. We're not really sure what letter it is.

Both "R" and the mystery letter above

Lauren Beddle-Stiles
Grade 4

GUIDELINES

- On a Brainstorm sheet, practice designing bubble and/or shape letters that spell out your first or last name.

- Redraw your letters so that they are nearly as tall as a paper strip 4″ high.
 - Use guidelines if you wish (i.e., *"Whisper lines"* that enable you to locate the tops and bottoms of your letters.
 - If your name is longer than 8.5″, add an additional strip.
 - Use *"whisper lines;"* draw and redraw your letters until you like the way they look.

- Devise at least one pattern for each letter.

- *"Finish in ink"* or color.

See also the writing project, *Name Acrostic* designed to accompany *Pattern that Name*, p. 148.

Norah Gilson
Grade 6

MATERIALS

Black Line
Master #23

Black Line
Master #25

Pencils and
erasers

Sharpie markers

Colored markers

Colored pencils

Drawing paper
5.5″ x 8.5″

5. Clowning Around

Though not everyone's been to a circus, clowns are universally known and loved. Clowns make a natural pattern subject. (It's common for every article of clown clothing to be covered with pattern.) Start this project with clown photos. The best resource I've seen is the Ringling Brothers and Barnum and Bailey Circus annual program, see **Resources**, p. 149. Kids will be amazed. (I know I was!)

GUIDELINES

- Using *"whisper lines"* and the *"E–Z Draw method,"* draw a clown that fills your paper.
 - Refer to *Black Line Master #25* for ideas or create an original clown character.

- Include at least four different patterns on your clown's clothing.
 - Refer to *Black Line Master #23* for ideas and/or use original patterns.

- Think about all the articles of clothing that could be patterned—hat, ribbon, tie, shirt, vest, jacket, pants, socks, shoes...

- It's okay to have some unpatterned places in your drawing.

- It's okay to repeat the same patterns in different parts of your drawing.

- *"Finish in ink"* or color.

1. While color patterns can be gorgeous, don't discount good old black and white. The use of checkerboards, parallel and cross hatched lines, stripes, polka dots, zig zags, etc. enable children to produce drawings that both dazzle, and photocopy beautifully.

2. Before passing out color media to students, be sure to review **Teacher Tips on Color** (p. 125). Insist in your *guidelines* (and verbally) that kids bring the same sense of *craftsmanship* and adventurousness to pattern projects that they brought to their color projects.

3. One of the lovely things about pattern is you don't need to be able to draw "accurately" or realistically to have a darn good time producing designs that are complex and original. Some children (and adults) prefer decorating and embellishing to any other kind of drawing.

"Patterns"
Julie Castillo
Teacher

4. Children's drawn patterns can be described as "common" and "creative." In the common category I'd place the "beginning patterns:" stripes, crosshatched lines, polka dots, checkerboards. Creative patterns are distinctive, original, unique in their playful intermingling of lines, shapes, colors. Once kids have internalized the "beginning patterns," encourage them to "get creative."

"Pattern Extension"
Martin Lindenmeyer
Grade 4

5. Pattern is a bridge that effortlessly and irresistibly connects the worlds of art and mathematics. Think of Escher's visual puzzles, the peerless tessellations of the Moslems, the playful geometrics of the Hopi and Navajo. Mathematics contributes logic, predictability, elegance. Art contributes decoration, craftsmanship, quirkiness.

Painted designs on pottery from the Southwest, 11th to 13th centuries.

Papago basket designs *(Museum of Indian Art and Culture, Santa Fe).*

SCIENCE

• Animal Close-ups

Patterns in nature are everywhere: spots on cheetahs, markings on turtle shells, scales on fish. Have students research and create "close up swatches" of patterned animal hides, skins, etc. Drawings can be fairly small (e.g., 5.5″ x 8″) and should be executed in color. Challenge kids to be as uncompromisingly realistic as they can be. When drawings are done, create a "Guess Who?" bulletin board. Mount drawings with the name of the animal hidden under a tab.

• Cycles

When viewed through the prism of time, cycles are patterns, too—events that repeat at regular intervals: the waxing and waning of the moon; the rotation of the earth on its axis and around the sun, the recurrence of the seasons. For older children, the zoetrope (p. 332) is an ideal device to display hand drawn and colored animated sequences showing natural cycles.

"Close up" of a giraffe's hide

A zoetrope strip showing the phases of the moon.

MATH

Pattern is a fundamental part of mathematical thinking. Discovering, and creating patterns, whether with numbers, manipulatives or markers helps to train the mind to seek out and discover similarities–to unite seemingly unrelated bits and pieces of information. Here children begin to perceive their world as manageable, logical, and to experience a satisfaction, even a beauty in predictability and orderliness.

Here are a few pattern projects that encourage both logical and creative thinking:

• Extend a pattern

Provide students with grade appropriate AB, ABC, or ABCD components like the ones below, then encourage them to extend the components repetitively across the page. Students will soon want to create their own pattern extensions.

Primary components

AB ABC ABCD

Intermediate components

AB ABC ABCD

It's okay to use guidelines. Guidelines are light pencil lines drawn with a ruler to help students keep their pattern lines relatively straight.

Some of the loveliest pattern extensions I've seen were
first drawn with *"whisper lines,"* then *"finished in ink."*

Sandy Egbers
Teacher

Kim Martin
Teacher

• **Grow a pattern**

Provide students with the beginning
components of a pattern that progres-
sively enlarges. Tell them they must
"grow it," then "shrink it" in
a logical, linear fashion.

A growth pattern based on the components above.

Growth patterns can be extended, too.

• Circle a Pattern

Pizza slices, flower petals, orange segments are all examples of circular patterns—repeating parts that "surround" a central point.

Provide students with a segmented circle with only one part designed like the one below. (You can use **Black Line Master #19**.) Then ask them to create either a repeating AB, or an ABC pattern depending on the number of "segments." (An even number of segments will be AB; multiples of three, ABC.)

An AB circle pattern based on six segments.

An ABC circle pattern based on nine segments.

$$3 \times 3 = 9$$
$$9 \div 3 = 3$$

Arrays, a common way to help children "visualize" multiplication (and area) become more complex and beautiful when patterns are drawn on paper "tiles."

"Array" by
 Janita Gaylor
 Teacher

LANGUAGE ARTS

Writing and Art

• Titles

Practicing the shape and pattern letters presented in **Extension #4**, (p. 138) will help students produce headings and titles for original reports, posters and book covers that are graphically arresting and unique. These offer an expressive, handmade alternative to the "same old" computer printer generated fonts.

"The Cracked Mirror,"
book cover

Brian Edwards
Grade 6

P • **Snakes** (**Extension #1**, p. 136) provides a great opportunity for young children to learn about describing words. If possible, before drawing begins, view and touch real snakes. If you can't, get to know snakes through pictures or videos. Brainstorm words that describe snakes. (Words may begin with "S," but not necessarily — e.g., "smooth," "slippery," "skinny," "scary," "slithery," "cool," "quick," "colorful," "darting," "daring," etc. After snakes are drawn and "patterned," students carefully cut them out and glue them on to pieces of colored construction paper. Along the edge of the snake's body print (or word process) and glue four or five of your favorite snake adjectives and conclude with the word, "snake."

• **Writing**

Name Acrostic. Here's a simple writing frame that can be used with *Pattern that Name* (**Extension #4**, p. 138). Each letter in the student's name is used to begin a sentence or phrase that describes something true and unique about her. For best results have students generate two or three *different* versions of each line, then chose their favorite, e.g., for the letter **N**:

Nebraska is where my dad lives.

Nuts, noodles and nachos are my favorite snack foods.

No, I don't eat meat.

Maddy's my nickname.

Always on time.

Dogs, especially German Shepherds, scare me.

Elephants make me laugh.

Love to shop at the Brass Plum.

Yellow is my favorite color.

Nebraska is where my dad lives.

RESOURCES

1. Ringling Bros. and Barnum and Bailey Circus Program.
*If you're doing any project having to do with circuses or clowns—beg, borrow or steal a copy of the current "**The Greatest Show on Earth**" program. The one I have sports fearless Mongolian horsemen, elephant equilibrists and clowns literally patterned from head to toe. Write or call Ringling Bros. and Barnum and Bailey, 8607 Westwood Center Drive, Vienna, VA 22182 tel. (703) 448–4000.*

2. Radice, Barbara. (1984). *Memphis.* **New York: Rizzoli.**
Memphis, a group of Italian architects and designers set the international design community on its ear in the 1980's. Their audacious drawings and prototypes of appliances, furniture, even buildings were whimsical, elegant and iconoclastic. Not to be missed—their trademark preoccupation with pattern which runs the gamut from "retro" to raucous. Though not a "children's book" per se, I've shared Memphis *with hundreds of students. Seeing it has fired their imaginations—and enriched their drawings.*

Shaerie Bruton
Teacher

Jeanne Mikesell
Teacher

3. McKee, David. (1968). *Elmer.* New York: Lorthrop, Lee & Shepard Books.

Elmer, the colorful, patchwork elephant discovers it's boring to be good and gray. McKee's fable for young children is timeless, true and still attractive thirty plus years after its first publication. The spread of parading pachyderms at the end of the book is the perfect place to begin the study of color and pattern.

4. Bulloch, Ivan. (1994). *Patterns.* New York: Thompson Learning.

Part of the handsome Math Action Series, Patterns *suggests many hands on arts and crafts activities designed to help children ages 5–10 "sort things into groups, match similar things, and find out how things fit together."*

5. Goble, Paul. (1978). *The Girl Who Loved Wild Horses.* New York: Bradbury Press.

Goble, an Englishman who fell in love with Native American peoples, has created a series of award winning books that celebrate the stories and myths of the plains Indians. Every page in The Girl Who Loved Wild Horses *brims with repeating patterns—horse manes, cattails, black-eyed Susans. In all of his books, Goble uses "informal" patterns to convey nature's profusion and harmony.*

6. Joosse, Barbara and Lavallee, Barbara–Illus. (1991). *Mama, Do You Love Me?* San Francisco: Chronicle Books.

This perfect picture book echoes Margaret Wise Brown's classic, The Run Away Bunny, *while giving it an Eskimo twist. Memorable for its touching message of unconditional love, its explication of Inuit culture, and Lavelle's vibrant watercolors of mother and daughter wearing many different patterned dresses.*

7. Carlson, Nancy, (1988). *I Like Me.* New York: Viking Kestrel.

A girl pig finds a lot to admire about herself. And for good reason: she's self-reliant, resourceful, resilient, and practices impeccable hygiene. Carlson's deceptively simple illustrations are always well composed and invariably crammed with jazzy patterns. Don't miss the memorable line, "When I get up in the morning I say (to myself), 'Hi, good looking!'"

8. Igus, Toyomi and Wood, Michelle–Illus. (1996). *Going Back Home*. San Francisco: Children's Book Press.
Artist Michelle Wood returns to the south fifty years after her family moved north to find a better life. Curious about the life her ancestors lived in the Mississippi Delta before and after the Civil War, she imagines, through her densely patterned paintings their work, sorrows, celebrations, rituals, music. Going Back Home *is both a highly personal journey of self–discovery, and a sympathetic portrait of African American hardship, courage and survival.*

9. Esbensen, Barbara, and Davis, Helen–Illus. (1996). *Echoes for the Eye—Poems to Celebrate Patterns in Nature*. New York: Harper Collins.
For years Esbensen, a first-rate poet, and Davis, a sensitive watercolorist, noticed recurring motifs in the natural world: circles, spirals, polygons, branches, meanders. Echoes for the Eye *presents a rare blending of language, science and art. More than that, it helps children glimpse the confluence of shape and pattern in the natural world.*

10. Dover Pictorial Archive Series, many titles. Mineola, NY: Dover Publications, Inc.
This striking series of inexpensive books lists titles like Arabic Geometrical Pattern and Design, Folk Art Motifs of Pennsylvania, *and* Decorative Art of the Southwestern Indians. *While the black and white images (patterns, pictographs, designs, symbols) presented express the prevailing aesthetics of distinct cultures, they also serve as textbooks on the endless variety of human decoration. Write for a catalog: Dover Publications, Inc., Dept CRX, 31 E. 2nd Street, Mineola, NY 11501.*

Tufted cloth pattern, Congo.

Faces

Lesson 9

"Self Portrait"
Mike Schwarzenberger
Grade 6

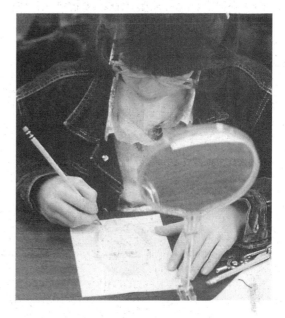

At her desk, eleven year old Brittany studied the reflection of her mouth in a small, round mirror. Pencil in hand, she shaped a likeness of her upper lip. Though the drawing wasn't perfect, it was progressing. Brittany erased the line dividing the upper and lower lip and tried again. I watched her draw, erase, and redraw her mouth three more times before she smiled approvingly and moved on to her next challenge: adjusting the width of her face.

Children's interest in drawing faces is universal; their appetite for information about it, inexhaustible. In my three decades of drawing with children, no subject has inspired them more, and none has elicited greater diligence. The difference between drawings of faces before and after instruction can be astonishing (below).

How does such a marvel occur? It occurs when children are provided with everything that supports their learning and growth as artists and illustrators: reliable information, quiet time to practice and an unabashedly supportive environment. It is a marvel that any classroom teacher can duplicate.

LESSON

1 Kids want to learn to draw all kinds of faces — funny, and "cartoony" as well as real. I've decided to devote our one hour lesson to drawing realistic faces for a couple of reasons: first I'll address the drawing (or designing) of "cartoony" faces in **Extension #1** (p. 164). Second, reliable information on drawing realistic faces for children is in short supply.

The following lesson is intended for students in grades 4 and older. (A simplified version of the same material, suitable for grades 1–3 can be found on p. 182.)

Whether you're teaching primary or upper grades, I suggest you read through the following version and practice the activities yourself. The knowledge and experience gained will be invaluable when teaching *Faces* to your students.

Drawings before and after instruction

Nathaniel Moore
Grade 7

I won't kid you, *Faces* is probably the most challenging lesson we'll do. There's more direct instruction, more *"mimicking,"* and more steps to follow than in previous lessons. *"Whisper lines"* will be used throughout (always a challenge), and some of the drawing is a little tricky (head shapes, noses, ears). To support your teaching of *Faces*, detailed **Black Line Masters** are available for overhead and student use. As usual, modeling the steps at the chalkboard is a more powerful teaching strategy than the use of the overhead alone.

The good news is, the process is quite forgiving. Even when your modeling or their drawings are off the mark some of the time, everyone will still learn a lot *and make progress.* As always, "practice makes better." Your first awkward attempts at the chalkboard will improve dramatically over time as long as you hang in there, emphasize learning and growing, and de-emphasize flawless performance. (If all else fails, you've got the **Black Line Masters** to fall back on.) And even when students struggle, they may eventually produce a face they're quite proud of.

Introducing Faces

Provide students with a small piece of drawing paper (4.25"x 5.5") and ask them to draw a face "anyway you like." (Give them no more than ten minutes.) These will be their "Before Instruction Drawings." After students have signed their drawings, collect and save them.

Ask students: *How many of you like drawing faces? What's easy and fun for you about drawing faces? What's hard?* Depending on the grade level and the group's skill level, answers will run the gamut from "I love drawing faces. They're easy!" to "I hate drawing faces. Mine look dorky."

Tell students: *Today we're going to learn the basics of drawing realistic (as opposed to cartoon or abstract) faces.* Start by sharing the the Norman Messenger books,

"Before Instruction" drawings, p. 154 and p. 155.

Making Faces and/or *Famous Faces* (see **Resources**, p. 180). Ask kids if they think Messenger is pretty good at drawing faces. *What do you like about his faces? What do you dislike? Do you think he had to practice a lot before he was able to draw faces so well?*

Drawing the Generic Face

Before children tackle recognizable faces (i.e., portraits or self-portraits), it's critical that they learn as much as possible about the generic face, its proportions and features. The dominant strategies for our one hour lesson will involve vocabulary acquisition, "*mimicking*" and "*E–Z Drawing*." (I'll discuss individualizing faces in the **Extensions**.)

Whisper Lines

Tell students: *As we create our faces, every line you draw should be a "whisper line." Let's warm up. Start by drawing two small shapes using "whisper lines." You can draw a circle, a square, a triangle—any two shapes you like. Your shapes should be about the size of a quarter.*

After students have drawn their shapes, tell them: *Now erase your shapes completely. If you're having any trouble erasing your lines, they're too dark. Every line needs to be drawn lightly so that once we start drawing faces, lines can be erased and redrawn. You'll need to do a lot of erasing as we create our generic face.*

Head and proportions

Run your hands along the sides of your face, under your chin, and on the top of your head. If you have a mirror, check out the shape of your face. What shape best describes your head? A circle? An oval? An egg shape? Yes, it's shaped a lot like an oval, maybe even more like an egg: round at the top and slightly pointed at the bottom. First we're going to draw the shape of the head.

Teacher Demo: Put **Black Line Master #26** on the overhead— Step 1 only. Using *"whisper lines,"* model the following:

1. **Draw a midline. Make sure it's a true vertical. (The vertical line will help you create an oval that doesn't lean.) Draw the two halves of the oval. Try and make them as symmetrical as possible. Erase and redraw until the two sides are pretty much the same.**

Mid line

Step 1.

Student Activity

- Use *"whisper lines."*
- On your paper, draw a midline.
- Draw a face shape about the size of a real egg, half on one side of the midline, half on the other.
- Hold the paper at arms length periodically to make sure the oval is pretty much straight on the page.
- This is one of the hardest parts of drawing faces. Don't expect your oval to be perfect. Just do your best.

Teacher Demo: On the overhead show **Black Line Master #26**—Steps 2 and 3. On the chalkboard, using *"whisper lines,"* divide your oval as follows:

2. **Add an eye line—halfway between the top of the head and the bottom of the chin.**

3. **Nose line—slightly more than halfway between the eye line and the chin. Follow with a mouth line—halfway between the nose line and the bottom of the chin.**

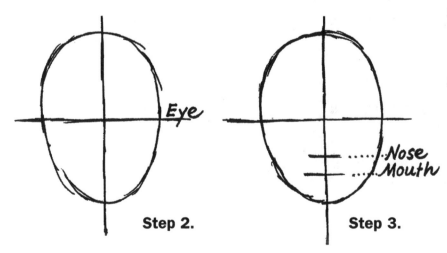

Eye

Step 2.

Nose
Mouth

Step 3.

- Use *"whisper lines."*
- Draw eye, nose and mouth lines.
- Hold the paper at arms length periodically to make sure the lines are straight on the page.

Features

Now we'll add the features to our face: the eyes, nose and mouth. Let's start with the eyes.

1. Eyes

Teacher Demo: On the overhead show **Black Line Master #26**—Step 4. On the chalkboard, using *"whisper lines"* position the eyes as follows:

- Using *"whisper lines,"* rough in the eye shapes.
- Check eye size and face width by very lightly drawing an eye in between the two eyes, and by drawing eyes at the edges (Fig. 4). Once your eyes are properly positioned, erase the "extra eyes."

As you draw, tell students: *Now I'll rough in the eyes. Draw simple shapes, no details. I'm going to draw them on (or below) the eye line. Notice that there's enough space for a third eye in between the two eyes. And there's almost room for two more eyes, one on the right side, the other on the left. (If I can fit full sized eyes at the edges of my face, it's probably too wide. (I'll need to make the face a little narrower.)*

Step 4.

Face width slightly less than five eyes wide.

Teacher Demo: Make photocopies of **Black Line Masters #27** and **#28** available for student use. Tell students: *Now we can add **detail** to our eyes. As I draw an eye on the chalkboard, check out your own eye in your mirror, look at a neighbor's eye, or check out the "Features Sheet."*

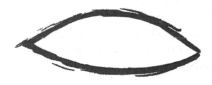

The eye is sort of shaped like a football.

Draw the iris so that the top part is slightly *under* the lid and the bottom is resting on the bottom of the eye shape. Notice the little pink shape. It's always at the edge of the eye that's closest to the nose.

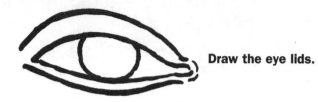

Draw the eye lids.

Ask students to notice all the eye *details* as you draw them (iris, pupil, glimmer, lashes).

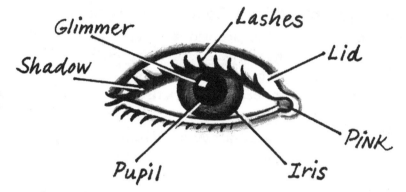

Glimmer

Lashes

Shadow

Lid

Pupil

Iris

Pink

From Black Line Master #27

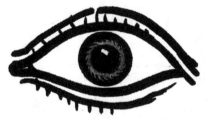

When irises are drawn with too much white around them, eyes look sick or spooked!

Student Activity

Practice drawing eyes (time permitting), then using *"whisper lines,"* add detailed eyes to your face.

2. Nose

Teacher Demo: Tell students: *Noses come in all sizes— long and thin, short and wide... Here's a formula for drawing noses. (This isn't the only way to draw them, but it's a start.) I'll draw one step by step. As I draw, check out your own nose in your mirror. Or you can look at your neighbor's nose and at the "Features Sheet."*

From Black Line Master #27

1. Draw the tip

2. *Rough* in the sides

ala

3. *Rough* in the alas

4. *Rough* in the nostrils

Practice drawing noses (time permitting), then, using *"whisper lines,"* add a nose to your face. It's okay if noses are pretty *rough* at this stage.

Student Activity

Mouth

Teacher Demo: *Before we draw the mouth, everyone find your philtrum. The philtrum is the little "U" shaped thing just below the fleshy bridge that separates your nostrils. Touch your philtrum. Look in the mirror or at your neighbor. Can you see the philtrum? Knowing about the philtrum will help us draw better mouths.*

Now let's look at the mouth. Some mouths are small. Some are wide. Look in the mirror if you have one, or you can look at your neighbor and at the "Features Sheet." Are your lips full? Are they skinny? Which lip is bigger, your top lip or your bottom lip?

Let's draw a mouth.

Teacher Demo: Using *"whisper lines"* draw a mouth on the chalkboard.

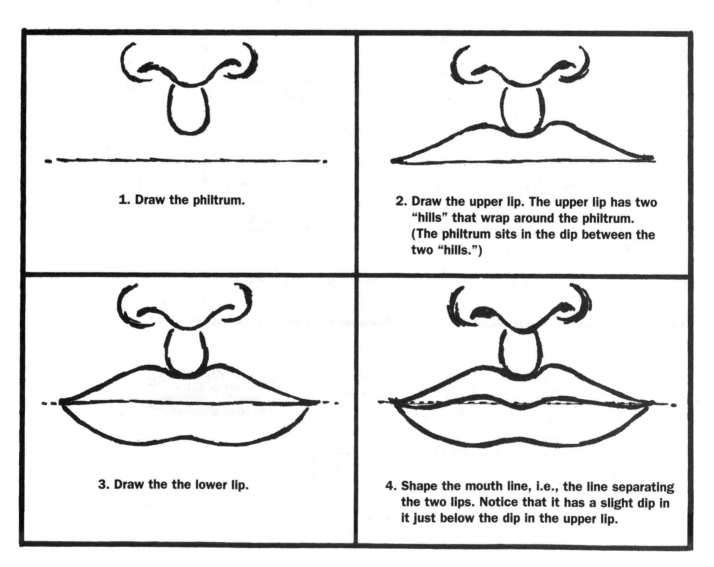

1. Draw the philtrum.

2. Draw the upper lip. The upper lip has two "hills" that wrap around the philtrum. (The philtrum sits in the dip between the two "hills.")

3. Draw the the lower lip.

4. Shape the mouth line, i.e., the line separating the two lips. Notice that it has a slight dip in it just below the dip in the upper lip.

Practice drawing philtrums and mouths (time permitting). Then, using *"whisper lines,"* add a philtrum and mouth to your face drawing.

Rechecking the face shape

Before adding hair and ears, students should check face shapes one last time. An oval that looked great without features may be a bit "off" with eyes, nose and mouth in place.

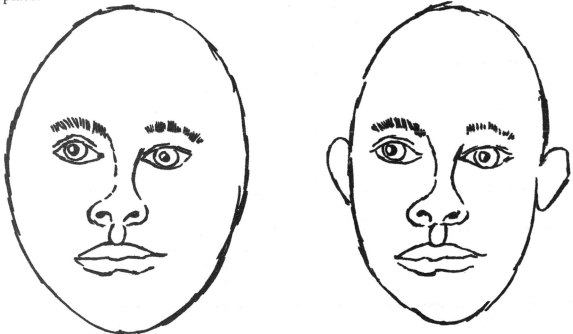

Readjusting the face shape even slightly may mean the difference between a drawing that looks awkward and one that looks terrific.

Have students "partner up" and look at each other's drawings. (If possible, pair a kid who has strong art skills with one who doesn't.) Be on the look out for these common mistakes:

 Student Activity

- The face is too wide or too narrow.
- Too much or too little chin.
- The eyes are too high.

Take a few minutes to reshape the face as required.

Fig. 1: Steps for drawing the ear.

Siimplified left and right ears. (See also ear drawing, p. 250.)

From Black Line Master #28

Ears

Now we'll add the ears. Look at one of your ears in your mirror. Or you can look at a neighbor, or at the "Features Sheet." Ears are probably the hardest feature to draw well, because they're so complicated. Remember, we're not drawing a side view of the head, so we won't see the whole ear. Where do you think we should draw our ears? Usually, no higher that the top of the ear, and no lower than the top of the mouth. Don't expect your ear to be perfect. Just do your best. (Fig. 1).

Teacher Demo: Using *"whisper lines"* add ears step by step.

1. Draw the basic shape.

2. Rough in the helix and the lobe.

3. Add the final bumps and curves.

Student Activity

Practice drawing ears looking in your mirror (time permitting), or at the "Features Sheet." Then, using *"whisper lines,"* add ears to the side of your head.

Hair

Creating convincing hair will be much easier when kids understand this sequence: "Draw hair shapes first, then individual strands."

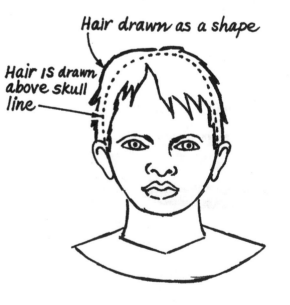

From Black Line Master #26

Hair is represented initially as a shape, or as a series of shapes. Notice that hair is always higher than the skull (unless the subject is bald!).

Individual strands can be drawn within the shape(s) to reflect the way hair is growing, or the way it's combed.

This strategy works particularly well when students are copying a real hairdo—either from a picture or from a live model.

Teacher Demo: Explain how to "draw hair shapes first, then strands" to kids by modeling the sequence above. If you're feeling brave, invite a child with a pretty simple hairdo up to the chalkboard. Have the child pose for you. Look at the child's hair as a series of simple shapes. Copy the hair shapes you see. Then look at the strands, and add those. (Obviously, you can't draw every strand. Just try to follow and record the general flow of hair within each shape.) If you're not feeling quite so brave, you can show **Black Line Master #26**, Steps 8 and 9 on the overhead.

Tell students: *Using **"whisper lines,"** draw "hair shapes first, then add strands." You can make up a hairdo (nothing silly, please), draw a classmate's, or draw your own hair while looking in a mirror.*

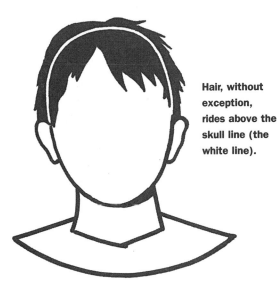

Hair, without exception, rides above the skull line (the white line).

Student Activity

Finishing Up

Once faces are pretty much complete, students can add the "final touches."

• **Neck**
Have students notice that the neck is nearly as wide as the face, and that the shoulders are considerably wider than the face. (A common mistake that children make is drawing necks far too skinny and shoulders ridiculously narrow.)

• **Clothing**
The suggestion of clothing–of whatever sort–just below the neck (shirts, collars, sweaters, buttons), adds immeasurably to the realism of the picture. Discourage kids from making stuff up. Encourage them to use the skills learned in *"E–Z Drawing"* and *"Seeing and Drawing"* as they observe and draw real clothing. (See p. 55.)

• **Eyes**
Eyes will look far more real if we "gray" the irises, and add a glimmer (a small reflected circle of light) to the blackened pupils. (See p. 158.)

Mollie Nelson
Grade 5

- **Darken lines**

 With our strong emphasis on the use of *"whisper lines"* during the drawing process, some faces may lack definition. This is the time to encourage children to darken the most important lines and to erase extraneous ones.

- **Soften lines**

 Not every line needs to be heavy or dark. Noses, for instance, may look silly when represented as a series of hard, distinct lines. Experiment. Certain lines, rubbed with a finger may yield a softer, more realistic looking edge.

MATERIALS

Pencils and erasers

Drawing paper

Black Line Masters #29, #30 and #31

EXTENSIONS

1. Characters

Characters is the perfect place for primary aged students to begin drawing faces that deviate from their "little kid" symbol system. And while six, seven and eight year olds are perfectly capable of drawing closely observed "realistic" portraits using the techniques described in *"Seeing and Drawing"* and on p. 182–183, *Characters* is less rigorous, and more fun. Most importantly, it introduces them to a whole new way of thinking about and drawing facial features.

Christine Griffith
Grade 4

Older children love *Characters* because they're empowered to playfully combine eyes, noses, mouths, hairdos at will—producing in the process—cow pokes, clowns, tough guys, movie stars, athletes, kids and grown ups of all ages, races and both genders.

See also People Poems, p. 176.

Melissa Thompson
Grade 5

GUIDELINES

■ **Practice drawing face shapes, facial features and hairdos from Black Line Masters #29, #30 and #31.**
 • Copying is okay, but feel free to introduce your own ideas

I • Start with *"whisper lines."*

■ **Draw different kinds of faces.**
 • Fill up your entire paper.

■ **You may add neck and shoulders to your faces (no bodies!).**

■ **Make each face distinctive.**
 • We should be able to tell whether your character is old, or young, male or female, clown or cowboy. (Add details accordingly.)

■ ***"Finish in ink."***
 • Create fancy ink drawings by adding solid blacks, dots, stripes and cross hatched lines. (See example below.)

Christine Griffith
Grade 4

The same drawing
"finished in ink"
without and with
fancy ink techniques.

Student
Grade 5

"Harry Truman"
Donovan Powell
Grade 6

2. Drawing Faces from Graphics

Whether doing a portrait of a family member or a famous person, graphics in the form of photos, drawings, paintings and illustrations are an ideal visual resource. Unlike restless models, these two dimensional images hold still indefinitely, providing young artists with plenty of time to make sense of the lines, shapes, tones and colors that comprise a specific face and its features.

Students working from graphics (or from life) shouldn't be expected to produce a convincing likeness of a subject until at least grade four, and then, only after they've had a lot of practice drawing generic faces (pp. 155–164) and *"Seeing and Drawing."*

GUIDELINES

■ **Chose a picture that's large enough for you to easily see the face and hair.**
 • **Try to find a frontal face.**

■ **Using *"E-Z Drawing"* draw the"macro" shapes (head oval, neck and shoulders).**

■ **Add the midline, and the lines for eyes, nose and mouth.**

ⓘ ■ **Use *"whisper lines"* to sketch in the features.**

■ ***"See and Draw"* the face shape, features and hair.**

■ ***"See and Draw"* neck and clothing.**

■ ***"Finish in ink."***

■ **Add color (optional).**

3. Faces From Life

Drawing a live model is more exciting than working from a picture, and it's more challenging. (Models don't always hold still and we can't always get as close as we'd like to.) Still there is an unmistakable electricity in classrooms where students are drawing from life. Rather than have a single person pose for the whole class (one face for thirty kids is just too small), I suggest having students work in pairs. Partners should sit facing each other with drawing papers on slates or clipboards. (One student poses while the other one draws. Then, after about ten minutes, they switch...) This **Extension** is great practice for *Family*

Stories (See **Curriculum Connections**, p. 173) and the perfect warm up for *Self-portraits* (p. 168). Intermediate age students should definitely use the system of drawing faces described in the **Lesson** starting on p. 152 in combination with the skills they learned while *"Seeing and Drawing."* Remind students frequently that their job is to draw a unique person, not a generic face.

MATERIALS
Pencils and erasers

Drawing paper

GUIDELINES
■ Draw a realistic picture of your partner.
 • Sit directly across from your partner (3–4 feet away).
 • Draw the face frontally.
 • Start by drawing the midline, oval and the lines for eyes, nose and mouth.
 • Use *"whisper lines"* to sketch in the features, the hair, neck and shoulders.
 • *"See and Draw"* the face shape, features and hair.
 • *"See and Draw"* neck and clothing.
 • Darken and soften lines as necessary.

"Portrait of a classmate"
Jed Jester
Grade 7

MATERIALS

Pencils and erasers

Black Line Master #33 (photocopied for student use)

Drawing paper

Flair pens

Prismacolor colored pencils (optional)

4. Self-portrait

Self portrait is the "jewel" of faces drawing. Done with patience and skill, it can be a milestone project of the school year and an important addition to student portfolios. Kids attempting this project should have done the *Faces* **Lesson,** practiced *"E-Z Drawing"* and *"Seeing and Drawing"* and have a mirror to work from (one mirror per each student, please). Kids may want to warm up by studying and sketching their features. Highly convincing likenesses are achievable by children fourth grade and older when face shapes are carefully monitored and features are drawn with uncompromising acuity.

GUIDELINES AND DRAWING STEPS

- Use a photocopy of Black Line Master #33. Draw an oval that pretty much fills the upper two thirds of the rectangle. (Black Line Master #32 can be used when necessary to help students who struggle drawing their ovals.)

- Use *"whisper lines."*

- Draw the midline and the lines for eyes, nose and mouth.

- Hold the paper at arms length regularly to check for symmetry and straightness on the paper.

- Sketch neck and shoulders in the lower third of the rectangle.

- Sketch in the features.
 - Draw eyes first, nose second, philtrum and mouth last.
 - Use *"Seeing and Drawing"* (70–30).
 - Don't make anything up. Remember, your job is to draw your features as they appear in the mirror. (You aren't drawing a generic face; you're drawing a unique face: yours!)
 - Erase and redraw as necessary.

- Refine face shape (a trouble spot!); recheck all features

- Draw ears and hair.

- Draw neck and clothing.
 - Use *"Seeing and Drawing"* as you carefully observe and draw shirts, collars and buttons (use as much care here as with facial features).
- Take your time. Always do your best.

- *"Finish in ink"* or add color (optional).
 - For best results use *"the tracing method"* before coloring. Doing so will yield copies without the smears, abrasions, furrows that are an inevitable (and desirable) part of the drawing prcess. These copies are much easier to color than rough drafts.

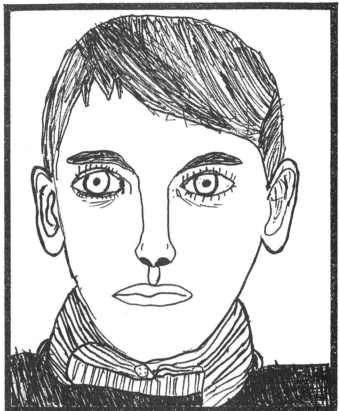

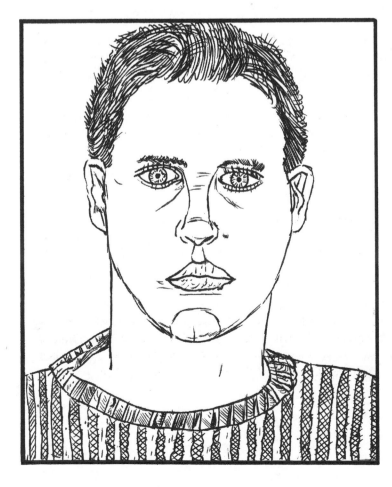

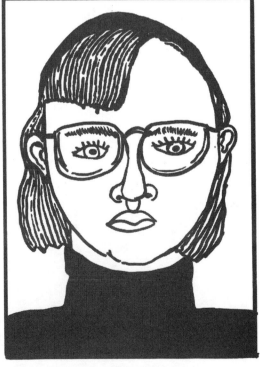

"Self-portraits" that have been *"finished in ink"* by
Jennifer Jones and Damion Leonard (top);
Chris Gordon and an unidentified student (bottom).
Grade 6

1. Throughout the *Faces* **Lesson**, remind kids—
 • *This is challenging. (It's probably the hardest lesson we'll do together.)*
 • *Don't expect your practice face to be perfect.*
 • *We'll learn and grow together.*

2. "I can't." For certain students (perfectionists, kids who have trouble keeping up, the "I can't" kid), the step by step approach to drawing faces may ignite self doubt. Often these kids come off as rigid, arrogant, or rebellious. When a child says, "Why do we have to draw faces this way—I already know how to draw faces!" more than likely the kid is saying, "Look, I'm comfortable doing it *my* way. I probably can't do it your way. I'll screw up. I'll fail." Tell him that you know he's a darned good face drawer, but that school and life are about trying new things, having new experiences. This isn't the only way to draw a face, it's just one way. As much as possible support his every minor success as *"mimicking"* goes forward. For this child, the **Lesson** may not be about drawing faces at all, but about risk taking, being willing to be out of his comfort zone, trying new things...

3. Modeling. As always, modeling will not only be a powerful motivator, it will demystify the drawing process. Practice drawing ovals, eyes, nose and mouth lines, features, etc., **(Black Line Master #26)** yourself before teaching them to your students. Yes, you can use **Black Line Masters #26** but nothing teaches like demonstrating. Each time you present the material to students it will go more smoothly. Remember, you can always say to kids, *Look I'm not very good at this, but like you I'm doing my best and I'm learning and growing.*

4. Be sure to review 70–30 *"Seeing and Drawing"* before students start portraits or self-portraits. Remind them that, *Instead of drawing veggies, we're drawing eyes, noses, ears. We should pay as much attention to collars as to eyes, as much attention to necks as to mouths. Remember, get your information from the subject you're observing. Don't make things up. Draw what you actually see (not what you think something looks like).* Persistent attentiveness will often be rewarded by a convincing likeness.

5. Drawing faces frontally is only the beginning. Children will want to draw three-quarter views as well as profiles. In the simplified diagrams at the right, notice the placement of the midline as well as lines for eyes, nose and mouth.

6. Just because children have been introduced to realistic faces doesn't mean they'll always want to draw that way. Nor should they be required to do so. Realism is a genre, a particular type of drawing, one way, not the way. Kids of all ages love to draw abstract and imaginative faces as well as the cartoony *characters* presented in **Extension #1**, p. 164 and below.)

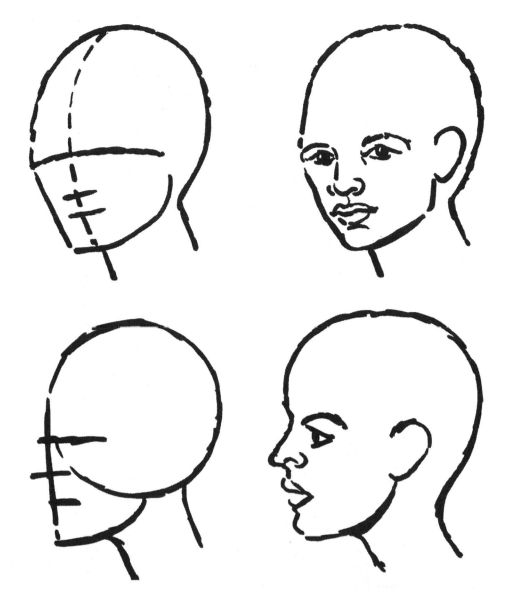

Diagrams showing 3/4 view and profile.

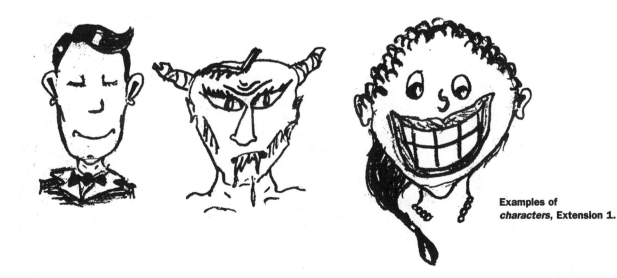

Examples of *characters*, Extension 1.

7. When *"finishing in ink,"* there are a few things that students can do that will greatly enrich their portraits.

- Blacken the pupil, "gray" or darken the iris, and leave a white gleam.

- "Gray" or texture the lips, but make sure the line dividing upper and lower lips shows up. (Thicken it, if necessary.)
- Put a shadow under the chin (example to the left).
- *"See and Draw"* strands of hair within the larger hair shapes (example below).
- If the hair is a very light color, consider a dark gray or black background to create greater *contrast*, (p. 115).

Shadow under the chin

8. When coloring faces:

- Color a traced copy of your drawn face, not the *rough draft*. (See *"The Tracing Method,"* p. 201.)
- Create a *thumbnail*, a practice color plan for the drawing (p. 127).
- Fully color the drawing. That means everything: face, hair, clothing and background.
- *"Nail the white."*
- Check out the wide spectrum of flesh tones available from Prismacolor. Used singly and mixed, the following colors will get you started: blush, peach, light peach, deco peach, terra cotta and burnt umber.

See finished colored self-portraits on the cover of *Drawing in the Classroom* and on Color Plate pp. 1 and 2.

Carefully add strands of hair

LANGUAGE ARTS

Literature/Art

Look at the different ways that various illustrators create faces. Representations run the gamut from simple (Tomie de Paola, James Marshall, David Diaz) to "cartoony" (Nancy Carlson, Maira Kalman, Mark Hanford); and from highly realistic (Susan Jeffers, Jerry Pinkney, Thomas Locker) to abstract (Gerald McDermott, Heidi Goennel, Ashley Bryan). Though children may prefer one way of portraying the human face over others, it's important for them to know that many different illustrational styles exist and succeed.
(See **Resources**, p. 180.)

Writing/Art

Family Stories

What better way to illustrate a family story than to create a portrait of one of its central characters—a sibling, parent, aunt, uncle or grandparent? Kids should try to draw from life whenever possible. Doing so makes it much easier for them to observe and record details that describe a unique indivdual. And collaborating to make the portrait, as artist and models inevitably do, creates a memory special for both. Children can draw from photos, but preferably, *only* when live models aren't available.

BART the BULLY

Big and nasty

Growls and glares at me

Is like a vicious dog ready to attack

If only I lived on another block.

Peg Porter
Teacher

See *People Poems*, p. 176.

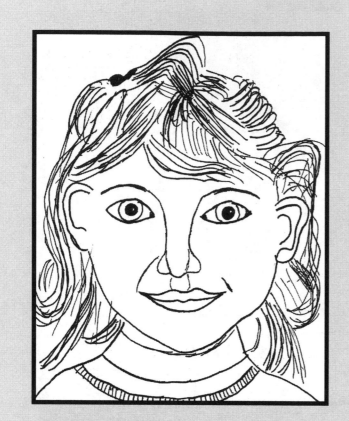

Liv tells her family story from the point of view of her three year old sister.

Story and drawing, Liv Kilpatrick
Grade 6

I can't quite reach these color crayons.
Where's the stool? Mommy and daddy
thought I couldn't reach them. Well I can!
Ahh, I got them now. Oh, purple and pink
and red and green. My favorite colors!
Why doesn't the wall have my pretty colors
on it? It must be lonely without my pretty
colors. I'll start with the red crayon...
Oops, I dropped it! Why can't they make
them square? Red clouds are pretty.
Purple. Where is the purple? Where is it?
Ooh, there it is. Purple flowers. "Roses are
red and violets are purple." Pretty!
A green wall so the doggie won't get lonely,
and a red caterpillar so the wall won't
get lonely.

I'm, done. The wall looks so happy!
I better show mommy. "Mommy, mommy!
Come see my pretty picture."

"I'll be there in a minute!"

I wonder what's taking her so long.
I better call her again. "MOMMY.
Oh, there you are."

"JILL!"

"Don't you like my pretty picture?"

"No. You messed up the wall.
Go to your room!"

I can't believe she didn't like it.
Oh well, there are always other walls.

Self-Portrait

A self-portrait *("finished in ink")* could be reduced on a photocopier and duplicates glued to the author's page of individual and class books published during the school year. Consider also the creation of class stationery. Draw a black, rectangular outline around the edge of each portrait. Reduce portraits on a copier so that they'll all fit on the outer edges of a sheet of paper 8.5"x 11" forming a spectacular faces border. Letters written on this stationery won't easily be forgotten.

I *Autobiography*

Students create a full color self-portrait (**Extension #4**) and a series of written chapters that might include "Self-Portrait: Physical Description," "My Ancestors," "My Parents," "Pets in My Life," "The Most Exciting Moment in My Life," "My Room," "Good and Bad Habits," "The Worst Day of My Life," "Sports and Me," etc. *Autobiography* is a great example of what educational reformers have been asking teachers to do for over a decade: integrate curriculum (art, health, writing) while leading children to manage complex projects *and* create products of exceptional quality. The array of skills practiced during *Autobiography* is impressive: drawing (visual acuity, concentration, hand-eye coordination, orchestration of visual elements, composition, craftsmanship, persistence...); writing, (drafting, revision, editing, publishing); and technology (word processing, document design).

A project like *Autobiography* begs for **reflection** throughout. While we don't want to burden students with yet another task (they already have plenty to do), it would be a shame to leave out the metacognitive piece. Too often, kids asked to *reflect* draw a blank. Why? Because the learning experience they're asked to comment on lacks substance or personal relevance. Not so, here.

Finished work—color copies of portraits (students seldom want to relinquish the original) and "published" writing—often end up in portfolios, as well they should. Process pieces (sketches, notes, rough drafts, reflective writing, etc.) can be included along with polished products.

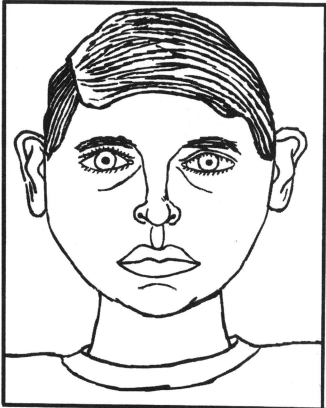

"Self Portrait," Tim Wilson
Grade 6

For the full color version of Tim's self portrait, see Color Plates, p. 2.

People Poems

This is the perfect written companion for **Extension #1**, *Characters*, p. 164. It is a fail-proof formula poem having six lines. Students select one of their characters, then follow these steps:

1. Name your character (real or imaginary).

2. Select two describing words that sum your character up.

3. Choose a phrase that begins with a verb and describes something your character might typically do.

4. Complete this sentence: "Is like…"

5. Complete this sentence: "If only…"

Here's an example:

Arnold Schwarznegger,

Big and muscular,

Shoots a lot,

Is like an ape on fire,

If only he didn't crack stale jokes.

"Mary Scary"
Amy T.
Grade 3

Mary Scary,

Dull and four eyed,

Swims at the beach and rides bikes,

Is like a desert island

If only she had a pretty face.

Amy T.

Characters from Literature

Students draw pictures of favorite characters from literature, then using the *People Poem* formula (above), write about them. (Don't be surprised if this simple project motivates even reluctant readers to look at literary characters with greater interest and enthusiasm.)

❶ *Protagonists and antagonists*
Glue each completed portrait and its accompanying poem onto a piece of colored construction paper, then separate the classes' work into two categories: protagonists in one, antagonists in the other. Divide a bulletin board in half and display the work under the headings "Heroes" (or "Protagonists") and "Villains" (or "Antagonists").

Aunt Spiker from Roald Dahl's *James and the Giant Peach*

Aunt Spiker

Aunt Spiker
Mean and spiteful
Pounces on happiness,
 then makes her kill
Like a tiger on the prowl
If only she could have
 learned to love from James.

Younger children love the challenge of drawing from graphics, too. Often they surprise themselves (and us) with their accuracy.

Presidents John Q. Adams and
Teddy Roosevelt
by Cory Poff
Grade 3

Abe Lincoln
by Michael Stockner
Grade 6

Social Studies

Students can work from drawings, paintings and prints when producing portraits of historical figures. (Be sure to check out *Dover's Portraits of Famous People*, see **Resources**, p. 181.) Pictures of Columbus, Martin Luther King, Jr., Chief Seattle, Emily Dickinson, George Washington, etc., will be infused with reality and personality as students combine their understanding of the generic face with careful observation. Kids are delighted when their portraits bear even slight resemblance to the original. With practice, they will.

Math

Math vocabulary can easily be used when teaching the *Faces* Lesson. Consider these mathematically based terms and concepts:

- A line of symmetry divides the face in half.
- The face is symmetrical.
- The two halves of the face are congruent.

- By drawing a line of symmetry (a vertical), and the eye line (a horizontal), we've divided the face into four parts. Do you think the area of each quarter is equal? What percentage of the whole does each part represent (approximately).
- If the face is (nearly) five eyes wide, what fraction is one eye of the total?
- What percentage of the whole would three eyes be?

Multicultural Study

With the skills developed while *"Seeing and Drawing,"* students become more sensitive to the nuances of the human face. By creating portraits of their multi-ethnic classmates they realize that, despite minor variations in eye shape, nose width, hair texture, skin color, we're all pretty much the same.

"Louis Armstrong"
Tracy Mitchell
Grade 4

RESOURCES

1. de Paola, Tomie. (1975). *Strega Nona.* New York: Simon and Schuster Books for Young Readers.
Even when de Paola's illustrations are "busy," every component, whether person, animal or building is rendered with uncompromising simplicity. His drawings of faces are no exception. With a minimalist's economy, gender, emotion, even age are conveyed with a few simple lines.

2. Bryan, Ashley. (1992). *Sing to the Sun.* New York: Harper Collins.
Bryan's sunny poems, inspired by jazz, blues, African-American spirituals, and Caribbean dialect, reverberate with sonorous language, hand clapping rhythms, even occasional Haiku-like similes ("The silver round/Of the full moon/Slips into the cloud/As a coin/Slips into a purse."). Happily, his illustrations are equal to the poems. Check out the abstract faces sprinkled throughout the book. Simultaneously childlike and masterfully designed, they barely separate from their swirling, colorful backgrounds.

3. Messenger, Norman. (1992). *Making Faces.* New York: Dorling Kindersley, Inc.
This ingenious "flip book" enables the reader to create innumerable characters (the publisher claims 65,000!) by repositioning parts of pages. The good news is that Messenger provides us with concise paintings of realistic faces that echo the drawing kids will be doing in the "Faces" **Lesson.** *The bad news is: the deeper you go into the book the more gratuitous gruesomeness you'll encounter. (If gore bothers you, avoid showing kids the final pages.)*

4. Messenger, Norman. (1995). *Famous Faces.* New York: Dorling Kindersley, Inc.
Messenger's second "flip book" mixes up the faces of John Wayne, Marilyn Monroe, Charlie Chaplin, Margaret Thatcher, etc. Besides being a hoot, it provides a peerless model for drawing realistic frontal faces.

5. Kalman, Maira. (1990). *Max Makes a Million.* New York: Viking.
Kalman's offbeat, faux naive illustrations and wacky New York humor have won her a cult following. This is her most accessible book. Don't miss the end papers: nearly a hundred quickie ink portraits of French artists, clowns, poets, philosophers and mimes.

"Faces" from the author's sketchbook.

6. Jardine, Don. (1989). *Creating Cartoon Characters.* **Tustin, CA: Walter Foster Publishing.**

This inexpensive "how to" book packs more information on drawing cartoon faces into its first twelve pages than some books do in a hundred. It's an indispensable resource for young cartoonists ages seven and older.

7. Rotner, S. and Kreisler, K. (1994). *Faces.* **New York: Macmillan.**

Fascinating photographic close-ups of children's faces from all over the world.

8. Say, Allen. (1993). *Grandfather's Journey.* **Boston: Houghton Mifflin.**

Wistful and elegiac, Grandfather's Journey *spans three generations. Though the book focuses on Say's grandfather's conflicted love for both Japan and California, we learn that the author is similarly torn. Say's Caldecott winning paintings, like treasured family photos, linger in the imagination after each page is turned. His haunting portraits of family members are simultaneously gossamer and rock solid.*

9. Spier, Peter. (1980). *People.* **New York: Doubleday.**

Behind Spier's charming drawings of people of every race, gender, age and economic circumstance lies a simple message—differences between people aren't something to be feared, rather celebrated. Of special interest to young artists are Spier's amusing drawings of eyes, noses, ears and hair at the beginning of the book.

10. Pinkney, Gloria and Pinkney, Jerry–Illus. (1992). *Back Home.* **New York: Dial Books for Young Readers.**

Ernestine, a city girl, returns to the family farm in rural North Carolina for a visit. Pinkney's lush watercolors evoke humid summer days spent in sun drenched fields, aromatic kitchens, damp barns. The faces of his realistically rendered African-American characters express nuances of emotion that perfectly match the story's text.

11. Hogarth, Charles. (1994). *Portraits of Famous People.* **New York: Dover Publications, Inc.**

Dover's archive of 121 famous people is a must for every classroom. Using Charles Hogarth's succinct black and white drawings as a starting point, kids will be able to create portraits of presidents, dictators, revolutionaries, artists and scientists with greater accuracy than ever before. One of the worlds's great bargains (around $5).

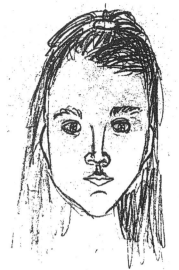

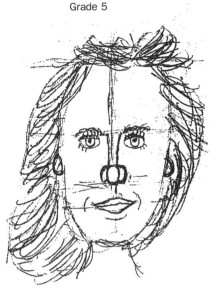

Student
Grade 5

Charles Hogarth's drawing of Florence Nightingale from *Dover's Portraits of Famous People.*

Drawing Realistic Faces—Primary

Here's a simplified version of the *Faces* Lesson (p. 153) for grades 1–3. The steps below are very similar to those suggested for learners Intermediate and older. However, the way you teach the material will be simpler. Modeling is even more important with primary than with intermediate. By encouraging children to draw along with you, you can can help them see lines, shapes, proportions and *details* that might otherwise go unnoticed. Here are a few more things to keep in mind when teaching 6–9 year olds:

- More than anything you want the experience to be positive. Validate everyone's best efforts— enthusiastically!

- Model, model, model.

- Tell kids regularly not to worry about producing great finished products. Remind them that *the goal of the lesson is to have fun learning all we can about faces, features and how everything fits together.*

- Use mirrors.

- Go slow.
 - Pause regularly to help students see where features are actually located, and to notice that the features are comprised of lines and shapes.

- This is a one time experience in drawing faces. If kids go right back to their old way of drawing— that's fine. We're not trying to change the way kids draw. Our goal should be to help them understand and see more.

"Self Portrait"
Grade 2

Drawing Steps to Model and Practice

1. Draw an oval.

2. Draw the the eye line.

3. Draw nose and mouth lines.

4. Draw the main features: eyes, nose and mouth.

5. Re-shape the face. (Make sure it's not too wide or too tall.)

6. Add the ears.

7. Draw the hair.
 - Draw the shape of the hair first, then the strands.

8. Draw neck and shoulders.

9. Add clothing.

10. Leave in pencil or *"Finish in ink."*

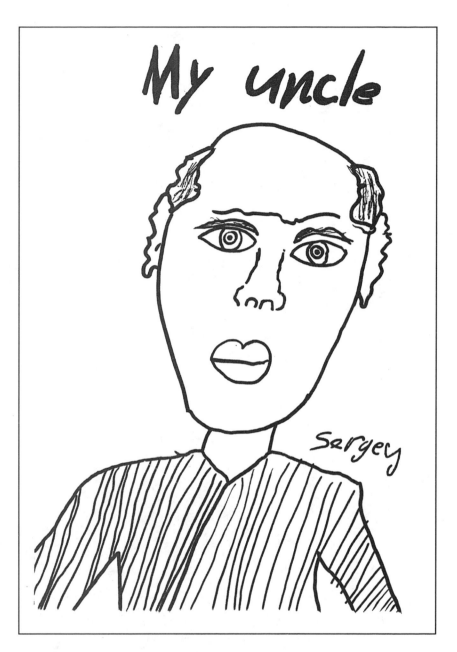

Sergey
Grade 3

Lesson 10 # Composition

"Unity is achieved when everything in a composition fits together as a coherent whole, each part contributing to the wholeness of the total image."
Betty Edwards, **Drawing on the Right Side of the Brain**

"Compostion is the art of arranging in a decorative manner the various elements at the artist's disposal for the expression of his feelings."
Henri Matisse

Illustration for her story, "Adventures." Rachelle Lankop Grade 4

Rachelle isn't the best artist in her 4th grade classroom. Yet, the family story she's illustrated, a drawing of her mom as a little girl falling off a Shetland pony, (opposite page) displays action, drama and a clear sense of place. While, the unexpected subject may intrigue us, all the different pictorial elements, (horse, rider, sidewalk, grass, hills) must work together, and they do. Rachelle has devised a strong and effective composition.

Composition asks students to consider the entire paper as they plan and draw the lines and shapes that will become their horses and hills, their soccer players and grassy fields. While younger children (ages 4–6) consistently produce fresh and balanced compositions, seemingly without effort (below), older children recycle tired formulas ad infinitum: a horizontal line for the ground, a stripe of blue sky across the top of the paper, etc. Or, they may become preoccupied with getting the details just right, faces, fingers, or the pattern in a curtain. Too often, the fussy parts don't add up to satisfying, unified pictures.

A typical illustration, by a six year old. The drawing fills the paper with energy and authority.

Patrick
Grade 1

MATERIALS
Overhead
projector

Black Line
Masters
#34–#41
(photocopied for
overhead use)

Black Line
Master #42
(photocopied for
student use)

As teachers of *composition*, we can provide students with opportunities to approach pictorial design in new and refreshing ways. More than that, we can offer them strategies for crafting whole pictures that convey visual information with clarity and expressive power.

Like color, *composition* is a big topic. During our hour lesson, if we can convey the following four points, we'll be providing students with a great foundation to build on:

1. Artists and illustrators don't just draw "neat" pictures of individual things—people, jets, houses. They design entire rectangles and squares. They fill their papers in visually pleasing ways.

2. Pictures can be designed in different ways. We can learn a lot from filmmakers who create *compositions* that are "long shots," "medium shots," or "close ups."

3. *Negative spaces*, the empty areas that surround the people, jets, houses are as important to artists and illustrators as the things they're drawing.

4. Pictures can tell us things: they deliver messages.

LESSON

Poor Drawing — Worse Composition

Tell students: *Today we're going to be talking about **composition**. **Composition** isn't about drawing neat pictures of individual items or things. It's about designing the entire rectangle or square that is our paper. In order for pictures to look their best, we have to create a satisfying whole.*

Put **Black Line Master #34**: on the overhead (or draw a facsimile of it on the chalkboard). Ask students, *How do you like this drawing?* Yuk!

Black Line Master #34

Point out the edges of the paper and ask, *Does the drawing fill the paper?* No!

Can you tell where this little character is, or what he's doing? Not really.

What's wrong with the picture? Name three things. The guy's too small. He's too skinny. The paper isn't filled up. No detail, etc.

Name three things we could do to make it better? Bigger person. More detail. Fill the space.

Tell students, *Actually, it's a picture of a guy eating a slice of pizza.* Oh, I thought it was a skinny guy blowing his nose!

Better Composition — The "Long Shot"

• Fill the space

Black Line Master #35

Place **Black Line Master #35** on the overhead. Point out the edges of the paper and ask, *Does this drawing fill the paper?*

Yes, it's better. The guy's still kind of small, but the paper's filled. There's a table with flowers. And there's a window and a poster...

Is it okay to have things going off the edges of the paper, like the window, the flowers or the pizza pan? Yes! Artists and illustrators do it all the time!

Can you tell what the little character is doing? It looks like he's eating pizza.

How can you tell? You can see he's holding a slice of pizza. The pizza has pepperoni on it.

Can you tell where this little character is? In a city. He's probably in a restaurant or pizza parlor.

How can you tell? We can see big buildings through the windows, so it's a city. It looks like a restaurant because there's a poster, a pizza pan and there's a vase of flowers...

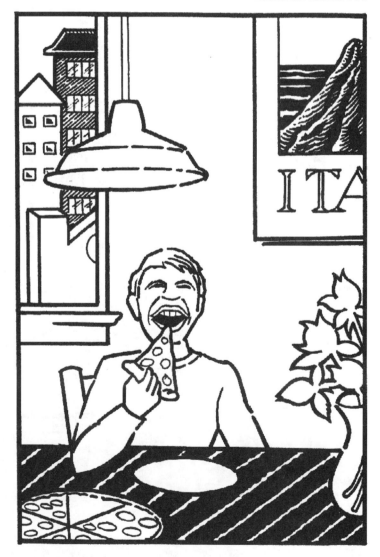

• Negative space is important, too

Put **Black Line Master #36** on top of **Black Line Master #35**. Align it so that the wall shape turns black (left).

*Now I want you to notice the **negative space**.*

*In this picture, the **negative space** is the black shape.*

***Negative spaces** are empty areas. Here, the **negative space** surrounds the pizza eater. Did you know that artists and illustrators are as interested in the **negative spaces** as they are in the positive ones, (the people and objects)? Notice how all the shapes in this composition fit together (the shape of the flowers, the pizza eater, the wall, the windows and poster). They're kind of like like puzzle pieces.*

Do you like this drawing? Do all the parts fit together to create a satisfying whole? How could it be improved?

• Notice How Pictures Deliver Messages

Can pictures tell us things? Can they deliver messages?

Yes!

If this picture were delivering a message, what do you think the message would be?

What do you think the "main idea" is? (i.e., the most important thing the illustrator wants us to know and understand?) Please put it into words.

There's a guy eating pizza in a restaurant or pizza parlor in a big city.

Better Composition — The "Medium Shot"

• Fill the Space

Put **Black Line Master #37** on the overhead. Point out the edges of the paper, and ask, *Does this drawing fill the paper?*

Yes.

Can you tell by the setting where this character is?

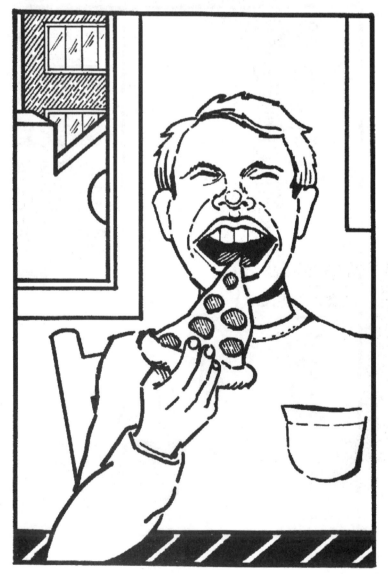

Yes. He's in a city. You can still see the buildings through the window. And he's probably in a restaurant.

Can you tell what this character is doing?

Oh, yeah. Easy. He's eating pizza.

Can you have things going off the edges of the paper, like the window?

Yes! Artists and illustrators have things going off the edges of their pictures all the time!

• **Negative space is important, too**

Does this drawing have negative space?

Yes!

Put **Black Line Master #38** on top of **Black Line Master #37**. Align it so that the wall shape turns black.

*Notice the **negative space**, the empty area. Again, the **negative space** is black. It's the shape that surrounds the pizza eater. It's a lot smaller than in the last picture we looked at, but it's still an important part of the **composition.***

Again, notice that all the different shapes that make up our picture (the pizza eater, the wall, the windows, the edge of the poster) are kind of like puzzle pieces. Do all these pieces fit together to create a satisfying whole? Can you think of ways to make this picture look even better?

• **Notice How Pictures Deliver Messages**

If this picture were delivering a message, what do you think the message would be? What's the "main idea," the most important thing the artist/illustrator wants us "to get?" Please put it into words.

Black Line Master #38

Black Line Master #39

Black Line Master #40

Better Composition—The "Close Up"

• Fill the Space

Put **Black Line Master #39** on the overhead. Point out the edges of the paper, and ask, *Does the drawing fill the paper?*

Yes!

Can you tell where this character is?

Not really. He could be at home, or in a restaurant. He might be in a city, but you can't really tell. There aren't any windows or large buildings.

Can you tell what this character is doing?

That's really obvious. He's eating pizza!

• Negative space is important, too

With **Black Line Master #39** still on the overhead, ask students, *Does this picture have **negative space**?*

Yes. It's the empty area around the pizza eaters head.

Put **Black Line Master #40** on top of **Black Line Master #39**. Align it so that the wall shape turns black.

*Now we can see the **negative space** really clearly. Does the **negative space** contribute anything to this picture?*

Yes. It's a lot smaller than the **negative space** we saw in the other two pictures, but it's still important. All the shapes inside the rectangle are important. They're kind of like puzzle pieces—the pizza eater, the slice of pizza, the hand, the wall. They all fit together and work together to achieve a satisfying whole.

• Notice How Pictures Deliver Messages

If this picture were delivering a message what do you think the message would be?

What's the "main idea?" i.e., the most important thing the artist/illustrator wants us "to get" from this picture. Please put it into words.

Easy. The guy *loves* eating his pizza.

Comparing the Three Drawings:
Long Shot, Medium Shot, and Close-Up

Put **Black Line Master #41** on the overhead. Now let's look at the three drawings together.

Long Shot

Medium Shot

Close-Up

Black Line Master #41

Who goes to the movies? Everyone! Have you heard the terms long shot (LS), medium shot (MS) and close-up (CU)? Which of these drawings is a long shot? Why do you think it's called a long shot? In a LS, it looks like you're a long way from the scene. The person is kind of small, and the setting is pretty important—the table and tablecloth, the window, the wall, the light, the flowers, etc.

How about the medium shot? What makes this a MS? With a medium shot, the person becomes much more important, and the setting becomes less important. Still, the setting usually provides enough information so that you can tell where the person is.

*How about the close up? What makes this a CU? Now the person fills up the whole picture. He's really big! There's hardly any background (**negative space**). We can't really say where the character is. Still, the CU has it's own clear message to deliver: a guy eating pizza!*

*Notice how our subject, a guy eating pizza, is seen three different ways. All are pretty good **compositions**. All three have **negative spaces**; and all three deliver slightly different messages.*

- *If I asked you which illustration best shows a guy absolutely loving his slice of pizza, which one would you chose?*

- *If I asked you which **composition** best shows a gentleman eating a slice of pizza in a comfortable downtown restaurant, which one would you chose?*

Pass out **Black Line Master #42**.
Take a few minutes now and copy the three pizza eaters in the rectangles I've given you.

- Make drawing #1 a LS, #2 a MS, and #3 a CU.

- Establish the **composition** of each drawing first. (Start with big simple shapes and lines.) Add **details** last.

- Don't try and copy the **Black Line Master** drawings. You'll be creating *your* version of the the three pizza eaters.

I - Start with *"whisper lines,"* work *"rough"* and *"clean up"* as you draw.

- Be aware of the **negative spaces** and how they surround the pizza eater in all three pictures.

- Label each of your drawings appropriately, LS, MS or CU.

- Make your pizza eater a specific character, i.e., a boy, girl, man or woman.

- Add **details** that will make your drawings more interesting (plates, dishes, more windows and buildings, wallpaper, etc.).

- *"Finish in ink,"* or color one or more of your drawings (time permitting).

- Write captions that convey the main idea in each of your pictures.

When students have finished their drawings, ask them to "partner up" and to answer these questions:
- Which drawing was the hardest to do? Why?
- Which drawing was the easiest to do? Why?
- Among the three drawings you copied, do you have a favorite? Which one? Why?

"Pizza Eater – Long Shot"
Norah Gilson
Grade 6

1. Positive Shapes and Negative Space

If anyone's still confused about *negative space*, this simple **Extension** should help clear things up.

Show students Lois Ehlert's picture book, *Circus*. All the familiar circus items, the elephants, acrobats, horses are all positive shapes while the background is the *negative space*. Have students notice how, on many of Ehlert's beautifully designed pages, the *negative spaces* are as strong and as interesting as the positives. (This is particularly true of the page with Samu, the tiger.) Remind students that for artists and illustrators, *negative spaces* and positive shapes are inseparable. They work together to make successful compositions.

2. Compositions Everywhere!

Students shouldn't think of visual *composition* as "something that happens only in school." Every artist, designer, photographer, cartoonist and illustrator thinks and works compositionally. To better appreciate this point, have students bring in one picture that really grabs them. (It could be a cartoon, an illustration, a painting, or photograph.) Bring one in yourself. (If possible, photocopy your image onto an overhead transparency and display it so that everyone can see it.)

The *negative spaces* (the white areas) show up dramatically when the rocker is presented as a silhouette. See also the black *negative spaces* in Jeanne's drawing on p. 339.

Jeanne Mikesell
Teacher

Using your image (or a student's) as an example, lead children through a discussion of these points:

- **Main idea**
 Name one of the most important things the artist/designer wants us to know as a result of having seen the image.

- **Use of *Negative Space***
 Where is it in the picture? Is it used effectively?

- **Use of contrasting colors (or dark and light).**
 Do the important parts of the picture show up? Why do they? Why don't they?

- **Type of shot used—LS, MS or CU.**
 What type of shot was used for this image? Was that a good choice? Why? Why not?

- **Research**
 Think of some of the things the artist may have had to do to get this image to look the way it does.
 Do you think she had to do research? Look at pictures? Travel? Make sketches?

Kelsi Herman
Grade 4

3. Frame It

MATERIALS

File folders
cut in half

Rulers

Pencils

No. 1 X-acto
knives
(with #11 blade)

Gather about 15 file folders; cut them in half. In the middle of each half, cut a rectangle measuring 1″ x 1.25.″ (Enlist the help of parent volunteers with X-acto knives.) Through these little frames, or viewfinders, students can see the world just like photographers, painters and film directors.

Model the framing of different kinds of shots for students. Close one eye and look through the frame with the open one. The closer you hold the opening to your eye, the more of a long shot you'll see; the farther away you hold it, the more you'll see a close up. Describe to students what you're doing and seeing as you move the viewfinder around. The most important thing to "get across" is that you are not just looking at the world through a hole, but that you're composing images as you move the viewfinder —i.e., consciously organizing objects, parts of objects, negative spaces, lines, shapes, colors within the boundaries of your rectangle. When you find an image that you really like, "freeze" the frame: hold your viewfinder perfectly still for at least ten seconds, and enjoy your discovery! As you look at your image, say a few words to students about *why* you like it.

A compositional "viewfinder." Through the small rectangular opening, students can find and frame long shots, medium shots and close ups.

I like my image this way because I can see the edge of the brick house across the street, and I can see a tall window. Through the window I can see a TV that's on. The screen keeps changing colors. The shrub next to the house is a shaggy silhouette; the negative space of the sky between the house and the shrub is a really cool shape.

Frame It takes a little practice, but is well worth the effort. Modeled properly, it delivers these important compositional lessons:

- *Compositions* are created.
- We can frame different kinds of images: LS, MS, and CU's.
- Some *compositions* are more visually engaging than others.
- There are usually reasons why we like one image more than another.

If possible, take your students outside, or to a location that's a little more exotic than your classroom.

I 4. Full Color Illustrations

This *major* project presents ***the drawing process*** in all of its richness and complexity. It is the zenith of classroom drawing. No project asks or gives more.

I won't kid you. Going through the entire process takes time. The reward can be exquisite, fully colored drawings like those in the Color Plates, pages 3, 4, 5 and 7. Often, children are surprised by the quality of their creations, and they're extremely proud of them. This process elicits from kids, the very best that's in them.

The color version of this illustration may be seen on the cover of *Drawing in the Classroom*.

Illustration for the family story "Dark Vietnam"

Ken Vu
Grade 4

Drawing Steps

A. Read the *Mysteries of Harris Burdick* by Chris Van Allsburg.

Discuss the relationship between the titles/captions, and the illustrations, i.e., the way the words tell us important things about the pictures, and the pictures amplify the meaning of the text.

B. Ask students to generate a list of their own captions.

Tell students that their captions can be funny, personal, mysterious, sad, descriptive, heart warming, scary. Share the following sample "captions list." (It was collected in a fifth grade classroom.) Then ask kids to create at least five captions of their own.

- Best friends
- The storm hit without warning
- An unforgettable birthday
- Catch some air
- Music is a joy of life

MATERIALS

The Mysteries of Harris Burdick by Chris Van Allsburg

Black Line Master #43

Pencils and erasers

White plastic erasers

Flair pen

Colored pencils (Prismacolor preferred)

8.5″ x 11″ drawing paper (20#) with a 5″ x 6″ rectangle drawn in the middle

Masking tape

Drawing paper 5″ x 6″

"Kung Fu: sparring with black belts, power kicks and punching the bag…"

Asa Henin
Grade 4

- The more people that were there, the lonelier it got
- Grandma's skin...
- At dawn he set out on foot
- Camping with my dad on Mt. Hood
- I never should have taken a bath
- I couldn't believe what had grown overnight in the garden
- My wallet was gone
- He could actually hear the bone break

C. Review composition and the notion that pictures convey messages.

Tell students: *Let's say I'd like to illustrate the caption, "Would he catch the ball?" If this were your caption, what would you include in your picture?* After a brief discussion, put **Black Line Master #43**. on the overhead and say,

1. **2.** **3.**

Black Line Master #43

Here are three possible **compositions** *for my caption. Let's look at each one. What do you think of the first picture?*

The guy's too small. The upper half of the paper is completely empty.

Picture #2?

Too big. We're right on top of the ball player. We can't really tell what he's doing. He could be doffing his cap, or waving to his mom in the crowd.

Picture #3?

Just right. Great motion. Nice *negative spaces*. We can see clearly where the ball player is and what he's doing. He fills the space nicely. Looking at this picture we really wonder whether he'll catch the ball or not. This would be a fine illustration to refine and color.

D. Student partners discuss *their* captions and decide which one they would most like to illustrate.

E. Student follows the stages of the drawing process.

• Intent

Who's the drawing for? Who will view it? Will it be part of an exhibition? Displayed in the classroom? Collected in a class book? Will it be reproduced? In black and white? In color? All of these questions will help you and your students determine the size and the medium of the drawing to be produced.

For this project, 5"x 6" is a fine paper size for these reasons.

- When drawings are to be *fully* colored, a smaller paper size works best. (Kids often become careless and bored when completely coloring larger papers.)

- Since you may elect to make color copies of some finished drawings, two 5"x 6" drawings will fit on a standard 8.5"x 11" sheet thus reducing your costs.

- Whether the drawings will be mounted on colored paper, or collected in a class book, a 5"x 6" drawing will fit standard sized colored papers (8.5"x 11" or 9"x 12") comfortably.

• Predrawing

Select drawing media to be used. (Practice using a medium, especially if it's new.) Do research. Gather supporting materials you may need (books, *picture files*, real items...) Brainstorm. Sketch. Practice. Get ready.

The evolution of a student drawing with a strong emphasis on establishing the composition first. Notice how the big divisions of the rectangle (or the "macros") are worked out first (Fig. 1). Then the "mediums" are added (Fig. 2). The details—or "micros"—are added last and the picture is refined (Fig. 3). The last version (Fig.4) shows the drawing *"finished in ink."*

Jenny Bedell–Stiles
Grade 4, for her story "Hide and Seek"

• Rough Draft

Measure and draw a 5″x 6″ rectangle in the middle of a piece of 8.5″x 11″ drawing paper; then make enough copies for student use. Student works *rough* within the boundaries of this rectangle. He uses *"whisper lines,"* erases and redraws until satisfied with the *composition* of his picture. Establishing a strong and satisfying *composition* first is critical to the project's success (Fig. 1, below). After adding *details*, he *"cleans up"*, i.e., erases all the extraneous lines, smudges, etc., that distract from the clarity of the picture.

Figure 1

Figure 2

Figure 3

Figure 4

- • **Finishing**

 - **Use the "tracing method"**

 When drawings are to be fully colored, the *"tracing method"* is highly recommended. It enables the student to create a facsimile of his *rough draft* that has none of the abrasions and depressions that result when an image is worked and reworked in pencil. He masking tapes his *rough draft* to a window, then tapes a fresh sheet of quality drawing paper (p. 263) on top of it. The light coming through the widow enables the student to see the ghost image of the rough draft on his new paper. He traces the drawing using a Flair pen (if he prefers a crisp outline), or colored pencil (if he prefers a softer one). The entire drawing can be traced in this way. Or, if the student prefers, the larger shapes can be drawn at the window and *details* can be added back at his desk. (Some students find tracing on a vertical surface to be awkward.)

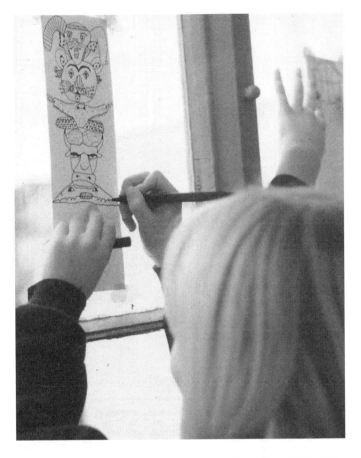

"The Tracing Method:" fourth graders trace their "rough drafts" on a window.

 - **Create a color "five shape" (optional)**

 Before a student starts the coloring process, she should produce a "five shape."

 (If she's already done so (p. 110), this step can be skipped.)

 - **Produce color "thumbnails"**

 Since the entire paper is to be colored, the student needs to make sure that the most important items in her pictures will show up. She must think about *contrasting colors* (p. 115). Producing *thumbnail* sketches (p. 127) will help students test their color choices before tackling the final drawing.

 - **Fully Color the drawing**

 While coloring their pictures, students are encouraged to *"nail the white"* through the application of single colors, or by mixing. When using high quality colored pencils, the mixtures that children create using a variety of pressures can be exotic and ravishing.

DRAWING

■ Create a fully colored 5″x 6″ color illustration that conveys the meaning of an original caption.

■ Do research as necessary.

■ Establish your *composition* first.
• Be aware of *negative spaces*.
• Use *"whisper lines,"* work *rough* and *clean up*.
• Use the *"tracing method."*
• Use *"E-Z Drawing"* and/or *"Seeing and Drawing"* as necessary.

■ Include interesting *details*.

■ Completely color your drawing.
• Make sure the most important parts of your drawing show up (think "contrast!").
• Use *"thumbnails"* to help you plan and coordinate your color.
• Use a variety of coloring techniques.

■ Include at least one pattern somewhere in your picture (optional).

WRITING

■ Using your drawing as a staring point, write a personal narrative or imaginary story.

■ Your caption may or may not appear in your writing.

■ After working through all the steps of the writing process (drafting, conferencing, revision, editing), "publish" the final draft.

Mount and display the finished illustration and the final draft of your story. (See p. 278.)

Illustration for an original story, "Death on the Bridge." Her caption read, "He rode his motorcycle and got into a terrible accident."

Amy Wood
Grade 4

1. Compositional thinking requires, first and foremost, the ability to see *the whole paper*, whether a small illustration or a large poster board. Students must realize, "I'm not just drawing a person, or a toucan, or a flying saucer. I've got to make the thing(s) I'm drawing fit, look good, and make sense within the boundaries of my paper."

2. *Composition* is the single most important element in successful picture making.

Even if the quality of drawing is high, color gorgeous and technique skillful, when pictures are poorly designed, it's hard to like 'em. Here's a short list of strategies that can help everyone achieve greater compositional success:

- Be clear about what you want the viewer to know after seeing your picture.
 - This will often mean literally zeroing in on your subject. Use a medium shot, or a close-up, not a long shot.

- Have elements go off the edges of the paper, or appear to be coming into the picture.

- "Shape" the negative space, i.e., purposefully try to make the ***negative space(s)*** intriguing and strong.

- Use ***overlapping*** somewhere, somehow.

3. *Composition* is a sophisticated concept. Many decisions enter into the making of a successful composition, e.g., type of shot, ***overlapping***, color usage, ***negative space*** and variety of sizes of shapes. If kids don't seem to "get it," just keep revisiting the concept. Talk about ***composition*** while looking at pictures by favored illustrators (See **Resources** on p. 207), prints by artists, even posters or advertisements. Our goals should be to help kids see that every image or design is planned within the boundaries of a particular rectangle (or square) and each conveys information of some sort.

P 4. With younger children I don't dwell on ***negative space***. I might mention it, but I don't insist that they "get it." Often by drawing something way too small, and asking kids, "How do you like my drawing?" (Fig. 1, above) the point is made. When kids "fill their papers," ***negative spaces*** often result. Showing kids that it's okay to have things going off the paper (Fig. 2) is another way to create richer ***negative spaces***.

Figure 1. Negative modeling can be an effective teaching technique. Draw something *way* too small, then ask younger children, "How do you like my drawing?" They'll tell you that "it's too small," and that "you should draw it larger."

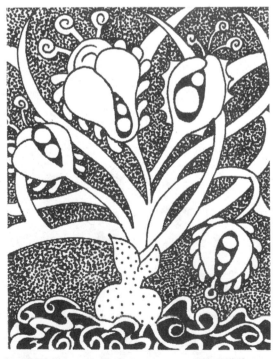

Figure 2. Fantastic plant leaves extend beyond the edges of the paper creating a series of intricate negative spaces.

Allison Trask
Teacher

First, check it for balance. Too much may be happening in one part of the rectangle and not enough in another (Fig. 3). Another quick check can be made using *"3-M."* Every successful **composition**, with rare exception, whether a masterpiece by Rembrandt or a cartoon panel by Scott Adams (creator of Dilbert), has a noticeable "macro," a series of medium sized shapes, and discernible "micros" (details that attract the eye). Another way of saying the same thing: check the composition for "variety of sizes of shapes." (If there's no variety, expect monotony.)

Figure 3. An example of a poorly balanced composition. Too much is happening in the middle and on the left side. The right side is almost empty.

6. When a picture is really successful, there's an alignment between form and content. Let's say the main thing I want to show in my illustration is that a little boy is frightened of the dark. My job, then, as illustrator is to figure out how to convey that visually. Using line, shape, space, color, and my best drawing skills, I compose the strongest picture I can. To the degree that the viewer gets my message, I've succeeded. If this sounds like a pretty sophisticated concept for elementary age artists, it is. Don't doubt for a moment that kids aren't up to the challenge.

Figure 4. The same picture with better "balance." Also notice its variety of sizes of shapes and strong *negative spaces*.

Based on a drawing by Michael Kim
Grade 4

7. Line, shape, space, color, pattern—the visual elements we've been discussing and practicing throughout *Drawing in the Classroom* don't count for much without the organizing principle of composition. A poorly composed picture is like an orchestra with neither a score to follow, nor a conductor to lead it.

CURRICULUM CONNECTIONS

LANGUAGE ARTS

Reading/Writing

Main idea, a difficult concept for many elementary aged students to grasp, can be taught as children develop illustrations for original stories. Ask this question *before* kids begin creating their pictures: "What's the most import thing you want the viewer to know as a result of having seen your picture?" Doing so changes illustration's usual role in the classroom. Instead of being a cursory afterthought, a kid-made picture now has the potential of being an intentional carrier of information.

Literature/Art

Looking at and discussing the ***compositions*** of artists and illustrators can significantly alter the way children think about their own drawings. Why does Chris Van Allsburg use the same curtains and stage setting for every single illustration in *The Z Was Zapped*? Why is every picture in *Hey, Al* a long shot? Do you think that David Wiesner's decision to superimpose one highly detailed image over an equally detailed background makes sense, or is the total effect too busy? Describe some of the similarities and differences between Amy Schwartz's and Van Allsburg's use of black and white in *Bea and Mr. Jones* and *Jumanji*. Why do you think Gretchen Simpson uses close-ups for every one of her paintings in *Gretchen's abc*? Questions like these challenge students to see more, make distinctions, analyze, compare, and realize that picture making doesn't happen arbitrarily. It results from thinking and making choices.

I KNOW HORSE SHOWS.

By: Emily McMurdo

I know horse shows. . .
The piercing whinny of a horse,
 the clop, clop of hooves,
 the announcer on the loud speaker,
 and spurs clinking against the pavement.

I know horse shows. . .
The pungent smell of horse manure,
 leather tack, fresh, clean sawdust,
 hoof clippings, and hoof black.

I know horse shows. . .
The beautiful sparkling silver, shiny fur,
dazzling outfits, cowboy hats, and dirt.

I know horse shows. . .
"First prize #227. . . " "Get him saddled!!"
"Walk your horses!" "Programs! Get your
 programs!" "Show them what you're made of!"
"Go knock them dead!"

I know horse shows!

"The Flower Book"

Bookcover by Laurelhurst Elementary students, Portland, Oregon,
5th Grade

Writing

"Frame it—Describe it" provides students with a wonderful opportunity to practice descriptive writing. It is designed to accompany **Extension #3**, (p. 195). After "framing" five or six images, have students select their favorite, then describe what they see, hear, even smell. (The descriptive writing should be done while the student is looking through her frame.) Here's an example:

> *There's a red bicycle on the playground. The bike looks old. It has rusty spots. One of its tires looks almost flat. Behind the bike there's a drinking fountain. A blond girl wearing a pink jacket walks up to the fountain, bends down and takes a drink...*

ART

Composition Across the Curriculum

With few exceptions, student products can be thought of as visual communications. Whether a student is publishing a book, writing a report or producing a poster, the words, symbols, pictures (or some combination of the three) must be organized in a way that makes sense and looks good. The compositional skills that students learn as illustrators and designers will help them become better visual organizers of information of all kinds. (See illustrations on pp. 206 and 207.)

Mayan poster

Drew Huskey
Grade 6

1. Ehlert, Lois. (1991). *Circus*. New York: Harper Collins.
While this is undeniably a picture book for early primary, it can also be seen as a textbook on composition. Every sumptuous two page spread teaches the same basic lesson: in a master designer's hands, positive shapes and negative spaces are interdependent, and they can be equally engaging.

2. Khalsa, Dayal Kaur. (1987). *I Want a Dog*. New York: Clarkson N. Potter.
In all of Khalsa's picture books details abound and colors are anything but subtle. Still, you can always make out the strong lines and shapes that give her handsome compositions backbone. Also, check out her pictures for "3-M." She's wonderfully consistent in her use of "macro," "medium" and "micro" color shapes. The result? Pictures that are packed with information, yet never overwhelm or confuse.

3. Van Allsburg, Chris. (1984). *The Mysteries of Harris Burdick*. Boston: Houghton Mifflin.
A house lifts off like a rocket; a kitchen knife hovers above a luminous pumpkin; a caterpillar spells out the word "good bye" in a little girl's hand. Though student's will never come close to Van Allsburg's magical technique, they'll appreciate the varied compositional strategies he uses to illustrate his titles and captions.

4. Goennel, Heidi. (1989). *Sometimes I Like to be Alone*. Boston: Little Brown.
I've used this book in many primary classrooms to prompt discussions about what we like to do when we're alone. Goennel's protagonist provides us with lots of good ideas: she paints pictures, bakes a cake, teaches her puppy new tricks, watches for shooting stars. The colorful illustrations in Sometimes I Like to be Alone *spare us the details while delivering striking, flawlessly composed pictures.*

5. Callaway, Nicholas—Editor. (1987). *One Hundred Flowers*. New York: Knopf in association with Callaway Editions.
Georgia O'Keefe's statement that, "For me, painting is filling space beautifully," is a first rate definition of composition. So is every one of her famous flower paintings. Check out almost any edge of any picture and you'll see how the shrewdly designed negative spaces support her luscious floral forms.

6. Heller, Ruth. (1988). *Kites Sail High*. New York: Grosset and Dunlap.
Heller's books have it all: darn good drawing, lush color, abundant patterns. Best of all are her compositions: a giant hand holds a peacock feather quill; a herd of wild horses thunders across the page... Often her backgrounds are left uncolored.

Report Illustration by Devin Graves
Grade 6

Amphibians of the Amazon Rain Forest

Far from being boring, they offer relief from all the detail. And they deliver the handsomest negative spaces this side of Lois Ehlert.

7. Schwartz, Amy. (1982). *Bea and Mr. Jones.* **New York: Bradbury Press.**
This great "trading places" comedy is filled with beautifully composed pictures of train interiors, restaurants, kindergarten classrooms and corporate boardrooms. Not to be overlooked: Schwartz's exemplary black and white pencil technique.

8. Simpson, Gretchen Dow. (1991). *Gretchen's abc.* **New York: Laura Geringer.**
Simpson presents us with an extraordinary series of alphabetic close ups. Each image is simultaneously exotic, abstract and recognizable. No picture book I know presents the "close-up" as an illustrational option more attractively.

9. Bunting, Eve. Diaz, David –Illus. (1994). *Smoky Night.* **New York: Harcourt Brace.**
A powerful picture book about urban rioting. Diaz's subdued colors, weird perspectives, and cramped compositions amplify the story's sense of uncertainty, fear and disorientation. Don't avoid it. It won the Caldecott medal, and has a happy ending.

10. Banyai, Istvan. (1995). *Zoom.* **New York: Viking.**
In Banyai's wordless picture book, nothing is as it seems. What you thought was New York City turns out to be a TV show being watched by a cowboy in Arizona. And the the cowboy turns out to be an image on a stamp on an envelope in the hand of a tribal chief in the Solomon Islands, Australia. Zoom is always surprising. What's more, every page is a quirky compositional gem.

"Rhino"
Alan Ardiente
Grade 3

Opposite page:

"Leopard"
Adam Wolotira
Grade 3

Imaginative Drawing

"The gift of fantasy has meant more to me than my talent for absorbing positive knowledge."
Albert Eistein

"Creativity and imagination are the beginning of problem solving for a young child."
Mr. (Fred) Rogers

"Bizarre Car"
Amanda Reed
Grade 4

A house with bulging eyes and a hot dog mailbox; flowers that sing and dance; guitar strumming aliens with multiple heads; a Monarch butterfly wearing sunglasses and carrying a suitcase: these are the images of children reinventing the world with pencils, pens and markers.

What better way to make visible weird ideas, wishful thinking and nebulous daydreams than through drawing? Yet, some teachers have asked me, "Why bother? Kids have better things to do and to draw—especially in school!" While *"Seeing and Drawing"* (see p. 48)will enhance fine motor skills, encourage patience and visual acuity, imaginative drawing stimulates another part of the child entirely. And, it's healthy to do so.

According to psychologists Dorothy and Jerome Singer, an active imagination is an important part of a child's development, well-being and happiness. In fact, imaginative children are more likely to be curious, to actively explore their environments, and to exercise better self control, than less imaginative kids. They smile more often, tend to be less aggressive and entertain themselves for longer periods. Most surprisingly, the Singers found that imaginative children were better able to distinguish between fantasy and reality than their less imaginative peers.

"Alien Skier"
Grade 4

While I am strongly committed to offering kids strategies for drawing the "real" world with greater accuracy, I am equally committed to providing them with opportunities for fantasy drawing. There is nothing like the fun, outrageousness, and original thinking that pervades the work of children who have been encouraged to strut their imaginative stuff. As we shall see, flights of fancy have their place, not only in the lives of healthy, happy children, but in the classroom where fun and learning *can* happen simultaneously.

"Silly Stack Up"
Grade 1

LESSON

For a one hour lesson, I'll confine myself to a single approach I call *"Dictated Fantasy."* Inspired by Richard de Mille's *Put Your Mother on The Ceiling* and drawing games invented by Marjorie and Brent Wilson, *"Dictated Fantasy"* asks children to listen to verbal prompts, and to draw specific items. Though the content of every child's drawing will be determined by the "dictating" teacher, each student's rendition will be original.

The following lesson is designed for primary aged students. For the intermediate lesson, see p. 213.

Ⓟ Silly Stack Ups

Read *"The Brementown Musicians"* aloud. Discuss the outrageous animal "stack up" engineered by the ingenious donkey, dog, cat, and rooster to frighten away the robbers.

Pass out drawing paper and Flair pens. Tell students, *Today we are going to create our own "stack up," but ours is going to be really silly. I will tell you what to draw and where to draw it. When you draw the item, draw it your way. It won't look like anyone else's, and that's good!*

- *First, draw a horizontal line near the bottom of your paper. Good! Now our stacked items will have something to rest on.*

- *On the line, draw a house.* (Indicate the approximate area that the house should occupy (See Fig. 1). *Is the house old or new? Is it a funny house? Is it haunted? Is it a castle? Does it have windows? Can you see anything through the windows?**

**A key to helping children develop powers of imagination is to ask a series of questions like the ones above. What you're really doing, of course, is saying to kids, "There are many different ways for you to draw this item. Think about the way that you want to represent 'house.' Remember, your house won't look like anyone else's, and that's good!"*

Position of items in a sample "silly stack up."

Fig. 1.

Give students a few minutes to draw the house. Be sure to encourage them to add interesting *details* to each item as it's dictated.

• Tell students: *You may not be done drawing your house. Don't worry. You'll have time to finish drawing it later. Now please, don't ask me how this happened—but on top of the house there's an elephant! Give students time to draw their **detailed** elephant.*

In sequence, dictate any of the following (or anything else you think children would enjoy drawing): ice cream cone, tree, whale, American flag, flower, boy or girl, dog, cat, star, school bus, fish, clown, cloud, alien, rainbow, moon. Give students a reasonable amount of time to draw each item.

The statement, *"Now please, don't ask me how this happened..."* with a pregnant pause before the next item is named, usually has the primary crowd on the edge of its seat—and often in stitches!

If children make mistakes with their unerasable Flair pens, encourage them to *"make a mistake work in your favor."* When their drawings are finished, they can be colored with colored pencil.

Here is the intermediate lesson:

I In A Weird Room

Before students start to draw, read or tell the following story.

There's a couple, Mr. and Mrs. Ghiradelli, who are very rich. They could live anywhere, but chose to live in a "weird room." (Take a minute to define the meaning of the word "weird." Students should get the message, the stuff in this room can be "unusual," "wacky," "bizarre" etc....). They're not home very much. They travel a lot because they love art and are always on the look out for great new paintings to purchase for their collection. You are going to draw a picture of the Ghiradelli's "weird room." Here are the items that you should include:

1. Window
It's usually located on the wall, but not necessarily. It may or may not have curtains or a shade, but it surely shows the view of a large mountain in full volcanic eruption.

"Silly Stack Up"
Grade 1

**"In a Weird
Room"**
Teacher

2. Painting

There's a large painting. Like the window, it's usually on the wall, but not necessarily. It's the Ghiradelli's most recent purchase. You decide what the painting looks like. Is it a portrait? A series of geometric shapes? The sun? An alien? Does it have an ornate, carved wooden frame, or a simple modern one? You can draw the painting and it's frame anyway you like, but remember: it's worth a lot of money.

3. Lamp

There's a tall floor lamp somewhere in the room. It may have a shade, but it doesn't have to have one. It can be symmetrical or asymmetrical. It can be geometric. It could be an ostrich—anything goes—but it needs to be a light source.

4. Rug

There's a rug. (Oriental? Rag? Highly patterned? Shag? Flying carpet?)

5. Chair

Rocker? Bean bag? Throne? "Musical?" (I once had a fifth grader draw a very convincing electric chair in his "weird room." Ouch!)

6. Snake

There is a critter in the Ghiradelli's neighborhood who likes nothing better than to ingest large paintings. His name? Sly, the snake. Sly has no trouble getting into the "weird room." He waits 'til the Ghiradelli's are out of town. There's always a new painting–their latest purchase–hanging on the wall. "Yum!" ("Dinner," as he likes to think of it.)

7. The "Guard Creature"

The Ghiradelli's aren't stupid. They know about Sly. Whenever they leave town, their "guard creature" is on duty. His job is to protect the painting. He could, of course, be a guard dog. He could also be the Loch Ness Monster or Big Foot or Good Dog Carl or...

8. Cracks in the wall

We're not sure what caused them. The erupting volcano? A recent earthquake? The cracks may be very minor, or they may seriously threaten the structure that houses the "weird room."

"In a Weird Room"
Maya Kukes
Grade 5

That's the story, and the list that students are given. The rest is up to them. Years ago, I used to indicate where each of the items was to go, thus helping kids create more "successful" *compositions*. My inclination these days is to encourage students to locate items anywhere they like.

Make copies of **Black Line Master #44** available to students. Before students start to draw encourage them to:

- Start in pencil—use *"whisper lines."*
- Work out the total composition first.
 - Do your best to fill the entire paper in an interesting and original way.
- Include all eight items.
 - Try to make each item detailed, special and unique.
- Remember: "weird" is the name of the game.
- Use *"E-Z Drawing"* for challenging items.
 - Look at pictures as needed, or work exclusively from imagination—your choice.
- Place items in a space like the one described on pp. 98 and 99 (optional). See also *"Weird Room"* drawings on pp. 214 and 215.
- *"Finish in ink."*
- Add color (optional).

MATERIALS

Balloon Trip
by Ron Wegen,

Hot Air Henry
by Mary Calhoun
and

*The Great Round
the World
Balloon Race*
by Sue Scullard

Pencil

Flair pen

Colored markers

Colored pencils

Drawing paper
11" x 17"

EXTENSIONS

P 1. Up in the Sky *(Guided Fantasy)*

While *"Dictated Fantasy"* instructs students to draw specific items, **Guided Fantasy** begins with the teacher reading a multi-sensory script. Children, often with eyes closed, listen intently, and try to visualize* the item, place or process being described. Afterwards, kids draw detailed, personally expressive interpretations of the material presented. Here's an example:

Share one or more of the books in **Materials** at the left. Then ask students, *How would you like to take a pretend hot air balloon trip? OK, in order to do that, we're going to have to use our imaginations.* (Spend a few minutes discussing imagination.) *I'm going to be your guide. In order for us to use our imaginations, we need to be very, very quiet. No talking; no sounds or sound effects—just be good listeners. You can put your head down on your desk if you*

*By visualize, I don't necessarily mean the formation of vivid, internal pictures. That sort of visualizing takes a lot of practice. (To better understand and use this skill see **Resources**, page 234, Richard de Mille's Put Your Mother on the Ceiling.) Yes, some kids will "see" everything you describe. Others will be "in the dark." That doesn't mean they can't participate and enjoy the experience. Tell everyone, "As I describe things to you, try and see them in your mind's eye. If you can't see what I'm describing, that's OK, just think about it."*

want to. You can close your eyes, or leave them open. As you read the following script—or make up your own—pause when you see three dots to allow students to digest the information and to "visualize."

Lets's pretend we're out on the playground...It's a beautiful day...Your hot air balloon is waiting for you...You can take anyone up with you that you'd like...Take a moment and think about who you'd like to take with you...Now you are in the basket of your hot air balloon...You feel great...You are ready to lift off. Remember, nothing can harm you... Now you are lifting off the ground...slowly, slowly, rising... past the tops of trees...Up above the tops of houses... Up over some tall buildings...into the blue sky...filled with kites...All kinds of brightly colored kites...Now we are rising, rising into a cloud where it's cold and a little damp...and out of the cloud, back into the blue sky...rising past a flock of geese...rising through a rainbow...through the purple part...everything's purple...through blue...through green...yellow...orange...red...

Fantasy drawing is an ideal prompt for imaginative writing. Elizabeth wrote about her "Up in the Sky" picture:

"The sun is drinking coke and chewing gum. There's a pencil on Mars, a dog on Pluto and a buffalo stampede on Saturn. I saw a girl alien in the window of the flying saucer. Me and my dog Jojo are the ones in the hot air balloon. Jojo took a bite out of the apple!"

Elizabeth
Grade 2

rising past a jumbo jet...The pilot waves to us...It's Mickey Mouse!...Rising past a rocket on it's way to the moon... and as we're rising now, the sky turns slowly from blue to black as we enter the cool darkness of outer space...(Put on a jacket if you get cold.) As we float up into the darkness, here are some things you might see... Stars of all sizes, twinkling brightly...Comets and meteors flying around... The moon, big and bright, covered with craters... As you float past it, you can see the astronauts landing...and you can see something amazing... little mice dressed in space suits...eating green cheese... and playing golf on the moon... Suddenly you hear a "Moooo"...It's the cow jumping over the moon...Off in the distance you can see planets... Saturn, with its silvery rings... Jupiter, with its giant red spot...Pluto, covered with barking dogs...You hear a "Whooooshing" sound... From out of nowhere a mysterious space craft appears... It's a flying saucer with many windows... and in each one there's an alien...

"In a Funny Neighborhood"

Grade 2

What I'd like to do now is give you a couple of minutes to think about five "up in the sky" things you'd like to include in your drawing...You might want to include some of the things I've mentioned...The things you include can be real, like a rainbow or stars or a jet...or they can be pretend things like mice playing golf on the moon, or a cow driving a flying saucer or astronauts eating giant green cheese ice cream cones...I'm going to give you some time to think now...I will call you back in a few minutes...

After two to three minutes, gently invite students back to earth. Ask them to share some of the things they'd like to include in their pictures. I often write down their ideas on the chalkboard, making certain to validate everything that's offered. (Nothing shoots down fantasy faster than quizzical or disapproving vibes from adults.)

Get to drawing after you've established an accepting atmosphere and the following:

GUIDELINES

- Fill your paper with all sorts of "up in the sky" items— real and/or imaginary.

- Work with any combination of pencil, Flair pen, colored markers and colored pencils.

- Add lots of *detail* to each of your items.
 - Make each thing you draw fancy, not plain.

- Include at least five patterns in your drawing.

- "Make a mistake work in your favor."

- Use *your* ideas.
 - Your drawing won't look like anyone else's and that's good!

Here are some other script ideas you might want to develop for Grades 1–3:

- "In a Funny Neighborhood"
- "Undersea Worlds"
- "I Was a Bubble in a Tide Pool"
- "A Visit to a Distant Planet"
- "I Woke Up One Morning and I Was a Giant Insect"
- "Day in the Life of a Shoe"
- "In the Land of Crazy Creatures"

2. Bizarre Cars

Kids are asked to draw a completely crazy, weird, outrageous, highly detailed car. I've had great success introducing this project using a variety of books: Harry Allard's *The Stupids Have a Ball* ("What would a car driven by "The Stupids" look like?") or Rodney Greenblatt's, *Uncle Wizmo's New Used Car*. Best of all is Harod Blank's, *Wild Wheels*, a book that proves the adage, "truth is stranger than fiction." (See **Resources**, p. 235.)

Cari Mayers
Grade 2

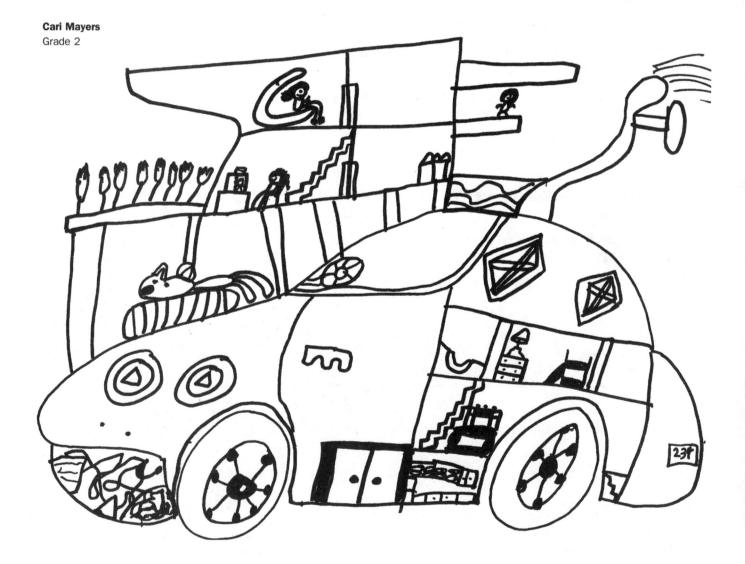

■ Look at real cars and identify basic parts (windshield, tail light, hood ornament, etc.).

■ Draw a Bizarre Car.
 • Do a rough draft (time permitting).
 • Your car should pretty much fill up your paper.
 • Include
 - a car body and some sort of passenger compartment.
 - at least one driver and one passenger (anything goes! vegetable, animal, human).
 - at least two tires.
 - some kind of head and tail light.
 - an exhaust pipe.
 - a minimum of four patterns.
 - interesting *details* (e.g., pepperoni and anchovies on your pizza tires).

■ Do research on items you'd like to include but don't know how to draw.

■ Use the *"E-Z Draw"* method whenever necessary.

■ Leave your drawing in pencil, *"Finish in ink,"* or fully color it.

I Older students may wish to use the *"tracing method"* for this project. See p. 201.

Armando Fernandez
Grade 5

MATERIALS

Black Line
Master #45
(photocopied for
student use)

Pencil

Flair pen

Colored markers

Colored pencils

Drawing paper
8.5" x 11"
as needed

3. Rooms We Can View

Students can use **Black Line Master #45,** or create a facade of their own design having invisible walls. It's important to talk about how wide the spectrum of possibilities for this project is. Students could create dream rooms, food rooms, creature rooms, rooms of the future, dance studios, silly rooms, the perfect sports, computer, music, game or bedroom. To introduce this project share *The Room, Full Moon Soup* (see **Resources**, p. 235) and/or *The House From Morning 'Til Night,* a lovely French book published in the U.S. by Crown.

GUIDELINES

■ Design four rooms anyway you like.
 • Rooms can be real and/or imaginary.
 • Include furniture, people, animals—anything goes!

■ Use *Black Line Master #45*, or create your own building with see through walls.
 • Do a rough draft (time permitting).

■ Do research on items you'd like to include but don't know how to draw.

■ Use the *"E-Z Draw"* method as required.
 • Include interesting *details*.

■ Leave your drawing in pencil, *"finish in Ink,"* or fully color it.

I Older students may wish to use the *"tracing method"* for this project. (See p. 201.)

Barbie B.
Grade 6

Three furry, gray, little beady eyed mice live in this room. The big papa mouse is out to work, and he is going to come home tired and hungry. Mama mouse sent baby mouse out to steal some fresh, warm runny cheese for their dinner. She said, "Beware, baby mouse, the cat is out there, and is very hungry. But he is fast asleep." Baby mouse got the cheese safely so the mice were very well satisfied. Big, tired and hungry Papa mouse was very proud.

There is a bright chestnut horse that lives in this room. Sometimes a little boy with a coal black dog rides around the interesting room. They use this little tiny brown stool to get up on the big horse because the boy and the dog are so small. They ride around and around in a circle all day long. They ride the horse from early in the morning until late at night. They neatly scrub slowly to get every little tiny speck of dirt, and they brush out the horse until he is totally dry.

A big, fat, chocolate cat named Boots lazily sleeps on a bright, dreamy, pink bed after his stuffing of Cal–Cat dinner. Boots has a favorite spot on the end of the bed that he warms up and sleeps on. From there he watches the big, black and brown spiders crawl around. Other nights he will watch the the big, bright yellow moon revolve around the room. Boots hardly ever leaves this room except to eat, so he never gets any exercise.

Some people believe he will never die. They think he will keep getting fatter and fatter and fatter until he will blow up. He has been in that room over fifty years.

A big crystal clear white cloud squeezed through the small window after a full delicious dinner. It comes in every beautiful day at the same time because it wants to fill the blue bathtub with soothing, bubbly, warm water. It fills the bathtub up at bath time so someone can have a relaxing bath.

After it fills it up, it flutters and floats to the outside. The cloud only belongs to this unbelievably strange bathroom. It only likes this weird bathroom.

Many children are inspired by fantasy well into the upper elementary years. Drawing projects like *"Rooms We Can View"* can be used to prompt both descriptive and imaginative writing.

Jill's writing (above) was done *after* her drawings were complete. Notice how each of the stories matches a particular room drawing (left), and amplifies its meaning.

Drawing and writing by Jill Austen
Grade 6

See Color Plates, p. 5.

1. Some teachers have said to me, "But my kids aren't imaginative." Don't believe it. Kids, especially younger than ten, were born to make believe, fantasize, play. What's imaginative drawing but graphic play? Sadly, in our media drenched world, kids aren't invited to imagine much. Everywhere they turn, there's someone else's imaginative product to consume (movie, song, TV show, comic book, computer/video game). It's little wonder that kids, when asked to use their imaginations, come up dry or regurgitate a sitcom plot. Imagination is like reading, drawing and free throw shooting: "practice makes better."

2. We wouldn't be teachers if we didn't want children to produce drawings that looked great *and* utilized the skills they've been learning. Still, we've got to be cautious when we enter the realm of the imaginative. While it's valid to establish **Guidelines**, we also need to be flexible. Be on the lookout for drawings that transcend instructions. There are times when originality should know no bounds.

3. Some drawing books suggest that children around nine or ten become interested in realism to the exclusion of every other kind of drawing. While it's true that children are hungry for information about making their drawings look more real and less childlike, many older kids *prefer* fantasy. They are fascinated by aliens, weird monsters, unicorns, crazy stuff, impossible inventions, funny faces, dream houses, cities of the future This preference doesn't make them misguided or immature, it makes them kids.

"Inter-galactic
Basketball Star"
Brandon Graska
Grade 3

4. One of the great attractions of imaginative (or fantasy) drawing is that there isn't one correct answer. If I'm drawing a champion alien ice skater, I can draw her (or him) ten different ways and still be right. If I'm drawing a funny house, it might have windows shaped like hearts, or Bart Simpson's hairdo, or fish. This is a crucial experience for kids to have in a world where, too often, they feel that there is only one correct response.

5. I detect a lot of ambivalence about creativity and especially imagination in schools. With greater emphasis being placed on test scores and accountability all the time, it gets easier to relegate these nebulous, hard to quantify issues to the back burner. The sentiment I run into in faculty rooms most often is: "We know they're a important, but..." The bottom line is this: if imagination and creativity aren't strongly valued by teachers, they won't be experienced very often by passive, pop culture saturated children.

6. It is critical that we keep the "why" of imagination in front of us. Besides the Singers' important research (p. 234) here are a few more reasons that relate specifically to imaginative drawing.

Student
Grade 3

When drawing imaginatively—
- Kids are in a world where there are no wrong answers.
- Every child, regardless of her drawing ability, can be a successful participant.
- Uniqueness and self-expression are central.
- Kids are encouraged to risk, trust their instincts, exercise intuition, innovate.

When the "why" is understood and valued, the time to work imaginatively is much more likely to be found.

7. Don't be put off by **Guided Fantasy's** nebulousness or unconventionality. It can be a powerful strategy for exciting imaginations. Here are a few guidelines that have served me well over the years:
- Develop a "script" so that you know where you're going with your subject. (Winging it can be risky.)

- Read or say your script slowly, pausing between phrases to allow kids to digest what they're hearing.

- Remind students that they may or may not see things in their mind's eye as they listen to your words. If they can't, that's okay. Remind them to "Just think about what's being said."

- Know that some topics will be inherently more interesting to certain kids than others.

- Insist on quiet so that every child can concentrate on what you're saying.

- The most receptive posture for **Guided Fantasy** is heads down and eyes closed. Most students enjoy the experience. With a few students (ADD, ADHD or highly kinesthetic kids), that may be asking too much. Settle for "no talking."

- Practice (for you and students) "makes better."

8. There are two schools of thought concerning **Guided Fantasy**. One says, let kids do most of the imagining (e.g., say to kids, "We're in outer space... and now we're approaching a giant planet...What color is it? Does it have any rings?..."). The other says that specificity excites imagination (e.g., "We're in outer space...and now we're approaching a giant planet. It's mostly red...with green oceans... silvery clouds float across its surface..."). I've tried both approaches, and both work.

9. Imagination and creativity don't mean "anything goes." In the realm of the imaginative, as with other kinds of drawing, it's appropriate to discuss and establish "community standards." We all have our limits and, in today's licentious world, we must. Many teachers draw the line at weaponry, and certainly, nudity. Over the years all I've had to say was, "No bodily fluids."

10. It's important to present models of audacious imagination—if you expect kids to be audaciously imaginative. Thankfully, imagination, once we begin to value it and seek it out, is as available as it is irrepressible. About ten years ago, while doing a major "Cats" project with first graders, I discovered cat books that students loved and I came to love, too: *Rotten Ralph, Hot Air Henry, The Tenth Good Thing About Barney*. Then, serendipitously, in a dusty bookstore in Seattle, I came across *VanderSteen's Cats*. VanderSteen, it turned out, was an obscure French artist who painted almost nothing but cats in the 1940 and '50s. His cats were unlike any I'd ever seen before: colorful, flamboyantly patterned, some with horns, some with manes,

"Design for an Apartment Building"
Kerry Grogon
Grade 5

leaping, twisting, staring, bug eyed. "Vincent Van Gogh meets Lewis Carroll," I thought. The first graders couldn't get enough of VanderSteen. They howled; they were awed. For days after, they came to school with drawings of outrageous cats—geometric cats, cats wearing scuba diving equipment, cats getting married. Everyday they asked me, "Do you have anymore VanderSteen?"

"Cats"
Student
Grade 1

11. Even when drawing imaginatively it's still entirely valid, and important, for some students to look at real things when they draw. If I'm drawing a weird "sports bug" with soccer ball eyes, golf club legs and a football helmet head, looking at pictures of some of these items (or the real thing) and using *"E-Z Drawing"* may dramatically improve my performance.

12. The best imaginative drawing is idiosyncratic, personal, unique. It won't appear in classrooms where kids feel judged or ridiculed by anyone. It's up to you to create a safe haven for audacious imagination.

13. If you feel self-conscious about the "weird" drawing that's going on in your room and you want a little "ammo" to justify what you're doing, share the following with parents, colleagues or administrators:

- A 1991 US Department of Labor report entitled *What Work Requires of School* identified a broad array of academic and non-academic competencies necessary for success in the modern workplace. At the top of the "non-academic" competencies list: Creative thinking, followed by decision making and problem solving.

The "Goren"

• "If in this day and time we do not tap into the creative side of a young person's brain in every possible way, then we are not going to have the innovation and the economic and cultural growth experience that the country must have."

— *Richard Riley, President Clinton's Secretary of Education*

See also quotes by Fred Rogers and Albert Einstein on p. 210. (A more complete rationale for drawing in schools can be found starting on p. 242.)

Design for a rocket

Keith Bender
Grade 5

"Stack Ups" Across the Curriculum.
 (See also p. 104)

SCIENCE ("Stack Ups")

Anytime young scientists are creating categories, "stack ups" can be used to great advantage. Over the years I've seen children produce "stack ups" consisting of mammals, dinosaurs, crustaceans, omnivores. "Stack ups" also lend themselves nicely to hierarchical organization. How about a "Food Chain" "stack up" showing vertebrates with the simplest forms of animal life on the bottom, and the most complex at the top?

LANGUAGE ARTS ("Stack Ups")

Stacked items consisting of people, animals, objects whether dictated by you or devised by students can be used as evocative story starters. You might say to students: *Select any four items from your stack up and create an imaginative story having a beginning, a middle and an end.* Or, if you're studying fairy tales, the "stack up" might include characters and elements from three or four different stories: e.g., a horse and carriage, a woodsman, a tower, an oven, a wolf, etc. Then, kids write original fairy tales based on items selected from this hybrid "stack up."

SOCIAL STUDIES ("Stack Ups")

Finally, let's not forget the ultimate "stack up," the totem pole. Kids love creating their own poles, whether they're based on the elegant, powerful imagery of the Indians of the Pacific Northwest, or on original designs. Recently, I challenged kids to create "Animal Self-Portrait Poles." Each animal selected had to symbolize a quality the student admired or identified with (e.g., the playfulness of a porpoise, grace of a gazelle, loyalty of a dog, endurance of a camel, etc.). The qualities were explained in their writing. Finished products were as intriguing as they were varied.

"Animal Stack-up"
Colleen Moran
Grade 4

Weird Science

"Weird Science" is my name for a group of projects that combines scientific facts, concepts, processes and imaginative drawing. Here are two examples.

- ### *Fantastic Flora*

 Let's say that fourth graders are studying flowers, and we want them to know the names of floral parts. Of course, kids could observe, draw and label the parts of real flowers. That would certainly be valid and worth- while (see *Seeing and Drawing*, **Extension #2**, p. 54). But, I've found that giving kids the opportunity to work imaginatively stimulates enormous creativity, while teaching floral anatomy just as effectively.

As fantastic (and outrageous) as the flowers below are, they meet the stated guidelines of the project. Namely, that each flower display these parts: blossom (with petals), stem, leaves and root system.

"Math Flower"
Rick Brown
Grade 5

"Sweet Treat Flower"
Anne
Grade 6

When time is limited, a *"brainstorm sheet"* can be completed in about an hour. Flower parts can be labeled or not, your choice. (See p. 44.) When there's more time, students create polished, fully colored drawings based on one (or a combination) of their ideas. (See "Flower on a Distant Planet," Color Plates, p. 7.)

*(*I've used almost the same **Guidelines**, with appropriate modifications, for projects involving insects, birds, reptiles and mammals.)*

Labeled diagram for the project "Fantasy Insect."

"Amazon Underground Grasshopper"
Jenny
Grade 3

• *Predators You Wouldn't Want to Know*

Studying predators? Why not give the unit a "weird science" spin? Discuss and research the many ways that animals capture and kill prey—e.g., ingesting them whole (African rock python), grabbing them with talons (osprey), smothering them with powerful tentacles (Atlantic octopus)... (Be sure to take a look at Bert Kitchen's brilliant *When Hunger Calls*.) After lists have been developed, students draw a hybrid predator that's capable of killing its prey at least four ways (primary) and eight ways (intermediate). It's a monster! It's imaginative! It embodies a lot of sound scientific understanding. While at first glance this project might seem gruesome, in fact it helps children face the fact that animals must kill to survive. As kids get deeper and deeper into their research (and their drawings), they become both more accepting of natural law, and, interestingly, less and less titillated by blood lust.

Though Kate's writing is imaginative, all the references to capturing, killing, and eating are factual.

The Goop eats lots of animals but it prefers two kinds of animals. It eats seals and snakes. How it kills a seal is by squeezing it with its octopus arms. Then it sucks it up with its Goop lips. Next it likes to eat snakes. How it kills a snake is it bites it with its fangs, but if the snake isn't dead yet, then it scratches it with its talons. Last, it sucks it up. Then the Goop goes to look for more food.

**Drawing and Writing
by Kate Eppler**
Grade 2

Guided Fantasy Across the Curriculum

Anytime you want students to better understand a process, or experience a particular historical moment, *Guided Fantasy* can be a highly effective strategy. (As I've said, *Guided Fantasy* always begins with a script that's read or spoken by the teacher.) Here are two examples:

SCIENCE *(Guided Fantasy)*

Life cycle of a plant

Your script might ask students to be a seed...to feel what it's like to be planted in rich, dark soil...to be watered to begin sprouting, etc. In incremental stages you would ask them to experience growth, flowering, pollination, seed production and eventually, the coming of autumn and death. At the conclusion of the *Guided Fantasy* experience, students could draw a series of pictures describing their experience.

SOCIAL STUDIES *(Guided Fantasy)*

"You Are There"

You can transport kids to Jamestown during "the starving time," describe a typical day on the Oregon Trail, or the battle of Gettysburg. (You'll need to create at least one historically accurate, multi-sensory script. Be sure to check out Paul Fleischman's exemplary *Bull Run*, a recreation of the famous first battle of the Civil War from the points of view of sixteen participants. Fleischman has really done his homework!) Not only will your "script" evoke another time and place, you'll be modeling accurate research, use of rich descriptive language and vivid *detail*. Encourage intermediate (and older) to create their own historically accurate scripts. Afterwards, they can create drawings that reflect the same commitment to research, and *detail*.

Drawn after seeing the Civil War battle film, "Glory."

Student
Grade 6

RESOURCES

1. Singer, Jerome. (1975). *The Inner World of Daydreaming.* New York: Harper and Row.

2. Singer, Dorothy and Singer, Jerome. (1977). *Partners in Play.* New York: Harper and Row.
The Singers' research on the play of younger children demonstrates that the "developed imagination helps memory, vocabulary, the sense of self, the ability to master the environment, and the capacity for adaptation." Anyone who questions the importance (or normality) of stimulated imaginations in the lives of kids should consult their work.

3. De Mille, Richard. (1976). *Put Your Mother On the Ceiling.* New York: Penguin Books.
De Mille's idiosyncratic classic accomplishes at least two things. First, it teaches children to "visualize," i.e., create vivid mental pictures. Second, it provides them with the opportunity to play a series of scripted imagination games with names like "Tick Tock," "Mirror" and "Ouch."

"Monsters"
Clark
Grade 1

De Mille is determined to help kids develop qualities that aren't always valued in traditional classrooms: intuition, self-expression, flexibility and perception. His provocative essay at the beginning of the book, "Why Put Mother on the Ceiling?" isn't just entertaining. It's a powerful argument in favor of whole brain education.

4. Wilson, Marjorie. and Wilson, Brent. (1981). *Teaching Children to Draw.* **Englewood, NJ: Prentice Hall.**
The book doesn't teach kids to draw so much as it stimulates their desire to want to do it. Influenced by de Mille's Put Your Mother on the Ceiling *and crammed with great drawing games, it has inspired my work with children for a decade. Alas, out of print. Look for it in school and community libraries.*

5. Bruckner, D.J.R. (1984). *VanderSteen's Cats.* **New York: Fromm International Publishing Corporation.**
If a caffeinated Vincent Van Gogh were to paint the dreams of the Cheshire Cat obsessively for twenty years, the resulting images might resemble Jan VanderSteen's best work. This rare book contains many preparatory ink drawings, as well as reproductions of his lush oil paintings. (Why isn't VanderSteen's work better known?)

6. Blank, Harod. (1993). *Wild Wheels.* **Petaluma, CA: Pomegranate Art Books.**
Gorgeous color photos of outrageous art cars with names like "Mirrormobile," "Jewel Box," and "Gator Car," and the stories of the people who created them. There are a few PG-13ish sex references in the book's introduction, so beware. Blank has many items relating to art cars to sell (including calendars and the video, "Wild Wheels," which was shown nationally on PBS). Contact him at 10341 San Pablo Ave., El Cerrito, CA 94530.

The list of great children's picture books that view the world imaginatively is practically endless. Here are a few from my favorites:

7. Graham, Alastair. (1991). *Full Moon Soup.* **New York: Dial Books for Young Readers.**
Graham, a British illustrator, has produced a wordless picture book for the ages. His cartoony portrait of the "Fall of the Hotel Splendide" is so deliciously detailed you won't know where to look first. Edgar Allen Poe meets Mad Magazine.

8. Ringgold, Faith. (1991). *Tar Beach.* **New York: Crown.**
Kids are fascinated by the idea that people might fly. Peter Pan. Mary Poppins and now Cassie and her brother, Be Be, gliding over a luminous New York City. Ringgold's mingling of memory and fantasy is as magical verbally as it is visually.

"Tree"
Jeanie
Grade 3

9. Gerstein, Mordacai. (1984). *The Room*. New York: Harper & Row.

A single room is rented over an undefined, but significant period of time by a couple that grows old, a magician, a band of Irish musicians, a lady who had too many cats, a dentist who loved ducks, etc. In the end the book is as much about the mysteries–time and change—as it is about the many characters who occupy the room.

10. Schwartz, Amy. (1982). *Bea and Mr. Jones*. New York: Bradbury Press.

A kindergartner and her advertising executive dad switch places. "I love advertising! What a challenge," says five year old Bea. "I feel more relaxed than I have in twenty years," says kindergartner, Mr. Jones. The beauty of this book is they both love the new arrangement and decide not to switch back!

11. Small, David. (1995). *Hoover's Bride*. New York: Random House.

The author of Imogene's Antlers *brings us the unlikely tale of a man who not only falls in love with a vacuum cleaner, he actually marries her! To give you a sense of Small's language and humor consider this couplet: "Said the priest, 'While this seems like the strangest alliance/I now pronounce you man and appliance.'"*

"Design Napeo"
Martha Burwell
Grade 4

12. Edens, Cooper. Lane, Daniel—Illus. (1991).
The Santa Cows. **New York: Green Tiger Press.**
On Christmas eve as Elwood and his wife eat clam cakes
and chopped eel, and the kids are "plugged into special
effects," caroling Herefords, Guernseys and Jerseys descend
from the heavens. The ending is as poetic as it is unexpected:
an all night baseball game in the snow with the Santa Cows.

13. Legge, David. (1994). *Bamboozled.* **New York:**
Scholastic.
A little girl can't quite put her finger on what's different at
her grandfather's house. Only everything! Legge's classy
watercolors will have kids begging to see the pictures close up,
and to create their own "what's wrong with this picture"
drawings.

14. Simon, Francesca. Ludlow, Karen—Illus. (1996).
The Topsy-Turvies. **New York: Dial Books.**
In the grand tradition of The Fools of Chelm and Amelia
Bedelia, we now have the British Topsy-Turvies They put on
pajamas when it's time to get dressed, comb their hair with
forks, and watch TV standing on their heads. As sweet as
their American cousins, The Stupids, they are equally imag-
inative at getting it all wrong.

15. Burger, Barbara. (1984). *Grandfather Twilight.*
New York: Philomel Books.
Grandfather Twilight removes yet another tiny moon pearl
from a magical necklace, walks through a forest of whisper-
ing leaves, and gently "gives the pearl to the silence above
the sea."

"Totem"
Todd Lawton
Grade 4

Projects Presented in Lessons

"City,"
One point
perspective
drawing.

D.J. Meyer
Grade 5

"Cheetah"
Sarah Lawson
Grade 5

"Fancy Ink"
Kaye Stafford
Teacher

Collograph print
Grade 3

Why Children Should Draw

"In the future visual skills of every kind, from drawing to visualizing, will stand equal with all our other skills... We need the full flow of all our human skills to deal with a future so challenging and so complex that we can hardly imagine it."

**Geraldine Schwartz, Ph.D.; Founder and President
Vancouver Learning Centre; Vancouver, British Columbia**

"Crown"

**Norah Gilson
Grade 1**

Why Children Should Draw: A Rationale
By Roger Kukes

1. Drawing helps children develop fine motor skills.

Fine motor skills are critical for building the coordination required for legible printing and writing.

2. Drawing appeals to visual learners.

Drawing is a natural way for visual learners (50–70% of elementary age students) to process information. For many of these children drawing may make learning easier, faster and more fun!

3. Drawing can help promote balanced, whole brain learning.

Drawing emphasizes the visual, spatial and intuitive, qualities usually associated with the right side of the brain. It's an activity that offers a welcome counter balance to the logic, language and linearity often associated with the left brain and with much of school curriculum.

Jermaine Brown displays an illustration for his story, "The Chair."
Grade 4

4. Drawing can help children grow as human beings.

Children who draw regularly tend to be more expressive and self-reliant than children who don't. Drawing can help children build observational skills, concentration and powers of imagination.

Permission is granted to reproduce pages 242–245 so that students, parents, educators and administrators may better understand the value of drawing in the lives of children, and drawing's place in the classroom.

5. Drawing can help children understand uniqueness and celebrate diversity.

Whether drawing something imaginary like a "Crazy Creature," or real, like a vase of flowers, students quickly notice that no two drawings produced by their classmates will ever be the same. The message is crystal clear: "We all have our own unique way of looking at things and expressing ourselves, and that's good. Viva la difference!"

6. Drawing can help children express visually/pictorially things that can't be expressed any other way.

This is especially important for younger children and special needs learners who may have limited (or non-existent) verbal and writing skills. Ernest Boyer, past president of the Carnegie Foundation for the Advancement of Teaching has said, "Art is an essential language that makes it possible to communicate feelings and ideas that words cannot express."

7. Drawing can help some under achieving students feel more successful in school.

Kids who struggle with academics — mathematics, reading and writing — inevitably suffer diminished self-esteem. Some of these students may excel at drawing, or at least enjoy it. For these children, drawing isn't a "fun frill," it's a "lifeline," and an area of strength that student and teacher can build on.

8. Drawing can teach children important non-academic skills that will be indispensable for success in an information age.

A 1991 U.S. Department of Labor report titled "What Work Requires of School" identified a broad array of academic and non-academic competencies necessaryfor success in the workplace of the new millennium. The non-academic

Patty Erwin
Teacher

competencies mentioned prominently in the report included: creative thinking, decision making, problem solving, learning how to learn, self responsibility — many of the same qualities that young artists and illustrators consistently practice.

"Bizarre Vehicles"
Colored pencil and
colored marker.
Grade 5

9. **Studying drawing, (especially as it's presented in *Drawing in the Classroom* helps kids become visually literate.**

"Visually literate" means that students are able to "read," appreciate, and critically discuss images and their meanings. Clearly, these are desirable skills to have at a time when so much of our information is delivered pictorially, whether through advertising, technology or the media.

10. **For certain "talented" kid artists, early exceptional ability might indicate the potential for a job or career in the vast and varied visual arts field as cartoonist, illustrator, designer, architect, animator, artist, etc.**

While literacy and reasoning skills will always be at the center of school curricula, we shouldn't overlook the fact that the dreamer, the doodler, the kid who won't stop drawing in the back of our classroom may be engaged in serious preparatory work. The 21st century will tap the talents of our most creative students in ways previously unimagined. The burgeoning computer related multimedia industry is a case in point. Barely existent five years ago, it offers a range of challenging well paying jobs—many requiring art smarts. Joel Kotkin, a senior fellow at the Pacific Research Institute, said in a recent *Washington Post* article, although "techies" still dominate the computer industry, "trends suggest they will increasingly look to artists to supply the content for their brilliant machines."

"Why Children Should Draw" is excerpted from Drawing in the Classroom *by Roger Kukes (1998) ISBN 0-9622330-1-3.*

For order information contact the publisher, Klassroom Kinetics at (503) 235-0933.

Drawing Media

"You have to begin drawing to know what you want to draw."
Pablo Picasso

"Each tool, each medium, has its own voice."
Edward Hill, The Language of Drawing

During my second year of college, I had a sculptor friend, Ernie. He was a married grad student, had two small children and hardly any money. The guy was a drawing marvel! His cramped studio walls were always covered with his gorgeous creations–haunting faces, undulating figures, turbulent landscapes. He prided himself on working with the *worst* materials he could find. "If I can draw with this junk," he used to say, "just think how good my drawings will look when I finally get some dough."

Ernie's beautiful drawings, done with ratty looking ball points, his kids' broken crayons and pencil stubs he'd found on buses, taught me an important lesson. It's not in the materials, it's in the artist's hand, eye and heart.

It would be tempting to end my discussion on drawing media right here by saying, it doesn't really matter what kids draw with, it only matters that they draw. That would be a cop out. While Ernie's story can inspire us in an age of reduced school spending, it's still possible to recommend a smorgasbord of drawing tools and materials that won't exhaust anyone's budget.

In the following section, brand names appear in bold face type and are listed in order of preference. Most items can be found in the catalogs listed below. Many items can be purchased locally at discount, variety and office supply stores. If all else fails, call a local art supply retailer. (*Always* ask for an educator's discount.)

"Ruff the Underwater Cat"
(Flair pen, colored markers and Prismacolor pencils)
Erin Welsh, Grade 1

When we make a variety of coloring tools available to younger children and show them mixing techniques, they frequently *"nail the white"* naturally.

Art Supply Catalogs (Call for a free catalog)
- Nasco: 1-800-558-9595 (Best selection–lowest prices)
- Pyramid: 1-800-446-1477
- Sax: 1-800-558-6696

Paper (and other Supplies)
- Arvey Paper: 1-800-556-9055 (Great paper source)
- Office Depot: 1-800-685-5010
- Office Max: 1-800-788-8080

"Toucan" (Pencil)
by Zak Tyler
Grade 5

Drawing Tools: The Basic Four

Anything that makes a mark on a surface can technically be called a "drawing tool."

Let's start with the basic four: pencil, ink, colored markers and colored pencils. They should be in every classroom. Used individually and in combination (as "mixed media"), they're capable of delivering a breadth and depth of line, shape, color and pattern that would make Matisse smile. All are pretty cheap (with one exception) and are universally available. These are the "classics," the classroom materials I come back to again and again. Kids love them, too.

Pencil

You can't get any more basic than pencil. Used skillfully, pencil can produce everything from *"whisper lines"* to velvety blacks, and from simple line drawings to polished *chiaroscuro.* Pencil is great for *rough drafts;* it revises easily, reproduces nicely on high quality photocopiers (even the grays) and laminates beautifully.

Pencils: Recommendations

Don't spend a lot of dough on fancy drawing pencils. (Berol Turquoise HB pencils can cost a dollar or more each!) Yellow pencils marked HB or 2/HB by many manufacturers (Dixon, Oriole, Eberhard Faber, American, Phoenix, etc.) are reasonably priced. Many schools already stock them. Look in your storeroom.

Erasers

White plastic (or vinyl) erasers are in a class by themselves. They're available from many manufacturers (Sakura, Staedler Mars, Sax, Eberhard Faber). Highly recommended is the reasonably priced **Factis** white eraser by General. Pink Pearl erasers are so-so by comparison. Gum erasers: Yuck!

Blending Stumps

Stumps are hard paper cylinders sharpened to a point. Rub them against pencil lines and you'll instantly get soft grays. They're unbeatable for evening out streaky grays and blacks, and for creating anything soft or wispy (animal fur, smoke, clouds). In lieu of buying stumps, roll a tissue around and over the tip of a pencil and rub. Warm fingers work, too.

"Praying Mantis"
(Pencil)
by Alex M.
Grade 2

A five part gray scale
produced with a
#2 HB pencil.

1. All pencils are not created equal.

Whenever possible use HB or #2 HB as opposed to straight #2's. The HB variety are softer, smoother pencils. They're easier to erase, and capable of producing richer blacks than their harder #2 cousins. Their only disadvantage is that they tend to smear.

2. Have good erasers on hand.

For intermediate age students who will be revising their drawings, the pink eraser at the end of the pencil may be inadequate. The new generation of terrific, inexpensive white plastic erasers are such a pleasure to use, they actually encourage revision!

They're also the perfect tool for erasing all pencil lines after kids have *"finished in ink."* Seven or eight erasers can be shared by a classroom of thirty.

3. Don't forget the grays.

Pencils are capable of delivering a full range of grays from the lightest to the darkest. When creating grays, pencil pressure is key. A series of parallel strokes usually works well. For darker grays, build up strokes gradually via cross hatching. If you want your grays to be seamless (very smooth and even), rub the specified area with a finger or a blending stump. (The gray scale above left was produced with a #2/HB pencil and a stump.) For a great example of pencil drawings displaying a full spectrum of grays, check out Amy Schwartz's pencil illustrations for *Bea and Mr. Jones*. (See **Resources**, p. 236.)

4. Try pencil on different papers.

Different papers have different surface qualities. Some are extremely smooth (20# computer printer paper). Others have more "tooth" or roughness (20# photocopier paper, manila, newsprint and the heavier weight 67# vellum bristols). Higher quality papers stand up better to vigorous reworking. Collect different kinds of papers. Encourage kids to experiment. (See Paper, p. 263.)

"Ear," pencil drawing
by the author shows a
full range of values.

Ink

By "ink," I mean the use of any *black* pen or marker. Ink is one of the most underrated of all drawing tools. With the many different pen types and nib sizes available, ink is capable of producing a full range of image qualities from delicate to bold. Ink's only drawback is that if you make a boo boo, there's no erasing. (Young artists can, of course *"make a mistake work in their favor,"* or create *"whisper line"* drawings, then *"finish in ink."* (If all else fails, reach for the white out!) Ink has a lot of pluses. It—

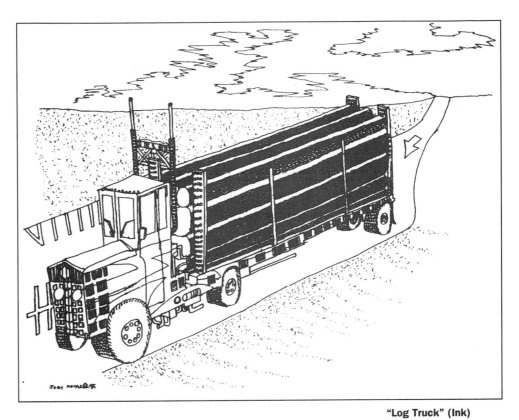

"Log Truck" (Ink)
by Joey Novak,
Grade 7

- Covers pencil drafts nicely.
- Is a great detail medium.
- Can be reduced or enlarged on photocopiers.
- Is a snap to scan.
- Laminates beautifully.

Ink: Recommendations

• Fine Line Pens

Ballpoint pens are "way cool" for fine lines and *detail*. Kids have known this for years. In the case of ball points, "cheap is beautiful." Use what's on hand. If you've got the budget, try either Niji's black **Stylist**, or Sanford's **Deluxe Micro Uni-ball**. The Stylist draws like an expensive technical pen, and the Uni-ball is unbeatable for fast, fluid sketching.

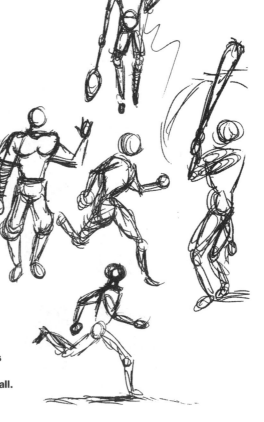

"Quickie" sketches
done with the
Delux Micro Uni-ball.

• Medium Line Pens

First choice: **Flair** (by Papermate) The white plastic "Pointguard" is more than a gimmick. It prevents the felt tip from turning to mush. **Flairs** hold up remarkably well, even when used by exuberant young artists. Still, they're not recommended for everyday use. Save them for special projects and for *"finishing-in-ink."*

Also recommended: black **Crayola** thin line marker (from the Classic Color set), **Pilot Razor Point**, and **Deluxe Fine Uni-ball**.

• Thicker Line Pens

First choice: **Sharpie** Fine Point Permanent Marker. Great for producing flowing, juicy lines that are still controllable, and for filling in black areas. There are a couple of draw backs to using **Sharpies** in the classroom. Because they're permanent, they can stain clothing. (Little kids shouldn't use them.) And when they're at their juiciest, they can bleed through papers and stain desktops. (Put a protective sheet under the paper students are drawing on.) Terrific for creating bold outlines. Also recommended: **Crayola** Broad line black marker (from the Classic Colors set). Washable. A good choice for ages eight and under.

In the three ink gray scales below, the density of the marks determines the value — i.e., the degree of lightness or darkness of each square. Students should practice creating a variety of densities using dots, hatched lines, and cross-hatched lines.

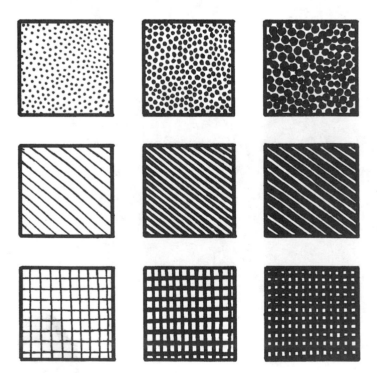

TIPS ON USING INK MORE EFFECTIVELY

1. Use different pens to create light, medium and heavy weight lines.

As we saw in **Lesson 1**, different line weights have different qualities. You can create delicate or wispy lines with extra fine ballpoints, medium lines with **Flair** pens, bolder lines with **Sharpies** and broad line **Crayola** black markers.

2. Don't forget the grays.

Ink is capable of delivering a full range of grays. As you can see in the three gray scales to the left, ink "grays" are quite a bit different than pencil grays. They're crisper, harder, less seamless and they're graphically stronger. (To actually see "the gray," you may have to blur your eyes, or hold the book at arms length and squint.)

3. To dramatically increase the graphic power of ink drawings —

- Vary line weights.
- Introduce a variety of "grays."
- Color some shapes black.

When students use all these techniques in a drawing, I congratulate them for being "fancy ink" artists.

4. Learn from the comics.

To see ink's richness and variety at a glance, open up any large daily newspaper to the comics page. While cartoonists' drawing skills run the gamut from meager to dazzling, everyone is using the same elements: multiple line weights, grays and solid black shapes.

In the examples here, notice how the drawing below is transformed by the "Fancy Ink" addition of a variety of *line weights*, *patterns*, inking techniques (p. 252) and solid black shapes.

"Fantastic Insect"
Brenda Recknagle
Teacher

5. Texture

Though we haven't discussed it much, texture is a key visual element. Nothing suggests it better than ink: woolly sweaters, leafy lettuce, shiny hairdos, prickly cacti, wrinkled elephants. They're all doable with a few well chosen strokes of the pen.

Colored Markers

During the past decade, colored markers have become the drawing medium of choice in many classrooms. Reasonably priced, durable marker sets like Crayola's are available in a rich assortment of colors, last a long time, and laminate well. The big nibbed markers are a fine tool for filling in larger areas with juicy color. On the down side, markers dry out if not properly capped, can be annoyingly streaky and are tricky to mix. And, since students usually purchase a single basic set each school year, they may end up repeating the same limited range of colors (grass green, sky blue, fire engine red, etc.) from first through eighth grades.

Colored Markers: Recommendations

- **Crayola Classic Markers** (set of 8 broad line water based pens). A great starter set and hey, what's wrong with grass green, sky blue and fire engine red, anyhow?

 Also available in washable colors (for younger students) and a thin line tip version.

- **Crayola Bold Markers** (set of 8 broad line water based pens). My second favorite set, and the perfect complement to Classic Markers. The colors are a bit more exotic: "raspberry," "marigold," "royal purple," etc. Also available in washable colors and a thin line tip version.

Other **Crayola Markers** sets worth checking out: "Tropical," "Sun Splashed," "Fluorescent," "Multicultural," "Brite," "Wildlife"... The number of Crayola marker colors just keeps on growing. All of the

"Cactus" by the author.

above are available in broad or thin line tip sets.

- **Flair** pens. Available in a variety of colors. (Blue, green, red are ubiquitous; orange and purple arc harder to find.) Terrific for outlining, detail work, and *"finishing in ink."*

- **Sharpie** Fine Line Markers (Permanent). Available in blue, green, red, orange, purple and yellow. A great bolder line pen. Watch out for its permanent ink on clothing and desk tops (not for younger children). One very important plus: you can color over **Sharpie** lines with water based markers and there's no smearing! Also available in Extra Fine and in a jumbo version—the **Super Sharpie** (broader tip, more ink).

"Toucan," (Colored Marker)
Ashley Sunderland
Grade 5

- Ballpoints (many brands available in blue, green and red). Wonderful for delicate colored drawings and for building up exotic mixtures through cross-hatching and "swirling." (See p. 260.)

- Pen sets made by **Pentel, Marvy** and **Berol**. Rich hues available in a rainbow of colors. These end up at the bottom of my list only because they're expensive, not because they're inappropriate. Kids are in awe of great markers, just as they're knocked out by great colored pencils. In the best of all worlds, kids would routinely have access to both.

1. Use a variety of colored markers.

Gather a potpourri of pens and nib sizes for student use—not just broad line **Classic Crayolas**. Ballpoint pens come in a wide selection of colors, as do **Flair** pens and **Sharpies**. Used for outlining, *detail*, even mixing (#4 and #5, below), the aforementioned dramatically change the look of colored marker drawings—for the better!

2. Use the right tool for the right job.

Broad or chiseled tipped markers are the tool of choice for filling larger shapes and backgrounds with solid color. Using skinny points for this purpose frustrates children and wastes time.

3. Don't forget the patterns.

Used skillfully, even a limited selection of marker colors are capable of producing a bounty of gorgeous patterns. The list is practically endless: straight, zig zag or wavy stripes, checkerboards, plaids, and polka dots of every size and density. (Imagine **Black Line Master #23** in color!)

**"Dog Delivering the Newspaper"
Colored marker drawing done
in a sketch book**
Grade 2

4. Mix those markers.

Though mixing markers can be a mess, it's not out of the question. By using water based, permanent and ball point pens in combination, it's possible to build up strange and beautiful *mixtures* and textures through hatching, cross hatching and "swirling" (p. 260). Give kids time to experiment. Share discoveries.

5. Light colors first—
dark colors last

A sure way to avoid muddy *mixtures* when using water base markers is to start with the lightest colors (pink, yellow, peach) and finish with the darker ones.

Colored Pencils

Colored pencils can be divided into three categories: "Supreme," "Okay" and "Useless." The sole occupant of the supreme category is **Prismacolor**. They're durable, blendable, soft, bees wax colored pencils. Far more versatile than colored markers, they're capable of producing everything from sumptuous, *"nail the white"* color to subtle *mixtures*. In the "Okay" range (**Prang, Crayola, Prismacolor Scholar, Liquitex**) are student grade pencils that deliver reasonably rich color, mix fairly well, and are available in a full spectrum of colors. At their worst, colored pencils aren't worth bothering with. Certain cheap brands comprised of hard waxes and almost no pigment make kids yawn (or groan).

"I Know About Training a Dog"

**Illustration for her poem.
Skylyn T.**
Grade 5

"Jungle House"
(Colored Pencil)
by Ashley
Grade 1

Colored Pencils: Recommendations

Supreme

• **Prismacolor** artist quality colored pencils—available in 120 colors. They're the single expensive item on my recommended list. Splurge here, or at the very least, put them at the top of your classroom drawing wish list. Too bad Sanford (the manufacturer) knows how good this product is. They keep raising the price. Still, bargains can be found. Costco is the cheapest place I know of to buy **Prismacolor** pencils. The only problem is, not all stores carry them. (If your Costco wholesaler doesn't have them, ask them to order them.) Office Depot sells sets regularly (their prices are more than competitive). All art supply stores will have them. The only advantage to buying the pencils through an art supply retailer is that you don't have to buy whole sets, you can purchase colors individually.

Okay

• **Prang** tops the list of okay colored pencils. Actually Prang is better than "okay," but not in the same league with Prismacolor. Pretty much interchangeable in quality are **Crayola** (50 colors currently available), **Liquitex** and **Prismacolor Scholar** (beware: the student grade pencil is nearly as expensive as their artist quality Prismacolor pencil!). Barely okay: **Coloray.**

Useless

• **Pedigree.** Hard leads, little pigment. The pits.

1. Teach colored pencil techniques.

Whether you are using the best, or second best, take the time to teach colored pencil techniques (p. 111 and p. 260). Students who have a range of techniques at their fingertips are far more likely to create memorable, expressive colored pencil drawings than students who don't.

2. On sharpening pencils. . .

When using the best colored pencils, get a good electric pencil sharpener (nothing beats the high powered Commercial Heaviest Duty by **Boston**) and don't let students do *any* sharpening. I know this sounds harsh, but your expensive colored pencils will last three times longer when you (or a parent volunteer) do the sharpening. A viable alternative: have kids fourth graders and older use small *manual* sharpeners.

3. How many colored pencils will you need?

For a classroom of thirty students, 90 minimum, 125 is ideal. I spread out all the pencils on a soft black cloth. Students can take three pencils at a time, share with a neighbor and/or return to the black cloth to trade colors anytime.

4. Purchasing Prismacolor pencils.

If you can get a good deal on large (48, 72, 120) sets of **Prismacolor** pencils, grab them. Otherwise, buy four each of 25 to 35 basic colors of your choice. While the big sets are drop dead gorgeous, look closely. You'll notice lots of browns, neutral greens and grays. With rare exceptions, kids avoid the drabber colors like the plague.

5. Mixing different brands.

When budgets are very tight, I purchase some **Prismacolor** pencils and a cheaper brand— usually **Crayola**. (Don't think that kids won't notice the difference.)

6. Reducing breakage.

Ever have a pencil—especially a good colored pencil—break on you repeatedly? The fault

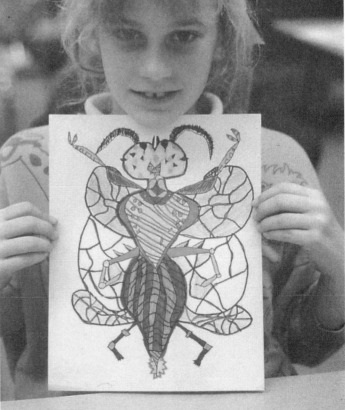

"Imaginary Insect"
(Colored Pencil)
Grade 4

Swirling **Step 1**

Swirling **Step 2**

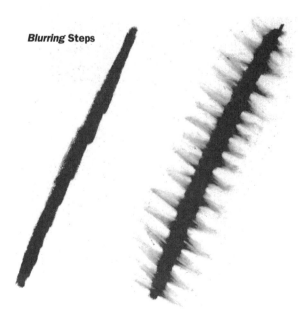

Blurring **Steps**

may not be in the *"nail the white"* pressure you're applying (**Prismacolor** pencils are famously sturdy), but in the pencil itself. Drop one and the lead *inside* the pencil can break. Every time you sharpen the pencil, you get broken pieces, not a point. If this happens consistently, take your pencils back (a whole shipment may have been dropped—ouch!). Admonish students to try not to drop them. (Alas, they will get dropped. I drop 'em, too.)

7. More techniques...

If you or your students are feeling ambitious, here are five more colored pencil techniques to practice. (Basic colored pencil and coloring techniques can be found starting on p. 111.)

• Swirling

Swirling will help you create rich and complex color *mixtures* that are also textural. Swirling may produce surfaces that look "woolly," "tangled," "energized"...

Swirling Steps (illustrated to the left)

1. **Create a background color**
 - **"Nail the white" with a light color. (For best results, pour on the pressure and the wax.)**
2. **"Swirl"**
 - **Select two additional colors that harmonize with the first.**
 - **Making sure your pencil point is very sharp, use additional color #1 to create a circular, looping motion as you cover the background color. Then, "swirl" with your second color over the first.**
 - **Fill as much or as little of your background with swirled color as you like.**

• Blurring

This is a great technique for softening hard lines. With it, you can create flower stamen, insect and alien antennae and legs, tree trunks in fog, etc.

Blurring Steps

1. **Create a line of any dark color. Use *"nail the white"* pressure.**
 - **Go over the line a couple of times to make sure there is rich, waxy residue.**
2. **With a white colored pencil and *heavy* pressure, rapidly "blur" the dark line by applying zig zag strokes over it from end to end.**

⬤ • Gradations

Gradation **Step 1**

Let's say you have a large area in a picture (sky or grass or beach, etc.), but you don't want it to be a single color. Gradation makes it possible to create transitions from one color to another within a shape. (This one takes practice!)

Start by choosing the two colors that will merge. (You'll have more success, at least initially, if your colors aren't dramatically different—e.g., try a dark blue and a light blue, not an orange and purple.)

Step 2

1. **Start with color #1. Use** *"nail the white"* **pressure, and create broad strokes, lessening the pressure at the point where you want the transition to the second color to begin.**

2. **With color #2, reverse the process.**
 • **Start below the section you've just colored. Use** *"nail the white"* **pressure and broad strokes, gradually diminishing the pressure as you move up toward color #1. (The two colors will start to overlap.) Turn your paper upside down, if you like.**

Step 3

Eventually you'll *"nail the white"* **as the third, transitional color is created.**

3. **Create a third color in between colors #1 and #2.**
 • **Go back to color #1 and, again, diminish the pressure as you move toward color #2. (Use diagonal strokes.) Use color #2 and diminish the pressure as you move up to color #1.**
 • **Repeat the process until the space between colors #1 and #2 fills in with a transitional, third color color.**

With practice you'll be able to create and teach seamless transitions between colors.

• Tinting

Great for making any color appear light and "creamy."

1. **Using any color and** *light* **pressure, color in one direction until the shape is filled in.**

2. **Using a white colored pencil and applying** *"nail the white"* **pressure, color at a right angle over the first color.**

Some colors change noticeably after white is added, others hardly at all. In either case, you should end up with a pastel version of your chosen color.

Tinting Step 1 **Step 2**

Glowing Step 1 **Step 2**

• Glowing

Makes shapes and drawn objects look as if they're emitting light or energy.

1. Using *"nail the white"* pressure, outline your shape.
2. Return to the outline. With the same color, gradually diminish the pressure of the colored pencil as you move away from the lines edge so the color appears to evaporate.
 • You may wish to add a second, lighter color, blend it with the first, and enlarge the area that "glows."

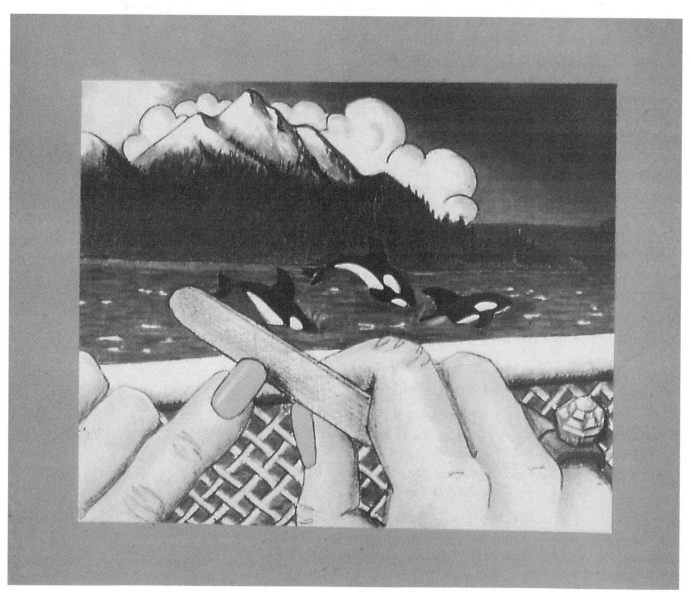

Illustration for a story (Prismacolor Colored Pencil)
Kay Smallwood
Teacher

Additional Materials

1. Paper

Drawing Paper

Paper is one place where we can reliably keep our costs down.

- Use generic 20# (pound) 8.5″ x 11″ white photocopy (or multi-purpose) paper for all sketches, brainstorming, free drawing and for the student activities associated with the lessons presented in *Drawing in the Classroom.*

- For special projects, **Extensions** and "finished" drawings, the white drawing paper routinely stocked in school supply rooms should suffice.

- A slightly superior, yet inexpensive drawing paper is the **67#** (pound) **Vellum Bristol** by **Wausau Papers**. It's durable, erases very well, and is receptive to every drawing medium. Besides white, it comes in a wide range of light colors (cream, ivory, tan, light green, salmon, gray, etc...) and in two sizes: 8.5″ x 11″ and 11″ x 17″. Check paper catalogs, Office Max and Office Depot. Best selection is available from Arvey Paper (p. 247).

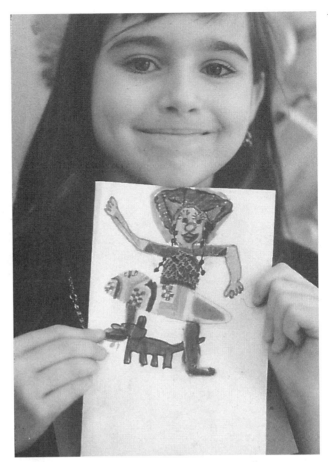

"Clown and Dog"
(Colored Pencil)
Grade 2

One last word. Though drawing on white paper is standard practice, there's no rule that says we must. Experiment! James Beard said, "Take chances. That's how great things are born." Draw on shopping bags, cardboard, wallpaper samples. Notice how drawing on patterned, tinted or very dark papers affects our color choices, and the mood of our pictures.

Papers for Mounting
(See Mounting Drawings, p. 278.)

For simple mounting, the colored construction papers found in school storage rooms are okay. (This is especially true of pencil and ink drawings, which—when mounted on black or red papers—look smashing.)

Before mounting "major" drawings, try and assemble the richest array of colored papers for students to chose from.

- Ask local printers and copy centers to save their trimmings.

Gorgeous papers can be culled in this way. (Scraps are often big enough to mount smaller drawings on.)

- Early in the school year, start a "special papers portfolio" consisting of light cardboards, wall paper samples, gift wrapping, oragami papers, and the **Astrobrights®** that may be found in many school offices. (What doesn't get used for mounted drawings can always be used for collage projects.)

- Check out local paper sellers. Office Depot, Staples and Office Max sell exotic colored papers, but usually in larger quantities. Kinkos sells individual sheets, but their selection is limited, and they're expensive. The best place to buy paper by the sheet is Arvey Paper. Their selection is enormous, any color, any weight. Call their 800 number (p. 247) for information on how and where to access their papers. They are a terrific paper source.

2. Glue

"Yes"

Almost unknown in schools, **"Yes,"** is a superior artist's glue. It's odorless, looks like Vaseline, and bonds papers flat (no buckling!). It's my glue of choice whenever I'm doing "fancy" mounting and/or have a stake in making sure the work survives over time. Apply the thinnest coat possible along the edges of the paper—with fingers. **"Yes"** washes off hands and out of clothing with warm water. Since it's fairly pricey, it should be used sparingly, and not by inattentive children. Available from better art supply retailers, or order it by calling 1-800-521-4263.

Glue Sticks

Fine for most light weight papers. The good news is: glue sticks bond papers nice and flat. The bad? Its staying power over time is questionable.

Elmer's

Nothing bonds better than **Elmer's**. It's fine for mounting papers as long as you use it *very* sparingly. Four "dots" of glue, one in each corner of the paper to be mounted, is usually plenty. For minimal buckling spread each dot with your finger before joining your papers. With thinner papers you'll still get some wrinkling. Use it copiously, and you'll get a lumpy mess.

Elmer's School Glue

It may be "kid friendly" (it washes off hands easily and out of clothing), but it's not as strong as **Elmer's**, and it takes much longer to set up and dry.

Rubber Cement

Banned in many school districts, and for good reason. It smells like the boiler room of a chemical factory in downtown Chernobyl. Less well known is the fact that it will seriously deteriorate papers over time. (The best work I did in a Color and Design class in grad school is completely browned and yellowed because I used rubber cement as my glue of choice.)

More Classroom Drawing Media

While "The Basic Four" may be enough to occupy you and your students for an entire school year, there's a world of media out there—from the pedestrian to the "far out." If something excites your imagination, give it a try. Where relevant, recommended brand names are presented in **bold type face** in order of preference.

Crayons

While they're cheap and ubiquitous, crayons have at least three disadvantages:

- The color they deliver isn't terribly rich.
- Their points don't hold up so control and detail are difficult to come by.
- Kids older than seven seldom get excited about the work they produce using crayons.

Crayons are an okay drawing and coloring tool for children pre-K through grade 2. And they're fine for a technique called watercolor resist.

"Horse House" (Crayon)
Heather
Grade 1

(Children create drawings with crayon, then wash over and in between their crayon lines with watercolor.) Crayon can also be used to produce scratchboard drawings, rubbings, even batik. All are described in Jean Romberg's admirable little book, *Let's Discover Crayon* (available from the Center of Applied Research in Education, West Nyack, NY 10994).

As a special treat, get a hold of a few boxes of fluorescent crayons. After children have produced their drawings, find a completely darkened room and light their pictures with a "black light." Weird things will happen. Warm colors may change to cool. Drawings can even look 3-D. Fluorescent crayons are available from **Crayola**. The "black light," a single bulb, can be purchased for around four bucks at specialty lighting stores.

Oil Pastels

Oil pastels are a waxy, oily crayon. Many people know them by the name **Cray-pas®**. They're capable of delivering color and luminosity that is a French Impressionist's dream come true. They're wonderfully blendable, cover large areas quickly and can be used on inexpensive colored construction paper. For some reason people think oil pastels are expensive. They're not, if you stick with **Pentel**. Costs can be reduced even further if you have kids share: two or even three kids to a box of 25; four kids to a box of 36. On the minus side, oil pastels can be a tad messy. (Keep them off the floor. Colors can get ground into your rug.) Don't try to laminate finished drawings. Colors will melt and run together unless you're very careful to keep the temperature of the laminator on the cool side.

Scratchboard

Not to be confused with **Scratch-Foam®** (below), scratchboard is a classic drawing medium. Using a drawing stylus, students scrape away the thin black ink coating that's painted onto a heavy, shiny white paper. The resulting white line drawings on a black ground can be as detailed as kids can make them. Though you can ink the papers yourself, the process can be messy and time consuming. Nasco makes a pre-inked paper (**Nasco**

The Scratchboard drawing below and those appearing on pages 276 and 294 were created by students in the Excel Program — Artistically Talented class, Monroe, Washington.

"Puffin" (Scratchboard)
Jared Fleming
Grade 5

Student Scratchboard) that's reasonably priced and high in quality. Drawings can be scratched onto the surface with any sharp point. Large nails and push pins are common drawing tools. Dissecting needles and X-acto knives work well but are inappropriate for younger children. The best drawing tool I've used is **Nasco's Scratch Stylist**, a round wooded cylinder with a slightly blunted steel point. (For more information on Nasco products, see catalogs, p.247.)

"The Little Mermaid"
(Computer Drawing)
Molly Olson
Kindergarten

Computers

Computers present great opportunities and dilemmas for young artists. During the past decade draw and paint programs such as **ClarisWorks, Kid Pix, Kid Pix Studio** and **Microsoft Painter** have made it possible for children to create lush, complex digitized pictures. Sadly, at the elementary level, few children really take the time to fully develop their images. Mostly kids doodle digitally, producing quickly made generic eye candy that's relies on software induced rubber stamps, stock images and glitzy patterns. The programs don't exactly encourage a lot of handmade images. (Have you ever tried to draw with a mouse?) Things may change fast once scanners, digitized drawing tablets and pens become routinely available for kids to use in schools. Still, standards will need to be raised, if students are to produce computer generated images that reflect the same degree of skill, visual acuity and persistence that we have come to expect from their handmade drawings.

dot ploot the earth by zach

"Don't Pollute the Earth"
(Computer Drawing)
Zach
Grade 1

"Underwater House" (Marker)
by Simone
Grade 1

Exotic Colored Markers

The number of markers available at art, office supply and variety stores is dizzying. You've got to love the selection—markers that double as paint brushes, smell like watermelon and chocolate, glow in the dark, have "crazy tips," change color, are permanent when drawn on fabric, and stamp moons, four leaf clovers and yin yang symbols... My take on the marker deluge is this: if it's a matter of buying gimmicky markers or high quality colored pencils go for the latter. For serious young artists who love markers, **Marvey** and **Pentel** make beautiful (and pricey) sets. Add them to your classroom wish list. Both brands are highly recommended.

Bleach Drawing

Mix a few drops of bleach with an equal amount of water in the caps of discarded jars or jugs. Using Q-tips® as their drawing tool, students dip into the bleach solution and draw directly on colored papers. (Nothing works better than dark colored tissue papers.) Moments after the bleach is applied, the color of the paper magically drains away leaving a clean white line on a colored background. (Children should always wear some sort of protective apron or smock.) Great for line and shape activities. I recently saw a series of "winter drawings"(snowmen, hills, clouds, sleds, kids wearing mittens and stocking hats...) done on blue tissue paper by first graders that were knock outs.

"Clown"
(Mixed Media)
by Jessie Edwards
Grade 2

Chalk

Chalk is as versatile as it is beautiful. It's capable of producing radiant lines, quick strokes, and big passages of soft color. It fills papers fast, can be laminated, sprayed with a pastel fixative, or even hair spray (not when kids are around!). And chalk is cheap. White and colored school chalks usually work just fine on inexpensive colored construction papers. If you're not satisfied with the colored chalks found in your supply room, check out **Omy-color** available from **Pyramid** (1-800-446-1477). I often use them on large pieces of black butcher paper to demonstrate drawing techniques during school visits. Soft and strongly pigmented, these inexpensive tinted chalks

glide across paper like a pat of butter across a hot skillet. Chalk's disadvantages: it can be messy and no matter how much care we take, drawings will smear.

Mixed Media

Combine at least two different art media and you've got "mixed media." I use "mixed media" routinely in the classrooms I visit: crayon and watercolor, ink and collage, chalk and oil pastel. I'm especially partial to combining all kinds of colored markers and colored pencils, especially in primary classrooms. Younger children can't always *"nail the white"* when using colored pencils. (It's hard for for

"Sounds of Spring"
(Mixed Media)
Maggie Olson
Grade 1

A **Scratch-Foam®** print (left) "pulled" from its inked styrofoam plate (right). Notice that the image is reversed.

Nicole Schuurmans
Grade 4

"Elephant" (*Scratch-Foam®* print)
Becky Nice
Teacher

some kids to apply the requisite pressure.) But these same students are more than capable of building up layers of gorgeous, mixed color and patterns by combining a variety of coloring tools.

Styrofoam Prints

Though not a pure drawing medium, this one's close enough. On a thin sheet of of soft styrofoam, student creates a drawing or design with pencil or ballpoint, breaking the surface as she draws. After the drawing is complete, a brayer is used to roll an even coat of a water soluble printmaking ink across the styrofoam. (Tempera *won't* work.) The rolled ink covers everything except the drawn (i.e., depressed) areas. Prints are produced by placing paper atop the inked surface and rubbing the back of the paper vigorously with both hands.

Styrofoam prints make stunning cards, as well as handsome, exotic illustrations. If black ink is to be used for the first print, additional "prints" can be created on a good photocopier.

As a styrofoam source I stopped using meat trays long ago. Use **Scratch-Foam®** instead. It's available at many craft and art supply stores and from art and educational catalog suppliers. Soft brayers and water soluble printing ink in black and a rainbow of colors are available from **Speedball**.

"Portrait"
(*Scratch-Foam®* print)
Leanna Moneta
Grade 3

Color 101

Colored Pencil

Gunnar Sample
Grade 5

Most teachers have had some exposure to basic color theory and terminology. If you haven't thought about the color wheel since college, or need a quick review, the following is for you.

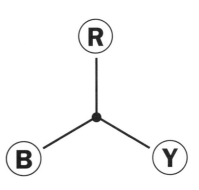

Primary Colors

The Color Wheel

The standard color wheel is comprised of 12 colors.

Its **primary colors** are Red (R), Blue (B) and Yellow (Y).

The **secondary colors** result when the primary colors are mixed together:

- Yellow and Red=Orange (O)
- Yellow and Blue=Green (G)
- Blue and Red=Violet (V)

Secondary Colors

The **tertiary** (or "third" ranking) colors are mixtures of "the primaries" and "the secondaries."

- Yellow and Orange=Yellow Orange (YO)
- Orange and Red=Red Orange (RO)
- Red and Violet= Reddish Violet (RV)
- Violet and Blue=Blue Violet (BV)
- Blue and Green=Blue Green (BG)
- Green and Yellow=Yellow Green (YG)

Tertiary Colors

Warm and Cool Colors

Yellow, orange and red (and their mixtures) are traditionally regarded as **"The Warm Colors"** (because of their association with things warm or hot: yellow—sun; red/ orange—fire, etc.).

Green, Blue and Violet* are usually thought of as being the **"Cool Colors"** (because of their association with things cool: green—grass; blue—water, etc.)

I prefer to call the mixture of red and blue-violet, not purple. Purple, often dominated by red, appears to be "a warm." Violet, on the other hand, is dominated by blue, and naturally aligns with the cools.

Color brainstorm paper for *Trees*, Extension #3, p. 112.

Complementary Colors

Draw a straight line from one color through the middle of the color wheel and you'll find its opposite or "complement." In a set of **complementary colors**, one color is inevitably warm, the other cool: red and green, blue violet and yellow orange, etc. A sure way to **neutralize** (below) or subdue the brightness of a color is to mix it with its "complement."

Why are there an infinity of colors?

Colors can be mixed ad infinitum. We know we'll get green if we mix yellow and blue together, but what happens if we add a small amount of orange to the green? And what happens if we add a touch of white to the green-orange?

Color 102: Other Color Terms Worth Mentioning

Value is the lightness or the darkness of a color. If we add white to red, its **value** is lighter. If we add black to red, its **value** is darker. Grays have **value**, too. (See the "gray scale" on p. 250.)

Tint — addition of white to a color. Extreme tints are often called "pastels."

Shade — addition of black to a color.

Analogous colors are a limited number of colors that are adjacent to one another on the color wheel, e.g., red, red orange, and orange...

Saturation refers to the purity of a color. The redder a red, the more saturated it is. Add white or black (or any other color) and the color becomes *less* saturated.

Bright—A color which seems to be emitting light, and that has brilliance.

Dull— A color which is subdued and lacks brilliance. Dull colors often contain black or gray. Just as bright colors jump out at us or "advance," duller colors hang back, or "retreat."

Neutralize

Neutralizing a color tends to make it less saturated, less brilliant. A color can be neutralized by adding gray, or by adding its "complement," (see **complementary colors above**).

Why "dull" or neutralize a color?

Variety isn't only the spice of life, it's a guiding principle in the visual arts. By neutralizing some, but not all colors, interesting tensions begin to operate pictorially. Since neutralized colors tend to recede, while brighter, lighter colors advance, spatialness is accentuated. And paradoxically, when some colors are neutralized and other colors are not, the overall impression of a picture is that it's more colorful, not less. Henri Matisse, a renowned colorist, consistently juxtaposed neutralized and brilliantly saturated color passages in his paintings and collages.

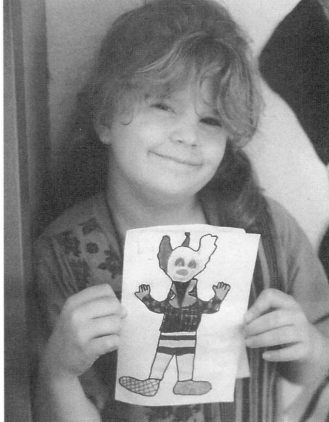

"Clown"
Colored Pencil
Grade 2

RESOURCES

Heller, Ruth. (1995). *Color.* New York: Putnam & Grosset.
The perfect picture book for reviewing color concepts and vocabulary with children. Besides illustrating mixing, tints, shades, warm, cool and complementary colors, Heller explains the four color printing process. Through the use of ingeniously designed transparencies she shows how four basic colors (yellow, magenta, cyan and black), printed in registration can reproduce an infinite spectrum of colors.

See Also Color **Resources,** p.130

Displaying and Appreciating Children's Drawings

"Gorilla"
Scratchboard drawing

Che Robinson-Oh
Grade 5

Displaying Children's Drawings

On a blustery Thursday evening in April, the school parking lot was filled before 6:30 p.m. The opening of "Art Fair" was a very big deal for scores of young artists and their parents at Redland Elementary. Kindergartners would be showing colorful fish collages; fourth graders, a large paper mural depicting life along the Oregon Trail; fifth graders, sci-fi illustrations done in fluorescent colors; sixth graders, detailed watercolors of birds. In the crowded hallway, Jeremy, a wiry second grader, grinned broadly as he yanked his mother into the gym and toward his dinosaur drawing. There, behind the cookie table hung his towering "T. Rex," a ferocious lizard menacing a pterodactyl with a broken wing.

Choosing colored mounts for her finished illustration.
Brianne King
Grade 3

Kids of every age get a big kick out of seeing their drawings displayed—especially when they're genuinely proud of their work. A display can be as simple as quickly pinning up the results of a twenty minute drawing activity on a classroom bulletin board. Or, it may be as elaborate as carefully mounting or matting fully colored drawings for an exhibition that will travel to a school administration building.

The following tips should help you get a handle on some of the options, logistics and materials involved in displaying student drawings.

Tips on Displaying Student Drawings

1. Pick your battles.

No one expects you to make a big deal out of every drawing that a kid produces. That doesn't mean we shouldn't ever go for the gold. Once or twice a year target a major project and allot the required time for students to do their very best work. It might be an **Extension** from

Drawing in the Classroom, a curriculum connected project, or fully colored illustrations for an individual or class book. At the end of the project make sure that the work is presented and displayed in a way that honors the time and energy that kids have invested. (See *"Mount or Mat Major Products"* below.)

2. Ask for help.

When you're nearing the completion of "major products" —drawings that need to be mounted or matted for a special project, publication or exhibition—call on parent volunteers to help. Paper cutting and gluing can be done by anyone with a discerning eye and a steady hand. Save your energy for "quality control," i.e., making sure that students have met established *guidelines*, and your high standards.

Mounting

There are two ways to make student products look their best: mounting and matting.

Either approach will:

• Proclaim the drawing "special" and worth exhibiting.

• Protect the drawing by giving it added weight and support (it's less likely to tear or wrinkle).

• Beautify the drawing.

Mounting means literally gluing finished drawings on to some sort of backing, usually colored paper or cardboard. (See **Papers for Mounting**, p. 263 and **Glue**, p. 264.)

Simple mounting

Simple mounting needs little explanation. Slap a drawing onto a piece of construction paper with a glue stick or **"Yes"** paste. Some people like fairly narrow borders (a half inch or so). Others prefer wider ones so the drawing can "breathe." (The size of your exhibition area may influence the width of the borders you chose.)

Mount #1

Mount #1 is trimmed to be slightly larger than the drawing (a quarter to a half inch). Then, center and glue the drawing to the mount.

Mount #2

For fancier mounting, trim mount #2 to be slightly larger than mount #1 (a half to three quarters of an inch). Then, center and glue mount #1 to mount #2.

Mount #3

Glue mount #2 to mount #3. Mount #3 should be noticeably wider than mount #2 on all sides.

"Fancy" Mounting

Fancy Mounting can make ho hum drawings look good, and very good drawings, fabulous!

The "fancy" treatment should be reserved for special projects and children's best work. It involves gluing the drawing to two overlapping color mounts which are then glued to a third, larger piece of colored paper (or cardboard). Mounted drawings can be exhibited, bound into books or stored in portfolios.

Mounts #1 (black), #2 (lighter gray) and #3 (darker gray) all together.

The bottom measurement of mount #3 should be slightly wider than the top or sides.

When mounting drawings

- Use glue sticks or **"Yes"** paste so that papers aren't bumpy. (See **Glues**, p. 264.)

- Add more space to the bottom of the final mount.
 - Professional framers do this all the time. It's a convention, based on the aesthetic notion that artwork looks better when the picture is buoyed by a weightier base.

- Make sure your mounting colors complement the drawing.
 - Mounts shouldn't compete with the drawing.
 - Use strong colors for strong images: black or a vibrant red looks great with ink drawings; less aggressive colored mounts (gray, tan, light blue) complement delicate pencil drawings.
 - When "Fancy Mounting" colored drawings, match mounting papers to colors in the drawing. I always encourage students to choose their own colored papers for mounting, but not before I model the selection process.

 - **The first, smallest mount should match a color in the drawing, but not one that reaches its edge.**

 - **The second mount should match a second color somewhere in the drawing.**

 - **The large, third mount should somehow harmonize with the two small mounts already selected, and the drawing as a whole. (Students should have the opportunity to place and replace drawings and mounts until they're satisfied with their color choices.)**

The author explaining the selection of color mounts to fifth graders at Estacada Grade School, Estacada, Oregon.

**Watercolor by
Rose Jackson**
Grade 6

Photography: Everice Moro

Matting the work

Mats are pieces of white or colored cardboard with "windows" cut out. The mat overlaps the edges of the drawing, which is taped to the back of the mat. Mats not only beautify drawings, they protect them. They are a necessity if work is going to travel. On the downside, good mat board is expensive and time consuming to cut.

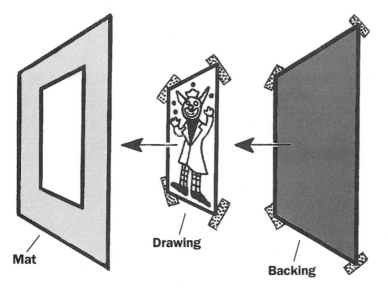

Mat

Drawing

Backing

Matted Drawing

Precut Mats

If you want to avoid the hassle of cutting your own mats (most schools do), and you can live with white mats only, consult a good art supply catalog (p. 247) and buy the mats pre-cut. **Nasco** offers a fine selection of sizes (from "window" dimension 5″ x 7″ to a giant 18″ x 24″). The mats are durable enough to be reused.

If you plan on using pre-cut mats, paper sizes will have to be determined before students draw. That way you can be sure the drawings produced will fit the mats you've purchased. Make sure drawings are about a half inch larger than the mat opening on all four sides.

1. **The sides and top of the mat have the same width, while the bottom is slightly wider.**

2. **The drawing is 1/4″ to 1/2″ *larger* than the opening in the mat on all four sides. The finished drawing is centered in the mat opening and taped to the back of the mat.**

3. **A cardboard (railroad or tag board) backing about an inch smaller than the edges of the mat, covers the drawing and tapes to the back of the mat. Work that is traveling off campus should always have a backing.**

4. Display everyone's work.

Displaying only "the best" work sends an unintended message to students: in our classroom there are winners and losers. This is last thing we want to say to kids during the elementary years. Classroom drawing is a learning process, a celebration of our growing skill, not a contest. While it may be true that some drawings are more "attractive" than others, kids should be made to feel that their personal best is good enough.

5. Go Public.

Going public means sharing children's drawings with an audience beyond your classroom. There are many ways to go about it. Here are a few of my favorites:

- **Send reproductions of kid drawings home on school/classroom communications.**

 Keep a file of small (or reduced) ink drawings created by students. Before class or school memos are photo-copied, glue a child's drawing onto your master. Sending student mini-drawings home on notes, letters, announcements, invitations, etc. says, in a way that words can't, "in our classroom/school, student drawings matter!"

- **Make a rubber stamp of one mini-kid drawing per year.**

 For about $25 you can transform a small student drawing into a rubber stamp that will last for years. Drawings need to be in black ink and no larger than about 2″ x 3.″ (Of course, you can reduce original drawings). Most printing and copy centers can have the stamps made for you in about a week. Kids are thrilled to see a drawing by one of their own stamped on papers, envelopes and intra-school communications. The only down side: every kid will want one of his drawings made into a stamp.

- **Send student illustrated books home—and invite comment.**

 Too often the lovely illustrated books that a classroom produces don't reach a larger audience. They should. After a book is "published," send it home with a student for a day or two. Be sure to include a blank page in the back with this heading: "Please share your positive comments!" Each time the book comes back, be sure to read the comments to the class.

Rubber stamp impression from a drawing by Norah Gilson
Grade 3

- **Go into business and sell kid art.**

I've visited a few schools that have figured out how to start and run student businesses involving drawing. The profits from the sale of their products were often used to support art programs. Puddle Jumper Press at Westridge Elementary in Lake Oswego, Oregon has published delightful kid drawn cards. They've even produced a series of handsome T-shirts, sweatshirts and sterling silver pins based on student drawings. In Mukilteo, Washington at Serene Lake Elementary, Diane Nuetzmann's classes created and sold a series of curriculum based calendars embellished with student drawings and writing (p. 287). Not only do participating students see their work reach a large, admiring audience, they develop business savvy and the confidence that goes with it.

- **Display student work off campus.**

When your kids have produced outstanding work, don't hesitate to get it in front of the public. Three consistently receptive locales are school administration buildings (they'd love to help you toot your horn!), local banks and community libraries. Often deadly dull places, they welcome the color and verve of children's drawings. Make sure that the work is sturdy enough to withstand the public exposure (use cardboard mats or mounts), and that it will be secure.

- **Have a classroom opening.**

Why wait for the annual art fair? If students have completed a major project, exhibit the work in your classroom and have "an opening." Send out announcements just like real galleries and museums do (kid designed, of course). Serve something sparkling. Put on some Mozart, and *mingle*.

Clown Card produced by the Puddle Jumper Press.

For more information about Puddle Jumper Press, contact Bonnie Ball, Westridge Elementary School, 3400 Royce Way, Lake Oswego, OR 97034 or phone (503) 635-0371 or (503) 223-1953 email: samsc@mail.clackesd.k12.or.us

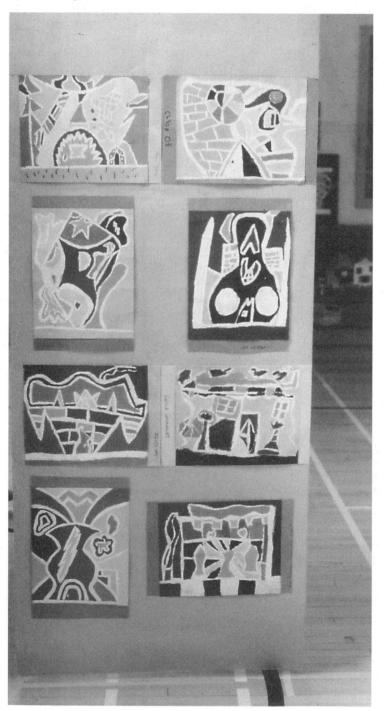

- **Display work on the Worldwide Web.**

 More and more schools are going high tech. Today, student drawings can be shared with "drawing" pals in Portugal, Bolivia and New Zealand in minutes. At Buckman Elementary, an arts magnet for the Portland Public Schools, Tim Lauer routinely displays work created by his K–2 students on the worldwide web. A recent alphabet book on outer space included drawings of astronauts Alan Shephard and Yuri Gregorran and the great Italian astronomer, Galileo. Check out the site yourself at http://www.buckman.pps.k12.or.us.

- **Call the press.**

 While big city newspapers may be tough to crack, smaller town and neighborhood papers are crying out for stories. They're happy to send a reporter if you can convince them that what you're doing will appeal to their readers. They seem to be most interested in stories that are connected to the community: drawings of historical buildings, portraits of seniors, studies of the flora or fauna of a particular place, etc. Don't be shy. Kids, teachers and schools need all the positive publicity they can get.

- **Have an Art Fair.**

 Depending on how ambitious you are (and how much parent support you have) an art fair can be done on a small scale or in a big way. Some of the happiest hours I've known professionally have been spent among beaming kids and their proud parents at climactic art exhibitions. These celebrations of children's art are more than just displays of drawings, paintings, sculpture, illustrated books and murals. They are powerful assertions of the collective will to keep art alive during a dark age of arts education.

"Appreciating" Children's Drawings

While displaying children's drawings can instill a sense of pride and the feeling of success, there is one more step we should take in our classrooms before the work is exhibited, laminated in books or stored in portfolios. It's a simple process I call *"appreciation."*

"Appreciation" works on a lot of different levels. It encourages thoughtful verbal communication, aesthetic analysis and helps build a sense of community. It creates satisfying closure for major projects, and not least, teaches the increasingly lost art of civility.

"Appreciation" consists of these four steps:

Photography: Barb Simmons

The author "appreciating" finished self-portraits with fifth graders, Estacada Grade School, Estacada, Oregon.

1. Display

After completing a major project, students gather close to the work. One drawing is displayed at a time. (I usually hold the work up so that I'm sure that *everyone* can see it.)

2. Scan

Students are asked to "scan" the drawing. During "scanning," my instructions are to "Study the drawing. Look at every part of it. Find something that you really admire about it, something that others might miss."

3. Deliver a "Specific Positive"

After about ten seconds of silent contemplation, students who wish to make a comment about the drawing raise their hands. The creator of the drawing calls on three people, one at a time. The student who's been selected says the artist's name, and delivers a "specific positive:"

- Sean, I think it's really neat the way you used three different line weights in your drawing.
- Jessica, your colors are beautiful. I love the way the dark trees show up against the light pink sky.
- Cassandra, your owl's eyes are amazing. The little white glimmer in the pupils makes them look like they're shiny and real.

4. Finish the communication cycle with a "Thank you."

- After receiving each "specific positive," the artist thanks the student making the comment.

Tips on Appreciating Drawings

1. "Appreciate" completed major projects only.

Don't bother with short exercises or even **Lessons**. Who has the time? Save "*Appreciation*" for **Extensions**, illustrations or drawings where a significant amount of time and effort have been invested.

2. Make sure that students deliver specific positives.

"I really like your drawing" is a positive comment, but it's not specific. We have no idea what the observer liked so much. It's a fine start, but urge students to go farther. Ask, "What's *one thing* that you really like about the drawing?".

"You used three different line weights," is specific, but it's not a "positive." It's an observation, a "neutral." "It's really neat the way you used three line weights" is a positive and it's specific. Small difference, you may say. It's the difference between simply noticing something, and praising something that you've noticed.

Since observations of this sort are usually meant as compliments anyway, why not teach kids to deliver them as such? It doesn't matter what a student says ("I like...," "I love...," "I admire...,") as long as the "positive" is present somewhere in their comment.

3. Be sure to model "Appreciation" for students.

"*Appreciation*" is easy to learn, but kids need to see the process modeled. Insist that they practice all four steps. The two things that students most often forget? Saying the artist's name when delivering a "specific positive," and saying "Thank you" when receiving the "specific positive."

4. During "Appreciation," make sure that the "Guidelines" for the project are on the chalkboard.

Ideally, we'd like "*Appreciation*" to be an enthusiastic, spontaneous and insightful response to student work.

Michael Stockner
Grade 6

Often it is. But sometimes, we need to point to the *guidelines* to help prompt quality responses. While we'd love to hear a student say, "The gradation you've used at the top of your sky creates a magnificent illusion of depth," there is nothing wrong with "positives" that come directly from guidelines, e.g., "I like the way you've used a lot of different ink techniques in your drawing," or "Great job *"nailing the white."*

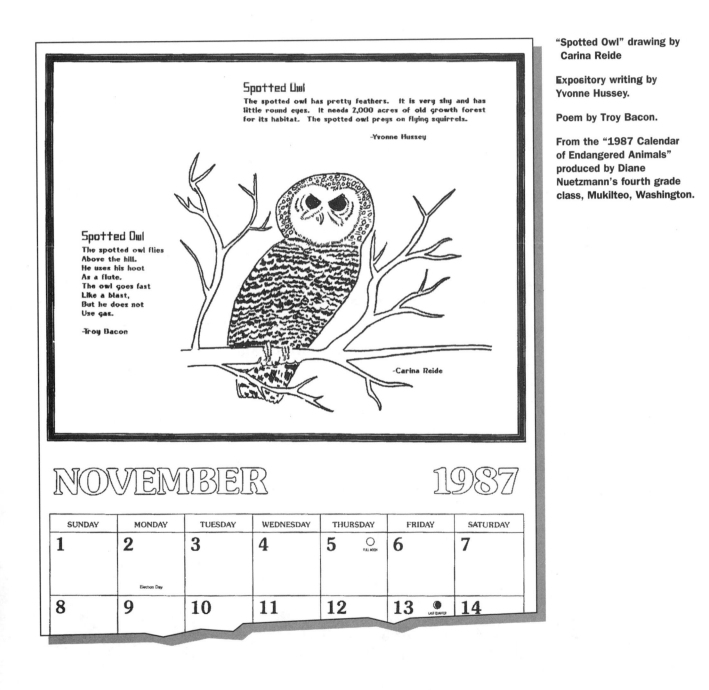

Spotted Owl

The spotted owl has pretty feathers. It is very shy and has little round eyes. It needs 2,000 acres of old growth forest for its habitat. The spotted owl preys on flying squirrels.

-Yvonne Hussey

Spotted Owl

The spotted owl flies
Above the hill.
He uses his hoot
As a flute.
The owl goes fast
Like a blast,
But he does not
Use gas.

-Troy Bacon

-Carina Reide

NOVEMBER 1987

SUNDAY	MONDAY	TUESDAY	WEDNESDAY	THURSDAY	FRIDAY	SATURDAY
1	2	3	4	5 ○ FULL MOON	6	7
	Election Day					
8	9	10	11	12	13 ◑ LAST QUARTER	14

"Spotted Owl" drawing by Carina Reide

Expository writing by Yvonne Hussey.

Poem by Troy Bacon.

From the "1987 Calendar of Endangered Animals" produced by Diane Nuetzmann's fourth grade class, Mukilteo, Washington.

5. Use names.

There are so many distractions in the average classroom. Saying the artist's name at the beginning of each comment creates a direct line of communication between the student making the comment and the artist who's about to receive it.

6. Make sure that the artist says, "Thank you" after receiving the specific positive.

This is especially important for the kid with lower self-esteem, or the child who doesn't feel successful. By saying, "Thank you," the student is compelled to acknowledge that something sincerely positive was said to him.

7. Encourage students to notice and praise something admirable *in the drawing.*

Discourage subjective reactions and personal stories that have little to do with the skill and/or decision making that the drawing showcases, e.g.,

- "Sarah, I really like your drawing. The colors in it remind me of a blanket we have at our summer cabin. Except ours has red stripes."

- "Lashona, your drawing of Haystack Rock is neat. I've been to Cannon Beach, too. My grandpa and grandma used to live there, but my grandpa died."

8. Discourage multiple "positives."

A single, fairly succinct positive is preferable to a rambling, complicated series of positives that may not make sense to the artist.

9. Discourage questions.

Though questions are certainly valid, they aren't what *"Appreciation"* is about. Save them for another time.

10. Make sure every drawing is appreciated— including works of lower quality.

Works of "lower quality" need not present problems during *"appreciation."* Nor should they ever be

"Pattern Extension"
Thuy Stonecypher
Grade 4

"Butterfly" (Mixed Media)
Sam Thompson
Grade 2

excluded. We can *always* find something to enjoy and acknowledge in a drawing, any drawing. Maybe it's a particular color combination, or an unusual shape, or one extraordinary detail. *"Appreciating"* the work means that if one drawing gets three "positives," every drawing should.

11. **Don't try and *"appreciate"* the entire class' work in a single session.**

Kids love *"appreciation,"* grasp it quickly and deliver surprisingly perceptive "positives." Still, there's a limit to everyone's attention span. Maximum time for *"appreciation"*? Twenty minutes—primary; thirty minutes—intermediate.

Assessment

"Assessment of learning is crucial in the arts. The success of an arts program cannot be asserted or taken on faith."
Howard Gardner
Professor, Graduate School of Education
Harvard University

"It is especially important that students not fear assessment, but use it both as a way to learn and as a way to measure their own progress... What is called for is a catalog of strategies and techniques for identifying student achievement."
Paul Lehman, Professor
School of Music, University of Michigan

Scratch-Foam® print
Stephanie Higgins
Grade 3

Toby had never used watercolors before. He could hardly wait to push his brush down into the glistening paints. He listened carefully to the teacher's instructions: "Don't use too much water. Don't make mud. Paint a picture of your neighborhood." It didn't take Toby long to paint the shapes of two houses, and a bunch of trees. Watercolors were easy to use. First he painted the houses red. They looked like they were made out of brick, but he didn't like bricks, so he made them darker. He liked that. Dark houses, kind of creepy, maybe haunted. As the houses were drying, he thought about the way he'd paint the sky. He wanted the sky to go with his houses. He thought of a sky he'd seen once riding with his mother. It was winter. Cold, damp dusk. The sky was a stormy gray, but it was bright, too, smeared with pink and gold. Toby painted the sky just the way he remembered it. He loved the way the house looked, silhouetted against the brooding sky. A week later, he got his painting back, with a "C" on it and the comment: "Skies are blue. Your houses are too dark." Bewildered, Toby folded his painting in half and shoved it into his desk.

Too often, well intentioned teachers and hard working students are miles apart when it comes to grades. Confusion about assessment is nothing new, but it is always distressing.

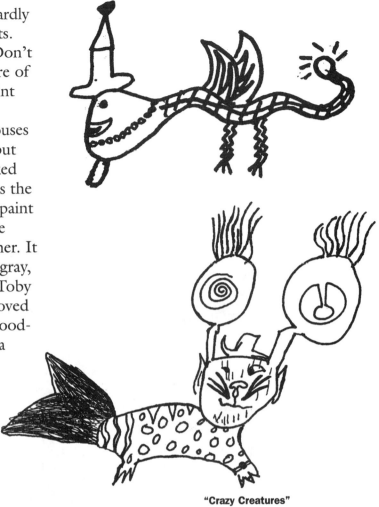

"Crazy Creatures"
Kriss Koch
Grade 3

Standards Based Performance Assessment

Traditionally, assessment in art (as in other subjects) has been "top down:" an omniscient teacher, responding subjectively to student work, assigns a grade. But things are changing, not just in the way art is being evaluated and graded, but in the way educators are thinking about standards and assessment systemically.

Simultaneous calls for teacher accountability and educational reform are transforming North American schools. Taxpayers, business leaders, legislators and parents have come to demand evidence of student learning. Furthermore, schools are under increasing pressure to show they aren't simply churning out literate cogs who can add and subtract. Success in today's dynamic service-information economy will certainly depend on traditional literacy

skills, but it will also require the ability to solve problems, think creatively, work autonomously and collaboratively, and learn throughout the adult years. The 21st century workplace has cast its long shadow into elementary classrooms and even into the world of arts education.

Drawing can play a part in helping students meet ambitious academic and non academic standards. The question we face here is is how to measure and describe student learning and performance in a way that isn't arbitrary or subjective, and does no harm to formative egos. This is a complicated issue, and there is plenty of disagreement about how best to evaluate children's fledgling creations —or even *if* we should.

Though we may have reservations about assessing artistic products in a domain traditionally regarded as intuitive and intensely personal, we should be clear about two points:

- Standards based education is taking hold in state after state. "Essential learnings" are being prescribed in the arts, just as they are for math and language arts.

- If the arts are to survive in our schools, they will need to be assessed along with traditional academic subjects.

Collograph (print)
Micki Towell
Teacher

New Attitudes in Assessing Student Learning, Products and Performances

While no one has all the answers, there are no shortage of opinions on the subject.

Before presenting specific assessment strategies, let me quickly share the principles that have guided my thinking about student performance and assessment in art/drawing since 1990:

All students can rise to high levels of achievement.

Every child, given clear information, quiet time to practice, and an unequivocally supportive environment can be a successful artist, illustrator and/or visual communicator

during the elementary years. Success means that the student—

- Understands basic concepts.
- Feels challenged.
- Notices that progress is being made.
- Feels reasonably satisfied with the drawings she is making.

Teacher expectation has a great deal to do with the quality of student performance.

In other words, what we expect from kids we often get. When I'm muddled about what I'm asking students to accomplish, I get muddled work. When I target and convey clear, high (and reasonable) expectations to my students, those expectations are usually met or exceeded. Think Escalante in "Stand and Deliver" or Richard Dreyfus in "Mr. Holland's Opus." Think about a teacher you may have been lucky enough to know who, through her faith, positivity, prodding and strongly communicated high expectations made you feel that only your very best was good enough.

"Portrait of a Student"
Scratch-Foam® print
Francey Heffernen
Teacher

Assessment can take many forms.

Gone are the days (we hope!) when assessment consisted exclusively of omniscient teachers passing judgment on work produced by kids. This doesn't mean that standards have gone out the window, or that teachers don't play an important role in the assessment process. Far from it. Today, performance in drawing invites the use of a variety of assessment instruments. *Reflection, portfolios,* peer response, *scoring guides* all have a place in the process of helping students become more engaged, self-responsible and successful learners.

"Raccoon"
Scratchboard
Haley Brown
Grade 5

Assess only what you teach.

While this may seem obvious, think about your own experience as a student: grades that seemed unfair, subjective comments by teachers that left you scratching your head, surprise test questions that came out of right field. This is something we can all take a closer look at.

Target student learning.

One of the most succinct and useful statements about student learning I've read in years comes from Jay Stiggins: "Students can hit any target they can see, and that will hold still for them." It means that we teachers have a responsibility to make our learning goals for students vivid, finite, specific. One particularly effective way we can do this is to establish *guidelines* for every assignment we make. These *guidelines* can be held up as a sort of "target" that students refer to regularly as they do their work. It doesn't matter if you're doing a simple exercise or a complex project: both can be targeted. (See my examples of **Guidelines** throughout the **Extensions** and on p. 296.)

Use models when you teach.

Show students finished samples of the project at hand. Many people have said to me, "But if I show students models, they'll copy them!" Not necessarily. By showing models we:

- *Expand a student's sense of what the project might be.*

 By showing *varied* examples we invite students to view project possibilities through a wider lens. Far from inhibiting creativity, this practice actually stimulates it.

- *Make* guidelines *vivid and concrete.*

 Each sample we share isn't just a "neat" product, it's an example of *guidelines* made concrete. If a *guideline* says, "Use contrasting colors," we can look at how two or three different students have interpreted and applied that concept.

- *Help students better understand different levels of accomplishment.*

 Comparing models allows us to discern differences in quality as well as variety in content. Higher quality work becomes less mysterious and more attainable when students can see it, discuss it, and identify its features. (If you're wondering how to save student work, see p. 320.)

Assessment: The Big Four

When assessing student work, we can do more than simply ask, "To what degree is this a good drawing?" Drawing is part of the equation, not *the* equation. Assessment can offer students valuable feedback on the progress they are making as learners, as well as on the products they are creating.

Here are four assessment tools that can be used individually and in combination to describe performance, while elevating achievement.

1. Scoring Guides

Scoring Guides (or "Rubrics") have become ubiquitous in the age of standards based education. They measure student performance against a preexisting set of criteria using a point system. The good news is, they have the potential of helping students look at their products with increased objectivity. ("Where was I most successful? Where can I still improve?") Better yet, they encourage student autonomy. ("I see where I am. I see where I can improve, and I know that only I can chose to make improvements.") The bad news is that unless kids feel *very* safe and supported while scoring and being scored, they may quickly feel that they are being judged and found wanting. During the elementary years, especially, we must fortify young egos as we endeavor to raise test scores. Informed, caring teachers are key players in making assessment feel like a learning experience, not a trip to the guillotine.

Preparing illustrations for an original book of poetry.
Grade 4

Before devising *scoring guides*

- **Create a clear set of *guidelines* for every project that will be scored.** (See sample, below.)

- **Teach to the *guidelines.***
 - Students should understand every guideline instruction. If they don't, they can't be successful.

- **Reiterate the *guidelines* as students work.**
 - Repetition is the key to skill acquisition and student internalization.

- **Tell students what will be assessed.**
 - Place an asterisk next to items in the *guidelines* that will be assessed. That way, students know from the very start of a project what their learning targets are.

Providing clear *guidelines* for student projects is the first step in fairly and accurately assessing student work. Here's a sample set of *guidelines*.

GUIDELINES: GEOMETRIC SOLIDS STACK UP

- **Create a stack up of geometric solids.**

- **Include at least one example of each of the five basic solids.**
 - **Draw each of the solids skillfully and convincingly.**
- **Draw geometric solids of varying sizes.**
 - **Some should be drawn large, some medum, some small.**
- **Draw a minimum of fifteen geometric solids.**
- **Use *overlapping* at least three times in your drawing.**
- **Start with *"whisper lines"* and *"finish in ink."***

Daniel Oltmann
Grade 7

When devising *scoring guides*

- **Limit the number of things to be assessed.**
 - Identify and score only the critically important issues of a particular project.
 - These should be garnered from the project's *guidelines.*

- **Create simple *scoring guides* for *each* component you're assessing.**
 See sample *scoring guides* on pp. 298 and 299.

- **Ask for student input.**
 - Kids who help design *scoring guides* are more actively engaged in their own learning than students who don't. You may not be able to do this every time, but do it when you can.

- **Focus on issues that can be easily recognized.**
 - For instance, "presence of five *line weights*" or "evidence of *overlapping.*"
 - Avoid scoring hard to quantify issues like creativity or problem solving.

- **Make sure that every student can be successful.**
 - Even when drawing is not one's forte, a student should always be able to demonstrate proficiency and meet standards. We are testing understanding and ability, not artistic talent.

- **Use the "KIS" (Keep it Simple) formula.**
 - Keep language in the criteria clear, succinct, simple.
 - Work with three easily recognizable levels of ability:

Three Ability Levels for Scoring

3* = Proficient
Clearly and confidently demonstrates understanding and ability.

2 = Competent
Pretty much understands concept and is able to show ability.

1 = Developing (or Emerging)
Just beginning to understand and be able to demonstrate ability.

**You could also add a 4 to indicate extraordinary ability ("super proficiency").*

Here are three "KIS" *scoring guides* designed to accompany the project "Geometric Solid Stack Up."

Scoring Guide: Geometric Solids

How skillfully have you drawn your geometric solids?

Criteria

3 = All five solids are drawn with skill and confidence.

2 = Three or four solids are drawn pretty skillfully.

1 = One or two solids are drawn skillfully.

Scoring Guide: Overlapping

Have you used overlapping at least three times in your drawing?

Criteria

3 = Overlapping is used more than three times in the drawing.

2 = Overlapping is used three times in the drawing.

1 = Overlapping is used once in the drawing.

Have you drawn geometric solids of varying sizes, i.e., some large, some medium, some small?

Criteria

3 = There is an obvious mix of large, medium and small solids.

2 = There is some variation in the size of the solids.

1 = Almost all of the geometric solids are the same size.

Now take a look at the four drawings of *Geometric Solids Stack Ups* by fourth graders on p. 298 and 299. It should be fairly easy to tell which examples are strongest and which are weakest using the three *scoring guides* above. One advantage to using a series of *scoring guides* is that the project won't be deemed altogether good or bad. One area (e.g., ability to draw geometric solids) may be strong, while another (e.g., *overlapping*) may need improvement.

2. Reflection

Reflection, a well known journal writing technique, encourages students to describe their learning experiences while an activity or project is under way and/or when it's finished. Good reflective questions invite honesty and specifics:

- What was difficult or frustrating about this project?
- What was easy or fun?
- Which of the colored pencil techniques did you like the most? Why?
- Describe something(s) that you learned about drawing, and/or about yourself as a learner?
- What would you do differently next time ?

Not long ago a teacher in one of my classes for educators said in essence, "Kids really don't have that much to say. They're shallow. *Reflection* is pretty much a waste of time." Nonsense. Howard Gardner, who first proposed his theory of multiple intelligences in *Frames of Mind* (1983), has said, "All of the intelligences begin with the Intrapersonal." I agree. *Reflection* is a powerful instance of the learner accessing a deeper learner, a human being awakening to him or herself. All the choices we make in learning and in life arise from that quiet, private place of reckoning. The only way sixth graders will be able to write and talk intelligently about their strengths and weaknesses, preferences and goals, will be if they begin to look at those very same issues as first graders.

When students consistently struggle with *reflection*, we can usually point to one of these culprits:

- Students don't know what they're supposed to do, or why they're doing it.
- *Reflection* hasn't been meaningfully modeled.
- The experience that they are being asked to reflect on lacks substance or personal relevance.

For those who have had little experience with *reflection* it may be helpful to work with prompts—e.g., "The hardest thing...," "I enjoyed...," "I learned..."

12/5/95
Fancy Ink

1. I thought the hardest thing about being a fancy ink artist was when I really had to think about what to draw. I'd come up with what I thought was the coolest idea— then I'd find that it probably wouldn't work at all! When I was trying to think about (a what to draw? and (b how should I draw it? ☆

2. Something I loved about fancy ink was once you chose what to draw, (the hard part) you could go wild with all types of lines. Another great thing about fancy ink is the fact that what you drew didn't have to be perfect. It could be as wierd as you wanted. You had a choice. ☆

3. I learned that black ink can be just as interesting or fun as pencil. Bold black looks maybe even better than pencil sometimes in drawings. Another great thing was that you could create something that you might have thought you really couldn't do before. ☆

"Fancy Ink"
Greta
Grade 4

Left: After practicing *"whisper lines,"* discovering a series of "fancy" inking techniques and producing a series of small ink drawings, a fourth grader, new to *reflection*, shared her thoughts.

1. At first I thought I wouldn't get it but I was wrong. I was really good at it! I think being a fancy ink artist is a real fun thing. Mr. Rukas how did you get the time to practice? And the most funnest thing about fancy ink drawing is making your own creation. I think that whoever thought of making fancy ink drawing is a genious!!!

An underachieving fourth grader had this to say about his experience with "fancy" ink drawing.

3. Portfolios

The original model for school *portfolios* was the artist's *portfolio*. Here, work representing the depth and breadth of an individual's abilities was collected to show to prospective buyers and art dealers. *Portfolios* are an ideal place for young artists to collect *their* classroom drawings as well.

A drawing *portfolio* can be as simple as a large folded piece of colored construction paper or a letter size file folder. I prefer storing student work lesson by lesson in individual three ring binders. As students work through the **Lessons** and **Extensions** they can look back and see their progress just by flipping punched pages. In fact, I've known a few students who have elected to do certain projects over because, as they leafed through their *portfolios*, they weren't satisfied with the quality.

Portfolios don't have to be a depository for drawings only. By including reflective writing along with **Lessons, Extensions**, even free drawings, a richer portrait of the student artist begins to emerge. Her growing self awareness, problem solving ability, and creative thinking are documented just as surely as is her improving drawing skill. Individual pages, whether drawings, text or both, can be removed from the looseleaf at any time for exhibition, reproduction, discussion or placement in a more general portfolio.

Teacher Christie Jackson and fifth grader Gunnar Sample discuss including his finished drawing in an art portflio. Estacada Grade School, Estacada, Oregon.

Some Reasons Why Portfolios Help Students

Portfolios help students:

- Become motivated to do their best work.

- Reflect on strengths and weaknesses.

- See their progress over time.

- Understand their versatility as young artists.

- Feel that the work they produce really matters.

Some Reasons Why Portfolios Help Teachers

Teachers use portfolios because doing so:

- Helps them view student progress over time.

- Establishes a safe place to store work samples that represent student decision making, problem solving, craftsmanship and persistence.

- Facilitates discussion that pinpoints student strengths, weaknesses, versatility, interests.

- Showcases student work for peers, parents, and district personnel.

**Scratch-Foam® print,
Elspeth Paterson**
Teacher

4. Grades

I am no fan of grades. Grades often create false hierarchies, winners and losers. Unless the grade is tied to well understood and specific standards it doesn't tell a kid very much about his performance. The problem is that grades are too general. The letter grade "C" or even an "A" doesn't provide a student with information that will support his continued growth as a learner. It doesn't tell him specifically, "Here's where you are strong. Here is where you have shown improvement. Here is where you need to work a bit harder."

Having said that, I do live in the real world. I work with many teachers who are obligated to assign art grades. If you must grade, here are a few suggestions.

Give everyone the opportunity to get an A.

The letter grade "A" should be a student choice, not a prize awarded to the talented few. When I say a student choice, I mean precisely that. Every student should have the opportunity to "target" an "A," and to hit his target. All he has to do is to meet preannounced standards for that grade.

Use a point system

A point system takes all the mystery and subjectivity out of grading. If a student earns seventy points (or whatever), he gets an "A." Sixty, and he can count on a "B," etc.

Base the point system, not on the "quality" of the work produced, but on some combination of the following:

- **Guidelines**
 The *Guidelines* presented for each **Lesson, Extension** or project can be used as a check list while a project is underway, and at its end. Students can self-assess at any time by placing the words "Have I..." in front of most *guidelines,* e.g., "Have I used *overlapping* at least three times in my drawing?" Students should know in advance that points will be subtracted for *guidelines* not addressed or inadequately met.

- **Craftsmanship**
 Does the student treat materials with respect? Use media with increasing skill? Take pride in the work in progress, and in the completed work?

- **Effort/Persistence**
 Is the student focused? Does he give his best to the project from start to finish?

"Crazy Creature"
Nicholas Apeland
Grade 3

- **Reflection (for selected projects)**
 Does the student attempt to describe strengths, weaknesses, successes, frustrations, set goals, etc.?

Give students the chance to earn extra credit points to elevate point totals and grades

Extra credit is a reasonable option for kids who:

- Like to draw at home.
- Can't seem to work within given *guidelines*.
- Don't finish work on time—occasionally.
- Are ambitious.

Extra credit shouldn't elevate a students grade more than one notch. Maintain standards for work done at home. *Never accept "junk."*

"In a Magic Garden"
Grade 1

Primary: Assessment

I can see no good reason for formal assessment involving numbers or letter grades during the primary years. Drawing at this stage should be playful, full of discovery and fun.

That doesn't mean you shouldn't teach drawing. Just make sure that, to the best of your ability, you're saying through your presentations of the **Lessons** and **Extensions**, "Give this a try. Have fun with this. Do it your way."

Guidelines and learning targets can certainly be presented. (How else to teach kids the value of *"whisper lines,"* about *overlapping* or that colors can me mixed?) As a primary teacher you know that a few simple *guidelines* work better than a shopping list. You will have to simplify some of the *guidelines* I've presented in the **Lessons** and **Extensions**. With primary, less is certainly more.

Mickey Morris
Kindergarten

Reflection

Primary aged students love to share their thoughts about learning. They can respond to these three reflective question regularly:

- Was there anything hard or frustrating about this experience?
- Describe two things that were really fun or easy.
- Tell us something you learned about drawing, or about being an artist.

Much of the time *reflection* can be done verbally at the end of a working session. I find it to be a natural way to wind down and to create closure. Another option: have children *reflect* with a partner. (Save written responses for major projects only.) The important thing is to invite students to begin to develop an awareness of the experiences and feelings they are having as learners, apart from the products they are producing.

Portfolios

Young artists usually want to take their work home. They should be able to do so. However, it's exhilarating for them to see the progress they are making. Earmark some projects as "*portfolio* pieces" so that students will know in advance the work won't be going home right away. Sign and date all drawings and place them in *portfolios* in chronological order. Every couple of months have students leaf through their *portfolios*. Invite them to comment verbally or on the written page on any of these topics:

- Which drawing in your portfolio do you like best. Why?

- Describe some of the things you're learning about drawing that you didn't know before.

- List some things you're good at drawing.

- Of all the drawing tools you've used so far, which one(s) are your favorite? Why?

- Describe the best drawing experience you've had so far at school this year.

- If you were a famous artist, what would your best drawing look like? Describe it.

"Shipwreck"
Randy Earle
Grade 3

RESOURCES

1. Winner, E. (1992). *Arts Propel: A Handbook for Visual Arts.* Cambridge, MA: Harvard University—Project Zero.
Exemplary program focusing on "production, perception and reflection." Strong emphasis on alternative forms of assessment. Designed for middle school and high school students, but much can be adapted for elementary.

2. Clemmons, J. Laase, L. etc. (1993). *Portfolios in the Classroom, A Teacher's Source Book.* Jefferson City, MO: Scholastic Professional Books.
A simple and vivid introduction to portfolios as an assessment instrument. Quick reading; many photos; lots of student samples culled from portfolios, grades 1–6.

3. Fredericks, A., Meinbach, A., and Rothlein, L. (1995). *The Complete Guide to Thematic Units.* Norwood, MA: Christopher–Gordon Publishers, Inc.
Though the book's primary focus is on designing thematic units, it's very current on "authentic assessment," especially portfolios and student reflection. Don't miss the great biblios on the wild west, time, geometry, architecture, the seasons and more...

4. Marzano, R., McTighe, J., and Pickering, D. (1994). *Assessing Student Outcomes.* Alexandria, VA: Association for Supervision and Curriculum Development.
Describes the changing face of educational assessment in America in the '90's. Strongly links assessment to teaching and learning. Proposes the use of rubrics and portfolios in the context of Marzano's Dimensions of Learning, an instructional model promoting higher level thinking skills.

5. Spandel, V. and Stiggins, R. (1996–Revised). *Creating Writers.* New York: Addison Wesley.
Spandel, an expert on the writing process, and Stiggins, an assessment guru, have produced a marvel of a book. They show convincingly how student writing can improve when instruction and assessment are linked from the outset. Writing samples and rubrics are presented with ample opportunities for the reader to practice scoring. Though their focus is writing, I've found that many of their sensible notions about assessment transfer nicely to the visual arts.

Jason Ray
Grade 3

6. Ernst, K. (1992). *Picturing Learning*. Portsmouth, NH: Heinemann.
A year in the life of an experienced middle school language arts teacher who consents to teach art to younger children. Ernst's expertise as a writing teacher leads her to use student journals as a way to help young artists make sense of their working processes. Ernst provides us with an inspiring look at the power of reflective writing in the artroom. A bonus: the book is filled with the author's sensitive "blind contour" drawings of her students at work.

7. Bumgardner, J. (1996). *Helping Students Learn to Write*. Needham Heights, MA: Allyn and Bacon.
Unpretentious, highly practical guide for front line teachers K–7 who delight in writing with children. Tons of writing ideas. Solid info on developing scoring guides for upper grades. Don't miss the compact chapter on portfolios.

8. *Classroom Assessment Connections.*
The newsletter of the The Assessment Training Institute provides useful tips on authentic assessment. To be on their mailing list call (800) 480-3060 or (503)228-3060 or write to them at 50 SW Second Ave., Suite 300, Portland, OR, 97204.

Example of "Fancy Ink"

Barbara Ayers
Teacher

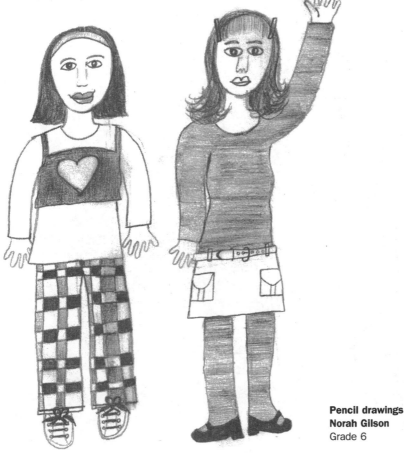

Pencil drawings
Norah Gilson
Grade 6

In Conclusion

"A teacher does not make an artist. The teacher can help your growth through inspirational approaches that deepen your understanding and stimulate your interest."
Vicci Sperry, The Art Experience

Conan So
Grade 2

Drawing in the Classroom: The Most Important Points

Alien Writing, Self-Portraits, Pattern Samplers, Bizarre Cars, Trees... As we have worked our way through **Lessons, Extensions** and **Curriculum Connections**, my hope is that you and your students have had fun, are clearer about the role that visual elements play in the creation of images, and have at your disposal, a rich array of drawing strategies.

I'll conclude with two lists describing what I consider to be "the most important points" of drawing in the classroom. One list is for teachers of primary aged students; the other for intermediate. Though the lists are similar, they take into account important developmental differences between younger and older children. I hope these lists will remind, support and inspire you and your students as you revisit the projects described in this book, or better yet, follow your own agenda.

"Ballet Dancer"
Student
Grade 2

Primary: "The Most Important Points"

1. Value drawing and be prepared to defend it

For some of your students, drawing isn't just a fun activity, a pleasant addition to the school day. It's a unique form of communication and a natural way to learn. And for some of your students, drawing may be the only time during the long school day when they feel totally relaxed or successful.

Alas, not everyone understands or appreciates drawing's value in children's lives.

As educators, we must arm ourselves with a few facts should parents, colleagues, or administrators question our commitment to classroom drawing. Here are four solid reasons that should serve you well in almost any situation:

• Drawing helps children develop fine motor skills which are critical for building the coordination required for printing and writing.

- A majority of students are visual learners. Drawing is an important way for these students to grasp concepts, understand and learn.
- Drawing can teach students important non-academic skills that will be indispensable for success in an information age: creative thinking, *craftsmanship*, decision making, problem solving and persistence.
- Studying drawing (especially as it's presented in *Drawing in the Classroom*), helps kids become visually literate. Visually literate students are able to "read," appreciate, and critically discuss pictures and their meanings. Clearly, this is a desirable skill to have at a time when so much of our information is delivered via images. (See also **"Why Children Should Draw: A Rationale,"** p. 242.)

"Things that Scare Me..."
Grade 2

2. Provide time for free drawing

Free, means unstructured, untutored, unsupervised. Kids alone decide what and how they'll draw. This kind of drawing can restore flagging energy and relieve stress. Try it at the end of a long day when everyone's brain dead, after testing, and as a respite from tasks academic. I know many teachers who allow free drawing during read aloud time. Some kids can actually listen better when they're drawing. (In lieu of reading aloud to students, put on a little classical music and break out the markers.)

3. Maintain a picture file

No matter what you're studying, pictures can support the research based drawings of young artists. Sure, kids can get books from the library, but real artists and illustrators maintain picture files in their studios. Ask parents to provide old magazines and the school secretary to contribute letter size file folders. Studying trees? Start a folder! Label folders generically (e.g., "Mammals," "Insects," "Weather," etc.) and store them alphabetically. There will always be a few kids who'll love to find pictures and help maintain the files. In a few years you'll have a cornucopia of images—from A to Z.

4. Share exemplary picture books

If drawing and illustrating are to be serious pursuits in our classrooms, children need to view and discuss exemplars regularly. Paintings and drawings by master artists are one obvious and worthwhile source. Not to be overlooked are picture books by contemporary illustrators. (We are living during a "golden age" of children's book illustration!) Whether our focus is line, color or composition, inspiring images in every imaginable style can often be found right in our school libraries. (You'll find lists of recommended books at the end of every chapter under **Resources.**)

5. Teach kids about *"whisper lines"*

While younger children love to wield their pens and markers with spontaneous abandon (and should), we can still teach them about *"whisper lines."* Using

Kyle Champion
Grade 2

"whisper lines" makes it possible for children to revise their drawings. The earlier we teach *"whisper lines"* the better. (Make sure kids have good erasers!) Fourth and fifth graders struggle with *"whisper lines"* because they're doing them for the first time at age nine or ten. When teaching *"whisper lines"* to younger children, proceed with caution. Some kids may not be ready for them. Still, many children will love the challenge and the flexibility that *"whisper lines"* offer. Make *"whisper lines"* fun when you teach them, and make them a choice, not mandatory.

6. Monitor paper size

Generally speaking, younger children prefer larger papers when they draw: 8.5" x 11" for **Lessons** and free drawing, even larger papers, 11" x 17" for *"Guided Fantasy"* projects like *Up in the Sky* (See p. 216). Smaller papers will work nicely for fully colored drawings. Some of the very best "mixed media" (combined colored pencil and marker) drawings I have seen primary age students produce were no larger than 6" x 8."

7. Revisit the most important issues of classroom drawing regularly

You can't review everything we've covered every time kids start a drawing, but there are five points worth revisiting regularly. (Remember, repetition is the mother of understanding *and* skill.)

Information

Often, little kids have no need of *picture files*, especially when they're drawing imaginatively. Still, everyone gets stuck sooner or later. Children should know that it's okay to look at pictures whenever they need to. (After all, that's what *real* artists and illustrators do.) If you spot a kid clearly frustrated in his attempt to draw a specific item, ask him, "Would you like to look at a picture?" Then, help him get the information he needs.

Composition

Remind students to fill the entire paper as they draw, that it's okay for some items to go off the edge, and that their drawings don't always have to be "long shots;" they can be medium shots" and "closeups" as well (see pp. 188–190). As you share picture books with students, pause now and then to discuss a particularly interesting or intriguing image. "What do you like or not like about it? If you'd been the illustrator, would you have done anything differently? What do you think this picture is telling us?" Kids love to share their opinions. They have important things to tell us.

"Dogs"
Ben
Grade 2

Craftsmanship

Good *craftsmanship* certainly relates to the way materials are being used—skillfully we hope, not carelessly. More than that, *craftsmanship* is an attitude that can be displayed by first graders as well as by sixth graders. "Are you respecting the materials you're working with? Are you looking after your papers, making sure they don't get wrinkled, torn or lost? Are you taking pride in the thing you're making? Are you taking your time, or rushing?" Asking these questions regularly of young artists conveys our high standards, and helps to foster an attitude that can be summed up as "Craftsmen always do their best. Craftsmen care!"

Creativity

Younger children bring to their picture making a rush of enthusiasm, fresh perceptions, and usually, a genuine love of drawing. What they need most from us is a safe, supportive atmosphere, the chance to use new, cool tools, and invitations to draw in varied ways. My inclination is to strongly emphasize imaginative drawing at this age (aliens, crazy creatures, dream houses, funny faces, fantastic undersea worlds, etc...). As school inevitably imposes its rules and routines, drawing is one sure way for children to "know no limits." (See **Imaginative Drawing**, p. 210.)

"Funny Dogs"
Kody
Grade 2

8. Teach students to use *"the drawing process"*

Little kids need lots of occasions to create "one shot" drawings (drawings created spontaneously during a single working session). Still, we can gently introduce them to *"the drawing process,"* especially when major projects are in the offing (illustrations for individual or class books, reports, cards, posters, calendar pages, etc.). Similar to the writing process described by Graves, Calkins, Murray, et al, my version of *"the drawing process"* can be summed up in four stages:

Intent

Before starting a major project ask, "Who's the drawing for? Who will view it? Will it be part of an exhibition? Displayed in the classroom? In a student produced book?. Will it be reproduced? In black and white? In color?" All of these questions will help you and your students determine the size and the medium of the drawing to be produced. Remember, even for younger children, smaller papers are appropriate some of the time.

Pre-drawing

Select drawing media to be used. (Practice using a medium, especially if it's new.) Gather supporting materials you may need (books, picture files, real items). Brainstorm, warm up, get ready.

Rough Draft

Review *"whisper lines"* before students start their drawings. (Their use should be an option.) *Rough drafts* should be done on paper that's the same size and quality as the final draft. Initially, students should work out their *compositions*, (a term that even first graders should be familiar with). Once the student is pretty clear about what she wants to do, she's given a choice: go ahead and "finish" the drawing on the rough draft paper, or recopy the rough draft onto the final draft paper.

Claire R.
Grade 3

Some kids love their *rough drafts* and don't feel the need to start again. Others know they can do "even better" and want another chance. Either way, students are making decisions and choices, just like real artists and illustrators do. (Note: *"the tracing method"* is *not* developmentally appropriate for younger children.)

Finishing

Nothing says that drawings need to be finished as in "polished-finished." Many of the loveliest, most original drawings I've seen little guys produce were the "one shot" variety mentioned above. Having said that, let me add:

"Finished" drawings occupy an important place in drawing classrooms in the same way that "publishing" does in writing ones. We should create "finished" drawings some of the time.

"Finishing" teaches skills that "one shot" drawings don't: craftsmanship, problem solving, perseverance, to name three. There are countless ways to finish drawings. Here are three tried and true methods: (See also **Media**, p. 246 and **More Classroom Drawing Media**, p. 265).

Whitney Soth
Grade 3

- **Pencil**

 If drawings are so light they're hard to see (not usually a problem with primary), the important lines should be darkened. If you make "stumps" available (p. 249), students will produce abundant, wispy grays. Encourage students to add interesting *details*, *patterns*, and to erase extraneous lines.

- **Ink**

 Ink is a great choice if drawings are going to be photocopied. Encourage students to add interesting details and patterns to their drawings. (Be sure to show them how to *"make a mistake work in your favor,"* p. 18) Solid blacks and a variety of *line weights*, tones and textures can be added using different nibbed inking tools. (See **Ink**, p. 251 and the insect drawings on p. 253.) If students have started their drawings in pencil, remind them to erase all pencil lines *after* the ink is dry.

The "Imaginary Insect" is fully colored while the background is left white.
Grade 3

• **Color**

When I work with younger children, color usually means some combination of Flair pens, colored pencils and colored markers (i.e., "mixed media"). In terms of paper, I usually go one of two ways:

– Larger paper (8.5″ x 11″)

One large figure (e.g., a bird, imaginary predator, or "fancy" fish, etc.) pretty much fills the paper. Students color *only* the figure and leave the background white.

– Smaller paper (anywhere from 3″ x 4″ to 6″ x 8″)

The *entire* paper is colored: foreground *and* background. This means that students need to make sure that the most important items in their pictures show up. They must think about *contrast* (p. 115). The smaller paper size makes it possible for even younger children to create magnificent, fully colored drawings *without* burning out. (The last thing we want to hear a little kid say is, "I'm tired of coloring.") Access to smaller pieces of paper, familiarity with a variety of coloring techniques and inspiring tools, should minimize the likelihood.

Whether students are working on larger or smaller papers, make sure they've been through the *five shape* color exercise (p. 110) before they start to color their pictures. That way we can be sure that they understand basic coloring vocabulary and techniques.

Most Primary aged kids are fully capable of *"nailing the white."* When they're not, encourage them to mix colors until the white of the paper is pretty much covered. The *mixtures* that children create using pens, markers and colored pencils in combination are often ravishing and unexpected.

When coloring with younger children, watch out for "the point of no return." Fatigue can set in 20 to 40 minutes after coloring begins, often without much warning.

When it does, kids can destroy in three minutes what they've worked at effectively for thirty. In order to insure the highest quality work, a few shorter work sessions are preferable to a couple of long (one hour) ones.

9. Deliver *"One Minute Mini-Lessons"*

Alas, many children will forget new concepts and techniques the day after they're taught and practiced. Kids won't fill their papers or *overlap* or *"nail the white"* unless they are reminded to do so. Even then, we know that often, reminding isn't enough. We must review. Delivering a *"One Minute Mini-Lesson"* on whatever topic(s) kids seem to have forgotten is often enough to quickly reawaken understanding, and noticeably upgrade the quality of student work.

10. Use *guidelines*

Presenting *Guidelines* for drawing projects is as valid for primary age children as it is for older students. *Guidelines* aren't just task instructions, they're learning targets you're asking students to take aim at. Two caveats:

- Make sure that students are familiar with *every* concept or technique that's on your *guidelines* list.
- Make sure your *guidelines* list is brief, simple, and crystal clear. (With primary, less is certainly more!)

"Animals"
Adam Bartholomew
Grade 2

11. Display student work regularly

Create a classroom drawing exhibition site. As you and your students work through the **Lessons** and **Extensions**, display *everyone's* work regularly. If *reflection* is something you value, exhibit selected written samples along with the drawings. (Enlarge salient sentences or paragraphs on a photocopier so they're eye catching and easy to read). Exhibiting everyone's work:

- challenges the notion that drawing is for the talented few.
- validates drawing's importance in the classroom.
- helps to build a sense of community.

12. Save student work to show future classes

Don't expect students to part with their best work. Understandably, they want to take it home, or place it in a *portfolio*. No problem. If color isn't a factor, make duplicates on school photocopiers. When it is, scan images into your computer's graphics file, then generate the best color print you can. Or, find a quality color copier

Putting the finishing touches on "The Money House."
Colored Pencil and Flair Pen.
Grade 3

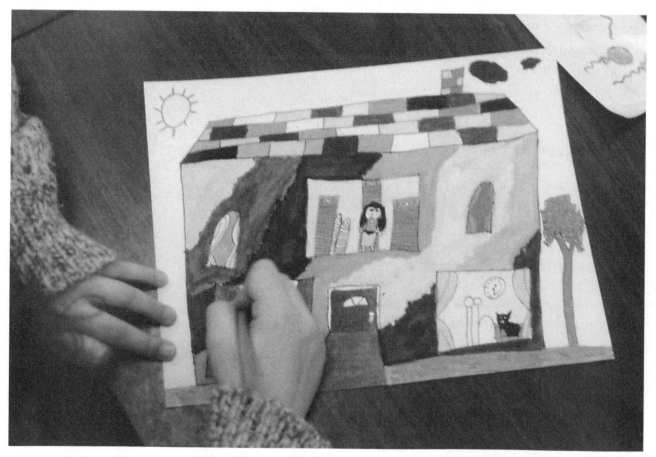

(highly recommended is the Canon 500, 700 or 800 available at many local duplicating centers, and at most Kinko's). For maximum color richness, ask the technician to set the light/dark gauge *two full clicks* into the dark.

Catie
Grade 1

13. Encourage student reflection

Reflection, done regularly enables younger children to

- practice writing that is personally meaningful.
- understand themselves better as learners.
- build powers of introspection.

While *reflection* is usually a journal writing activity, it can take other forms as well. "Partners" (two students sitting together for two or three minutes) can take turns sharing learning experiences and describing successes. Don't expect kids to master either written or verbal *reflection* overnight. You'll need to model both processes regularly for students.

14. *"Appreciate"* completed major projects (See p. 285)

Taking the time to *"appreciate"* major projects:

Drawngs developed from the letter "B."
Grade 1

- enhances visual acuity.
- teaches civility.
- reminds students that "positives rule."
- helps build a sense of community.
- creates satisfying closure.

15. Encourage students to practice drawing at home, and to bring their drawings to school

Some kids can't get enough of drawing. For them, it's not just a fun activity, it's an important part of who they are; it's an empowering experience. Sharing their homemade drawings is a way for them to shine in their classmates' eyes, and in yours. For some children this may be their only "shining" talent. Honor it.

16. Remind students to sign their drawings

A signature on a drawing signifies closure and ownership. It says to any viewer, "This is *my* work." Professional artists sign their work routinely. So should students—with pride.

Intermediate: "The Most Important Points"

1. Value drawing and be prepared to defend it.

For some of your students, drawing isn't just a fun activity, a pleasant addition to the school day. It's a unique form of communication and a natural way to learn. And for some of your students, drawing may be the only time during the long school day when they feel totally relaxed or successful.

Alas, not everyone understands or appreciates drawing's value in children's lives.

As educators, we ought to arm ourselves with a few facts should parents, colleagues, or administrators question our commitment to classroom drawing. Here are four solid reasons that will serve you well in almost any situation:

- Drawing helps children develop fine motor skills which are critical for building the coordination required for printing and writing.

- A majority of students are visual learners. Drawing is an important way for these students to grasp concepts, understand and learn.

- Drawing can teach students important non-academic skills that will be indispensable for success in an information age: creative thinking, craftsmanship, decision making, problem solving and persistence.

- Studying drawing (especially as it's presented in *Drawing in the Classroom*), helps kids become visually literate. Visually literate students are able to "read," appreciate, and critically discuss pictures and their meanings. Clearly, this is a desirable skill to have at a time when so much of our information is delivered via images.

(See also **"Why Children Should Draw: A Rationale,"** p. 242.)

"Cheetah"
Colin Gadler
Grade 5

2. Provide time for free drawing

Free, means unstructured, untutored, unsupervised. Kids alone decide what and how they'll draw. This kind of drawing can restore flagging energy and relieve stress. Try it at the end of a long day when everyone's brain dead, after testing, or as a respite from tasks academic. I know many teachers who allow free drawing during read aloud time. Some kids can actually listen better *when* they're drawing. (In lieu of reading aloud to students, put on a little classical music and break out the markers.)

3. Maintain a picture file

No matter what you're studying, pictures can support the research based drawings of young artists. Sure, kids can get books from the library, but real artists and illustrators maintain *picture files* in their studios. Ask parents to provide old magazines and the school secretary to contribute letter size file folders. Studying trees? Start a folder! Label folders generically (e.g., "Mammals," "Insects," "Weather," etc.) and store them alphabetically. There will always be a few kids who'll love to find pictures and help maintain the files. In a few years you'll have a cornucopia of images—from A to Z.

4. Share exemplary picture books

If drawing and illustrating are to be serious pursuits in our classrooms, children need to view and discuss exemplars regularly. Paintings and drawings by master artists are one obvious and worthwhile source. Not to be overlooked are picture books by contemporary illustrators. (During this golden age of children's book illustration, picture books are hardly just for "little kids.") Whether our focus is line, color or *composition*, inspiring images in every imaginable style can often be found right in our school libraries. (You'll find lists of recommended books at the end of every chapter under **Resources**.)

Free drawing of a robot, by Marc Jacob
Grade 5

5. Teach kids about "whisper lines"

There is no drawing technique that's more important for intermediate age youngsters to learn and to practice. Using *"whisper lines"* makes it possible for children to revise their drawings. Said another way, students aren't stuck with their first graphic impulses. Changes (for the better) can be made! Most children nine and older are ready to develop a drawing gradually by erasing and redrawing. Some kids, no matter what we do, simply won't have the patience or the fine motor skills to do it.

6. Monitor paper size

There is an absolute correlation between the size of a piece of paper and the time students will need to complete a drawing. (Not that every drawing has to be completed...) Smaller papers will work beautifully for many exercises and projects. Some of the very best, fully colored drawings I have seen intermediate age students produce, were no larger than 5"x6."

7. Revisit these centrally important issues of classroom drawing regularly:

Information

I agree with Brent Wilson who said, "Without proper information, no one can draw properly." Adequate information and improved drawing are synonymous. If I'm drawing a dolphin, and I've got a good picture of one in front of me, I've got enough information. If I'm drawing a self-portrait and I can see my face clearly in a mirror, I've got enough information. If I'm drawing a dream house, I may be able to rely on imagination, or I may need to look at pictures of real or fantasy houses to get ideas. A question we can ask students when they appear to be stuck might be, "Do you have enough information?" The next inevitable question is, "What can you do to access the information you need?" (Get a better picture? Readjust your mirror? Look at pictures of houses designed by Frank Lloyd Wright?)

Composition

Remind students to fill the entire paper as they draw, that it's okay for some items to go off the edge, and that their *compositions* don't always have to be "long

Mattie
Grade 4

shots," they can be "medium shots" and "close-ups" as well (see p. 188–190). Remind them, too, that *negative spaces* are just as important as positives. As you share picture books with students, pause now and then to ask them about a particularly interesting or intriguing image: "What do you like, or not like about it? If you'd been the illustrator, would you have done anything differently? What do you think this picture is trying to tell us?" Kids love to share their opinions. They have important things to tell us.

Illustration for her poem, "I Know Marine Biology." Colored pencil and Flair pen.
April Storm
Grade 5

Craftsmanship

Good *craftsmanship* certainly relates to the way materials are being used—skillfully we hope, not carelessly. More than that, *craftsmanship* is an attitude that can be displayed throughout the intermediate years. "Are you respecting the materials you're working with? Are you looking after your papers, making sure they don't get wrinkled, torn or lost? Are you taking pride in the thing you're making? Are you taking your time, or rushing?" Asking these questions regularly of young artists conveys our high standards, and helps to foster an attitude that can be summed up as: "Craftsmen always do their best. Craftsmen care!"

Creativity

Creativity suggests originality, invention, looking at things with fresh eyes, open minds. It may not be relevant to every project that kids tackle, but it's still an important item to have on our list. There are a couple of ways to encourage creativity. First, show examples of artists (Monet, Picasso, O'Keefe), illustrators (Eric Carl, Maira Kalman, Ed Young), and designers (Milton Glaser, J. Otto Siebold) who were or are innovators. Second, talk about it. Intermediate age children want to be accepted, to fit in, to be like

Fifth grader, Gunnar Sample using the "tracing method." The finished drawing can be seen on p. 272.

everyone else. Social pressures can stifle the best, most original impulses in our kids. Unquestionably, creativity involves risk taking and the willingness to be different. It's an issue having repercussions far beyond the drawing classroom.

8. Teach Students the *"Tracing Method"*

When *rough drafts* are really *rough* (lots of extraneous lines and erasures), or when a cleaner look is desired, the *"tracing method"* is a great option for kids nine and older. The student masking tapes his *rough draft* to a window, then tapes a fresh sheet of drawing paper on top of it. The light coming in through the window enables him to see the ghost image of the *rough draft* on his fresh paper. He traces the drawing using a fine nibbed black marker if he prefers a "crisp" look, or colored pencil if he prefers a "softer" one. The entire drawing can be traced in this way. Or, if the student is uncomfortable drawing vertically, he may trace larger shapes at the window, then add *details* back at his desk.

When drawings are to be colored with colored pencils, the *tracing method* is highly recommended. (Constant erasing and redrawing can abrade the paper's surface, and sharp pencils leave depressions that are difficult to fill in.) Even when pictures are to be colored with markers, or a combination of colored pencils and markers, most children prefer the *tracing method* to coloring their rough drafts. Still, the *tracing method* should be a choice, not a must.

9. Deliver *"One Minute Mini-Lessons"*

Alas, many children will forget new concepts, processes and techniques the day after they're taught and practiced. Kids won't *overlap* or *"nail the white"* or use the *"E–Z Draw Method"* unless they are reminded to do so. Even then, we know that often, reminding isn't enough. We must review. Delivering a *"One Minute Mini-Lesson"* on whatever topic(s) kids seem to have forgotten is often enough to quickly reawaken understanding, and noticeably upgrade the quality of student work.

10. Use *guidelines*

Guidelines limit and pinpoint learning targets for teacher and student alike. Here's another plus: when a student asks "Is this what you want?" simply refer her to the *guidelines*. (Your life is made easier, and students are encouraged to assume greater responsibility of their own learning.) Two caveats:

- Make sure that students are familiar with every concept or technique that's on your *guidelines* list.
- Make sure your *guidelines* list is challenging, but not overwhelming.

Kelsi Herman
Grade 4

11. Teach "the drawing process"

While students throughout the elementary years are often satisfied with "one shot drawings" (i.e., drawings done spontaneously in a few minutes, or in a single working session), they welcome the opportunity to develop and craft their drawings just like real artists and illustrators. The problem is, hardly anyone can show them how to do it. While there are no absolute formulas for successful drawing in the classroom, or elsewhere, I can describe a process that's served me and my intermediate students well for many years. Similar to "the writing process" described by Graves, Calkins, Murray, et al, my version of *"the drawing process"* can be summed up in four stages:

Intent

Before starting a major project ask, "Who's the drawing for? Who will view it? Will it be part of an exhibition? Displayed in the classroom? In a student produced book? Will it be reproduced? In black and white? In color?" All of these questions will help you and your students determine the size and the medium of the drawing to be produced.

Pre-Drawing

Select drawing media to be used. (Practice, if the medium is new to you.) Gather supporting materials you may need (books, *picture files*, real items). Brainstorm. Sketch. Practice drawing challenging items.

Tracy Meese
Grade 6

Rough Draft

Student uses *"whisper lines,"* erases and redraws until he's satisfied with the look of his picture. By erasing and redrawing (i.e., *revising*), the student exercises considerable control over the outcome and the quality of his final drawing. Drawings can be left in this state or "finished."

"Finishing"

When "finishing" drawings, here are three tried and true ways to go. (See also **Media**, p. 246.)

- **Pencil**

 Some pencil drawings are meant to be light, delicate, even wispy. Where they're not, pencil lines can be darkened, and/or a full range of gray tones, and velvety blacks added to create a finished product that's graphically stronger. Don't hesitate to use erasers to get rid of extraneous marks or lines, and to brighten whites.

- **"Finish in Ink"**

 After the drawing is resolved in light pencil, the student goes over pencil lines with a Flair pen. Lovely, lucid line drawings can be completed in this way. When a richer, more complex image is desired, additional line weights, tones and textures can be added with a variety of inking tools. (See **Ink,** p. 251 and the insect drawings on p. 253.) In either case, all pencil lines should be erased after the ink is dry.

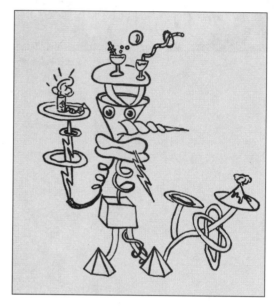

"Alien Waiter"
by Nichole Clark
Grade 4

Pencil drawing

Ky Carson
Grade 6

- **Color**

 Fully colored pictures are the zenith of classroom drawing. They take patience, skill and stamina to produce. Students work through a series of sequential steps until the entire paper is covered with a magnificent skin of color (i.e., they *"nail the white"*).

 – One color medium can be used, or media can be "mixed." (See **Media**, p. 246.) The *mixtures* that children create using a variety of coloring tools can be ravishing and unexpected.

 –When the whole paper is to be colored, papers should be kept on the small side, (no larger than 5″ x 6″).

 –Before students start the coloring process, they should produce a *five shape* (p. 110). That way we can be sure that they understand basic coloring techniques and vocabulary.

 –Since the entire paper is to be colored, students need to make sure that the most important items in their pictures will show up. They must think about *contrast* (p. 115). Producing *thumbnail* sketches (p. 127) to test *contrast* and color combinations optimizes student performance.

12. "Finished drawings:" pick your battles

Many of the loveliest, most original drawings I've seen children produce were the "one shot" variety mentioned above. Still, children should be given the opportunity to "finish"— to optimize—some of their drawings some of the time. "Finishing" occupies an important place in drawing classrooms in the same way that "publishing" does in writing ones. It teaches students skills that the "one shot" variety don't: *craftsmanship*, problem solving, and persistence, to name three.

Amy Cartwright
Grade 6

Displaying "Fantastic Faces" in
the classroom.

White chalk and oil pastel.
Grade 5

Pick your battles. Three or four times during the school year, go for the gold. When kids are "finishing" their drawings, make sure that they are given adequate time to do their very best work, *and that you accept nothing less.*

13. Display student work regularly

Create a classroom drawing exhibition site. As you and your students work through the **Lessons** and **Extensions**, display everyone's work regularly. If *reflection* is something you value, exhibit selected written samples along with the drawings. (Enlarge salient sentences or paragraphs on a photocopier so they're eye catching and easy to read.). Exhibiting everyone's work:

- challenges the notion that drawing is for the talented few.
- validates drawing's importance in the classroom.
- helps to build a sense of community.

14. Save student work to show future classes

Don't expect students to part with their best work. Understandably, they want to take it home, or place it in a *portfolio*. No problem. If color isn't a factor, make duplicates on school photocopiers. When it is, scan images into your computer's graphics file, then generate the best color print you can. Or, find a quality color copier (highly recommended is the Canon 500, 700 or 800 — available at many local duplicating centers, and at most Kinko's). For maximum color richness, ask the technician to set the light/dark gauge *two full clicks* into the dark.

15. Encourage student *reflection*

Reflection, done regularly helps children

- understand themselves better as learners.
- identify strengths and weaknesses.
- set goals.
- build powers of introspection.

While *reflection* is usually a journal writing activity, it can take other forms as well.

"Partners" (two students sitting together for two or three minutes) can take turns sharing learning experiences, identifying problems and describing successes. Don't expect kids to master either written or verbal *reflection* overnight. You'll need to model both processes regularly for students.

16. *"Appreciate"* completed major projects (See p. 285)

Taking the time to *"appreciate"* major projects

- enhances visual acuity.
- teaches civility.
- reminds students that "positives rule."
- helps build a sense of community.
- creates satisfying closure.

17. Encourage students to practice drawing at home, and to bring their drawings to school

Some kids can't get enough of drawing. For them, it's not just a fun activity, it's an important part of who they are; it's an empowering experience. Sharing their home-made drawings is a way for them to shine in their class-mates' eyes, and in yours. For some children this may be their only "shining" talent. Honor it.

18. Remind students to sign their drawings

A signature on a drawing signifies closure and owner-ship. It says to any viewer, "This is my work." Professional artists sign their work routinely. So should students— with pride.

Mollie Bellman
Teacher

The Zoetrope Book

The zoetrope is an ingenious optical toy first built in the mid ninteenth century to display drawings and photographs as moving pictures. In today's zoetropes, image strips, drawn and colored by children, come to life as animation.

The zoetrope's mechanics are refreshingly simple. A drum, with twelve equally spaced slits, is mounted on a turntable or "lazy susan." A paper strip consisting of a series of progressively changing images, like the ones to the left, is coiled around the inside of the drum. The turntable is spun, the viewer looks through the slits and sees—believe it or not—a gracefully galloping horse.

The version described in *The Zoetrope Book* is made from a 2 or 3 gallon cardboard ice cream drum (available from almost any commercial ice cream store) and a 10.5″ Rubbermaid® turntable (available at any drug or variety chain outlet).

THE ZOETROPE BOOK
By Roger Kukes

ISBN 0-9622330-0-5
144 pages
$15.

- Simple instructions for building inexpensive, durable zoetropes.
- How to make great zoetrope strips.
- Nine full size strips you can cut out and view in your zoetrope.
- A special section on how to use the zoetrope for fun and learning in any classroom.
- Hundreds of helpful illustrations.

"Weightlifter"
Nancy McElroy
Teacher

To order *The Zoetrope Book* by Roger Kukes, see p. 333.

ORDER FORM (Photocopy okay)

Quantity	Title	Unit Price	Total
	Drawing in the Classroom	$26.	
	The Zoetrope Book	$15.	

Subtotal _____

Shipping/Handling
Add $5. for 1 item; $8. for 2;
Add $1.25 for each additional item.

Shipping & Handling _____

TOTAL _____

Ship Books to:

Name _____

Address _____

City _____ State _____ Zip _____

Payment

Purchase Orders accepted from schools/institutions.
Personal checks or money orders must accompany orders from individuals. (No credit cards.)

Questions

Send Purchase Order or prepayment to:

Klassroom Kinetics
3758 SE Taylor Street
Portland, OR 97214

Telephone Orders: (503)235-0933 • e-mail: kukes@teleport.com

Glossary

"Zebra"
Scratch-Foam® print,
Lisa Dorsing
Teacher

While many of the terms mentioned in the **Glossary** (and in the **Lessons**) are familiar art vocabulary, some terms are part of an "art speak" of my own invention. *"3–M," "Nail the White," "Shapes Galore,"* etc., helped me explain concepts or techniques to large groups of students, and to make them memorable. These original terms are always presented in quotation marks. My apologies to art purists.

The page numbers adjacent to prominent terms will help you find more information on the topic.

"All Kinds O' Lines" (p. 13)

Refers to the array of lines that artists and illustrators use as they develop and complete their pictures. My list includes: straight, curved, "whisper," thick and thin ("T n' T"), tapered, broken, pattern, parallel, hatched and cross hatched.

"Appreciation" (p. 285)

A technique used by teachers and students to convey sincere support and enthusiasm for completed work.

Brainstorm Paper

Drawing paper on which ideas are collected — the more the merrier! This is where many projects begin. Brainstorm papers for young artists might include words, but are usually sketches, drawings, color tests, etc.

Chiaroscuro

A technique that utilizes a full range of darks and lights in drawings and paintings to create dramatic, three-dimensional illusions. For a great example of *chiaroscuro* see Chris Van Allsburg's 1984 picture book, *The Mysteries of Harris Burdick*, p. 207.

Clean Up

Erasing extraneous pencil lines during the drawing process, or once the drawing is finished. (See also *Rough* below.)

Composition (p. 184)

The organization of all the visual elements (lines, shapes, colors, etc.) within the boundaries of a rectangle or square so that a visually satisfying whole results.

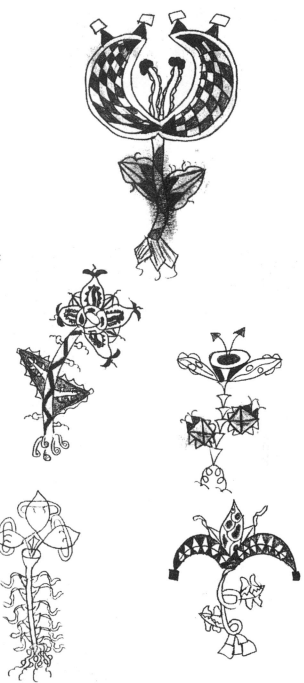

Brainstorm paper for the project, Fantastic Flora (p. 230). Often brainstorm papers are the first stage of more complex projects. (See also fully colored flower drawings in Color Plates, p. 6 and 7.)

High Contrast **Low Contrast**

Contrast (p. 115)

The degree to which the colors (or *values*) in a picture separate from one another. When contrast is high, colors separate noticeably. When contrast is low, there's very little difference between adjacent colors.

Craftsmanship

Craftsmanship as I use it throughout *Drawing in the Classroom* means:

- Treating materials with respect.
- Caring about the work we are doing.
- Taking pride in the skills we are developing.
- Noticing that there is a very real connection between the way we do things, and the quality of the outcome.

Detail (p. 37 and p. 45)

All of the individual parts that comprise a larger item. Drawings that include abundant detail usually give the viewer more to look at, and are therefore more engaging.

"Dictated Fantasy" (p. 212)

Students are asked to draw a series of specific items. Though every student will draw the same items, no two students will draw them in the same way.

"The Drawing Process" (pp. 199–201)

Similar to "the writing process" described by Graves, Calkins, Murray et al, my version of *the drawing process* can be summed up in these four stages: "intent," "predrawing," "rough draft" and "finishing."

"E-Z Drawing" (p. 35. See also "3-M" below)

My name for a process that helps children draw practically anything successfully by using *"whisper lines"* and *"3-M."*

"Fish Diagram,"
showing the individual parts or details.
Kelsey Edwards
Grade 4

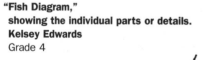
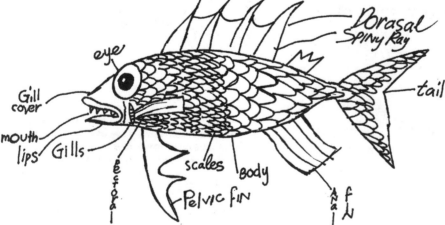

"Fancy ink" (pp. 252 – 253)

Drawings that use a full range of *line weights, patterns,* inking techniques and solid blacks.

"Finish in ink"

After drawings are developed in light pencil (*"whisper lines"*), they are darkened with a black Flair pen—or its equivalent. After the ink has dried, all pencil lines are erased.

Floor Line (p. 98)

A drawn line of demarcation that separates the wall and floor.

Foreshortening (p. 101)

A graphic device or "trick" designed to add greater three-dimensionality to pictures. By drawing an item so that one of its parts appears to be *noticeably closer* to the viewer than another, the illusion of depth is exaggerated.

Guided Fantasy (pp. 216 – 219)

A teacher led activity in which a script is read or spoken describing in detail any thing, person, process or place. Children, usually with eyes closed, listen intently, and try to "visualize" or internally reconstruct the material being described.

Guidelines

A list of task instructions presented with every significant project. The *Guidelines* list:

- Helps students focus on the project's main points.
- Provides clear learning targets every student can hit.
- Conveys our high standards.
- Presents a list of concepts/topics that can be assessed via scoring guides.

Horizon Line (p. 88)

A drawn line of demarcation that separates the ground (or ocean) from the sky.

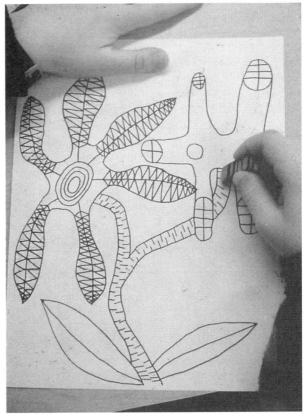

Erasing pencil lines is the final stage of *"Finishing in ink."*

"Fantasy Flower"
Grade 5

Drawings that are *"Finished in ink"* **reduce, enlarge and reproduce beautifully on good photocopiers. And, they can be scanned into a computer's graphics file where they can be further manipulated.**

"Cucumber slice,"
"Finished in ink" **and reduced on a photocopier.**
Jenna Blazer
Grade 4

Drawing displaying varying line weights.

"Mosquito"
Becky
Grade 2

Internal critic (p. 57)

The part of us that's a "doubting Thomas" (or Dolores), doesn't care about our growth, and can be ruthlessly harsh. "It" (or he or she) may say things like, "Why bother? You can't draw! You're wasting your time!" (or worse!)

"Limited Palette" (p. 118)

By limiting the number of colors to be used in a drawing to six or fewer, it becomes necessary to repeat the same colors in different parts of a drawing. Repetition of color tends to unify the composition. *Limited Palette* is an especially good strategy for children (or adults) who struggle with color choices and results.

Line weight (p. 13)

The relative thickness of a line. Lines have an infinite number of qualities from slender to bold.

"Make a mistake work in your favor" (p. 18)

When working "straight ahead" with unerasable ink (or colored marker), the student regards a mistake, not as a "catastrophe," but as an opportunity. She takes a deep breath and says to herself, "Okay, I've got a boo-boo here. I know I can't erase. Now how can I make this into something that will make my drawing even better."

Mimicking (p. 7)

A time tested method for learning art techniques: a teacher models and students copy.

Mimicking is one highly effective method for helping students build basic skills.

Mixture (p. 112)

Combining two or more colors to create a new color.

"Nail the white" (p. 111)

Completely covering the white of the paper with a single color or a mixture of colors.

Negative Space (p. 188 and p. 339)

Refers to the empty areas around the objects, people, animals, etc. that comprise any two dimensional design,

drawing or painting. Learning to see, fill and shape negative space is an important part of creating successful *compositions*.

"One Minute Mini Lesson"

A quick review of material students seem to have forgotten or inadequately understood. We should never underestimate children's capacity for forgetfulness; nor should we forget how much repetition it takes to authentically build skills.

Overlapping (pp. 85–87)

The part of a drawing where one thing appears to be in front of or behind another.

Pattern

Patterns can be simple or complex, "formal" or "informal," but they must be predictably repetitive. "Formal" patterns, usually man-made, are rigorously predictable. "Informal" patterns, often existing in nature, may be less exact, but are still repetitive.

**The black represents the *negative space*
in "Rocking Chair," adapted from a drawing.
Jeanne Mikesell**
Teacher

"Pattern Extension"
Teacher

Picture File (p. 44)

File folders containing pictures of houses, insects, trees, etc. usually culled from magazines, are labeled and stored alphabetically. Students access the folders whenever they need more visual information. Whether a child is drawing a frog, a sailboat or a clown, having access to clear pictorial samples is often the difference between success and frustration.

Portfolio (p. 302 and p. 307)

A storage folder containing an individual student's work. *Portfolios* usually house a student's best work, but they may also contain **brainstorm papers**, sketches, **thumbnails**, even reflective writing.

Reflection (p. 300 and p. 306)

A quasi journal writing technique through which students describe their learning experiences. It is a peerless tool for helping students come to know themselves better as learners, and build powers of introspection.

Revision

The process of drawing, erasing and drawing again. Change is the essence of revision. The process is very similar to revision in "the writing process." The goal in both domains is to make the work better by making discerning changes.

Rough

The earliest, "roughest" stage of a drawing. *"Whisper lines"* are used to initially establish simple lines and shapes.

Sample of a "rough" and its more refined "clean up."

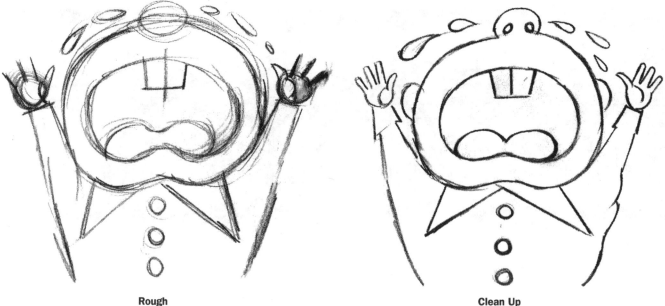

Rough

Clean Up

Rough Draft (p. 200)

A drawing that shows the inevitable marks of process: false starts, abrasions, erasures, etc. *Rough drafts* can be left "as is," or, where a more finished product is desired, recopied or traced on to another piece of drawing paper. (See also the *"tracing method"* below.)

Scoring Guide (p. 295)

Scoring guides measure student performance against a preexisting set of criteria using a point system.

"Seeing and Drawing" (pp. 50–52)

Drawing based on careful observation. This approach works best if used when students are drawing real things, and not from photos or graphics. The student looks at the subject *at least 70%* of the time, and at the paper *not more than 30%*. That way she is encouraged to draw the subject as it actually appears, not as she *thinks* it appears.

"Shapes Galore" (pp. 23–25)

My name for the array of shapes available to artists and illustrators as they develop and complete their pictures. There are three shape categories: "shapes with names," "free form shapes" and geometric solids.

"Size and location" (pp. 87–89)

A term suggesting that the illusion of depth can be heightened in a drawing when items appearing closer to the viewer are drawn larger and lower on the paper; and those in the distance are drawn smaller and higher.

Spatial drawing

Drawings that successfully convey the illusion of depth. Among the techniques that artists use to achieve it are: *overlapping, "size and location"* and color.

"Straight ahead" ink

A drawing done with a pen or marker from the start that can't be erased. It's a technique that requires that its practitioners also *"Make a mistake work in their favor."*

Though the drawing paper is flat, the illusion of depth can be heightened by using "size and location." In the drawing above, one tree appears to be closer to the viewer; the other tree, farther away.

"3-M" (Macro, Medium and Micro) (pp. 35–38)

The three steps students follow when practicing *"E–Z Drawing."* First the young artist observes and draws the "macros," the largest, simplest shapes and the longest lines. Next she observes and draws the "mediums," and finally the "micros," or details.

The three stages of "E-Z Drawing."

"Teddy Bear" Brandy Bender
Grade 5

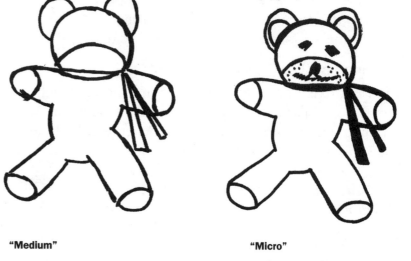

"Macro" "Medium" "Micro"

I *"3-M"* can also be used as a recipe for creating richer, more successful *compositions* (p. 200). When designing pictures or illustrations, we can ask students to think first about the largest, simplest divisions—the "macros." Next, the "medium" shapes that begin to flesh out the form of the specific items they'll be including, and lastly the "micros."

Below, developing a composition using "3-M"

Jenny Beddell-Stiles
Grade 4

"Macro"

"Medium"

"Micro"

Thumbnail (p. 127)

A small, quasi replica of a drawing, design or illustration where color choices can be tested quickly before final drafts are colored.

I The "Tracing Method" (p. 201)

Enables older students to produce high quality final products *"finished in ink"* or completely colored. After doing a *rough draft* in pencil on a lighter weight paper (e.g., 20# photocopy paper), student traces the image onto a fresh sheet of drawing paper.

Value

The lightness or darkness of a color.

"Whisper lines"

Lightly drawn or sketched pencil lines that can be easily erased and redrawn. Use of *"whisper lines"* makes it much easier for students to **revise** their drawings.

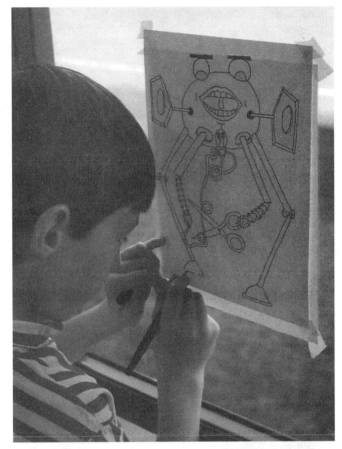

The tracing method
Grade 4

Finished *composition* based on *"3-M"* development shown on previous page.

Jenny Beddell-Stiles
Grade 4

Black Line Masters

"Crazy Creatures"
Colored pencil and Flair pen.
Grade 3

WHY
WAIT A
WEEK

**WHY
WAIT A
WEEK**

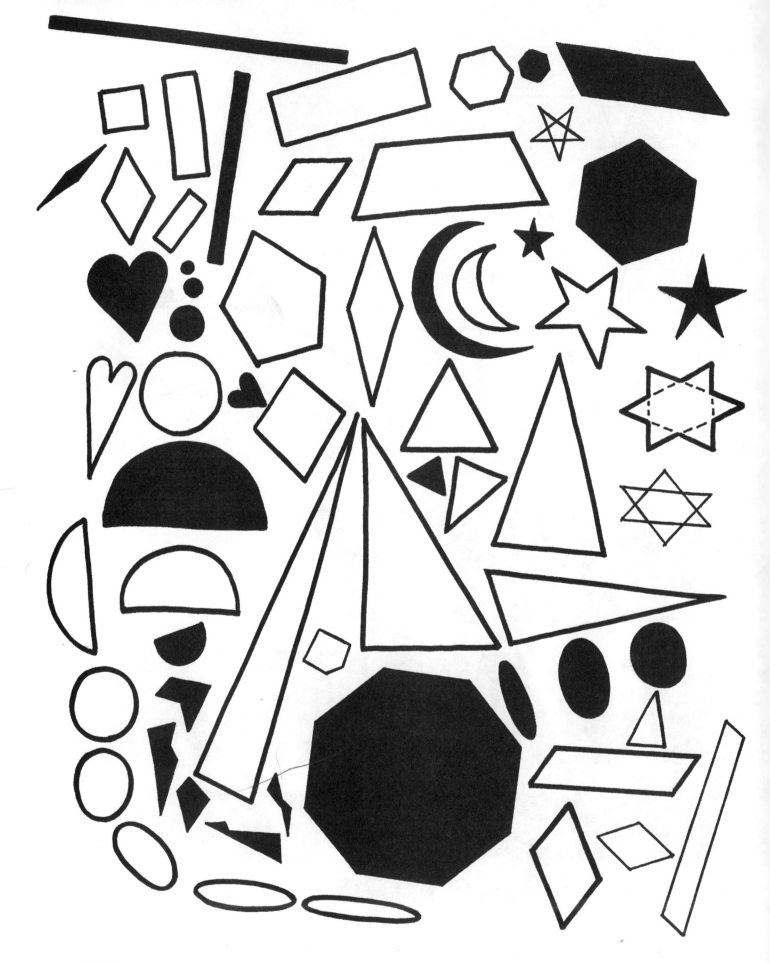

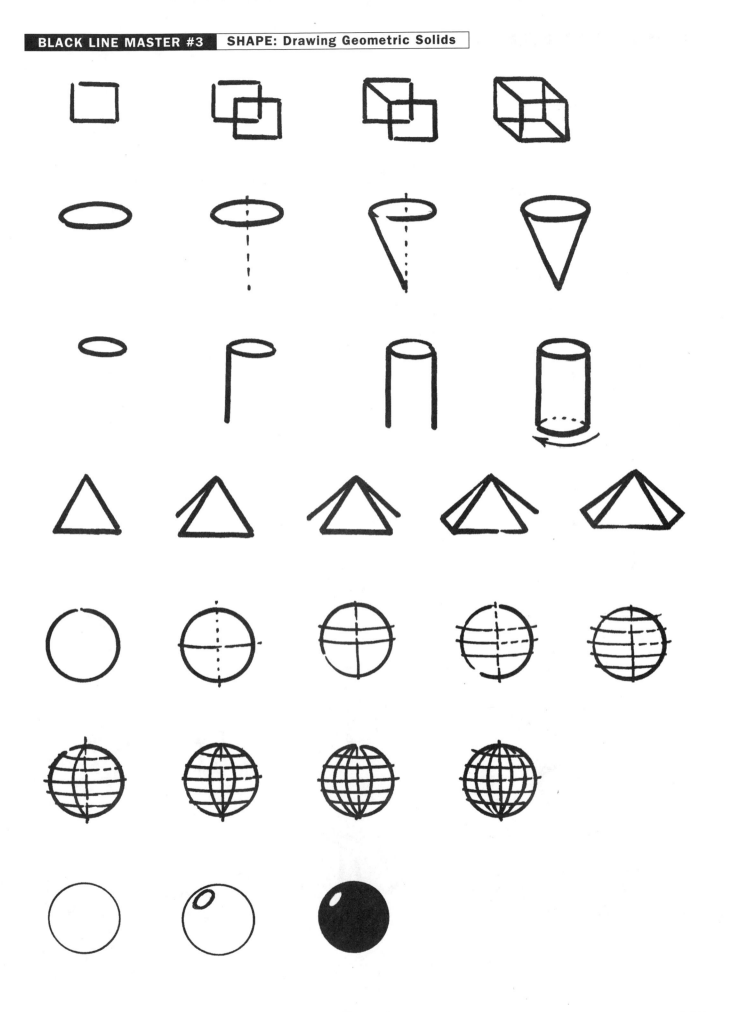

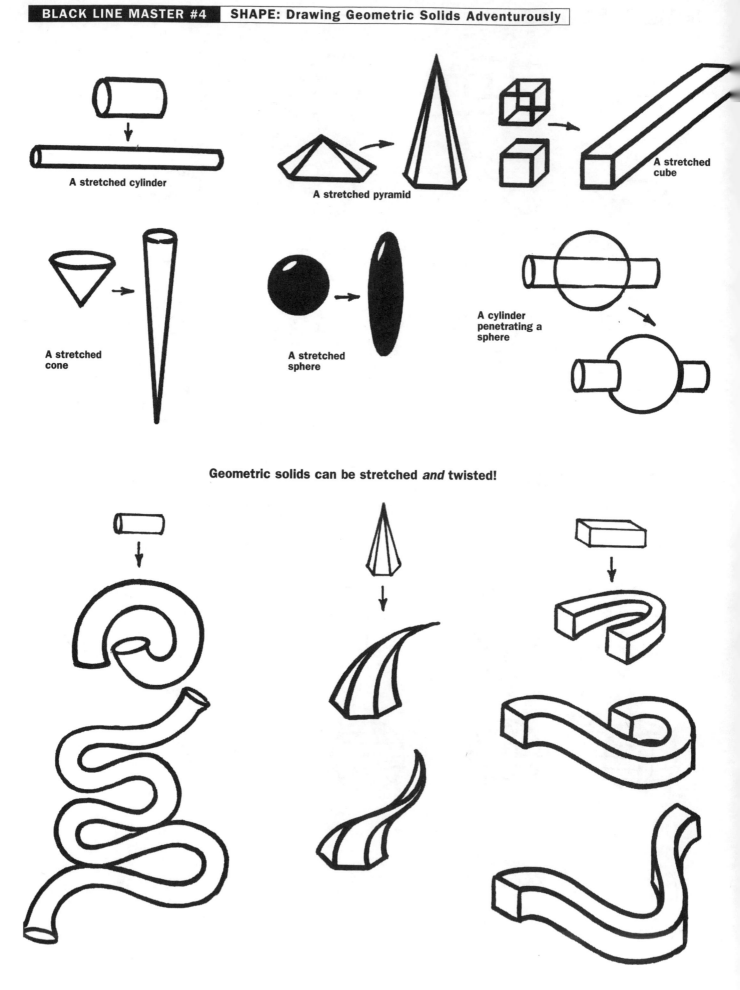

A stretched cylinder

A stretched pyramid

A stretched cube

A stretched cone

A stretched sphere

A cylinder penetrating a sphere

Geometric solids can be stretched *and* twisted!

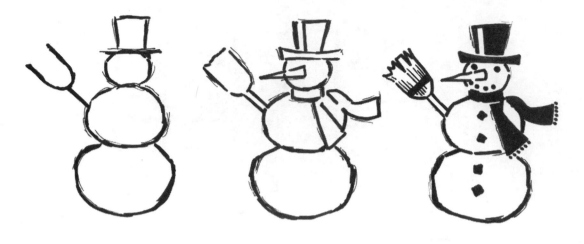

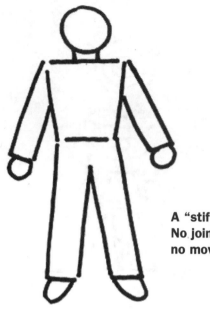

A "stiff" figure.
No joints means
no movement.

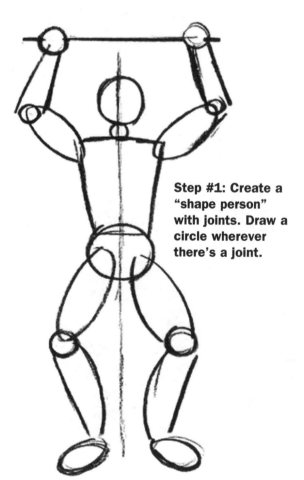

Step #1: Create a
"shape person"
with joints. Draw a
circle wherever
there's a joint.

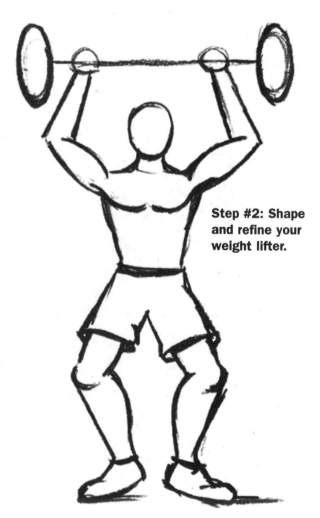

Step #2: Shape
and refine your
weight lifter.

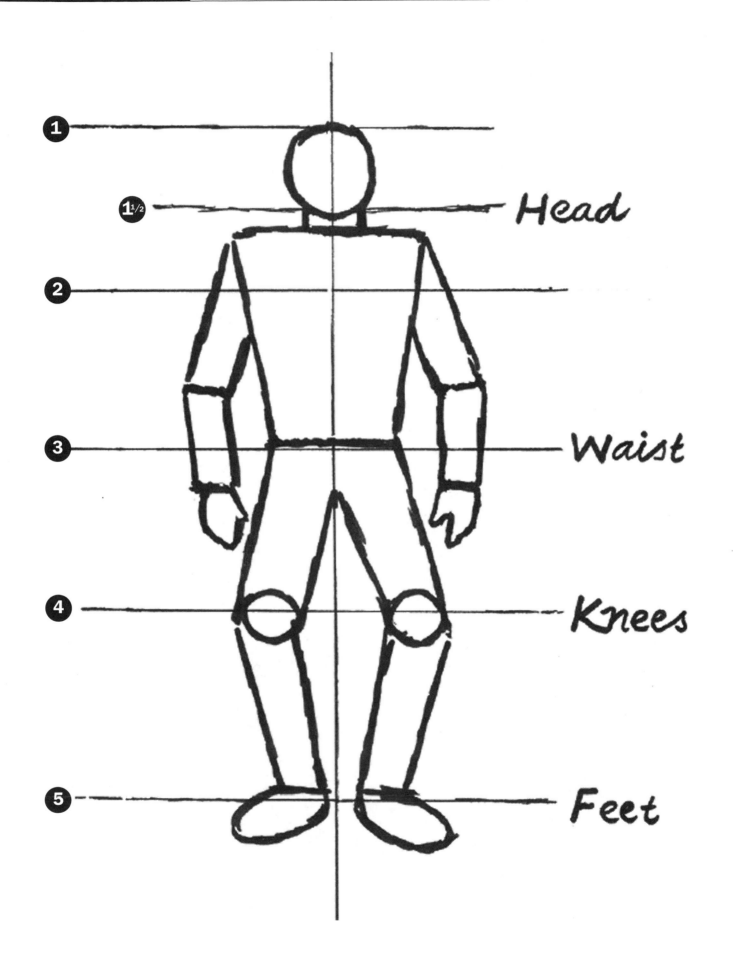

1

1½ Head

2

3 Waist

4 Knees

5 Feet

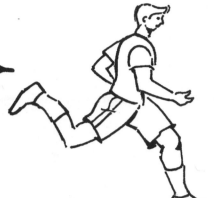

GUIDELINES

- Use *"whisper lines."*

- Create a "shape person" before refining the figure. Draw circles to indicate joints.

- Revise (i.e., erase and redraw) until you get your shapes and joints "right."

- Refine the figure
 - Shape it; make your athlete into a "character." (Male or female? Young or older? Muscular or puny?)

- Add interesting *details*.

- *"Finish in ink."*

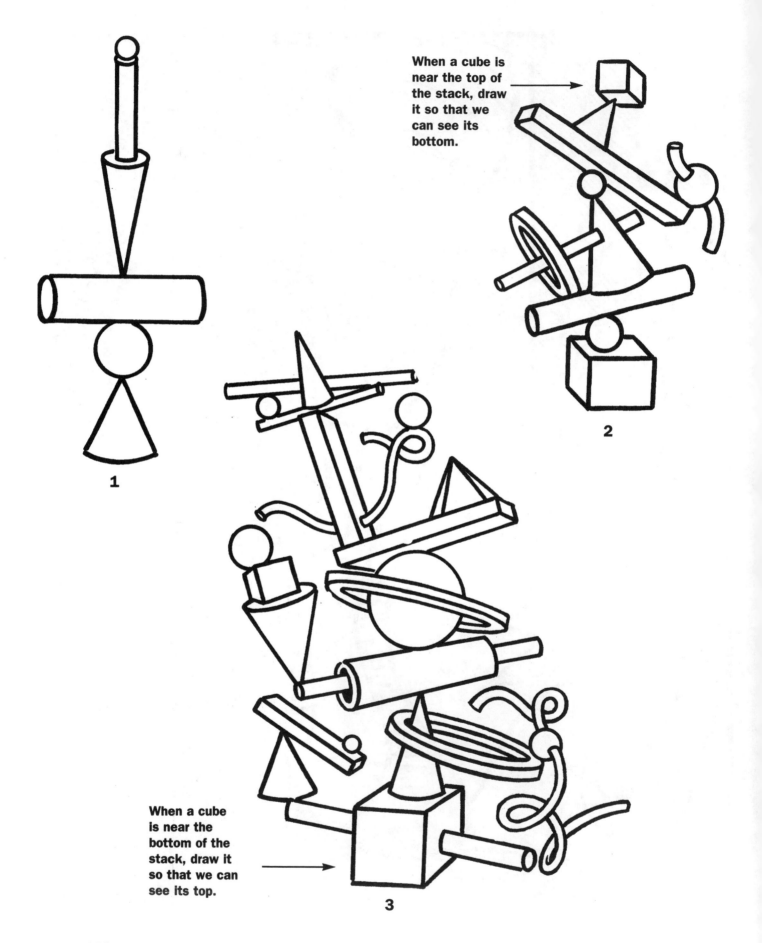

When a cube is near the top of the stack, draw it so that we can see its bottom.

1

2

When a cube is near the bottom of the stack, draw it so that we can see its top.

3

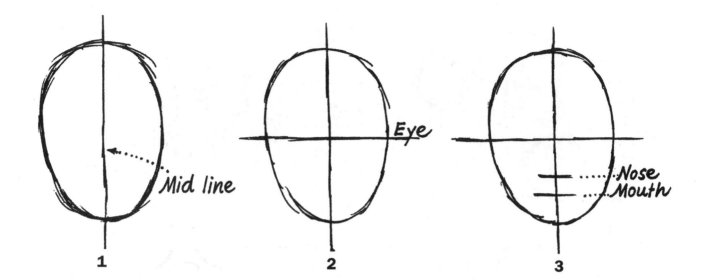

1 Mid line

2 Eye

3 Nose / Mouth

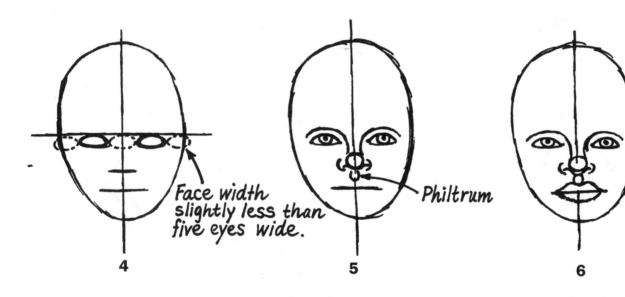

4 Face width slightly less than five eyes wide.

5 Philtrum

6

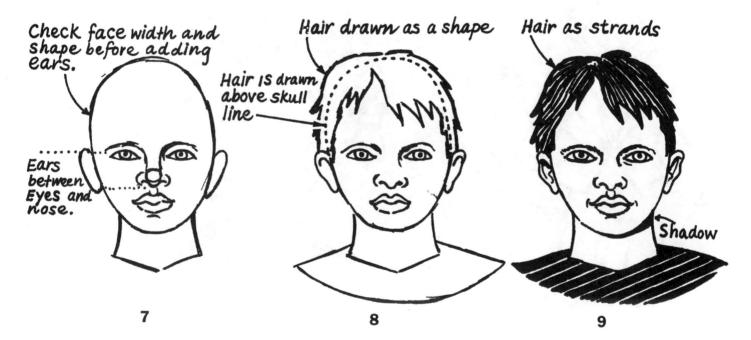

7 Check face width and shape before adding ears.

Ears between Eyes and nose.

8 Hair drawn as a shape

Hair IS drawn above skull line

9 Hair as strands

Shadow

Noses

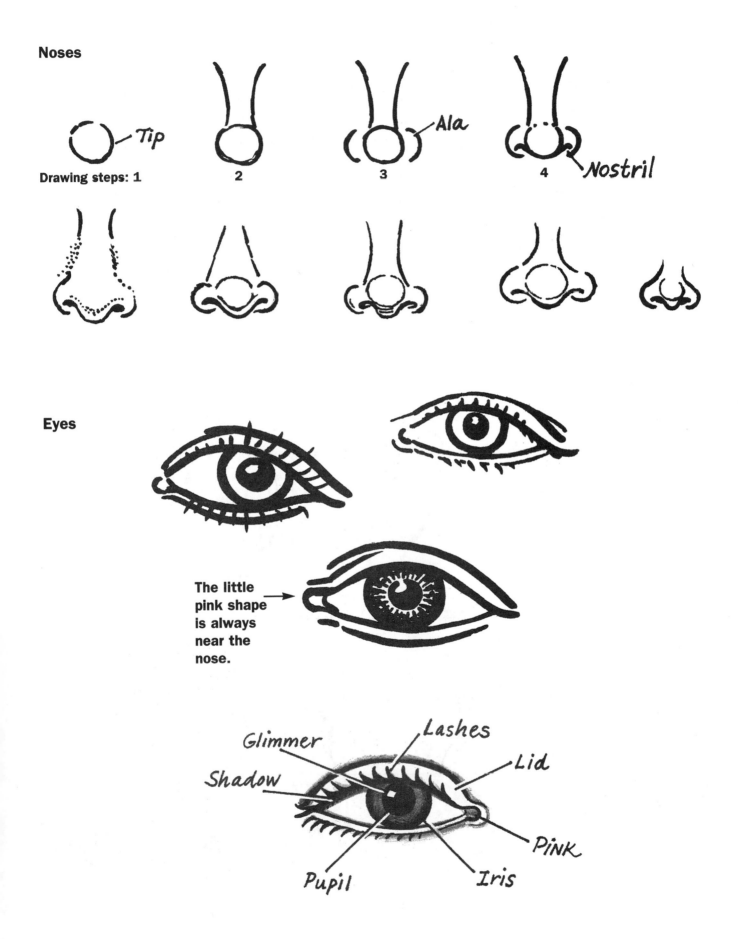

Tip

Drawing steps: 1 2 3 Ala 4 Nostril

Eyes

The little pink shape is always near the nose.

Glimmer Lashes

Shadow Lid

Pupil Iris Pink

Mouths

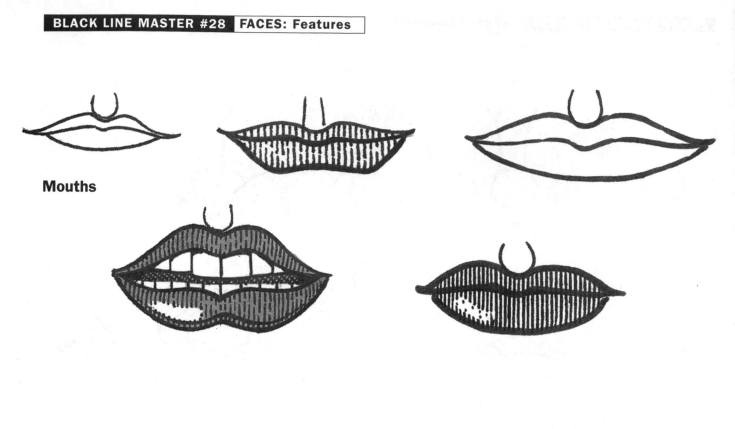

Ears

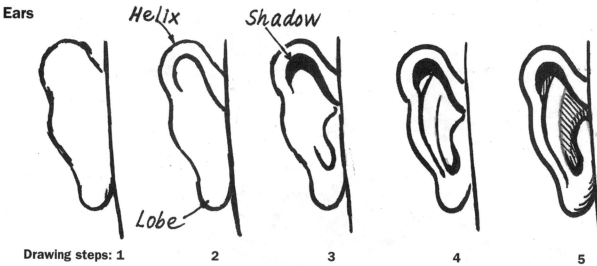

Helix Shadow

Lobe

Drawing steps: 1 **2** **3** **4** **5**

Hair

Face shapes and clothing

More Face Shapes

Eye Brows

Eyes

Noses

Mouths

Ears

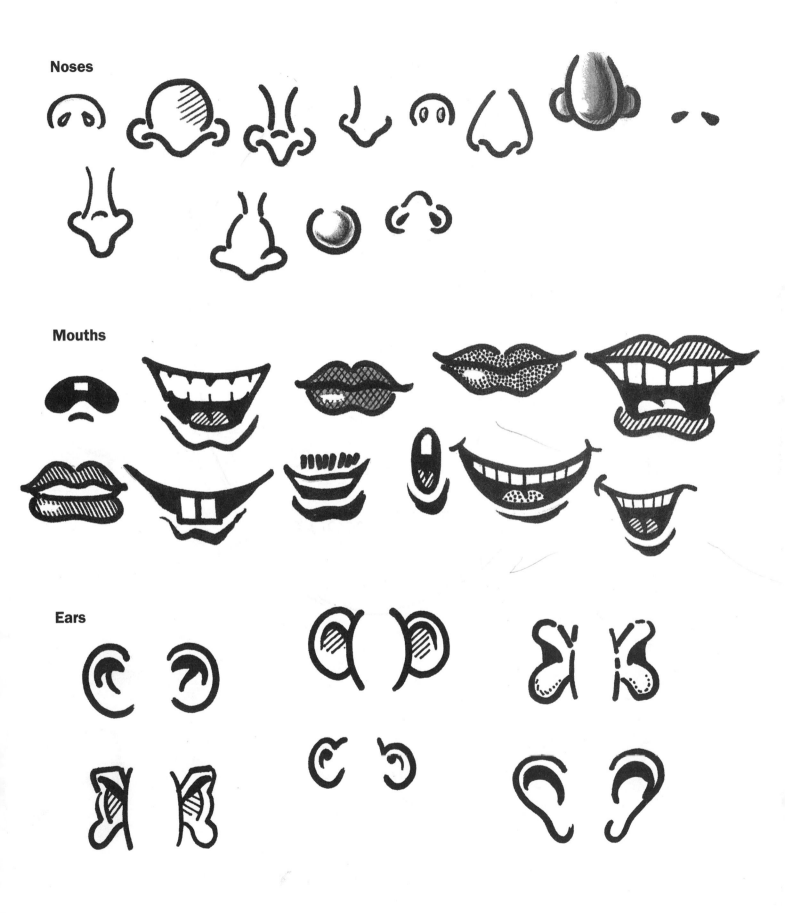

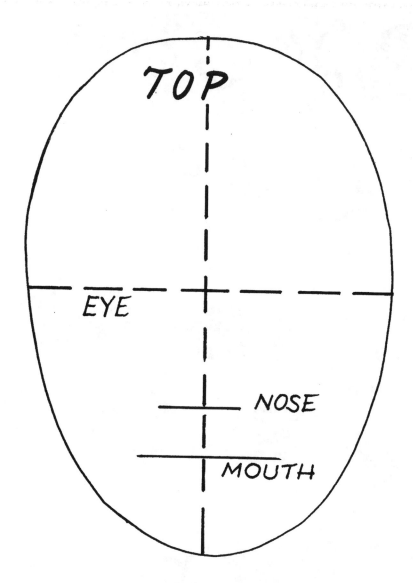

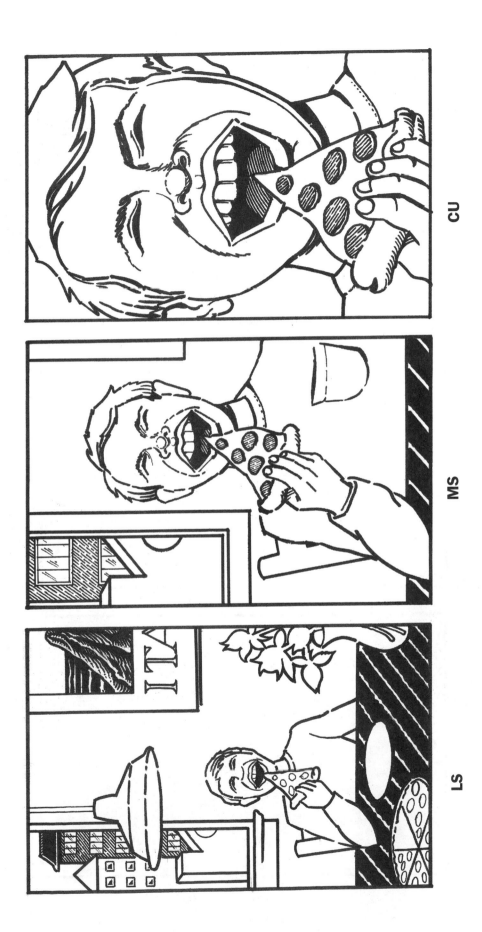

Top

3.

2.

1.

1. Window

It's usually located on the wall, but not necessarily. It may or may not have curtains or a shade, but it surely shows the view of a large mountain in full volcanic eruption.

2. Painting

There's a large painting. Like the window, it's usually on the wall, but not necessarily. It's the Ghiradelli's most recent purchase. You decide what the painting looks like. Is it a portrait? A series of geometric shapes? The sun? An alien? Does it have an ornate, carved wooden frame, or a simple modern one? You can draw the painting and it's frame anyway you like, but remember: it's worth a lot of money.

3. Lamp

There's a tall floor lamp somewhere in the room. It may have a shade, but it doesn't have to have one. It can be symmetrical or asymmetrical. It can be geometric. It could be an ostrich—anything goes—but it needs to be a light source.

4. Rug

There's a rug. (Oriental? Rag? Highly patterned? Shag? Flying carpet?)

5. Chair

Rocker? Bean bag? Throne? "Musical?"

6. Snake

There is a critter in the Ghiradelli's neighborhood who likes nothing better than to ingest large paintings. His name? Sly, the snake. Sly has no trouble getting into the "weird room." He waits 'til the Ghiradelli's are out of town. There's always a new painting—their latest purchase—hanging on the wall. "Yum!" ("Dinner" as he likes to think of it.)

7. The "Guard Creature"

The Ghiradelli's aren't stupid. They know about Sly. Whenever they leave town, their "guard creature" is on duty. His job is to protect the painting. He could, of course, be a guard dog. He could also be the Loch Ness Monster or Big Foot or Good Dog Carl or...

8. Cracks in the wall

We're not sure what caused them. The erupting volcano? A recent earthquake? The cracks may be very minor, or they may seriously threaten the structure that houses the "weird room."

School Visits and Courses for Educators

Also available through Klassroom Kinetics: School visits and presentations for educators with Roger Kukes.

Roger Kukes School Visits (K–8)

- **"The Power of Art"** (All School Assembly)
 - Showcases drawings and animation by Roger Kukes.
 - Presents exemplary drawing and writing projects by elementary age artists/illustrators.
 - Tips on how children can improve drawings.
 - Underscores the value of practice and persistence.

- **"Anyone Can Draw"**

 Age appropriate, hands on drawing presentations for up to 60 students focus on drawing fundamentals and stimulating creativity.

Courses for Educators

- **One Day Presentations for Educators**
 - Integrating the Visual Arts
 - The Art-Math Connection
 - Connecting Drawing and Writing

- **Graduate Level Courses for Educators**
 - Art Across the Curriculum
 - Connecting Art and Mathematics
 - Encouraging Reading and Writing Through Art

Please inquire:

Klassroom Kinetics
Roger Kukes
3758 SE Taylor Street
Portland, OR 97214

tel: (503) 235-0933
e-mail: kukes@teleport.com

Photography: Barb Simmons